HENRI ROUSSEAU

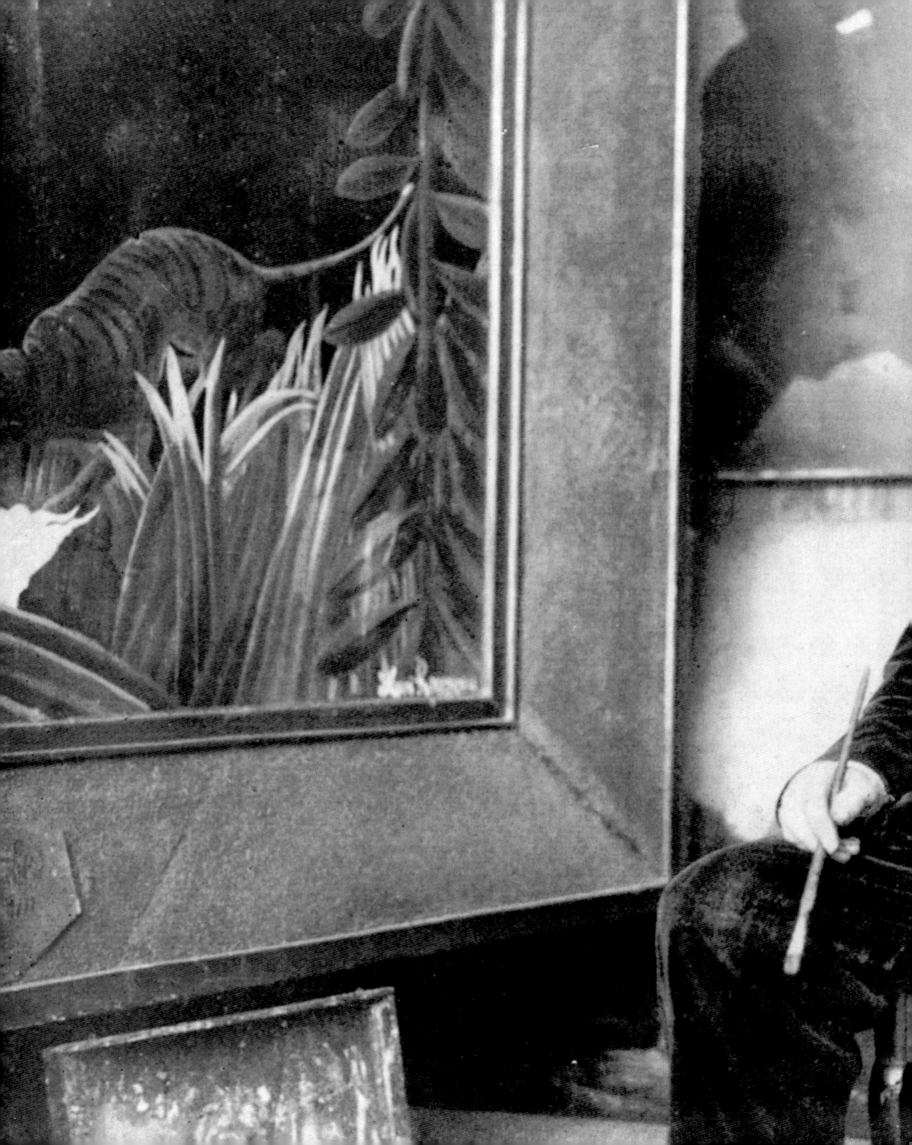

Götz Adriani

HENRI ROUSSEAU

YALE UNIVERSITY PRESS

New Haven and London

First published in German in 2001 by
DuMont Buchverlag Köln, as a catalogue
to accompany the exhibition
*Henri Rousseau, der Zöllner: Grenzgänger
zur Moderne*
[Henri Rousseau, The Customs Officer:
Crossing the Border to Modernism]
Kunsthalle Tübingen, 3 February–17 June 2001
Conception by Götz Adriani
Supported by DaimlerChrysler

Edited by Karin Thomas
Designed by Birgit Haermeyer
Translated by Scott Kleager and Jenny Marsh
Design revised by Jane Havell
Origination by Litho Köcher, Köln
Printed in Germany by Rasch, Bramsche

Library of Congress Control Number: 2001091773
ISBN 0-300-09055-2
Catalogue records for this book are available from
The Library of Congress and The British Library

pp. 2–3: Henri Rousseau in his studio, Paris 1907
Opposite: Henri Rousseau, c. 1880

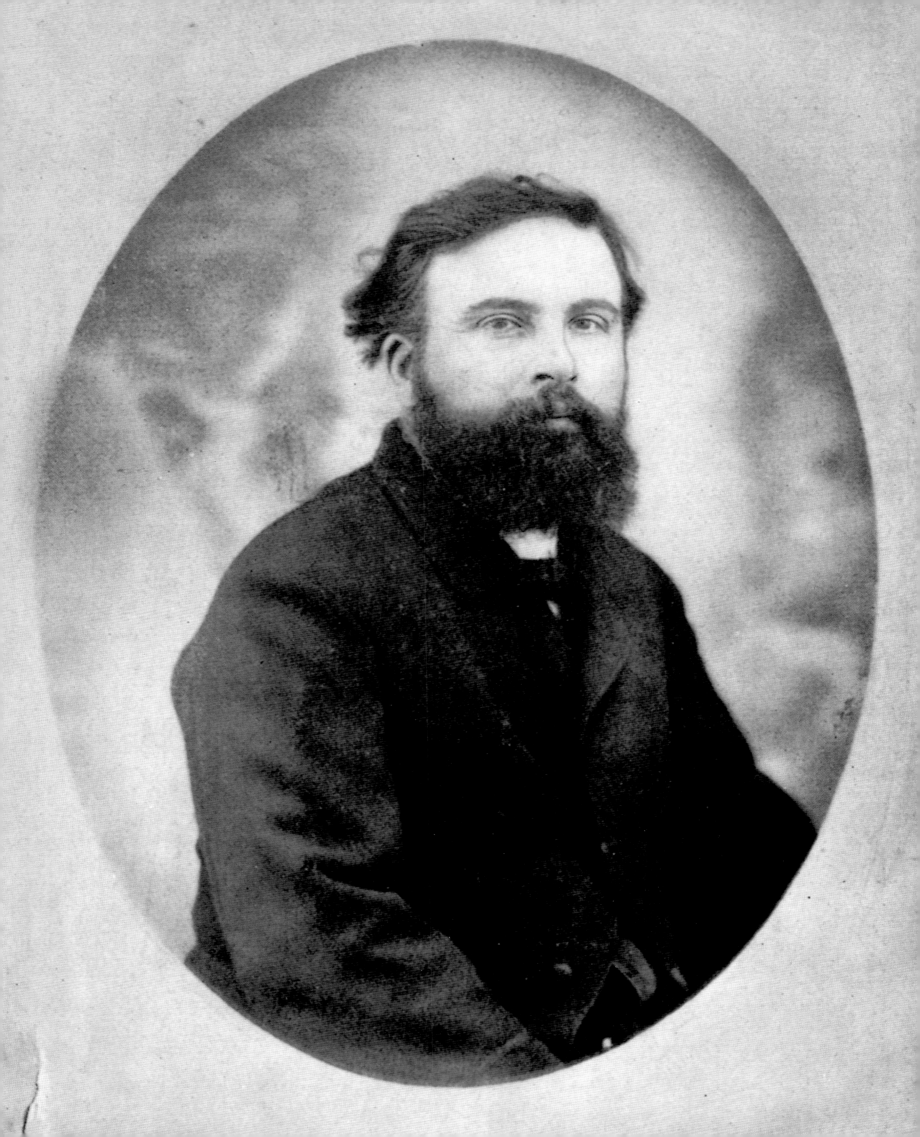

Lenders to the Exhibition

Basel	Öffentliche Kunstsammlung Basel, Kunstmuseum; Katharina Schmidt	Munich	Städtische Galerie im Lenbachhaus; Helmut Friedel, Annegret Hoberg
Basel/Riehen	Fondation Beyeler; Ernst Beyeler	Nagano	Harmo Museum, Shimosuwa; Takako Seki
Berne	E. W. K. Collection	New York	The Metropolitan Museum of Art; Philippe de Montebello
Bielefeld	Kunsthalle Bielefeld; Thomas Kellein, Jutta Hülsewig-Johnen	New York	The Museum of Modern Art; Kirk Varnedoe, Cora Rosevear
Bönnigheim	Museum Charlotte Zander	New York	Solomon R. Guggenheim Museum; Thomas Krens, Lisa Dennison
Buffalo	Albright-Knox Art Gallery; Douglas G. Schultz	New York	Collection of Joan Whitney Payson
Cleveland	The Cleveland Museum of Art; Katharine Lee Reid, William H. Robinson	Paris	Musée d'Orsay; Henri Loyrette
Columbus	Columbus Museum of Art; Irvin M. Lippmann	Paris	Centre Georges Pompidou, Musée national d'art moderne; Werner Spies
Detroit	The Detroit Institute of Arts; Graham W. J. Beal	Paris	Musée Picasso; Gérard Regnier
Düsseldorf	Kunstsammlung Nordrhein-Westfalen; Armin Zweite	Paris	Fondation Dina Vierny; Musée Maillol
Frankfurt am Main	Städtische Galerie im Städelschen Kunstinstitut; Herbert Beck, Sabine Schulze	Philadelphia	Philadelphia Museum of Art; Joseph J. Rishel
Göteborg	Göteborgs Konstmuseum; Ingmari Desaix	Pittsburgh	Carnegie Museum of Art; Richard Armstrong
Hamburg	Hamburger Kunsthalle; Uwe M. Schneede, Ulrich Luckhardt	Providence	Museum of Art, Rhode Island School of Design; Phillip M. Johnston
Hombroich	Stiftung Insel Hombroich; Karl-Heinrich Müller, Kitty Kemr	Stuttgart	Staatsgalerie Stuttgart; Christian von Holst, Karin Frank-von Maur
Karlsruhe	Staatliche Kunsthalle Karlsruhe; Klaus Schrenk	Tokyo	The National Museum of Modern Art; Tetsuo Tsujimura
Kiel	Kunsthalle zu Kiel; Beate Ermacora	Tokyo	Bridgestone Museum of Art; Hideo Tomiyama, Katsumi Miyazaki
Laval	Musée du Vieux-Château; Marie-Colette Depierre	Tokyo	Setagaya Art Museum; Seiji Oshima, Yukihiko Ishii
London	Tate Gallery; Nicholas Serota	Washington	National Gallery of Art; Earl A. Powell III, D. Dodge Thompson
London	Courtauld Gallery, Courtauld Institute of Art; John Murdoch, Catherine Pütz	Washington	The Phillips Collection; Jay Gates
London	The Mayor Gallery; James Mayor, Andrew Murray	Winterthur	Kunstmuseum Winterthur; Dieter Schwarz
		Zug	Galerie Gmurzynska
Moscow	Pushkin State Museum for the Fine Arts; Irina Antonova	Zürich	Kunsthaus Zürich; Christoph Becker, Christian Klemm

plus other lenders who wish to remain anonymous

Contents

8 Foreword

13 Henri Rousseau
The Customs Officer: Crossing the Border to Modernism

41 Catalogue

272 Biography

276 References Cited

279 Exhibitions and Exhibition Catalogues

280 Index

282 Picture Credits

Foreword

The catchwords generally used in connection with Henri Rousseau are 'the Douanier' (customs officer) and 'naive'. These stereotypes have been in circulation ever since people first became aware of him in the 1880s. There are also vague associations with jungles on large-format canvases, which are regarded as 'typical' Rousseaus although they only amount to a fraction of his creative output. The anecdotes about the customs employee stigmatised as a 'Simplicissimus' (the hero of Hans Jakob Christoffel von Grimmelshausen's classic novel of 1668) who painted have become fixed components of the history of assimilation of the modern era. Such commonplaces, which have left behind images of Van Gogh's damaged ear, Toulouse-Lautrec's brothels and Gauguin's exotics, at least have the advantage that generations of interpreters can devote themselves to trying to correct them. Whether Rousseau spent his years in the civil service as a customs inspector or as a supervisor in the municipal toll office, whether he was inclined to naivety or not, has been sufficiently discussed in the literature.

The biographical evidence too has been explored in every direction and has proved fairly unproductive. Rarely has so little been known about a famous artist whose pictures have long since degenerated into clichés on posters, T-shirts and ties, so that legends have had to stand in for the missing facts. More was heard about him than was known about him. The truth of his biography was transformed – not least by Apollinaire – into fiction to such a degree that it is only partially possible to trace an existence that is but modestly documented by events. Even his first biographer, the German art historian Wilhelm Uhde, was forced to admit that 'we know as few precise facts about Rousseau as about many an artist of the Middle Ages . . . And it will be a long time before we know who this wonderful old man whom we knew and loved was, and what the scope of his work is.'

Following Uhde's fundamental monographic representation of 1911, authors such as André Salmon, Philippe Soupault, Adolphe Basler and Christian Zervos sought to dismantle the mountain of myths. However, more detailed knowledge about Rousseau's œuvre was first produced by Henry Certigny and Dora Vallier. The strong reception accorded to Rousseau's work in Germany on the basis of the Uhde publication – which, prior to the First World War, found expression primarily in Kandinsky's and Franz Marc's support for him as well as in the numerous acquisitions made by the collectors Paul von Mendelssohn-Bartholdy and Edwin Suermondt – continued later in the well-founded studies by Cornelia Stabenow and Eva Müller.

The aim of the Tübingen Rousseau project – part of a series that has included retrospectives of the work of Cézanne, Degas, Toulouse-Lautrec,

Renoir and Picasso – is to follow the two exhibitions that first presented Rousseau's art in an exemplary fashion. One of these took place in Chicago and New York (at The Museum of Modern Art in 1942, those responsible being Daniel Catton Rich and Alfred H. Barr. The other – under the aegis of Michel Hoog and William Rubin – was seen in Paris at the Grand Palais and in New York at The Museum of Modern Art in 1984–85.

As the third of the trio, this Rousseau retrospective in Tübingen can claim to present the artist's œuvre in a comprehensive, academic fashion for the first time in Germany, where smaller Rousseau exhibitions were organised by the art dealers Herwarth Walden in 1913 and Alfred Flechtheim in 1926. It is also our intention to make people aware of the Douanier as in truth a 'Grenzgänger' – somebody crossing the border – to modernism by comparing his paintings with works by other artists who admired him and who confronted his œuvre in completely different ways. I hope that such comparisons, never before seen in this manner, will make comprehensible Rousseau's status, not just in his own time but beyond it, for the protagonists of modernism – for Picasso, Delaunay, Kandinsky, Marc, Léger, Beckmann, Schlemmer, Max Ernst and others.

My grateful thanks are due to all those involved in this exhibition for the fact that we have succeeded in displaying Rousseau's artistic development through a cross-section of well-known and less well-known works on a scale that – apart from the Paris and New York retrospective of 1984–85 – is so far unrivalled. Our objectives would have been doomed to failure without the trust and kind cooperation of lenders who made major works from their collections available: here we name only Gérard Regnier, Henri Loyrette, Ernst Beyeler, Katharina Schmidt, Christoph Becker, Earl A. Powell, Katharine Lee Reid and Joseph J. Rishel. And it was thanks only to the help of friends that I was able to tackle this difficult project, especially Ev Sharf, Alexander Apsis, Ingeborg Henze-Ketterer, Heide Rentschler, Peter Nathan and Pieter Coray. As so often, I was supported by Hans Baumgart, not just as a representative of the sponsor and as director of the Daimler Chrysler Collection, but also as a friend and adviser. We worked together in many cases to convince people about our plan, which was sponsored by Daimler-Chrysler. Production of the catalogue was left in the capable hands of DuMont Buchverlag; my thanks to Gottfried Honnefelder, Karin Thomas, Peter Dreesen and Birgit Haermeyer for the beautiful book that is the result. Thanks too to my colleagues, particularly Gerlinde Engelhardt and Martin Mäntele, for their enormous efforts in preparing and realising the exhibition. Their commitment played a vital role in its success. G. A.

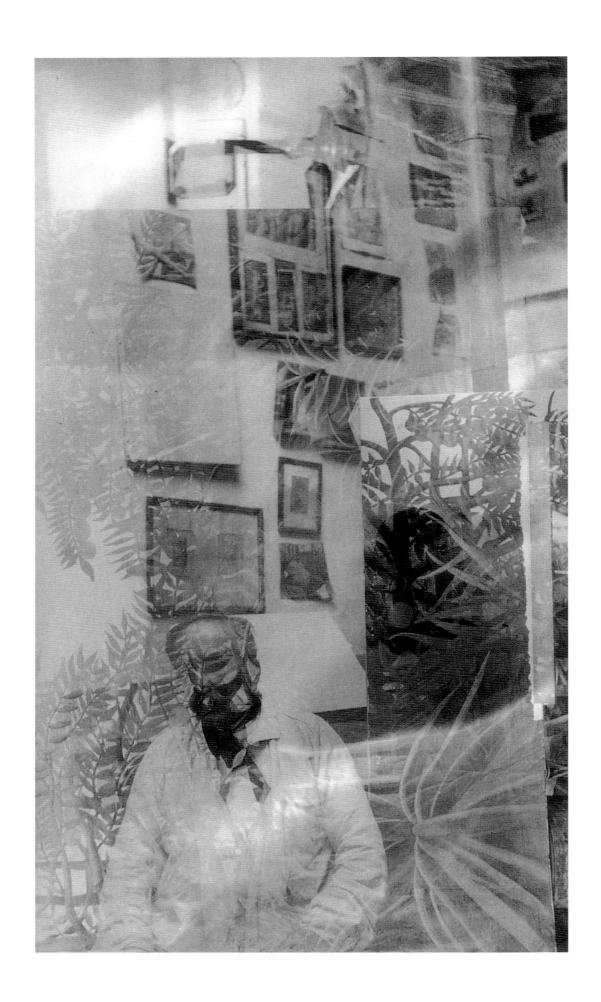

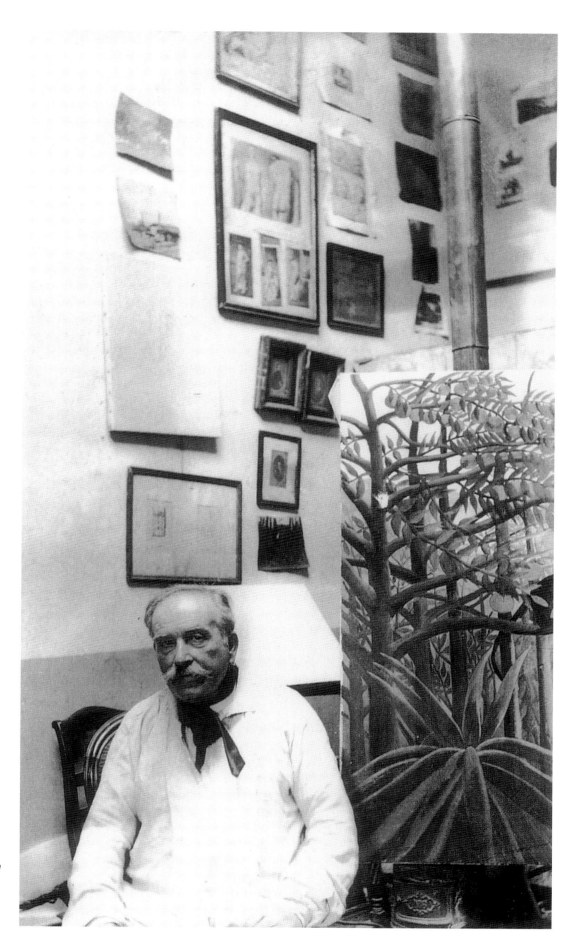

Pablo Picasso, *Rousseau in his studio, Rue Perrel 2bis*, Paris 1910
Musée Picasso, Paris (left page: double exposure)

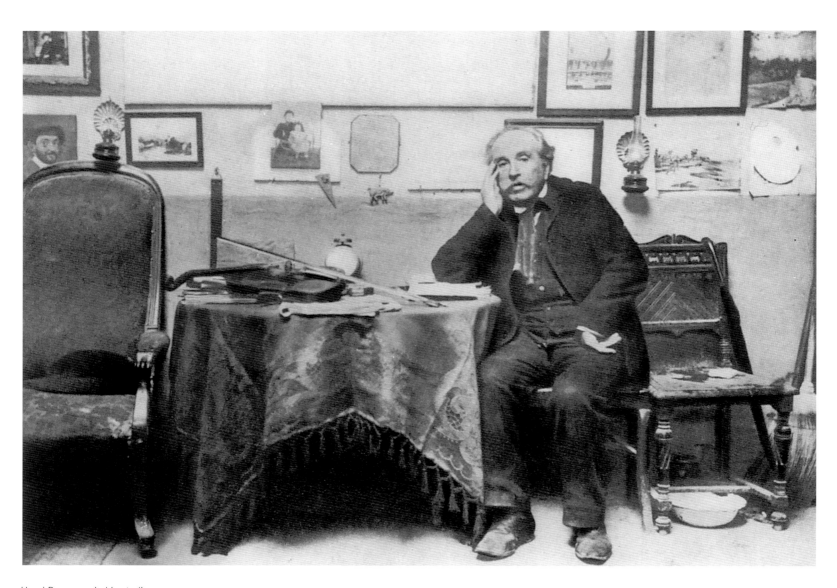

Henri Rousseau in his studio
apartment, Rue Perrel 2bis,
Paris 1908

Henri Rousseau

The Customs Officer: Crossing the Border to Modernism

Beginning with Van Gogh, we are all to a certain extent (regardless of how great we want to be) autodidactic – indeed, one could almost say, naive – artists. Artists no longer live within a tradition, and each of us has to create his own possible modes of expression. Every modern artist possesses the right to create his own vocabulary from A to Z.

Picasso[1]

I

Rousseau lived and worked in two worlds. A customs officer (nicknamed 'Le Douanier' by the poet Apollinaire), he felt deep in his soul that he was destined for a higher calling. He managed to walk the thin line between his lowly job and his complete dedication to the art of painting without losing his balance.

He was born in 1844, in a medieval gatehouse to the French town of Laval, Mayenne. Traffic passed before the eyes of the growing boy in rhythm with the well-ordered life of a small town; according to Alfred Jarry, Laval consisted of a gentle arrangement of 'monasteries, artisans' workshops, military barracks, charitable institutions, churches and well-to-do neighbour-hoods'.[2] The coming and going of people and possessions was also a feature of Rousseau's life at the customs office in an outlying district of Paris where, at the age of 22, he began his career as an inspector.

When he dared to leave the financial security of this position to dive recklessly into the adventure of being an artist, he risked crossing the border between reality and fantasy. To convert his poverty into artistic riches, he took the prejudices of the petty bourgeoisie in which he was imprisoned and turned them to greatness through an all-encompassing passion for painting. From the restrictions of his professional life he was able to defect into a world of art that knew no boundaries. The limited outlook of his origins sought its counterpart in an openness that promised a maximum of independence. At the end of the nineteenth and the dawn of the twentieth centuries, the future promised to be a time in which traditional social barriers would be ruthlessly torn down and only a few indispensable professions would endure.

Unconstrained, Rousseau the painter crossed the borders of all artistic genres. His interests were wide-ranging: he was dedicated to music and poetry no less than to the visual arts. Spurred on by an unshakeable belief in

The references cited below are given in full in the bibliography, pp. 276 ff.

1 Gilot-Lake 1987, p. 59.

2 Giedion-Welcker 1960, p. 135.

13

his own abilities, he tried his hand at poetry and drama, composed waltzes and played the violin. In order to pad out his paltry earnings, he gave lessons in watercolour painting and music, took part in street concerts and played his violin in the private courtyards of Paris.[3]

What stands out from the half-dark of this marginal existence is the substantial body of paintings which, with the exception of a few early attempts (nos 1–5), was created between 1885 and 1910. For Rousseau, his oeuvre compensated for things that were denied him – social and material success, professional recognition, family happiness. Painting helped him to step out of an almost unseen existence, to make the inconspicuous worth seeing and to obtain the remote from the familiar. As an artist, he was able to convert the everyday into the unusual, to bring fantasy and extreme precision together in dialectic tension.

In order to create a universe from the attitudes and views of the low-ranking civil servant, a universe into which his wishes, hopes and fears could flow, Rousseau needed a great deal of self-confidence. Just how much he cultivated this quality can be seen in a revealing text that he sent, unprompted, to the publisher Girard-Coutances on 10 July 1895, in which he made an assessment of his own worth as an artist for the coming century that turned out to be entirely correct.[4] Girard-Coutances had published a collection of short biographies of writers which he called *Portrait of the Next Century*, and was planning a companion volume for visual artists. Rousseau's exposé, written in the third person, moves between a sober listing of facts and a self-assessment in highly wrought language. It gave a picture of the artist written with the greatest possible objectivity, but ended with this subjective declaration: 'He was born in Laval in the year 1844 and at the beginning, due to the humble circumstances of his parents, had to pursue a different profession from the one to which his artistic inclinations most directed him. Because of this, when, after several disappointments, he was able to dedicate himself to art, the decision to do so came solely from himself; he had no teacher other than nature and some advice from Gérôme and Clément.' Impelled to earn a living and lacking an appropriate artistic education, it was not until 1885 that this self-taught man felt confident enough to go public with two paintings (now lost) and begin his career as an artist. He attributed his new calling mainly to nature, but also to advice from two Academy artists popular among the art-loving public.[5] Emphasising his originality as a realist, he went on: 'Only after much difficulty was he able to make a name for himself among the many artists who are now gathered around him. He has perfected more and more the style he represents and is becoming one of our best realistic painters . . . He will never forget the members of the press establishment who were able to understand him and who supported him in his moments of discouragement, and who thus have helped him to become what he had to become.'[6]

Rousseau could be gullible, tolerant and helpful, but also difficult when his own interests were at stake. On trial in 1907 for cheque fraud, he insisted that his superiors at the customs office who had given him the opportunity to become an artist were patriots: 'My superiors at the city

3 Apollinaire 1914, pp. 7, 11, 17 (pp. 627 ff.).

4 Soupault 1927, pp. 11 ff.

5 In this connection, in a letter that Rousseau wrote on 13 December 1907 he stated: 'I was almost forty when I entered the realm of art for the first time. I was encouraged by painters already famous at that time such as Gérôme, Cabanel, Ralli, Valton, Bouguereau and others. Even Monsieur Fallières, who was then the Minister for Education and is today the President of the French Republic, was asked by his friend, the deceased painter Clément, to help me and support me. Monsieur Clément was the director of the Académie des Beaux-Arts in Lyon; he was my neighbour at Rue de Sèvres 135, where I lived for twenty years.' – Vallier 1961, p. 30.

6 Soupault 1927, p. 13.

customs office gave me an easier job so that I could work undisturbed. For this I am thankful to this day. They helped a son of France, our beloved country, who had only one goal in mind: to raise the fame of France in the eyes of the world.'[7] At another point, he wrote to his judge: 'According to the late Clément, if my parents had believed in my talent as a painter . . . then today I would be the most famous and the richest painter in France.'[8] He told his defence counsel: 'If I am found guilty, then it will not be I who suffer an injustice: art itself will suffer.'[9]

Rousseau did not even consider the possibility of failure, a concern that occupied Degas and Cézanne their whole lives. Without a trace of self-doubt, he was buoyed up by the evidence of his own abilities. For the most part, this spared him constant searching for what he needed – he was so confident that he simply expected to find it. He was busy enough bringing just a small part of the persuasive power of his artistic demands to his paintings, and holding his own against those who rewarded his seriousness with peals of laughter.[10]

Rousseau's character as an artist did not at all accord with what French society of his time imagined the artist to be – whether an Academician, a Salon virtuoso, or a rebel and Bohemian. Rousseau was, and always remained, an honest son of France; content with his subordinate social position, he performed his artistic activities with the same conscientiousness as he did his civil service. Proud of his service to art and country, this man from the provinces favoured a world of exceptional order and cleanliness, even when living in the city. In this world he placed correctly trimmed trees and hedges between rows of houses where people strolled in their Sunday best or posed in high spirits. Captured on canvas as dignified versions of themselves, his subjects were for the most part recruited from his own neighbourhood and their patronage afforded Rousseau a small level of material support (nos 11, 12, 16, 36–38). Even after he was honoured as a 'Son of the Grand Nation' and had finally achieved respect from colleagues, art dealers and collectors, Rousseau saw no reason to renounce his social class and its long-standing values. His first biographer, the German Wilhelm Uhde, characterised this as 'the subordinate, concierge-like character of his existence',[11] while Fernand Léger wrote that 'our little father Rousseau, the great painter, had a respect for the French hierarchy the likes of which only a member of the petty bourgeois and a former civil servant could have. A long-standing tradition or social rank was of great importance to him.'[12]

The discrepancy between the civil servant's mentality and the expansive gesture of the artist defined Rousseau's personality. His character swung between arrogance and unselfishness; often the result was awkwardness, because he could choose only between shyness and aggression. Max Beckmann spoke of him as the 'Homer in the porter's lodge',[13] referring both to these contradictions of character and to his more or less unconscious wisdom; Rousseau compensated for his behavioural oddities with depth of feeling and richness of artistic sensibility.

Any characterisation of Rousseau entirely denying his naivety would be both misguided and misleading, and would make him seem too one-sided.

7 Certigny 1961, p. 302.

8 Ibid., p. 305.

9 Ibid., p. 307.

10 'Few artists have been more derided in their lifetime than the customs officer,' reported Apollinaire, 'and few people have stood up so calmly to the mockery and the impolite and coarse expressions that were heaped upon him. This composed old man always maintained the calm of humour, and as a consequence of his happy disposition he saw, even in the ridicule, the interest that in his opinion even those most ill-disposed towards him must take in his work. The Douanier was conscious of his power. A couple of times he let slip the remark that he was the most powerful painter of his time. And it is possible that in many points he was not even so very mistaken.' – Apollinaire 1914, pp. 24 f. (pp. 637 f.).

11 Uhde 1911 and 1914, p. 25.

12 Verdet 1955, p. 65.

13 Beckmann 1984, p. 141.

True, he could be stubborn and cunning, but he was good-natured and had a tender side; in his dealings with people he was both self-critical and intuitively emotional.[14] But when the opportunity presented itself, did the old painter flirt with a fake naivety, perhaps following the advice of the two Academicians?[15] Or did an unspoilt mind, one that lacked a certain sharpness of intellect, adopt naivety in order to achieve a certain distance from reality? Whatever the case, he may have deliberately created a protective zone, similar to the confusing behaviour of Van Gogh who, on 24 March 1889, wrote to his brother Theo that he was willing to take on the role of an insane man, just as Degas had taken on the trappings of a notary.[16]

Those who propagated the notion that Rousseau was a naive innocent have successors who still maintain the fiction of the 'painter pure of heart'.[17] Often they do not see that the apparent simplicity of his 'naturalness' is contradicted by the fascinating variety of artistic possibilities that were open to him; he is one of very few painters who were able to turn their well-meaning tendencies into art. He claimed for himself an authentic, natural gift for painting through a somewhat starry-eyed view of the world; but this was an attitude that gave him the freedom to brave convention, and that lent his paintings an unorthodox form and a courageous use of colour. Attempts to impute to him a romantically transfigured naive innocence are doomed to failure.

Beginning in 1886, Rousseau exhibited almost every year at the Salon des Artistes Indépendants, the jury-free Salon in which independent artists showed their work in public (see no. 7).[18] It is hardly surprising that those who saw his paintings for the first time felt challenged by this dilettante, who claimed to be able to create works of art and who understood that viewers saw his works, surrounded as they were by representative paintings, as an audacious act in and of themselves, and who used this fact as a conscious act of self-assertion. From the moment he first exhibited, critics in magazines and art journals tried to outdo each other with negative descriptions of his work, using terms such as 'naive', 'childlike', 'primitive', 'intuitive', 'laughable', 'grotesque' and even 'crazy'.[19] To them it seemed unthinkable that an artist untouched by current notions of taste, without any knowledge of the trends in painting, could exhibit his works in a contemporary context as a progressive creation based only on his own self-assessment. These critics could see no intellectual scheme behind his relief-like images, and sought to disqualify them as old-fashioned. They criticised what they considered to be a lack of reflection and an absence of technical perfection; such amateurism, they thought, deprived his paintings of any artistic character. They intentionally overlooked the fact that Rousseau was one of art's first autodidacts; to him, art was more than just an outlet for the yearnings of the petty bourgeoisie, the hobby of a 'Sunday afternoon' painter. Rousseau steadfastly believed in his own abilities as a true artist.

However, from 1887 onwards, a few voices could be heard acknowledging that the 'primitive' Rousseau was a serious independent painter.[20] They were quick to draw an analogy between him and the so-called 'primitive' Italians of the pre-Renaissance period. Indeed, his concentration on the

14 The critic Gustave Coquiot, who had known Rousseau since 1888, remarked: 'All those who knew Rousseau well, remember a man who could be unbearable and whose spitefulness exceeded everything.' – Coquiot 1920, p. 130.

15 Rousseau wrote on 1 April 1910 to the critic André Dupont: '. . . if I have kept my naivety, then that is because Mr Gérôme, former professor at the Ecole des Beaux-Arts, and Mr Clément, director of the Lyon art school, always impressed upon me that I should do so. In future you will no longer find that astonishing. People have also told me that I do not belong to our century. I cannot now change the manner that I have achieved through intensive work, as you can imagine.' – Apollinaire 1914, p. 57.

16 *Vincent Van Gogh. Sämtliche Briefe an den Bruder Theo*, edited by Fritz Erpel, Berlin 1965, 4, p. 258.

17 Uhde 1947, p. 24.

18 Coquiot 1920, pp. 130 ff.

19 Müller 1993, pp. 13 ff., 67 ff.

20 Apollinaire 1914, pp. 12 f. (p. 630); Vallier 1961, p. 35.

obvious possesses something of the elemental quality of discovery to be found in Trecentro and early Quattrocento painters of the Siena school. Those artists had closely observed the Gothic structures of their cities and the surrounding landscapes, until 1420 when Florentine artists began to replace their magical freshness with a procedure based on centralised perspective which would determine visual concepts in the western world for nearly five hundred years.

While Rousseau was initially criticised for being naive, he was later renowned for the very same attribute. His rejection of the standard procedure to give a subject depth – found in landscapes, figure paintings, historical paintings and still-lifes – by moving it visually back into the painting following the rules of centralised perspective, and his emphasis instead on colour and his favouring of two-dimensional and roughly drawn shapes constituted enough of a reason either to ridicule him or accept him completely. His passionate liking for the obects in his pictures might seem naive.[21] However, the precision with which he brought together his special vision and his desire for exact rendering were part of a conceptual method based on his particular ability to visualise in an unbiased way while perceiving what he saw intuitively. Behind the occasionally thought-out iconography of his compositions was always the desire to create a style of his own, one whose application was preceded by reflection. However, though his inherently visual logic bears witness to a systematic methodology, it is a logic dedicated more to intuition than to reflection, one that prefers to describe rather than explain, one that is based more on the perception of a subject than knowledge about it. Even if Rousseau's love of description tended towards exquisite exaggeration, his paintings never ended in the same simple style of many later naive painters who relied on his discoveries and canonised him as a kind of patron saint. In contrast to their obvious literalness, the candour of Rousseau's curiosity enabled him to sublimate his amazement at the newly discovered form through creative power.

21 Cooper 1951, p. 56.

II

Henri Rousseau was given a posthumous honour unique in the history of art. Three of his friends, all major artists in a modern movement that had become firmly established, erected a monument to him in 1912. Unspectacular in itself, it is none the less noteworthy because the singular rank accorded to Rousseau by modern artists is in great part due to the collaboration of these three to give him public recognition after his death. Robert Delaunay, assisted by Pablo Picasso, paid for a thirty-year licence on a grave for Rousseau, who had been buried in a pauper's grave in September 1910 (see nos 36, 37). Bearing an inscription by Apollinaire, spokesman for the Parisian avant-garde, the stone was carved by none other than Constantin Brancusí.[22] Seldom has anyone been remembered in such a 'prominent' way.

22 Apollinaire 1914, p. 29 (p. 641).

With their homage, these important young artists documented the role that Rousseau played in the advent of the Modern Movement, recognising him as one of its true fathers, along with Van Gogh, Gauguin, Cézanne, Kandinsky, Léger and De Chirico.[23]

'Père Rousseau', as his young admirers termed him, was in no way pre-destined to play such a role. An admirer of the celebrated 'derrière-garde' of the late nineteenth century, he could scarcely understand the esteem in which the avant-garde held him during the last years of his life. In age Rousseau was of the same generation as the Impressionists; artistically, however, he was closer to the Neo-impressionists and the Symbolists. But neither the struggle for recognition nor the methods of these different groups of artists earned Rousseau's regard. He was not influenced by the poetically veiled intentions of the Symbolists, nor did he have any under-standing of what the new century promised to bring. Between 1880 and 1914, when these new movements were upsetting the complacency of the Third Republic with an explosive mix of modernism, primitivism and anarchy, Rousseau remained himself and a singularity. He seemed to hover outside the major artistic groupings of his time – the systems encompassing works from Gérôme to Picasso, from Academy traditionalists to Impressionists, from Neo-impressionists to Fauvists and Cubists. Rousseau refused to adhere to any of these 'isms' and took no part in the artistic debates that accompanied the development of the art scene well into the new century.

On the contrary, he had a high regard for those artists who took part in the official Salon exhibitions and for whom the Paris crowds were so

Official Salon exhibition, Paris 1889, Palais des Beaux-Arts

enthusiastic. Despite increasing pressure from the non-sanctioned artists, those who were represented in the official exhibitions continued to be the major influence on the artistic taste of both high and popular culture until the turn of the century. Aided by grants from public funds, they were suc-cessful society painters who undoubtedly contributed to a boom in the art industry in general and who helped to improve the process by which works of art were marketed. Although Courbet, Manet and the Impressionists had revealed how trite and outdated most of their works were (making a strong case for other forms of art in the process), the specialists of the *pompiers* found a dependable and reassuring supporter in Rousseau.[24]

Besides contemporary stars of the art scene such as Bouguereau, Bonnat and the fashionable portrait painter Cabanel, Rousseau considered

23 Cf. Lanchner - Rubin 1984–85, pp. 37 ff., 35 ff.

24 Cf. note 5; this was also confirmed by Maurice de Vlaminck, who met Rousseau in 1908 at the art dealer's, Vollard: 'He was no academic, he was a splendid ignoramus . . . He owes not the slightest to either the masters of the past or those of the present: neither Greco nor Poussin, neither Corot nor Renoir or Cézanne; at the most the *Petit Journal Illustré*, some schoolbook or other on natural history or a book on botany. He loved Bouguereau and spoke of him to me with boundless admiration. Bouguereau was for him the greatest painter, nobody was his equal.' – Maurice de Vlaminck, *Portrait avant Décès*, Paris 1943; Rousseau 1958, p. 99.

his mentors to be the Orientalist Félix-Auguste Clément and the master of the 'neo-Greek' and desert lion genres Jean-Léon Gérôme. By claiming that they had 'advised' him, this self-taught artist was able to give the impression that he had had at least some academic training.[25] Whether or not the two Academicians had a real interest in Rousseau, and whether his claim was true in fact or mere wishful thinking cannot be determined with certainty. He might have met Clément, whose imposing house, 137 rue de Sèvres, was not far from where Rousseau lived,[26] but it is unlikely that he ever had any personal contact with Gérôme, who regarded everything outside the Academy and Salon as unimportant or, if important, as an object of derision.

While the Impressionists and the Neo-impressionists confronted the triviality of these Salon 'heroes' and were vehemently opposed to the perfectionism cultivated by the Ecole des Beaux-Arts, Rousseau's position was the opposite. He was all too willing to be recognised as part of the art establishment, but not if it meant being associated with a highly controversial type of painting that propagated a spontaneous brush stroke technique and that abandoned the complete visual representation of the subject in favour of an open-ended visual 'organisation' of it. Rousseau considered the 'professional' painter's goal to be the intentional representation of perfection of visual form. He wanted to emulate the Academicians' variety of subject – pompous histories and battle panoramas, melodramatic genre paintings, elegant portraits or decorative still lifes and landscapes – and to be remembered as an honoured and fashionable painter of the Third Republic. In short, Rousseau wanted to be part of an art movement that is today all but forgotten.

Luckily, our customs officer lacked the training to achieve this lofty goal, and he also lacked some important basic characteristics as a painter. Indeed, by refusing to adhere to any of the 'isms' of his time, Rousseau preserved his ability to express himself on canvas with complete freedom. Only in this way could he have become the individualistic personality to whom the best painters of his time gave their support – including Pissarro, Renoir and Redon, but also Toulouse-Lautrec, Gauguin, Seurat and even Signac.[27] Only in this way could he have become the painter who inspired the best of those who came after him, including Beckmann and Ernst (see pp. 123, 171, 175, 269). The reason his development was so different from the famous artists of the time was due in part to the fact that he did not become a professional painter until he was over forty. He had no systematic

Jean-Léon Gérôme, *Lion Lying in Wait*, c. 1885 The Cleveland Museum of Art

25 Soupault 1927, p. 12.

26 Cf. note 5; Certigny 1961, pp. 83 ff.

27 Perruchot 1957, pp. 23 ff., 37; Zervos 1927, p. 12.

CHARIVARI-SALON — PAR DRANER

Pour bien rendre combien Cendrillon trouve le temps long, le peintre l'a passée au laminoir.

Pour que l'allégorie fût juste, il aurait fallu que la Comédie parût moins longue que la Tragédie.

Se rappelant qu'on se nourrit pendant le siège de pain de sciure de bois, un jeune naufragé se soutient en mangeant une vergue.

EN RIBOTTE — par Ribot.

Crapaud nouveau modèle pour jeux de tonneau.

— Ça, Théo? Allons donc! C'est une forte commère, par Comerre.

A L'HÉRISSÉ.

SOUVENIRS SANS REGRETS.

« Ne me chatouillez pas... » Romance jouée par Mme Judic.

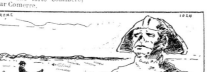

Prévoyant Sainte-Hélène, le grand homme, en voyant ce nez cassé, se dit : « V'là pourtant comme je serai un jour. »

— Ne regardez pas, ça m'intimide.

Exercice de haute école sur violoncelle.

« Ah! que les plaisirs son doux » Quand on a des clous » Plantes j' sais bien où ! »

Commande par le docteur X..., pour sa fameuse pommade Absalon régénératrice de la chevelure.

PEINTURE HÉRALDIQUE

LANDEMER ENGLOUTI PAR LES TERRES « Et le sable montait toujours! »

LA PEINTURE APPLIQUÉE A L'ENSEIGNEMENT DE L'ALPHABET

Le grand Inquisiteur hypnotisant son roi par la seule force de sa parole. La reine demande grâce pour lui.

Jules Draner, cartoons on the official Salon exhibition, published in *Le Charivari*, 6 May 1886

art education, no knowledge of art history or anatomy; even an adequate emulation of the techniques of the Academicians would have been beyond his abilities. While the Impressionists consciously revolted against the traditions and standards of the Academy, which they knew, Rousseau had to make do without them. He could not comprehend nor confront them in his paintings in the way that, say, the young Cézanne did so radically, putting all the traditions of art in doubt during his first decade, and spending the rest of his life struggling to conform to them in new ways.[28] Completely unfamiliar with the rebellion of Cézanne, Rousseau for the most part understood the limited nature of his abilities, and knew that he had to compensate for his lack of education with imagination and self-presentation. He must have admitted, to himself, that he wanted something he could not achieve. And what he was in fact able to achieve was something that for years hardly anybody wanted to see exhibited. But the gap between his goals and his abilities did not matter to the next generation, who judged him only by what he had achieved on canvas.

28 Cf. Götz Adriani, *Paul Cézanne 'Der Liebeskampf'. Aspekte zum Frühwerk Cézannes*, Munich 1980.

All attempts, therefore, to attribute Rousseau's visual cosmos, his suggestiveness and his bizarre audacity to any specific stylistic movement fail in the light of their incompatibility and nonconformity. Convinced of the importance of his task, this artist-painter created a space just large enough to satisfy the aesthetic needs and the directness of his mode of expression. To try to establish a line of development in the independence of his visual world, or to characterise his progression as a painter and then evaluate it by comparing it to the stylistic achievements of the nineteenth and early twentieth centuries are risky enterprises indeed. It seems that this late developer, who discovered his art outside the Academy, had just enough time to go back to the origins of a forgotten period of art, and to rediscover them. Misunderstood most of his life, Rousseau knew little of the world around him yet courageously opened himself to the unknown. He challenged indifference by putting at the centre of his artistic consciousness a powerful intuition that was not limited by a lack of critical reflection.

Rousseau's paintings, seen as a kind of folk art, offered an alternative to the dynamic art milieu of his time in which the very premises of art were being redefined. He himself was convinced of the path that he had set out for himself, and had neither the wish nor the ability to use contemporary developments to help find his own voice. The eloquence of his pictorial language was based on a vocabulary that had not yet been formulated, one that exaggerated without going overboard, that abstracted only to the extent that it did not impinge upon what seemed natural. He steadily improved his ability to translate this intuitive thinking into images on canvas. He became more and more able to give his subjects an aura of authenticity. He shortened the distance between the imaginary and the visual image by distinguishing ever more sharply between the two. Despite his employment of some stereotypes, his will to expression and his ability to explain this in his art became more and more closely unified.

As long as the art-loving public saw Rousseau as a laughable eccentric, the harder it was for the few to recognise the authority of his visual

creations. It is evident only in retrospect that the exceptional singularity of Rousseau's art saw with the eyes of the nineteenth century but was understood within the parameters of the art of the twentieth century: it possessed a modern sensitivity ahead of its time. Only those viewers open to his strongly abstract tendencies were able to keep his paintings out of the currents of naivety, and to assign them to the place from which the stylistic attributes of modern art evolved.

III

It is surely one of art history's paradoxes that Rousseau's almost reactionary aesthetic orientation, supported by values he firmly believed to be unshakeable, found expression in methods that were strikingly revolutionary. It was not Rousseau's intention to revolt against conventional, or even bad, taste, as embodied in the attitude of Courbet and especially of Cézanne in the 1860s. On the contrary, Rousseau made an effort to conceal his inability to emulate the standards required by the Academy. Because the 'rules' of art were out of his reach, he compensated by developing a style and voice that were appropriate to himself as a painter. His belief in his abilities gave him the freedom to pursue quasi-naturalistic or anti-illusionist creative principles, which were relatively easy to realise.

Rousseau's somewhat slow intuition could not match the speedy ingenuity and the obsession with detail of those he sought to emulate, and he tended from the beginning to deviate from their methods anyway (methods that had already been largely discredited by the Impressionists), and these qualities irritated most exhibition-goers. The Parisian art public – spoiled by Salon virtuosos and gradually becoming accustomed to the innovations of the Impressionists – were scared off by the 'artlessness' of Rousseau. A painter who avoided a bold brush stroke, who preferred parallel planes to spatial depth and who contrasted colour in unusual ways operated outside traditional notions of artistic taste. An *ignorant* who seemed to lack understanding and who made no effort at a convincing portrayal of the human body (a requirement of European art since the Antique period) could not find acceptance in his own time.[29] Measured by such academic criteria, Rousseau's paintings are indeed undistinguished, even clumsy, works. Nevertheless, their calculated style created the basis on which twentieth-century artists were to claim 'artlessness' for themselves.

By the middle of the 1880s even popular Salon artists had begun to use Impressionistic techniques, and Rousseau's paintings were scorned for lying outside them. He mistrusted their dynamic expression of realism, as well as their open-ended visual systems. In contrast to the intentions of the Impressionists, Rousseau wanted to transmit to canvas his own way of seeing, one that was not filtered through methodological processes, and to present it as precisely as possible – in clear colours and unmistakable forms – to as many people as possible. It was also his intention to make the viewer more

29 Concerning this we learn from Gustave Coquiot, who was a regular visitor to the exhibitions of the Indépendants: 'The roars of laughter that Rousseau's paintings provoked, even though the hanging committee had already banned them to the chilliest corners of the exhibition, still ring in our ears. Thanks to a system of usefully positioned puddles of water, Rousseau's works were made more or less inaccessible, but the pranksters and jokers who prepare their stock of witticisms for every Salon went looking for them. And when they eventually found the pictures, then the huts were rocked and shaken by gales and explosions of laughter.' – Coquiot 1920, p. 131.

conscious of the importance of how content was expressed through a combination of form and colour. The concerns of the Impressionists – the play of light, chance, visual fragmentation – were stricken from his visual vocabulary; instead, he used structures to convey completeness, uniformity and stability. The idea of visual dissolution in painting, based on the notion that the moment cannot be grasped visually in its entirety, was returned by Rousseau to a solid objectivity, which was clearly outlined and coloured. He sought to capture in a profound way the unmistakable visual condition of things, and to keep them intact.

The sarcastic comment of the art critic Georges Clarietie that a work by Rousseau 'resembles the window of a fruit shop'[30] is correct in the sense that the artist struggled, as a shopkeeper would, to present his products constantly in full abundance and at their best. They were placed in the light so as to appear like real things. Wherever possible, Rousseau avoided oblique or abbreviated views of his subjects. Nothing should deviate from the reality, and nothing should be lost in the distance or to the shadows. For Rousseau, an illusionistic impression caused by distortion was unthinkable.

By employing light to capture diverse phenomena of time, and centralised perspective to establish the congruence between empty space and matter, relativistic visual images aim to present a complete moment to the viewer. In contrast, Rousseau sought to bring the complexity of things closer, to focus on several observable moments at once and, from the sum of different visual angles, to achieve as complete an impression of a subject as possible. In order to reproduce motifs more completely and to make them easier to understand, he found it necessary to disengage them from perspectival space and to remove from them the play of light that would have lent them a sense of existence at a particular moment in time.

For centuries it had been normal practice for artists to visualise and present reality on canvas organised around a central point in space. The discovery that visual 'reality' allows for other forms of perspective cannot be attributed exclusively to Cézanne, Picasso and Braque; Rousseau contributed as well. While Cézanne was breaking down the visual organisation around a centralised perspective – thus abrogating a world view that had survived intact from the early Renaissance in Italy[31] – Rousseau struggled hard to master perspective at the beginning of his career, but found it beyond him. With time, however, perspective became easier and easier for him to ignore. Because he never learned how to use the methods that, according to classical notions, would enable him to dispose of his visual images 'correctly', he felt forced to find solutions that would not make this deficiency so obvious. He was never confident in employing centralised perspective because he had only a rudimentary understanding of how to apply it in his paintings. The notion of an illusory space opening up over the subject corresponded neither to his visual experience nor to the intensely reflective images he brought to canvas. Centralised perspective organisation, with its points of intersection and conscious obscurities, could not have been the intention of a painter whose explanative power was based on a genuinely different way of seeing things – someone who, by his own

30 Perruchot 1957, p. 65.

31 Cf. Fritz Novotny, *Cézanne und das Ende der wissenschaftlichen Perspektive*, Vienna 1938.

estimation, wanted to see his way within the frame of the painting. His realist tendencies gave intuitive categories preference over thought-out facets: he believed that spaces that could be directly experienced by the viewer were more important than spaces that were hypothetically construed. So immediate was his method that he was almost able to renounce centralised perspective completely. Instead of taking steps to centre his spatial organisation, Rousseau used a system that centralised content by emphasising vertical, horizontal and oblique views of the subject.

Because his perspective was improvised in this way, Rousseau removed illusion from the field of vision. And because he dropped the control mechanisms of a centralised vanishing point, he was able to unravel visual continuity in such an expansive way that it became an artistic construct, if an imperceptible one. His many-sided spatial dramaturgy was conceptual rather than illusionary: it employed paths and rivers or rows of trees or houses as mere adaptations of the notion of centralised perspective. The result was that the traditional aspects of organisation in his paintings seem to want to fall apart – and it is for this reason that his work was of great interest to the Cubists.

Viewers of his paintings have trouble orienting themselves in these visual spaces, which were adapted to the requirements of the surface. Only now and then does he offer help by way of an axis to hold things together. Visual barriers make things more difficult: it is impossible for viewers ever to escape into endless distance. The extension of space remains undefined; discontingencies cross the continuum of the painting in the form of motifs clearly separated from each other. The importance of distance and certain size relations have been renounced. Rousseau altered location, and sequential and proportional relationships according to need. Foreground abruptly turns into background and background into foreground. Now and then, terse angles of perspective cut through the continuum, created by verticals and horizontals. A net-like structure encompasses the relief-like planes of the painting without making a commitment to spatial extension. Orthogonal principles are given preference over perspectival elements, which – consisting of architectural or landscape features – are put together like the scenery of a play and then placed in a neutral stage-like lighting.

This neglect of perspectival elements allowed for a more dynamic handling of the painted surface. Landscape motifs, for instance, were enriched by being shown from various angles, either as wide expanses or as worm's or bird's eye views. Commuted to the surface are steep-seeming streets, rivers bursting with water, and towering trees and buildings that slope up or down. In the visual spaces of Rousseau's paintings, infinite depth is transformed into finite visual spaces that play themselves out in two dimensions. Indeed, the tension between these surface elements is often the painting's determining principle – it is the basic form of depiction and everything depends on its interactions. The symmetrically or isocephalically correct placement of subjects on the surface, which allows figures and objects to come forwards or go back according to their importance, was more important to Rousseau than their 'correct' placement within space.

Corresponding to this reproduction of three-dimensional figures in space, and in tense accord with the two-dimensionality of the painting's surface, is Rousseau's handling of light, which is usually frontal and uniformly bright. Although the intensely colourful sphere of a sun or moon is a well-known part of his inventory, nevertheless we look in vain in these crystal-clear paintings for either a natural falling of light or even a use of the effects of light. In order to avoid any change in the form of his subjects, Rousseau manipulated light to shine on them in a diffuse, strangely indifferent way, almost to the point of being completely devoid of shadows. The source of the light is hardly ever locatable.

The light is, however, tranquil, lending powerful luminosity to his colours, which are an important characteristic in all of Rousseau's paintings. He was careful to distribute colours in a way that achieves a planned density; colours usually play an equal role, and are hardly ever irregular or impulsive. His colourfully rhythmic constellations were put down on sketched areas, in which a smoothed surface betrays neither the perception of brush stroke nor the different characteristics of the materials used. Even when the individual values of local colours are intensified by contrast, Rousseau's colour schemes in their totality are always characterised by a balanced calm. This was an artist who could express himself with only a few colours, mixed from standard paint tubes.[32] His palette was mostly cool, but it did possess some warm tones. Intensive black and an unbroken white form the outer limits of his spectrum, between which are suspended full shimmering nuances of green, turquoise, sumptuous variations of red, as well as a splendid contrast between blue and yellow. Intense, colourful energy is expressed through piercing tones that are either complementary or dissonant. At the same time, he manages to achieve a calmness by bringing it all into balanced harmony. Rousseau's preference for small dabs of natural green was contrasted with large areas of an unnatural black (sacrilege to the Impressionists, but which Rousseau lent an authority that was approved by Gauguin and others[33]). This combination of black and green was also addressed by Robert Delaunay, who wrote: 'The black areas are spaces without light that seem to the eye to be prismatic colours with no affinity to each other. This black shines and lives in the middle of a thousand green areas that combine to form trees, hedges and forests. Rousseau did not copy the outer impression of a tree. He created an inner and rhythmic totality that presented the true, pure and essential relationship of a tree, and its leaves, to the forest. He reproduced contrasts by adding a whole spectrum of green tones whose abundance bear witness to a near-scientific knowledge of his métier.'[34]

32 Maximilien Gauthier gave more precise details about their composition which are taken from the books of Paul Foinet, Rousseau's paint supplier: silver white, ultramarine, cobalt blue, deep red, yellow ochre, ivory black, Pozzolana red, raw Sienna, raw Terra d'Italia, emerald green, vermilion, Prussian blue, Naples yellow, chrome yellow. – Perruchot 1957, p. 101.

33 Salmon 1927, p. 18.

34 Delaunay 1920, p. 229.

IV

Although Rousseau does not, in the history of art, occupy the position of Cézanne (between Impressionism and Cubism), he was similar to Cézanne

in that he forced the forms of nature to conform to his own visual pre-requisites. 'Without ever referring to style and tradition, Rousseau was richer in this respect than most of the painters of his generation,' Robert Delaunay remarked in 1920. 'A painting was for him first and foremost a surface with which he had to deal physically in order to project his thoughts on to canvas.'[35] Out of this awareness of style, Rousseau created paintings that reflect a deeply felt affinity with the landscapes and people of his immediate surroundings, and to which he did justice in a strangely sober way.

That he set it as his goal to become one 'of the best realistic painters'[36] can be attributed the subjectivity of his style and the fact that he sought objectively to reproduce on canvas what he observed and imagined. Equipped with only a minimal amount of artistic training, he concerned himself with reality using the immediacy of his understanding. We hear from Jarry and Apollinaire, for instance, that he transferred to scale the size of a model and his or her physiognomy on to canvas after careful 'measurement.'[37] He compared his tubes of paint with the flesh tones of his subject in order to be able to match colour and complexion accurately. The amazing thing here is the conscientiousness with which Rousseau measured 'to scale' and yet the degree of nonchalance with which he could neglect exact proportioning in his paintings.

He pursued his desire to be seen as a realist by holding fast to the criteria of realism. But he qualified these criteria more and more through his power of imagination, and was able to distance himself from the methods by which they could be expressed. For things should be painted not as they appear, but rather in the way that the artist believes they are worth seeing. As soon as Rousseau realised this kind of reality on canvas, he then abstracted it in a way that had never been seen before. Absurd perspectives, exaggeration and disproportion became major design characteristics of his paintings. Because he was far removed from creating the illusion of reality, his desire to produce things exactly gave way to a reality of possibly true forms, whose ambiguity cannot always be clearly defined. According to the proportion of a rich fantasy, his imitative instincts and his intentions to reproduce true form became major characteristics between the prosaic and the imaginary. Indeed, in Rousseau, fantasy contributed to a realism that isolated something enduring in existence, that deformed in order to remove the illusion of reality, that simplified in order to strengthen. A reality shrouded in incomprehensibility was presented by pithy associative symbols, so that even banal things could be fitted out with an unusually strong visual appeal (or at least its potential), and nature could be concentrated into the smallest landscapes. Reality intensified to the point of being unreal, nature made almost unnatural, proved to be much more expressive than any form of staged illusion on canvas – which had in any case by that time been rendered obsolete by the discovery of photography.

Beyond this laconic presentation, this kind of compromised reality makes even the familiar seem remote, strange and inaccessible. Rousseau's over-emphasised foreground was balanced by stiff and ungainly forms. His sense of the materiality and solitary nature of things would influence

35 Ibid., p. 228.

36 Soupault 1927, p. 13.

37 Uhde 1911, p. 48; Uhde 1914, p. 47.

Picasso, De Chirico, Beckmann and Kandinsky (in his early writings, the latter placed the spiritual in art within 'great abstraction' on the one side and Rousseau's 'great realism' on the other, and called Rousseau's ascetic visual reality a fantasy made of the hardest materials; see p. 227).

This does not contradict the fact that Rousseau yearned for detail, and that he deliberated on detail with the same vigour that he applied to the rhythmical organisation of the overall picture. In a completely non-pedantic way, he pondered on his paintings with a consistent attention to detail and combined their individual parts into a grandiose totality. It was sufficient to present the disorder of life by compact forms of organisation that allowed the neatly painted particulars to counterbalance the harmony of the whole. Instead of fussing with reconstructing parts of reality, Rousseau sought to construct something that was tectonically well grounded.

Rousseau's elementary layering of the surface, as well as his sharply conceived contours and colours, are attributes of a rather cold, hard visual system. In his representative frontality none of his figures, objects or land-scapes is subservient to the passing of time, none is permeated with light or a specific tone to indicate that they take part in the changing of season or clock. With the exception of a few dynamic motifs, this frontality is not submitted to any movement that would indicate direction or to the nervous gesture of brush stroke. With his mute and motionless subjects, Rousseau seems to have surrendered to that permanent moratorium on the passing of time and the changing of place that suggests consistent observation. One gets the impression here that the present has stopped breathing for a moment, as if specific occurrences have slowed the moment down to a full stop and that the passing of time itself has stepped into the infiniteness of the painting. Nothing is left to chance. The transitory has been eliminated from all levels of the painting. The line of movement indicated by paths and street motifs has been retracted, and a hard rain falls diagonally through the picture in a rigid, decorative way similar to Japanese woodcut sketches (ill. p. 154). The water of rivers and lakes – developed by the Impressionists into flowing, gliding and reflecting elements – possesses a dammed-up, almost static, character. Stars are incorporated into the firmament as fixed points, and the struggle for survival in the jungle plays itself out with little or no gestures, before a curtain of plants unmoved by what is happening. The figures are placed in the scene as stiff as statues. Singly, in groups or as decorative elements, they do not possess lifelike depth, nor are they involved in any kind of task or work. They are not treated to reflect any anec-dotal action. Rousseau's figures take their bourgeois strolls and seem to float rather than possess an active demeanour; one looks here in vain for the perfect visual perception of the passer-by, developed by Degas into an art form in and of itself. As if they have been lifted up from the ground, without anything stationary under their feet, Rousseau's figures possess no movement. Unreal and schematised at the same time, their bodies allow for no posing, either. The locations in these paintings appear isolated, the houses empty and the factories deserted. Even aeroplanes, fulfilling the dream of flight, abide in the sky as monuments of unknown origin.

Rousseau was not concerned with the social and cultural outcasts of industrialised society. He did not pay much attention to end-of-the-century city life moving inexorably towards the *belle époque*. The cafés and cabarets, the circus, theatres and brothels – all these interiors where the *jeunesse dorée* met and which Daumier, Manet, Degas and Toulouse-Lautrec made their own milieu – remained inaccessible to Rousseau. Unconcerned with the city squares in which, starting with Baudelaire, Paris's modernity was manifested, Rousseau opened his heart more to the new suburbs, the botanical and zoological gardens. Things were simpler in these parts of the metropolis. The forms there were sharper and stood out more clearly. Rousseau's hermetic sensibilities preferred a Sunday world, one packed with disturbing passivity, one that hardly left him room for reference to the fact that he was once a 'Sunday afternoon painter' himself. Instead of the wide explanses of the Montagne Sainte-Victoire of Cézanne, which would have been beyond Rousseau's comprehension, he made ever more extensive and isolated paths for himself through fantasy wildernesses, painting wonderfully tropical vegetation in barren Paris neighbourhoods on huge canvases.

With all the double meaning and ambivalence of his iconography, Rousseau never went beyond the presentation of what seems real. Jungles and deserts were just as accessible to him as the country lanes before the bulwarks of the city. These not only turned in his paintings into boulevards, but he allowed no doubt about their reality as visual fictions, regardless of whether they followed the absurd logic of dreams or were completely unfamiliar. His visual subjects, mysteriously strange and inspired by the distance of fantasy, are none the less immediate and sharply contoured. The Surrealists, who wanted to make Rousseau an agent of their own secret visual systems and saw their own world view in his paintings, could not change this fact.[38] Rousseau would have not understood Lautréamont's idea of making commonplace images unfamiliar by placing them in strange surroundings, not to mention seeing them as an enigmatic affirmation of ancient myths and archetypes. Underlying Rousseau's visual systems were natural facts, including those he garnered from dreams, facts that he endeavoured to illuminate by placing them within a well-chosen visual purity. Rousseau took the theme of a dream world – one being developed at the same time by Redon and the Symbolists – and turned it into an imaginative visual reality that, despite some paradoxes and despite the somewhat exaggerated interpretations of Soupault, Tzara and Cocteau, yields little by way of symbolic meaning.

Always intent on visual clarity, Rousseau held fast to a thematic repertoire that had been around since antiquity but whose emphasis had been modified by landscape painters of the mid nineteenth century such as Théodore Rousseau who sought a more realistic treatment of nature. Henri Rousseau's affinity with traditional iconography represents a wide spectrum – from portraits (usually under contract for friends), landscapes, cityscapes, flowery still-lifes (also used in payment), right up to full-length portraits of individuals and groups (cf. nos 11, 16, 31). Moreover, Rousseau dared to employ the genres of history and allegory, which had been rejected by the

38 Cf. Rubin 1972, pp. 127 f.

Impressionists (cf. nos 9, 13, 40, 41. In highly pleasing metaphors of life and death, fame and prestige, man and woman, he attempted to give imagination expression in a way that went beyond immediate experience. Religious or mythological subjects were exceptions (no. 32), and he completely ignored the minor genre of the interior. When Rousseau was finally able to put down on canvas the historical timelessness of the jungle to form an ancient-seeming world, he was dealing with the theme of an unfamiliar and uninhabited natural setting of both paradise and brutishness. He did so in order to emphasise his personal interpretation of nature, one that he had constructed to reflect human needs, the familiarity of which none the less appears strange to us (nos 33, 43, 58, 59).

Along with the extremely large jungle paintings, Rousseau was especially fond of large paintings with allegorical content, which he chose carefully and which he described to the art dealer Ambroise Vollard as his 'creations'. To convey the meaning of these allegories required considerable creative diversity and allowed the artist little room for spontaneity in their creation. That these challenging works were valued twenty times higher than the portraits, the small landscapes and the still-lifes is due not only to their size. The Academy considered historical and allegorical paintings, making use of a hierarchy of themes dating back to the seventeenth century, to be of the greatest importance. Historical, genre and landscape specialists among the Academicians sought to test their abilities by painting on colossal canvases, the bigger the better. Even those outside the Academy employed the large format – including, among others, Courbet and Manet, Renoir, Caillebotte and Gauguin, Seurat (*La Grande Jatte*), Cézanne (the late *Bathers*), Monet (the garden panoramas) and Picasso in some early works. The ambitious Rousseau did not want to be left out of this tradition. He wanted to cause a sensation with huge canvases and extravagant frames, even though he could hardly afford the materials and despite the fact that small-scale measurements dominate in his oeuvre. Evidently, he thought his reputation would be improved among exhibition-visitors by the overwhelming effect of such dimensions.

V

Rousseau was no longer a customs officer who painted but had already become an autonomous artistic personality by the time that art was confronted for the first time by the Modern movement. Had he lived in the first half of the nineteenth century, he would have found his metamorphosis impossible, but would surely have had to settle for illustrating the signboards of taverns or colouring broadsheets. Even just a few years prior to his emancipation as an artist, convention would have made such a change fraught with insurmountable difficulties. These conventions first began to break down when the Impressionists discredited the standards dictated by classical–historical provenance. None the less, it was some time before

Rousseau's singularity was recognised, especially since he himself measured his talent among the artists of the twentieth century by seeking to be compared to the forgotten greats of the nineteenth. Because his art did not correspond either to the doctrine of the Academy or to that of those outside it, Rousseau enjoyed considerable prestige among young writers and artists who had taken upon themselves the ruthless re-evaluation of the traditional concepts that had governed artistic endeavour for centuries.

The writer Alfred Jarry was foremost among those who thought Rousseau to be the embodiment of an artist who was independent of tradition.[39] The 20-year-old Jarry met Rousseau in early 1894; he had moved to Paris on finishing school three years earlier, and was also a native of Laval. The fact that they shared a home town is hardly sufficient to explain how the two men, with a thirty-year age gap, got on so well – the older painter busy following his destiny, and the brilliant young nonconformist who frequented the circle of intellectuals that centred on the Symbolist-leaning publication *Le Mercure de France*. Perhaps the two had a certain affinity since both were concerned with the simplicity of their own art. 'A simplicity that does not always have to be simple,' as Jarry wrote in the Introduction to *Les Minutes de sable: mémorial* on 11 August 1894, 'but rather one that is interwoven and permeated by complexity.'

Jarry was at the forefront of the artistic scene in Paris at the time, and for him Rousseau was the embodiment of charm, almost like a painting himself. By giving recognition to this painter who worked in isolation, Jarry

39 Apollinaire 1914, p. 7 (p. 627); Certigny 1961, pp. 135 ff.; Vallier 1961, pp. 48, 50, 52 ff.; Shattuck 1963, pp. 180 ff.; Henri Béhar, 'Jarry, Rousseau et le populaire', in the exhibition catalogues Paris 1984–85, pp. 25 ff., and New York 1985, pp. 23 ff.; Müller 1993, pp. 88 f.

hoped to challenge the exhibition-going public. The writer, who loved cycling and fishing, looked to find in Rousseau the same attributes that he sought in his own characters: he called Rousseau 'le mirifique' (the fabulous).[40] What captivated Jarry and later Apollinaire was the ease with which the artist moved outside aesthetic norms and his independence from the dictates of 'good taste'. Rousseau emphasised the crassness of his sense of reality to the point of being grotesque, and they found that inspiring. Moreover, because the *belle époque* bore its over-cultivated fruit from

40 Apollinaire 1914, p. 7 (p. 627).

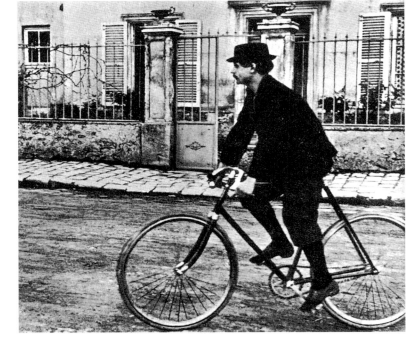

Alfred Jarry on a bicycle, c. 1895

Paris to London and Vienna, making the 'decadent' artist influential in society, the straight-laced civil servant-turned-painter simply had to be an outsider. It is really no wonder, then, that Rousseau, who avoided all forms of extravagance, became the epitome of extravagance for eccentrics like

Jarry, who championed him in order to further his own career. How successful he was at this is impossible to say, since Rousseau had the common sense to see through Jarry's publicity-seeking intentions. But Rousseau brought a growing confidence to his newly found role as the uneducated artist who created works of genius without consciously knowing why – in *La Revue blanche* of 15 June 1901 Jarry called him 'this well-known philanthropist painter'.

Jarry aimed his verbal excesses at a world that threatened to become more and more machine-like and technical. His preference in his metaphor-rich poems was for everything French, especially proletarian themes including street songs, and he believed he could find in Rousseau's art – and this undoubtedly included literature and music – something of the folklore aspects that he wanted to propagate in the magazine *L'Ymagier* which he had founded with Rémy de Gourmont. As early as 1894 these two French editors were focusing on legends, folk songs and fairy tales – long before Kandinsky and Franz Marc dealt with similar themes in the almanac *Der Blaue Reiter* in Germany in 1912 (see pp. 227 ff). Their main goal was to revive a longstanding tradition of rough-cut wood carvings of saints and religious symbols, woodcut prints and lithographs, similar to the pictorial broadsheets *Imageries populaires* from Epinal that were familiar to just about everyone in France at the time. In their opinion, this popular tradition was art, and valuable enough to serve as a source of artistic inspiration. They made Rousseau one of their 'Ymagists' when they published a lithograph of *La Guerre* (no. 14) in their second issue. *L'Ymagier* was only to last for five issues before it ran out of money, but during this time Jarry sat for a portrait by Rousseau which was exhibited at the Salon des Indépendants in April 1895. Unfortunately, the portrait is lost: Jarry, by this time an alcoholic, destroyed it in a drunken fit.[41] Evidently, he felt the likeness to be so close that he could not refrain, in an act of self-liberation, from shooting holes in it.

Jarry's *Ubu Roi* startled the sleepy *fin de siècle*. Premiered in 1896, the play concerns the rise and fall of an infernal, puppet-like monster who is simple-minded, evil and burlesque beyond even Chaplin's cynical *Dictator*. Its *succès de scandale* gave Jarry the publicity he so desperately wanted, but not the expected profits. After his father's inheritance had been used up, the poet left his flat in the boulevard Saint-Germain, and moved in with his friend Rousseau at 14 avenue de Maine, where the painter agreed to let him stay from August to November 1897. During this time, Jarry worked on the text for *Gestes et opinions du Docteur Faustroll, Pataphysicien*. In the chapter (dedicated to Bonnard) entitled 'How to Go About Procuring a Canvas', Jarry, in a highly sarcastic way, takes to task the rich, successful artists in Paris at the time.[42] The location where they prostituted their talents he called the 'warehouse of the nation' and gave it the name 'Au luxe bourgeois'. This was the Musée du Luxembourg, which was reserved for contemporary artists. Jarry made Rousseau into their calm executioner; he described him as 'Monsieur Henri Rousseau, known as "the customs officer", a praiseworthy and distinguished artist and *décorateur*'. Jarry let the famous Salon painters

41 Ibid., p. 7 (p. 627); Certigny 1961, pp. 172 ff.

42 'Comment on se procura de la toile. Henri Rousseau vu par Alfred Jarry', in *Art de France*, 2, 1962, p. 329.

Bouguereau, Bonnat and Detaille drown in the gold of their profits, and entrusted Rousseau with the 'direction of a mechanical monster', a kind of 'painting machine', which 'within a span of 63 days [would] paint over with great care and singularity the helpless confusion of the monstrosities of the National collection.' Exempt from this action, which would have sufficed for someone like Arnulf Rainer, was only a small exhibition hall that contained works of art that Jarry glorified as 'icons of the saints'. In this text, Jarry stood up for artists who had not yet been completely sanctioned for greatness by the art world: 'Take your hat off to the Poor Fisherman [Puvis de Chavannes], bow before the Monets, kneel down before the Degas and the Whistlers, crawl when seeing the Cézannes, throw yourself down at the feet of the Renoirs and lick the sawdust from the spittoons under the frame of Olympia [Manet].'

In 1907, after Jarry's early death, the poet, essayist and art critic Guillaume Apollinaire de Kostrowitzy took over as Rousseau's interpreter and apologist. Always on the lookout for artistic experimentation, always ready to interpret artists' innovations and support them, Apollinaire – then in his mid twenties – became the most influential promoter and, one could say, exaggerator, of the Paris avant-garde before World War I. Passionate and presumptuous, he mainly represented the interests of the Fauvists and Cubists. At the same time, however, Apollinaire gave a new dimension to the growing interest in Rousseau's painting.[43] A leading figure in the Paris art

43 Vallier 1961, pp. 81 ff.; Shattuck 1963, pp. 241 ff.

scene, Apollinaire had met the artist through Jarry in the spring of 1906. He reacted with amusement to Rousseau's exhibited paintings of 1907 and 1908, but gradually changed his mind – probably because he recognised how good it could be for his image to swim against the tide of general outrage. After his original reservations, Apollinaire's opinion of Rousseau became more and more positive until, in *Les Soirées de Paris* of 15 January 1914, under his editorship, he published a monographic study of the life and works of Henri Rousseau.[44] Even though the painter was still living, Apollinaire allowed himself the poetic freedom to transfigure what he felt to be Rousseau's rather banal biography, attributing to the painter wartime acts of heroism, military expeditions overseas and treks through the jungles of Mexico. Through this enrichment of a résumé that said very little

44 Apollinaire 1914, pp. 7 ff. (pp. 627 ff.).

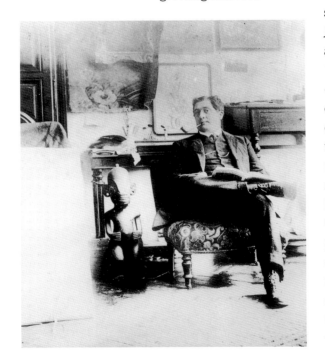

Pablo Picasso, *Guillaume Apollinaire in Picasso's Boulevard de Clichy studio*, Paris 1910
Musée Picasso, Paris

indeed, Apollinaire was able to give the sympathetic reader, and also the artist himself, the necessary clarification for the sudden appearance of the exotic jungle paintings.

Rousseau was surely aware that his young friends saw him as a curious individualist, a man who had been able to retain a childlike sense of discovery in what he saw, an attribute Picasso struggled his entire life to

retain. That literary figures such as Jarry and Apollinaire – two men who did not take truth too seriously – contributed to the creation of his legend, indeed created a real Rousseau myth, confirmed and validated Rousseau's work as an artist. He understood their language as little as they understood his. They were much younger than him, and his milieu and the way he behaved in public were not the same as theirs. They valued the ludicrousness of the man. But they took him seriously as an artist, and he had no objection to being seen as a naive genius of the simple brush stroke.

It might sound anachronistic, but for those at the time who were on the lookout for alternative models, Rousseau – who became nothing less than an institution during the last years of his life – must have cut a strange, almost antiquated figure. It was, therefore, that much more important to them to save Rousseau's minimalist visual world – one that polarised the trivial with the meaningful – and to integrate it into the modern consciousness. His helpless attempts at playing the self-confident artist were probably so disarming that people around him got used to taking his words literally. They must have finally began to accept the unpretentiousness of this man who had used the complete spectrum of his talents in the most various of ways to realise his dream of leading the life of an artist, and who became so famous in the process that he turned into an institution in his own right.

VI

Rousseau reflected with a certain pride on the 'universality' of his talent, comparable perhaps to that of the Belgian artist James Ensor who also composed music for military bands. The concept of the 'universal' artist, however, invented by the Dadaist Tristan Tzara to describe Rousseau,[45] was hardly accurate: contrary to his euphoric analysis, Rousseau's writing and musical works were insignificant, and scarcely better than any other banal creations of the time. Although painting became Rousseau's most important form of artistic communication, his own priorities might have been revealed in the notice he displayed on the door of his studio: 'Courses in elocution, music, painting and singing'.[46] The sentimentality of his poetic and musical dabblings did not become a source of humour until after his death, among much younger artists.

Beginning in 1907, Rousseau's artistic endeavours were expressed in carefully planned performances, his legendary 'fêtes familiales, artistiques, littéraires et musicales'.[47] Friends and neighbours were invited to his studio over Armand Quéval's plaster-casting shop at 2 rue Perrel. The programme always began with the *Marseillaise* and Rousseau was responsible for everything – he loved, for example, to play his own compositions on the violin. His cast consisted of artisans and shop-owners from the local quarter of La Plaisance – the milkman, the married couple who owned the butcher's shop, or the baker's wife, whose children were taking lessons from

45 Tristan Tzara, 'Henri Rousseau oder vom Begriff des "totalen Künstlers"', in Rousseau 1958, pp. 8 ff. Tzara was one of the most active members of the Dada movement in Zurich and Paris and was among the Dada personalities most strongly interested in African and Oceanic art as well as in the idea of primitivism.

46 Uhde 1911 and 1914, p. 9.

47 Apollinaire 1914, pp. 13 ff. (pp. 630 f.); cf. letter to Ambroise Vollard of 21 June 1910. – Viatte 1962, p. 335.

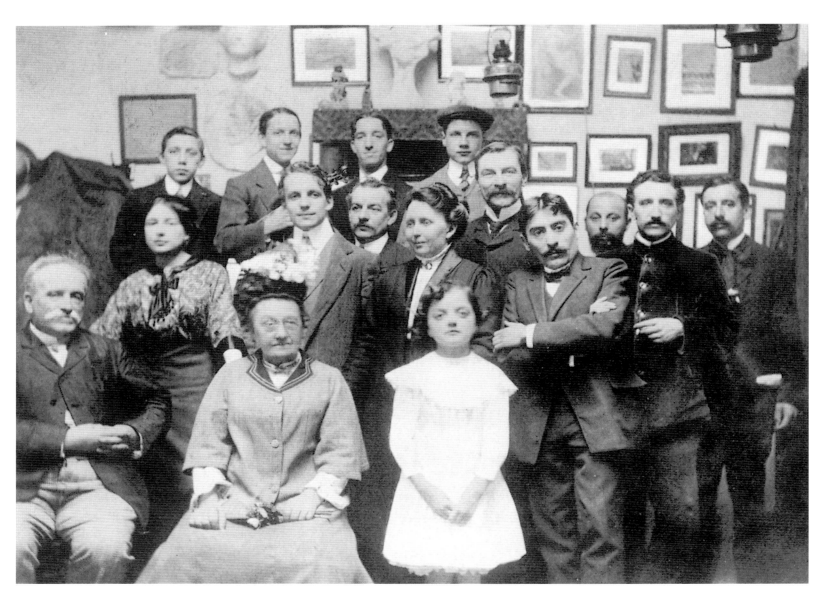

Social gathering in
Rousseau's apartment in
Rue Perrel, Paris 1909/1910;
Rousseau seated on the left

Rousseau in music, drawing and painting. These 'musical', 'literary' and 'philosophical' performances quickly became popular among young painters and writers, who attended not so much for the melodramatic performances but rather, as sincere admirers, to learn more about their host. The list of those who were regularly present reads like a *Who's Who* of the current avant-garde. Almost always there were their spokesman, the tireless Apollinaire, accompanied by his girlfriend Marie Laurencin, the painters Delaunay and Vlaminck and the Romanian sculptor Brancusí. From Montmartre came Picasso, the writers Max Jacob and André Salmon, and Georges Braque with his accordion. Philippe Soupault, Georges Duhamel, Félix Fénéon, Francis Carco, André Warnod and Maurice Raynal were sometimes there as well. The crowd could also include the American painter Max Weber, a talented singer who treated the crowd to Handel arias; the German writer Wilhelm Uhde; the Italian artist Ardengo Soffici with his Russian lover, and the Baroness Hélène d'Oettingen with her brother Serge Jastrebzoff.[48] The amusing evenings at Rousseau's studio were as popular in artistic circles as the daily *jour fixe* at Mallarmé's.

48 Soupault 1927, pp. 28 ff.; Basler 1927, pp. 10 f.; Olivier 1982, p. 56.

The most spectacular occurrence in a rather unspectacular life was surely the legendary banquet in Rousseau's honour put on at the end of November 1908 by Picasso and his girlfriend Fernande Olivier.[49] The Paris art scene, both admirers and those who kept a certain ironic distance, was at Rousseau's feet; *le bohème* from Montmartre were preparing to make a cult figure out of this 'primitive'. Picasso's banquet quickly developed into a 'happening', an apotheosis of the older man, while at the same time constituting the first exuberant public celebration of the new century's young artists. This impromptu celebration of Rousseau's work was mixed with amusement at its creator – these impertinent young people were not quite sure whether to see Rousseau as the founder of a new direction in art or simply misguided. That the well-respected 27-year-old Picasso had organised a banquet for someone still regarded by the art-going public as something of a joke was seen in Paris, and especially in Montmartre, as a small sensation, and it contributed greatly to Rousseau's fame.

49 Shattuck 1963, pp. 72 ff.; Müller 1993, pp. 132 ff.

When Parisian cafés in the nineteenth century became important centres of artistic life, banquets held by associations and student societies acted as major occasions of political, scientific and social intercourse. The immediate inspiration for this most memorable of banquets, which linked the names of Rousseau and Picasso for ever, was Picasso's purchase of Rousseau's *Portrait of a Woman* (no. 16). The venue was Picasso's studio in Montmartre, a former locksmith's shop and piano factory at 13 rue Ravignan, called the *bateau-lavoir* because it looked like one of the laundry boats common on the Seine at the time.[50] Built of wood, its small rooms had been converted into studios in 1889; Gauguin worked there in 1893, and Picasso and Fernande Olivier lived in two studios, one on the ground floor from 1904 to 1909, then another in the basement until 1912. With neither gas nor electricity, the artists had to work after dark by candlelight or using petroleum lamps, and there was just one sink in the hall. Picasso's fellow artists in this gloomy building were the painters Van Dongen, Juan Gris,

50 Cf. Jeanine Warnod, *Bateau-Lavoir. Wiege des Kubismus*, Geneva 1976.

Modigliani, Herbin and Otto Freundlich, as well as the writers André Salmon and Max Jacob (Jacob was to honour the studios' inner courtyard with the title 'Acropolis of Cubism'). Two extraordinary events will forever be associated with this exceptional art laboratory: Picasso's painting of the Cubist masterpiece *Les Demoiselles d'Avignon* during the first half of 1907, and the banquet in honour of Rousseau in the late autumn of 1908.

Fernande Olivier later recalled that Picasso invited 'about thirty people' and adorned the studio lovingly for the occasion.[51] 'The entire decoration was complete with columns, rafters overhead and tablecloths wrapped round by foliage. At the back was Rousseau's seat, a kind of throne which consisted of a chair on top of a box, behind which were flags and Chinese lamps. Above the chair was a wide banner with the words "Long live Rousseau!" The table consisted of a long board on wooden blocks.' Chairs and cutlery were borrowed from a nearby hotel. Olivier continued: 'Everything was ready. The guests [who included Georges Braque, Brancusí, Apollinaire and Marie Laurencin, Salmon and Raynal, as well as Gertrude Stein and her brother Leo] were squeezed into the studio, which was too small. By eight o'clock everyone was still waiting for the evening meal, which had been ordered from a restaurant. It finally came the next day, around midday!' Picasso had got the dates mixed up. After food and drink had been hastily procured from restaurants and cafés in the neighbourhood, and Marie Laurencin, already rather drunk, 'had fallen into the cake on the divan . . . we sat down to eat.' Rousseau, who had arrived with Apollinaire 'thinking supper had been delivered, sat down with due seriousness and tears in his eyes under the canopy erected in his honour. He drank more than he usually did and finally became quiet and drowsy. There were speeches and songs composed for the occasion. Apollinaire recited a specially written poem of his own with his dull-sounding voice, in which he evoked Rousseau's glorious military past (about which we are not sure to this day) . . . Choking with emotion, Rousseau stammered words of thanks to those present. He was so happy that he stoically endured wax from a lamp dripping on his head the entire evening . . . Then he began to play a short piece on his violin, which he had brought with him. It was a picturesque evening! . . . After supper, almost the entire population of Montmartre filed through the studio . . . Rousseau began his favourite song "Aie, aie, aie, que j'ai mal aux dents . . ." but he could not finish it, and fell asleep to snore softly . . . This reception, which he naively felt to be in homage to his genius as an artist, long remained one of his fondest memories and he wrote a nice letter of thanks to Picasso.'

So much for Fernande Olivier's somewhat patronising description, written in 1933. Maurice Raynal gave a report of the banquet in 1914,[52] one that was more or less confirmed by Gertrude Stein in 1933[53] and by André Salmon in 1956.[54] Salmon's retelling is more sober than the exaggerated descriptions by Stein and Raynal, but the banquet could not have been in such a serious vein as he claims. In fact, the exuberant goings-on must have taken on the character of a Dadaist spectacle approaching farce, what with the mistakes in organising the banquet, the hurriedly improvised replacement food, the speeches and the recitals.

51 Olivier 1933, pp. 78 ff.; Olivier 1982, pp. 56, 59 ff.

52 Maurice Raynal, 'Le "Banquet" Rousseau', in Apollinaire 1914, pp. 69 ff.; Rousseau 1958, pp. 65 ff.

53 Gertrude Stein, *The Autobiography of Alice B. Toklas*, New York 1933; Rousseau 1958, pp. 71 ff.

54 Salmon 1956, pp. 48 ff.; Rousseau 1958, pp. 68 ff.

Pablo Picasso, *Fernande Olivier and Georges Braque at the bar*, Paris 1908 Musée Picasso, Paris

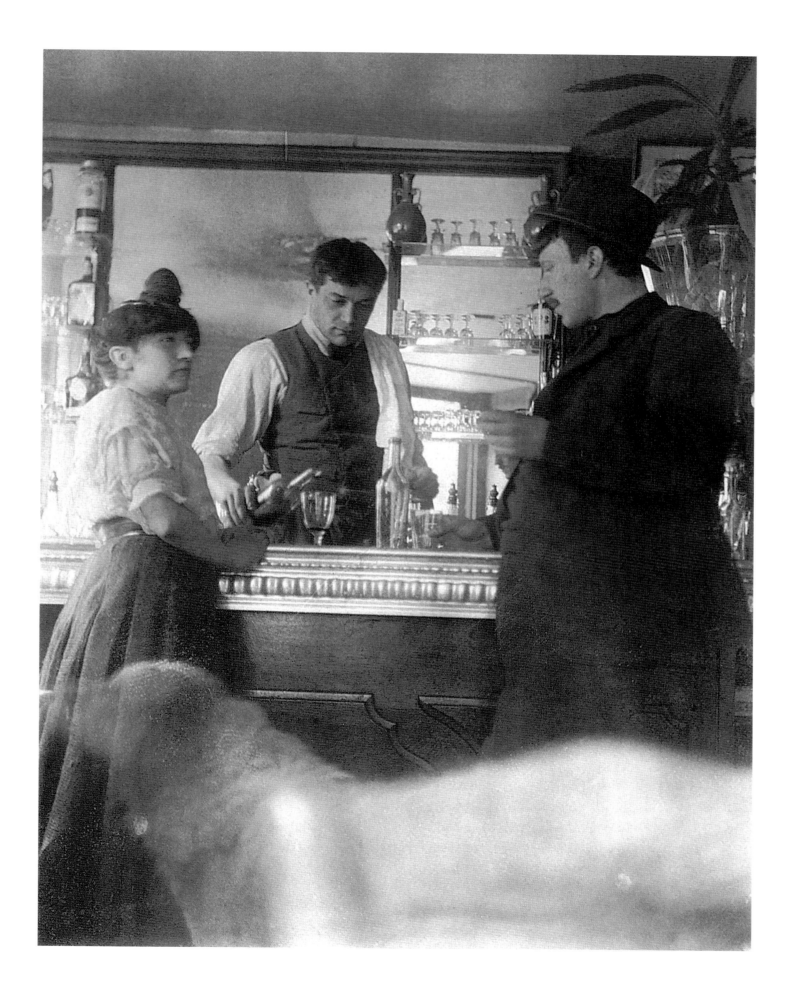

It was on this occasion, an important event in the history of the Modern movement, that Rousseau made a statement concerning Picasso that sounds absurd but was in fact enlightened. It comes down to us from Fernande Olivier, who reports Rousseau as stating: 'We are the two greatest painters of the era, you in the Egyptian genre, I in the modern genre.'[55] Rousseau thus described Picasso's Cubist experiments after he completed *Les Demoiselles d'Avignon* as 'Egyptian', noting also the younger artist's enthusiasm for African tribal art; he described as 'modern' his own reputation among the Paris avant-garde, as well as his inclusion in art of the newest technical advances.[56]

55 Olivier 1933, p. 113; Olivier 1982, p. 80.

56 Rubin 1984, p. 300.

The curiosity that Picasso and his Montmartre friends had for Rousseau, which began in about 1905, was virtually contemporary with their

well-documented interest, from 1906, in the archaic, in African or Oceanic art, and folk art. What was, at least to European eyes, strange gave them something with which to balance their own feelings of alienation. Attracted to the originality and vitality of such art, they felt that it promised to open up new artistic horizons. 'Native' art seemed to express a unity between man and nature that had been lost in Europe. In the wake of Gauguin's romantic yearning for the primitive, native art was deemed an appropriate way to lend fresh impetus to a positivistic art based on observation.[57] The theory among French intellectuals of 'the primitive genius', first applied to the paintings of Italian and Flemish artists of the fourteenth and fifteenth centuries, was also applied to Henri Rousseau. Although they could hardly make true primitivism apply when it came to Rousseau, they none the less made him their local 'primitive' because he occupied a kind of aesthetic no man's land.

57 The Gauguin retrospective took place in 1906 at the Salon d'Automne.

Pablo Picasso, *André Salmon in Picasso's Bateau-Lavoir studio*, Paris 1908
Musée Picasso, Paris

As art, in the wake of Cézanne, gradually began to move away from being bound to reality, Rousseau remained an exponent of a continuous tradition of empirical representation. His creative power recognised things in a dimension that was all his own, one that excluded all ephemeral things. This allowed him to express himself with a power whose source was fresh and whose forms were strangely heavy, a power that held out the prospect of greater depth and productivity than the artistic solutions being offered at the time by Neo-impressionism and Symbolism. When intellectuals explained the process by which the simple and genuine became noble, they often referred to Rousseau's images because they were thought to contain something ancient and native-like, to be an expression of something genuine that had forced its way to the surface from untapped depths of the creative consciousness. In the ingenuous realm of Rousseau's fantasies, one runs into the premise of a consciousness beyond intellectual thought – a breakthrough that painters had always wanted to achieve. Like Van Gogh and Gauguin, both of whom began painting late in life, Rousseau injected the primal and primitive into high art and contributed to its becoming an integral

part of modern art. With the ideals of Jean-Jacques Rousseau in mind, to go back to the sources of visual representation was a central concern of artists at the start of the twentieth century.

What caused the avant-garde – especially Picasso, Delaunay and Kandinsky – to be so interested in Rousseau was the concision and compact rhythm in his treatment of line and surface, along with his concentration of form and colour. They saw a visual intimacy that has never been achieved since, one presented in a way that was not naturalistic but natural, not elitist but accessible to everyone. That the paintings seemed out of place when they were first exhibited yet have stood the test of time can be attributed to how they sprang unexpectedly into the present, seemingly from a far-distant past, as if they had arrived unannounced from a distant province to materialise suddenly in the capital city of art. Apparently without indicating where they come from or where they are going, these paintings reveal situations that are inaccessible and inscrutable to the viewer, and that exploit urgency in ways other than the use of traditional perspective. Especially, they are attractive to the eye, and this even though Rousseau – who made strange things seem familiar in them and familiar things seem strange – did his best to avoid developing a relationship between himself as painter and the viewer of his work.[58]

The artist Félix Vallotton was perhaps the first to attempt an objective judgement of Rousseau's paintings, in *Le Journal Suisse* of 25 March 1891. He emphasised the aura and the representational tendencies of Rousseau's art and claimed, disquietingly, that: 'he is a terrible neighbour, who grinds up everything close to him'.[59] In the same vein, André Derain later wrote that it is really quite simple to judge him: 'Hang a Rousseau between two old or modern paintings . . . it's the Rousseau that will always make the stronger impression of balance and intensity'.[60]

Both interpreters point out the fact that Rousseau's paintings, in whatever context they appear, always catch the eye. They possess a certain inevitability. From the first moment they are seen, their astounding presence makes them unforgettable. Their iconic weight is relentless: it seems great even in the smaller paintings and ingenious in its pretended naivety. These massively formed monoliths from one of art's greatest visual constructers hold their own in a changing artistic landscape. Without connection to a past and without reference to a future of assumed progress, they persist in a monumental presence.

58 'Rousseau was a forerunner of this century, in which the promises of mechanisation are found together with the discovery of poetry in the functional object,' Tristan Tzara noted in 1947. 'From Rousseau's paraffin lamp to the guitar, newspaper, playing cards and tobacco packet of Picasso, Braque and Gris the path leads via Apollinaire's (and later Léger's) "esprit nouveau", via the "Tour Eiffel" and Delaunay's "fenêtres" to Futurism. In the first steps of this developing modern age is revealed a love of the familiar object, the simple, everyday object, the object in its visible and perceptible entirety . . .' – Rousseau 1958, p. 12.

59 Certigny 1961, p. 115.

60 Gauthier 1949, p. 21.

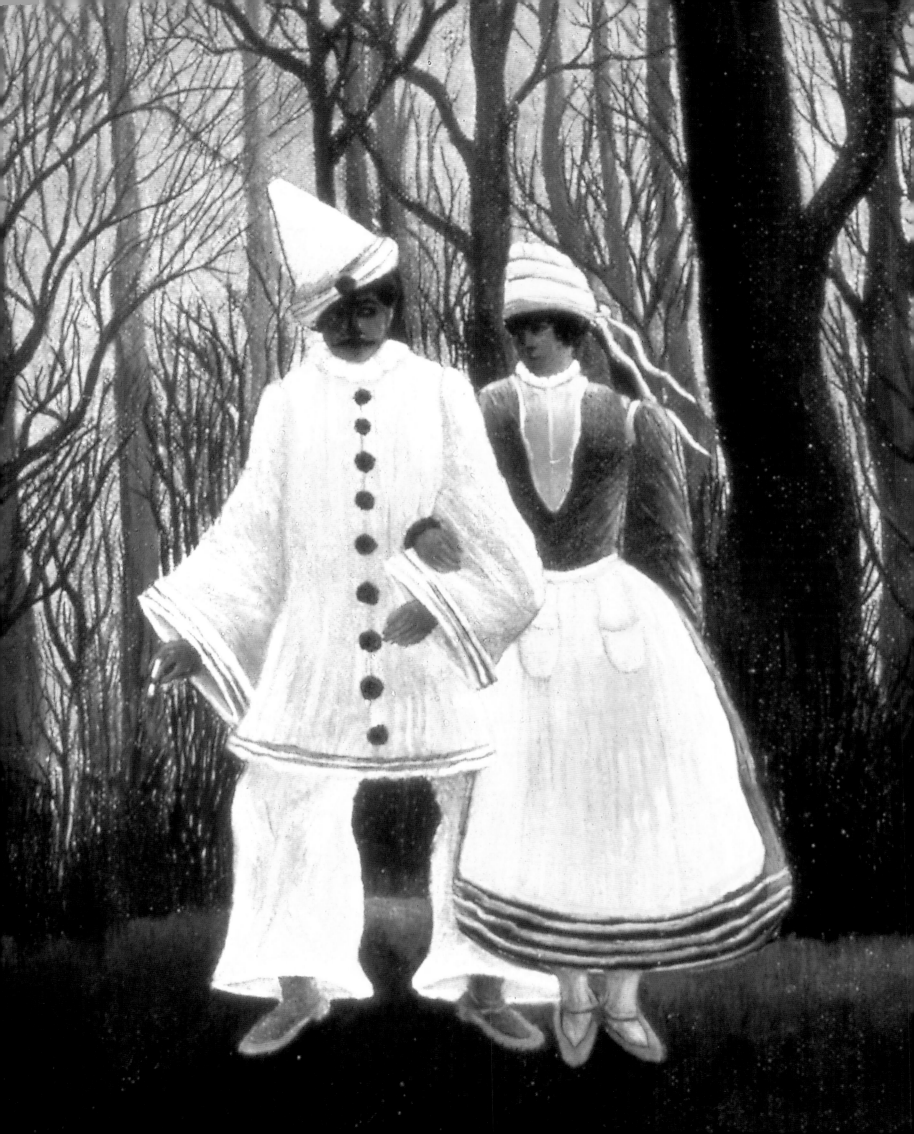

Catalogue

Preliminary remarks

Abbreviated selected reading and exhibition references for the paintings can be found on pp. 276 ff. In most cases the paintings were signed, but they were seldom dated; we may assume, however, that Rousseau completed many of his paintings shortly before the date they were first exhibited. With the exception of preliminary sketches, he almost exclusively used canvas in standard formats. He often sketched motifs on the canvas in charcoal before painting. According to his paint dealer Foinet, Rousseau's favourite colours were silver white, ultramarine, cobalt blue, deep red, yellow ochre, ivory black, Pozzolana red, raw Sienna, raw Terra d'Italia, emerald green, vermilion, Prussian blue, Naples yellow and chrome yellow. The size of each painting is listed, height × width in centimetres; slight differences in these sizes are not documented if the exact size could not be determined because of the frame. The number of paintings attributed to Rousseau, at around 180, is relatively small (Cézanne left over 950, Renoir over 6,000). This led to a number of forgeries appearing quite soon after his paintings had become famous, which caused major problems with the authentication of genuine works.

Landscape with Bridge
Paysage, le pont

Rousseau's first biographer, Wilhelm Uhde, felt this early attempt at a landscape important enough to include in his Rousseau publications (1914 and 1921) alongside the major works not long after the artist's death. It was in the Edwin Suermondt collection in Aachen from 1914, and is still in Germany.

A beginner's uncertainty permeates this picture. Hill and valley, bridge and river, figures, trees and houses are painted at the level of folk art. With no regard to proportion or perspective, the tree branches alone indicate a direction; through them, the work achieves a minimum of visual cohesion.

When referring to his purchase of *Promenade Through the Forest* (no. 6) from a Paris washerwoman, Uhde mentioned his discovery around 1912 of what he calls Rousseau's 'three oldest' pictures. 'This washerwoman had relatives in the country, who owned a farm in Normandy. I drove there from Amiens one day . . . I found the three oldest paintings known to be by Rousseau [probably *Landscape with Bridge* as well as the two mill motifs, nos 3, 4]. The owners were not particularly keen on selling the paintings . . . because they were "bibelots" which reminded them of Père Rousseau or, in the case of the farmer, of his youth spent in Paris.'[1]

Wilhelm Uhde, a lawyer and art historian from Freideberg in Brandenburg, came to Paris in 1904 at the age of 30, where he quickly became familiar with the art scene and became a successful collector (see p. 54).[2] As early as 1905 he began to buy works by Picasso, Braque, Derain, Vlaminck and Dufy. In the summer of 1907 he was introduced to Rousseau by Robert Delaunay's mother, after which he became, along with Delaunay, the artist's friend and most important promoter (see pp. 219 ff). In September 1911, his monograph on Rousseau appeared, and in 1912 he organised the major Rousseau retrospective at the Bernheim Jeune Gallery.[3] An advocate of the Fauves and Cubists as well as of Rousseau, Uhde was forced to leave France in 1914; his collection was declared a possession of France after World War I and was sold at auction. Nevertheless, he returned to Paris in 1924. During World War II he was forced into hiding in southern France but managed to save his new collection from confiscation by the Nazis. He died in Paris on 17 August 1947.

1875-77
Oil on canvas
27 × 35 cm
Insel Hombroich Foundation

1 Uhde 1921, p. 73.

2 Thiel 1992, pp. 307 ff.

3 The young Paul Klee sought out Uhde in order to learn more about Rousseau. On 12 April 1912 he wrote in his diary: 'On the tower of Notre Dame. Afternoon with Uhde, Rousseau, Picasso, Braque.' *Paul Klee Tagebücher 1898–1918*, edited by Wolfgang Kersten, Stuttgart 1988, p. 325.

Provenance: Wilhelm Uhde, Paris; Edwin Suermondt, Aachen (1914); Martha Suermondt, Drove; Alex Vömel, Düsseldorf; Hans Redmann, Berlin; sold at auction Sotheby's, London, 2 July 1980, no. 112

Bibliography: Uhde 1914, ill.; Uhde 1920, p. 55; Uhde 1921, p. 10, ill. p. 73; Zervos 1927, ill. 86b; Uhde 1947, p. 57; Bouret 1961, p. 177, ill. 53; Vallier 1969, p. 115, no. L3, ill.; Certigny 1984, pp. 4 f., no. 2, ill.

Exhibitions: Basel 1933, no. 1

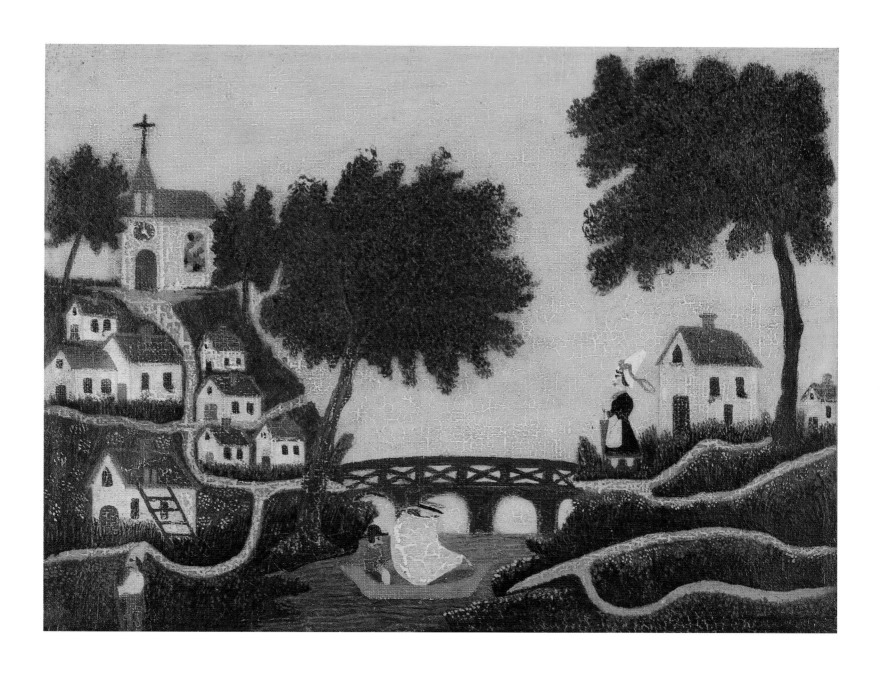

LANDSCAPE WITH BRIDGE

The Little Cavalier, Don Juan
Le petit chevalier, Don Juan

Supposedly painted from a model, this scene seems to represent a stage with a landscape backdrop. The sparse furniture consists of a chest of drawers with a can of tobacco, an armchair and the curtain before which the cavalier poses. The protagonist, in the costume of a sixteenth-century courtier, seems to be reaching out his hand to a dance partner out of the picture. What role the dog plays in the foreground, and what circumstances determined the discrepancy between the costume and the rather baroque-looking, dark-toned ambience of the painting is unclear.

The painting first appeared in 1922, and was shown under the title *Don Juan* at a Rousseau exhibition at the Flechtheim Gallery, Berlin, in 1926. The Rousseau expert Wilhelm Uhde (see p. 42) wrote the introduction to the catalogue of this exhibition, which was the last of its kind in Germany. Certigny attributed to this work the date 1880–90, but that is surely too late. Doubts from Dora Vallier concerning its authenticity were resolved when she herself authenticated it on 23 April 1996.

1877–80
Oil on canvas
32.7 × 25.8 cm
The Mayor Gallery, London

Provenance: Hans Simon, Berlin; Galerie Alfred Flechtheim, Berlin; The Leicester Galleries, London; Sir Roland Penrose, London; Suzanna Penrose, London; Scottish National Gallery of Modern Art, Edinburgh (on loan 1993–96)

Bibliography: Grey 1922, ill.; Kolle 1922, ill. 3; Vallier 1969, p. 118, no. F1, ill.; Roland Penrose: *Scrapbook 1900–1981*, London 1981, p. 167, ill.; Certigny 1984, pp. 40 f., no. 22, ill.

Exhibitions: Berlin 1926, no. 9; *Primitive Eye*, Mercury Gallery, London 1966, no. 63, ill.

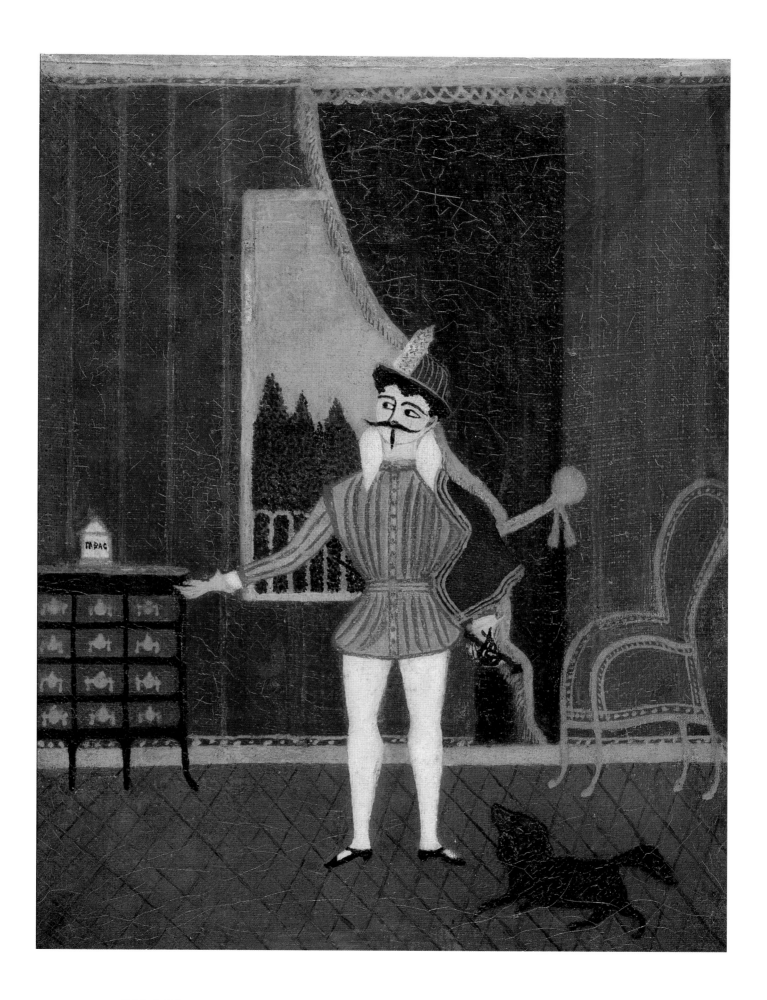

THE LITTLE CAVALIER, DON JUAN

Wagon in Front of the Mill
L'Attelage devant le moulin

Wilhelm Uhde published this painting of a river landscape with a massive mill complex, along with no. 4, in the German edition of his Rousseau monograph of 1914 and in 1921 referred to its purchase (see no. 1). Two somewhat altered versions of this subject are known and might be the earliest examples of motif repetition in Rousseau's oeuvre; the location has not been identified.[1]

We see a widening of the range of forms here, as well as an improvement in the representation of shapes and colours compared with no. 2. The painting has more spatial depth; fore-, mid- and background are clearly differentiated from each other by the path of the road, the bushes lining the river, the trees and the view of the opposite bank.

Rousseau had achieved enough self-confidence to sign and date his landscapes from 1879, proof that this untrained artist was convinced of his own improvement and no longer regarded himself as an anonymous dilettante. From the beginning he needed to test his visual fantasies when dealing with nature, and the landscape with figure was a major component of this. The discovery of a specific visual perception of nature in the work of his namesake Théodore Rousseau and the painters of the Barbizon school remained important for Rousseau even decades later, and was the reason for his effusive deification of trees, forests and the use of green.

1879
Oil on canvas
32.5 × 55.5 cm
Signed bottom right and dated:
H. Rousseau / 1879
Göteborgs Konstmuseum
(Inv. No. GKM 735)

1 Vallier 1969, no. L 1b; Certigny 1984, nos 5, 6 (incorrectly assigned).

Provenance: Wilhelm Uhde, Paris; Galerie Justin Thannhauser, Munich

Bibliography: Uhde 1914, ill.; Rousseau 1918, p. 259, ill.; Uhde 1920, p. 55; Uhde 1921, p. 73; Kolle 1922, pp. 14, ill. 18; Uhde 1947, p. 57; Lo Duca 1951, ill.; Perruchot 1957, p. 96; Bouret 1961, p. 177, ill. 51; Shattuck 1963, p. 93, ill. 16; Vallier 1969, p. 115, no. L 1a, ill.; Keay 1976, p. 115, ill. 1; Alley 1978, p. 10, ill. 2; Le Pichon 1981, p. 118, ill.; Certigny 1984, pp. 2, 6 ff., no. 3, ill., pp. 10, 12

The Mill
Le Moulin

Without a doubt, at the end of the 1870s Rousseau was already an extensive hobby painter. At this time he was spending seventy hours a week in the service of the Paris City Customs Office, but the work could not have been all that exhausting. He must, at least sporadically, have pursued his 'artistic inclinations',[1] and found time to search for motifs, jot down visual notes on paper and possibly, equipped with painting tools and boards, sketch motifs on the spot. He was able to observe nature and people, to study their particularities and follow closely changes in daylight and season. He must have taken every possible opportunity to let light and shadow work their magic to find out about the changing colour constellations, and to create in paint beautified versions of his often dull surroundings.

The Mill is one of Rousseau's 'three oldest pictures' that Uhde found in Normandy and published in 1914 (see nos 1, 3). There is a second version of this structure, possibly on the Oise River, showing a rather narrower view of it.[2]

1879
Oil on canvas
32 × 55 cm
Foundation Dina Vierny,
Musée Maillol, Paris

1 Soupault 1927, p. 12.

2 Vallier 1969, no. L 2; Certigny 1984, no. 7.

Provenance: Wilhelm Uhde, Paris; R. H. Meier, Dresden; Max Leon Flemming, Hamburg, Berlin; Galerie Alfred Flechtheim, Berlin; Erich and Valerie Alport, Hamburg; sold at auction Christie's, London, 2 July 1974, no. 86

Bibliography: Uhde 1914, ill.; Uhde 1920, p. 55; Uhde 1921, p. 15, ill. p. 73; Grey 1922, ill.; Kolle 1922, p. 14, ill. 22; Uhde 1923, ill.; Roh 1924, ill.; Zervos 1927, ill. 54; Soupault 1927, ill. 24; Uhde 1947, p. 57; Rousseau 1958, ill. 19; Bouret 1961, p. 177, ill. 54; Vallier 1961, ill. 62; Vallier 1969, p. 97, no. 88, ill.; Keay 1976, p. 127, ill. 17; Certigny 1984, pp. 2, 8 f., no. 4, ill.

Exhibitions: Berlin 1926, no. 17, ill.; Odakyu 1981, no. 61, ill.; Tokyo 1985, no. 1, ill.

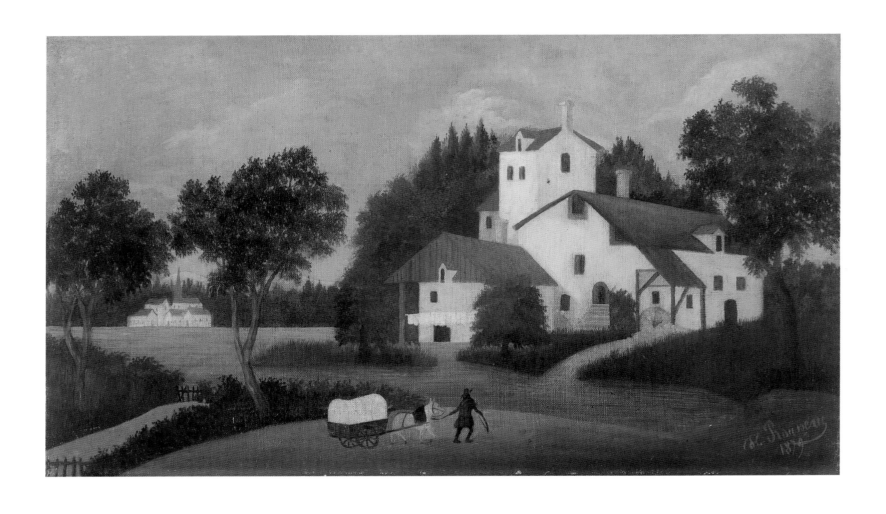

WAGON IN FRONT OF THE MILL

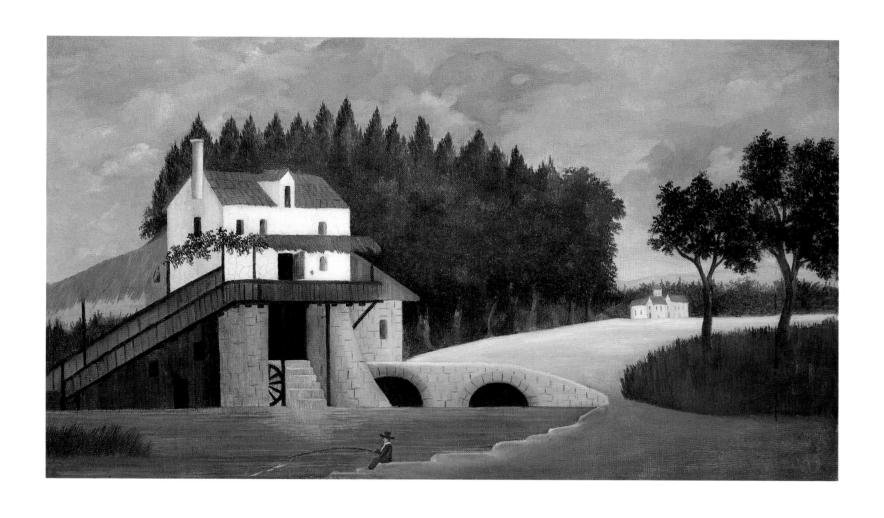

THE MILL

Landscape
Paysage

This charming landscape, adapted to a tall, thin format, gives a view of a steeply rising ridge studded with trees and buildings; it has been that the upper group of buildings seems to shoot up into the air. A small human figure, a row of trees set parallel to the picture plane and a multi-storeyed row of house façades make up the lower third of the visual field. Behind these, the eye is led up the ridge to an unworldly grey-blue sky, indicated by the pointed roof of the church. Even Paul Klee could not have produced a more poetical composition.

By the middle of the 1870s, after more or less following traditional methods of perspective in the visual field of his paintings (nos 3, 4), Rousseau developed his own compositional plan (nos 6–8), to which he remained true for years. It is a spatially compromised, frontally oriented visual organisation, a separation of upper and lower zones with, in many cases, towering tree shapes that play a connecting role. The stylistic tendencies in this work are obvious and include the repetition of individual elements, specifically the schematic-seeming addition of trees and foliage, as well as the repetition of figures and architectural features.

The first documentary evidence of Rousseau as a painter dates from 1884, a permit from the Ministry of Education to copy in the Louvre, in the contemporary art rooms at the Musée du Luxembourg, at Versailles and Saint-Germain-en-Laye. Making such copies was part of the academic training of artists, even those who felt that what they were copying was outdated. Every time Cézanne was in Paris, for instance, he made sketches – from antique statues all the way to Rococo busts.[1] This permit is virtually the only evidence that Rousseau did the same thing.[2]

c. 1885
Oil on canvas (stretched over wood)
34.7 × 21.8 cm
Signed bottom left: H. Rousseau
Private collection

Permit for copying in state-run museums, 1884

1 Götz Adriani, *Paul Cézanne. Zeichnungen,* Cologne 1978, pp. 61 ff., 71 f.

2 Certigny 1984, no. 10.

Provenance: Stanislaus Stückgold, Munich; Bernheim Jeune & Co., Zürich; Georg Reinhart, Winterthur (since 1921); Hermann Hubacher, Zürich (gift of Georg Reinhart)

Bibliography: Georg Reinhart, *Katalog meiner Sammlung*, Winterthur 1922, no. 117, ill. XXXIV; Courthion 1944, ill. frontispiece; Uhde 1948, ill. 1; Bouret 1961, p. 178, ill. 56; Vallier 1969, p. 115, no. L 4, ill.; Keay 1976, p. 115, ill. 2; Certigny 1984, pp. 16 f., no. 8, ill.

Exhibitions: Basel 1933, no. 5; *Die Sammlung Georg Reinhart,* Kunstmuseum Winterthur, Winterthur 1998, p. 52 ill., p. 258, no. 46

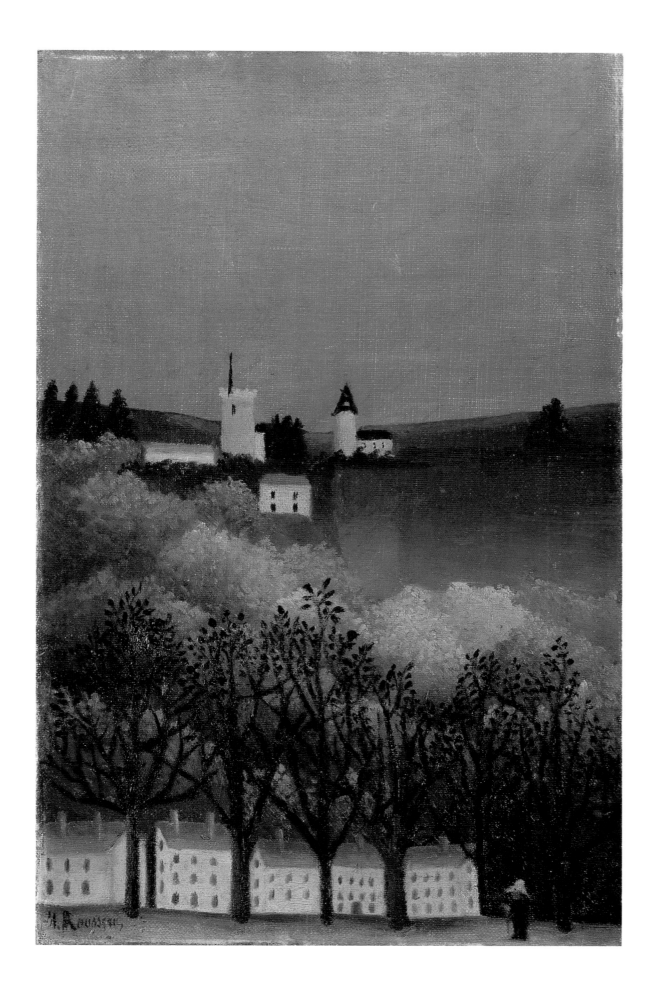

LANDSCAPE

Forest Promenade
La Promenade dans la fôret

In his autobiographical note of July 1895, Rousseau wrote that he was able to dedicate himself to art from 1885. Evidently, when he wrote this he ignored what he had created before that date.[1] Perhaps the date was the point in his life when he felt capable of going public: that year he participated in a group exhibition with two paintings (now lost). By the mid 1880s, Rousseau the hobby painter with escapist tendencies had become an artistic personality of some importance, reflected in the quality of the works from this period (nos 7, 8).

These include *Forest Promenade*, which shows a partly cloudy spring day and a fashionably dressed woman holding an umbrella on a forest path. Under the thin foliage of leaves the woman seems strangely out of place, with her close-fitting dress and the hint of a bustle. Having come to a stop, she turns in surprise and looks back to communicate with somebody beyond the edge of the picture. A branch stump can be seen above her head; the cut branch lies on the ground at the bottom of the picture.

The content of this picture is singularly tense. It suggests the cycle of life and death in nature and contrasts it with an airy, almost ethereal colouring that finds a crescendo in the red-brown of the woman's dress. This Rousseau seems to emphasise, by the brown and grey of the tree trunks, the fine greens, the pink, the yellow and sky blue. Writing about the Rousseau retrospective at the Galerie Bernheim Jeune, a critic in the magazine *La France* of 8 October 1912 referred to the quality of the colours in this painting: '*Forest Promenade* offers an ensemble of fine blues and greens in an incomparably wide spectrum of combinations, which is of extremely high quality and delicacy.'

Whether the woman in the painting is the artist's first wife Clémence, as their daughter Julia maintained at a later date, is questionable. The model for this lonely person, haphazardly integrated into a natural setting, could just as well have come from a picture in a fashion magazine.[2]

Rousseau was perhaps at his most original when painting landscapes, the genre that included the painters of the Barbizon group, the Impressionists, the Fauves and the Cubists, who pushed the Modern movement furthest and who had the greatest influence on future artists. If one wished to classify Rousseau within a single genre, then it would be this one: he bestowed a mature brilliance on his forests, on the plants and trees both local and exotic, on their crowns and foliage.

Regarding this painting's provenance, Wilhelm Uhde wrote: 'My little book about Rousseau [published 1911] sold a lot of copies, and I believe that it contributed to strengthen and increase the number of his sympathisers.

c. 1886
Oil on canvas
70 × 60.5 cm
Signed bottom left: H. Rousseau
Kunsthaus Zürich (purchased 1939, Inv. No. 2479)

1 Soupault 1927, p. 12.

2 Men and women alone in natural surroundings were a central theme of Rousseau. This is dealt with in a similar way in two jungle paintings, where fashionably attired female figures, seemingly bound up with the green of the jungle, are posed front-on to the viewer. Vallier 1969, nos 174, 202; Certigny 1984, nos 302, 315.

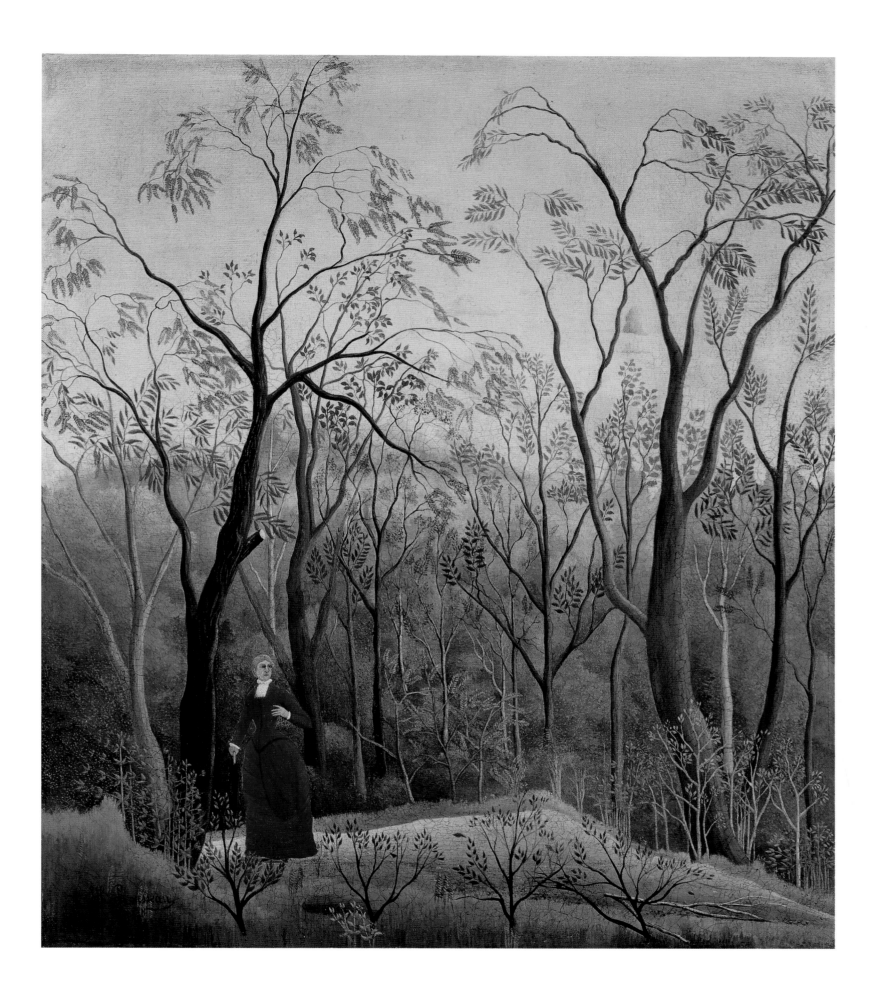

FOREST PROMENADE

Whatever the case, I received from the art dealer Bernheim the job of organising a retrospective of the works of Henri Rousseau, as far as they were known [1912]. This gave me the opportunity to gather together all the paintings from dealers and collectors that are known to me, and thereafter to unearth works of his, unknown until now, among the ordinary people of his neighbourhood. For I knew that he gave his paintings as gifts to the women he loved, and to the families with whom he was friends. When I got a hint of

a painting, I spent entire days going from house to house, from concierge to concierge following its trail. The success of this endeavour was, at least in the number of paintings I found, not all that great, but I was able to save a few beautiful works from being lost. These include an early painting of a woman in a red dress presented in a spring landscape, a painting owned by a washerwoman who lives in a small cul-de-sac off the avenue du Maine [Rousseau had a studio and apartment in that street for several years]. The painting was covered in soot, because for years the owners had used it as a firescreen.'[3] In 1948, Uhde expanded: 'it wasn't until the large retrospective that I organised in 1912 at Bernheim Jeune (Félix Fénéon was head of the modern collection then), that there was a decisive increase in the valuation of his paintings. This came soon after the exhibition, with the relatively high prices they achieved at public auctions. After the first war, I put up for auction, one of several sold from my own collection as German property for the benefit of the French state [1921] . . . the painting of the woman in the red dress who is taking a walk through the forest on a spring day, which I had purchased from a washerwoman for 40 francs,[4] and which sold for 26,000 francs. Upon my return to Paris three years later, in 1924, they were asking 300,000 francs for the same picture.'[5]

3 Uhde 1921, pp. 72 f.

4 A letter of 25 June 1911 from Serge Jastrebzoff to Ardengo Soffici confirms this purchase: 'Met Hhude [sic] today, he'd bought another Rousseau, from a washerwoman for 40 francs, very nice . . .' Certigny 1984, p. 54.

5 Uhde 1948, pp. 26 f.

Provenance: Wilhelm Uhde, Paris; sold at auction Hôtel Drouot, Paris, 30 May 1921; Léon Giraud, Paris; Antoine Villard, Paris

Bibliography: Uhde 1911, pp. 46, 50, ill. 7; Uhde 1914, pp. 45, 48, ill.; Uhde 1920, p. 55; Uhde 1921, pp. 53 f., 56, 73; Kolle 1922, p. 14, ill. 11; Roh 1924, p. 714, ill.; Scheffer 1926, p. 292; Salmon 1927, p. 46; Zervos 1927, ill. 43; Grey 1943, ill. 75; Courthion 1944, p. 18, ill. XXII; Uhde 1947, p. 43, ill., pp. 50, 52, 57, 59 f; Uhde 1948, pp. 26 f., ill. 2; Cooper 1951, p. 4, ill.; Lo Duca 1951, p. 6, ill.; Rousseau 1958, ill. 14; Bouret 1961, p. 61, ill. 1; Certigny 1961, p. 95; Vallier 1961, p. 115, ill. 41; Shattuck 1963, p. 95; Vallier 1969, p. 21, ill. V, p. 91, no. 23, ill.; Bihalji-Merin 1971, pp. 29, 83 f., 103, ill. 3; Bihalji-Merin 1976, pp. 46, 48 f., ill. 1, pp. 116, 119, 130; Keay 1976, pp. 30, 117, ill. 4; Alley 1978, pp. 12, 20, ill. 10; Stabenow 1980, pp. 89, 174 ff., 195, 200, 205; Le Pichon 1981, pp. 82 f., ill.; Vallier 1981, p. 14, ill.; Certigny 1984, pp. 54 f., no. 28, ill., p. 62; Goldwater 1986, p. 182, ill.; Rousseau 1986, p. 33, ill.; Werner 1987, no. 8, ill.; Stabenow 1994, p. 17, ill.; Schmalenbach 1998, p. 16, ill., p. 18.

Exhibitions: Paris 1911, no. 22; Paris 1912, no. 6; Basel 1933, no. 19; Paris 1961, no. 2, ill.; Zürich–Munich 1975, no. h.1, ill.; Paris 1984, pp. 85, 110, 112 f., no. 3, ill.; New York 1985, pp. 75, 100, 120 f., no. 3, ill.

A Carnival Evening
Un soir de carnaval

In the mysterious beauty of this painting of the night to which the noise of carnival has yielded, art history finds its modern counterpart to *Flight to Egypt*, painted in 1609 by the German Adam Elsheimer, then living in Rome. Worlds lie between the visual intentions of these two paintings, of course. While the earlier painting, meant to evoke Rubens, Rembrandt and Claude Lorrain, can be seen as coming shortly before the Baroque,[1] *A Carnival Evening* is a poetic culmination of the romantic moonlit nights of the century of Caspar David Friedrich.

1885–86
Oil on canvas
106.9 × 89.3 cm
Signed bottom right: H. Rousseau.
Philadelphia Museum of Art,
The Louis E. Stern Collection
(Inv. No. 1963-181-64)

1 Götz Adriani, *Deutsche Malerei im 17. Jahrhundert*, Cologne 1977, p. 23.

Analogies between the two paintings transcend the various historically identifiable premises and the difference in the vertical and horizontal formats. Both Elsheimer and Rousseau address the theme of the cosmic night sky, and do so using similar methods, in that they place an illuminated couple against a dark background. In both works the couples, one sacred and one

Adam Elsheimer, *The Flight to Egypt*, 1609
Bayerische Staatsgemälde-sammlungen, Alte Pinakothek, Munich

secular, seem small against the nobility of the universe. They are placed close to the viewer in the foreground, beneath the endless distance of a night-blue firmament under a full moon. Narrow rows of trees in each picture attempt, through diagonal placement, to bridge the distance between what is near and what is distant. Unlike Rousseau's ice-cold moonlight that lends his realistic painting an unreal atmosphere, Elsheimer's stars were included to show his knowledge of natural phenomena.

Rousseau's scene, with its dark-skinned Pierrot and his companion (probably drawn from models), is theatrically transported out of prosaic reality into the world of dreams. His moonlight has become a source of the ostensible and fantastical. In front of two floating cloud-banks that permeate the vault-like sky are the delicate, nerve-like branches of leafless trees that grow across the sky like flowers frozen on a frigid night. A small, stage-like zone is kept free for the costumed couple who, light-footed, quietly arm-in-arm, are leaving a summer-house decorated with a lantern and a mask.

This is Rousseau's first large-scale major work; its creation is surprising and hardly to be expected from the works that preceded it. He decided to present himself on the Paris art scene not as a hobby painter but as an artist among equals. He exhibited this work in his first public exhibition, in the summer of 1886, in the Salon de la Société des Artistes Indépendants,[2] where a group of independent artists including Redon, Seurat and Signac had met two years earlier to proclaim a jury-free zone of tolerance. This was the same year, by the way, that the Impressionists had their eighth and final exhibition. Among more than five hundred paintings grouped by a hanging committee under Signac, Rousseau's entry was hardly noticed, and if so then only as the laughable concoction of a dilettante. The art critic de la Brière criticised the painting mercilessly in *Le Soleil* of 20 August 1886: 'A small negro and negress in fancy dress are lost in a forest made of zinc, a carnival evening under the round of a moon that shines without illuminating anything, while against a black sky rises a bizarre constellation of a blue and pink cone . . .'

Although the emphasis of the exhibition in 1886 was Neo-impressionism, and there were passionate discussions concerning the Pointillism of Seurat's *La Grande Jatte*, Pissarro – to whom Cézanne also owed much – was amazed by how the subject was handled in this painting, as well as by the quality of the colouring.[3] Indeed, it is structured in such a way, with such a peculiar character (an atmospheric disposition as clear as glass) so complete in itself that one cannot think of it as the lucky accident of a beginner. We must assume that in the years leading up to this exhibition Rousseau had produced an early body of work that was much more extensive than the available evidence would suggest. There is no other explanation for the skill apparent from 1885 in the painter who, in 1910, maintained that he was 'already 42 years old . . . when he first picked up a brush'.[4]

2 In the margin of a scrapbook in which Rousseau collected articles written about his work, he proudly noted by the first newspaper article that contained his name: '1886, first exhibition in Société des Artistes Indépendants, to which I now belong.' Vallier 1961, p. 35.

3 Gustave Kahn, *Le Mercure de France*, 1 August 1923.

4 According to an interview with Arsène Alexandre in *Comoedia*, 19 March 1910 (Certigny 1984, p. 700).

Provenance: Between 1929 and 1934, the painting was in the possession of a maid of the aunt of Michel Kikoine, who later sold for 30,000 francs to a collector in the USA; Rittman & Brenner, New York; Louis E. Stern, New York

Bibliography: Rich 1942, ill. frontispiece, pp. 14 ff., 30, 64, 69; Uhde 1948, p. 5, ill.; Cooper 1951, pp. 53 f.; Lo Duca 1951, p. 5, ill.; Perruchot 1957, p. 23; Bouret 1961, pp. 14, 63, ill. 2; Certigny 1961, pp. 92, 157; Vallier 1961, pp. 29, 60, 105, 114 f., 120, ill. 35; Tzara 1962, p. 326; Shattuck 1963, pp. 58, 62, 64, 85 ff., 94 f., 100, 347, ill. 14; Vallier 1969, p. 17, ill. I, pp. 89 ff., no. 6, ill.; Vallier 1970, pp. 90, 93, ill. 9; Bihalji-Merin 1971, pp. 7, 28, 70, 101, ill. 1; Descargues 1972, pp. 10, 72 ff., ill., pp. 113, 117, 136, ill.; Bihalji-Merin 1976, pp. 17, 44 ff., ill. 10, pp. 116 f., 119; Keay 1976, pp. 8, 12, 30, 49, ill. I; Werner 1976, pp. 6, 10, 16 f., ill.; Alley 1978, pp. 12, 21, ill. 11, p. 42; Stabenow 1980, pp. 138, 173 ff., 186, 195 f., 198 f., 207 f., 225, 249; Le Pichon 1981, p. 35, ill., p. 253; Vallier 1981, pp. 7, 14, ill.; Certigny 1984, pp. 16, 30, 32 f., no. 16, ill., pp. 62, 278; *Paintings from Europe and the Americas in the Philadelphia Museum of Art. A Concise Catalogue*, Philadelphia, p. 422, ill.; Werner 1987, no. 6, ill.; Certigny 1991, p. 9; Müller 1993, pp. 12, 14, 167; Stabenow 1994, pp. 6 ff., ill., p. 94; Schmalenbach 1998, pp. 16 ff., ill., p. 23

Exhibitions: Paris 1886, no. 336; Chicago–New York 1942; Paris 1984–85, pp. 13, 102, 108 ff., no. 1, ill., p. 112 (not exhibited in Paris); New York 1985, pp. 13, 92, 98 ff., no. 1, ill., p. 102

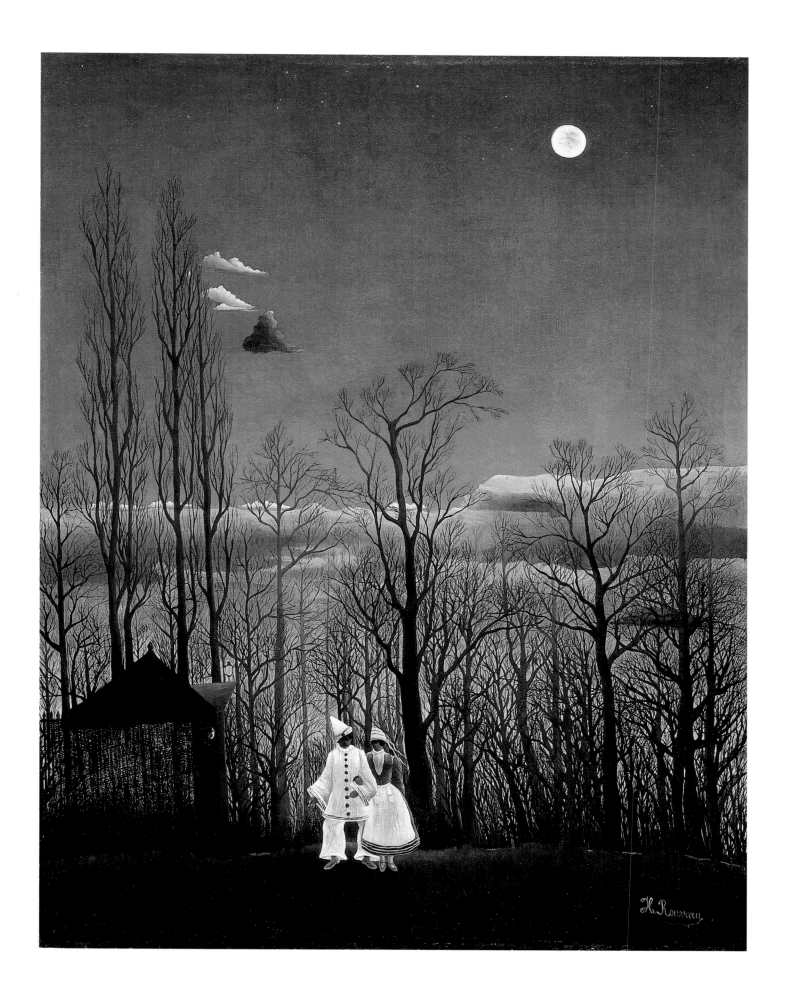

A CARNIVAL EVENING

Forest Rendezvous
Rendez-vous dans la fôret

8

The content of Rousseau's pictures is seldom set in the past, and he rarely intensified the immediate reality of his subject matter through allegory (see nos 9, 13, 32, 40, 41). In this forest landscape, figures in Rococo dress, representatives of civilisation, are placed in the middle of wildly overgrown vegetation. To achieve a fairytale-like reality, he deployed lovers on horseback in eighteenth-century clothing in front of a partially hidden castle on a hill. A path leads through the thicket to a clearing which the horses and riders have just reached, undisturbed by the dark clouds overhead. The scene is put into strong relief by the colourful costumes of the gallant and his lover, which express little more than the popular contemporary taste for anecdotal Neo-rococo decoration, but it is handled in a way that pulls the eye of the viewer through the foliage and the play of light into a richly articulated forest interior.

Together with *Forest Promenade* (no. 6) and *Carnival Evening* (no. 7), it represents the first highpoint in Rousseau's career as a painter. All three compositions give different variations on a walk through a forested area, based on a formal design developed around 1885 that continued to evolve until the later jungle paintings. Distance is indicated not by perspective but by differentiation between the lower and upper parts of the visual field. Before a background of neutral colours, tree trunks and branches rise, level after level and in rich contrast, until they create a terse definition of space overhead. The human figures, which could have been modelled on photographs or engravings, remain strangely suspended in space, so that the existence of the forest seems more realistic than the almost ornamental figures.

1886–89
Oil on canvas
92 × 73 cm
Signed bottom right:
Henri Rousseau
National Gallery of Art,
Washington.
Gift of the W. Averell Harriman
Foundation in memory of Marie
N. Harriman (Inv. No. 1972.9.20)

Provenance: Antoine Boy, Vincennes; Anna Boy, Vincennes; sold at auction Hôtel Drouot, Paris, 20–21 December 1926, no. 170; Bela Hein, Paris; Marie and W. Averell Harriman, New York (since 1931); W. Averell Harriman Foundation, New York

Bibliography: Rich 1942, pp. 16 ff., ill.; Bouret 1961, p. 180, ill. 62; Vallier 1961, ill. 40; Vallier 1969, p. 19, ill. III, p. 91, no. 21, ill.; Bihalji-Merin 1971, pp. 29, 102, ill. 2; *European Paintings: An Illustrated Summary Catalogue,* National Gallery of Art, Washington 1975, p. 312, ill.; Bihalji-Merin 1976, pp. 47 f., ill. 11, p. 119; Keay 1976, p. 118, ill. 5; Alley 1978, pp. 12 f., ill. 4; Stabenow 1980, pp. 89, 195, 200; Le Pichon 1981, p. 37, ill.; Certigny 1984, pp. 74, 76 ff., no. 43, ill., p. 80; John Walker, *National Gallery of Art, Washington*, New York 1984, p. 536, no. 806, ill.; *European Paintings: An Illustrated Catalogue*, National Gallery of Art, Washington 1985, p. 358, ill.; Werner 1987, ill. near no. 6; Stabenow 1994, pp. 10 f., ill., p. 75; Schmalenbach 1998, p. 16, ill., p. 18

Exhibitions: *Henri Rousseau*, Marie Harriman Gallery, New York, 2 January–12 February 1931, no. 3; *The Nineteenth Century: French Art in Retrospect*, The Buffalo Fine Arts Academy, Albright Art Gallery, Buffalo 1932, no. 54; *Constable and the Landscape*, Marie Harriman Gallery, New York 1937, no. 19; *Modern French Masters*, Marie Harriman Gallery, New York 1939, no. 12; Chicago–New York 1942; *Six Masters of Post-Impressionism*, Wildenstein & Co., New York 1948, no. 37, ill.; *Exhibition of the Marie and Averell Harriman Collection*, National Gallery of Art, Washington 1961, ill. 23; Paris 1964, no. 3, ill.; Paris 1984–85, pp. 110 f., no. 2, ill.; New York 1985, pp. 100 f., no. 2, ill.

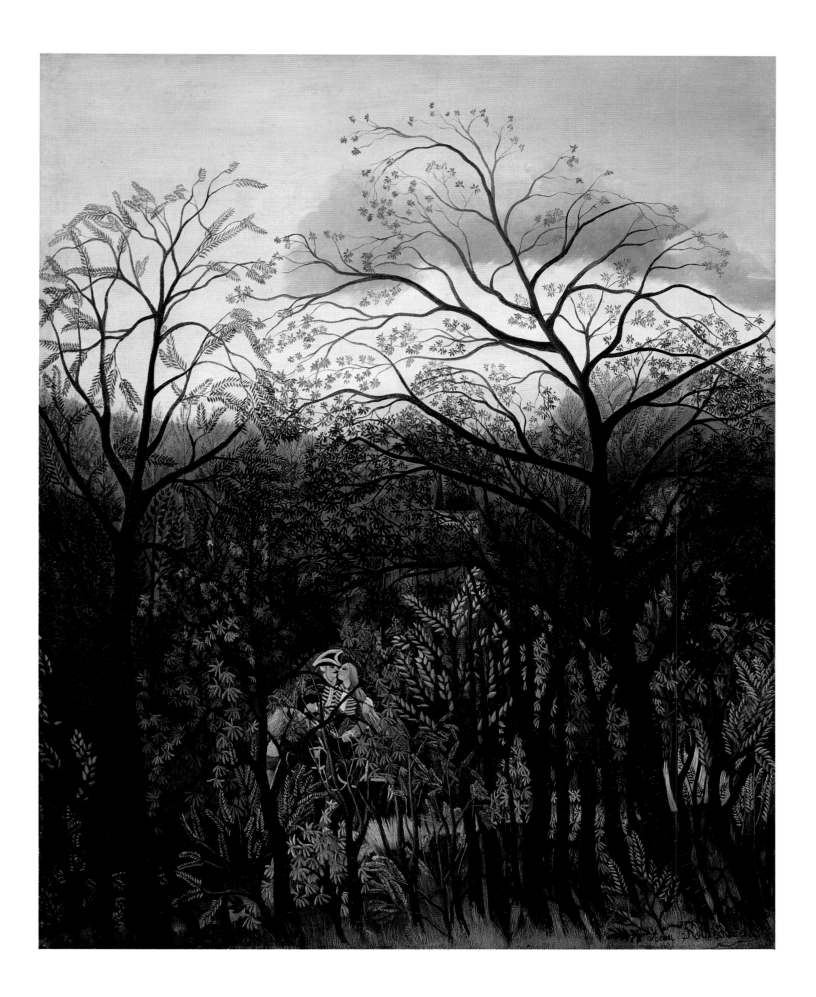

FOREST RENDEZVOUS

The Carmagnole
La Carmagnole

The Third Republic hosted the 1889 World's Fair in Paris and used the opportunity to celebrate the hundredth anniversary of the French Revolution. At the foot of the technical miracle of Gustave Eiffel's tower, France presented itself with its newest industrial and colonial achievements. Rousseau, swept up in the national fervour of the festivities[1] did what was expected and produced *Vaudeville: A Visit to the World's Fair of 1889* in three acts and ten tableaux.[2]

The celebration was continued in two gorgeously colourful paintings with the same subject, whose nationalistic programme one would expect to have found at the Academy-dominated Salon des Artistes Françaises rather than from an artist who was a member of the Independents (see no. 41). The larger of the two, bearing the title *Centennial Celebration of Independence*, is dated 1892 and at the Salon des Indépendants included the text: 'People are dancing around two Republics, that of 1792 and that of 1892, holding hands and singing the song "Auprès de ma blonde . . ."'[3] The second painting was perhaps more appropriate to the founding of the French Republic. The Carmagnole, and its associated song 'Dansons la Carmagnole', is the dance of independence; the name comes from the short jackets worn by workers from the town of Carmagnola in Piedmont, which were introduced to Paris as Jacobite jackets by revolutionary forces from Marseilles. The French Revolution reached its peak in 1793, when the King was beheaded, a new Republican constitution was written and Robespierre, Danton and Marat began their reign of terror (Victor Hugo's historical novel of 1874, *Quatre-Vingt-Treize,* took as its subject the dramatic developments of that year).

In the centre of this composition, celebrating the revolutionary virtues of liberty and equality, is a 'liberty tree' decorated with red, white and blue pennants. Stuck in the ground in front of it is the Tricolour and the blue and red flag of the municipalities. The people dance and sing on a festively decorated meadow, lined on both sides by flags, wearing the revolutionary Jacobite hat around the personifications of the First and Third Republics; the figures are taken more or less exactly from a woodcut engraving of Fortuné Méaulle's *The Festivals of Andorra*, published in the Appendix of the magazine *Petit Journal*.[4] At the edge of the painting are representatives of the Ancien Régime, clearly identified by their powdered wigs and Rococo-style clothing, as well as the double eagle of Marie Antoinette and the House of Habsburg on the yellow flags fluttering above them.

Rousseau chose the centennial date of 1893 not only because he was a patriot and a good citizen of the Third Republic who wanted to paint an allegorical representation of the glory and greatness of France and to

1893
Oil on canvas
20.5 × 75 cm
Signed bottom right: H. Rousseau
In the middle is a flag with the year 1893
Harmo Museum, Shimosuwa, Nagano

1 Vallier 1961, pp. 38 ff.

2 For more about Rousseau's published dramas, see Tristan Tzara's text, written originally in 1947, 'Henri Rousseau or the concept of the "total artist"', in Rousseau 1958, pp. 8 ff., 30 ff.; Vallier 1961, pp. 148 ff.

3 Vallier 1969, no. 54; Certigny 1984, no. 69.

4 Ibid., p. 128.

perpetuate the victory of the revolution in art, but because he felt secure enough in his own abilities to apply for public monies to do so.[5] On 30 March 1893, the Bulletin of the City of Paris announced a competition for the decoration of the banquet hall at the City Hall of Bagnolet; the contest rules were made available on 14 June for those wishing to enter. Henri Rousseau did so, designing this second version of *Centennial Celebration of Liberty* that summer in the required scale of one to ten. The size of the banquet hall required Rousseau to change the proportions of the original. The extreme oblong format of *La Carmagnole* was intended to cover 3.66 × 7.70 metres of the side wall of the banquet hall, and is identical in size to *View of the Bridge at Grennelle with Liberty Statue*.[6] But it never reached the larger stage. The jury – consisting of Puvis de Chavannes, himself experienced in wall design, Gérôme's student Alfred Roll, and Luc Merson who was entrusted with several public projects and who lived in the same building as Rousseau in the impasse du Maine 18[bis] – rejected his ambitious entry on 10 November 1893.

5 Certigny 1961, pp. 126 ff.

6 Vallier 1969, no. 49; Certigny 1984, no. 26.

7 Apollinaire 1914, p. 26 (p. 639).

Fortuné Méaulle, *The Festivals of Andorra*, illustration published in *Petit Journal*, 11 April 1891

Apollinaire described *La Carmagnole* in *Les Soirées* of 15 January 1914 as a preliminary study: 'Among the beautiful studies of Rousseau, none is as amazing as the small painting with the title *La Carmagnole*. It is a study done for *A Centennial Celebration of Liberty* . . . The nervous sketching, the variety, the grace and delicacy of its tones, make this study a small but excellent piece.'[7] Robert Delaunay recalled: 'One day Rousseau told me excitedly about how he took part in a contest, put on by the mayor of a suburb, for a painting to decorate a large banquet hall at the city hall. The jury congratulated him, he said, but found his study to be too revolutionary. This anecdote did not surprise me much, for I knew that the criteria of the jury was pretty much that of the art-going public. I had already forgotten his story when, a few months after Rousseau's death, I was at the second-hand book dealers on the quay – right opposite the Art Academy (how ironic!) – and happened to see out in the open air, between old books, the elongated format of the small masterpiece, the painting with the title *Liberty of the Republic* or *La Carmagnole*. A few days later at the same location, I came across the painting *Bridge of Grenelle* in the same format. I recalled the anecdote of the

61

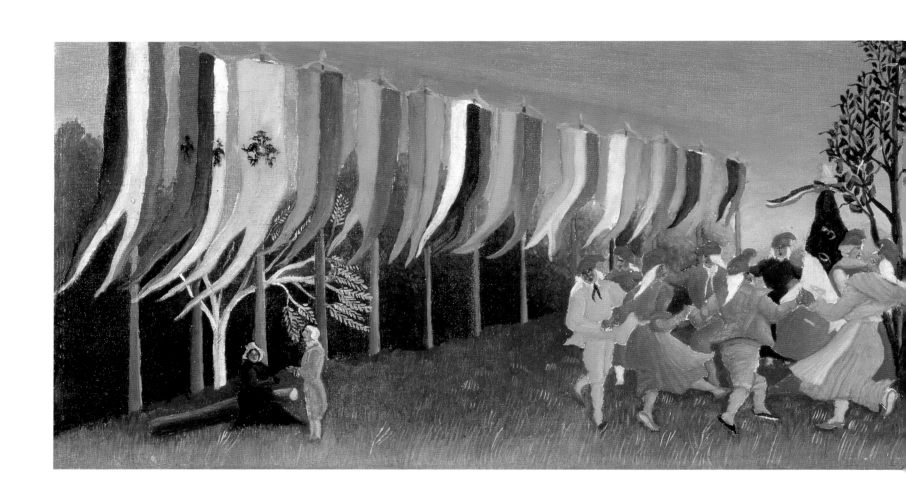

THE CARMAGNOLE

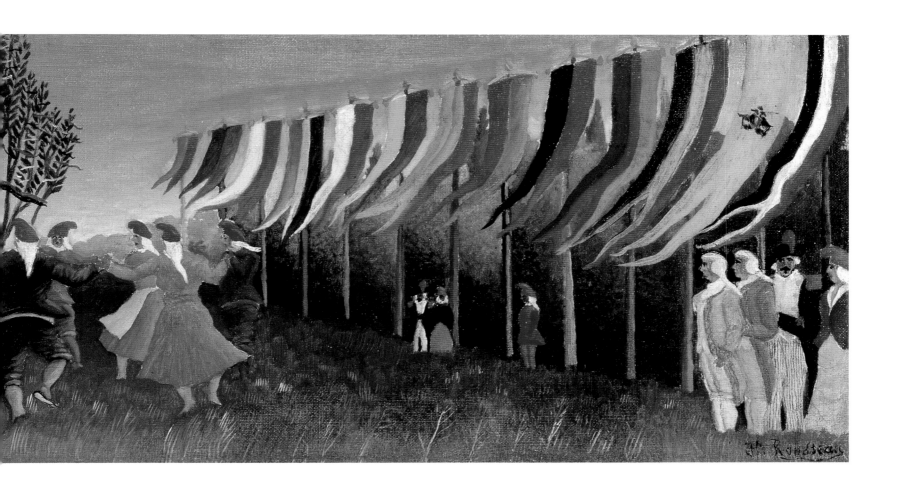

customs officer. I stood before both studies, which he had entered in the contest for that city hall. I remembered what Rousseau had told me. Happily, the people dance on grass around a 'tree of the republic' decorated with flags. What a sense for surface! What a feeling for life! How wonderful the size! And with what enthusiasm Rousseau threw himself into this kind of work. Rousseau did not meet with public acclaim, which should have been his right and of which he dreamed most deeply. In other centuries, he would have been contracted by rich patrons to decorate the walls of palaces. In our century he had to play the middle-class buffoon, he who was so conscious of tradition, so well-mannered and orderly. What an absurd fate!'[8]

8 Delaunay 1952, 21 August, p. 7.

Provenance: Robert Delaunay, Paris (since 1910); Mark Conroy, USA; Franck Conroy, USA

Bibliography: Apollinaire 1914, p. 26 (p. 639); Delaunay 1920, p. 228, ill.; Basler 1927, p. 3 Appendix, ill.; Rich 1942, pp. 20 f., ill.; Cooper 1951, p. 55; Delaunay 1952, p. 7; Bouret 1961, pp. 20 f., 186, ill. 76; Certigny 1961, pp. 118, 147; Vallier 1961, pp. 40, 130, 132, ill. 55, 56; Shattuck 1963, p. 98; Vallier 1969, pp. 87, 94 f., no. 64, ill.; Vallier 1970, p. 91, ill. 3, p. 93; Bihalji-Merin 1971, pp. 63, 141, ill. 41; Koella 1974, p. 118; Bihalji-Merin 1976, pp. 106 f.; Bryars 1976, pp. 312 f.; Alley 1978, p. 26; Stabenow 1980, p. 161; Le Pichon 1981, pp. 187, 189, 194, ill., p. 256; Certigny 1984, pp. 51, 128, 144 f., no. 77, ill. (with bibliography); exhibition catalogue Paris 1984–85, pp. 35, 124, 188; New York 1985, pp. 115, 180

Exhibitions: Paris 1911, no. 32; Paris 1912, no. 20; Berlin 1913, no. 6; Chicago–New York 1942

The Customs House
Station d'octroi

The only painting in which Rousseau makes reference to his job, *The Customs House* shows one of the many checkpoints that at the start of the twentieth century still encircled the outskirts of Paris along the old city fortifications. Loads of wine and grain, and delivery wagons full of combustibles or all kinds of milk products were checked for customs liability as they entered the city. Rousseau began his career with the Seine Prefectorate in 1871 at the customs houses of Auteuil, Porte de Vanves, Porte de Meudon and Pont de Tournelles. He also worked as a guard at the depots and warehouses on the Seine quayside. Wherever he was posted – at the gates and customs houses, on the quays of Henri IV (no. 52), Louvre and Austerlitz – he became familiar with that Paris district. Although more committed to art from 1885, he none the less continued to work as a *gabelou*, a low-ranking customs officer, and was presumably more or less undisturbed by the daily responsibilities of his job. In December 1893 he took early retirement after 22 years' service, with a small annual pension of 1,019 francs. At that point he gave up the civil service position that had

1890-95
Oil on canvas
40.6 × 32.75 cm
Signed bottom right: H. Rousseau
Courtauld Gallery,
Courtauld Institute of Art, London
(Inv. No. P 1948. SC.349)

Eugène Atget, *The Porte d'Arcueil*, Paris c. 1900

earned him a certain amount of respect among his neighbours, and set off to work as an *artiste-peintre*, as he confidently described himself on his calling cards.

Some of the Paris customs houses were documented in the photographs of Eugène Atget between 1890 and 1910,[1] but the station in this painting has not been identified. All the details are correct – the metal fence with gold spike ends, gas lanterns, the earth walls and casemates of the former fortifications, the border stones and the sentry box. Perhaps at the end of his career Rousseau felt the need to sum up his impressions during his years as a customs official.

Contrary to his usual practice of placing the subject as centrally as possible, Rousseau positions the gate and the watchful customs officials to the left. With this, he created space on the right for the four tall trees which, like the men in uniform, stand to attention, and for the straight paths in the foreground and an almost minimalist representation of a garden. Characteristic of Rousseau's paintings by this time is the variety of green tones and the complementary brick red of the wall, roofs and chimneys, which are wonderfully combined with the neutral grey of the paths, house walls and clouds.

1 Certigny 1984, pp. 160, 162.

Provenance: According to Sonia Delaunay, this painting was for sale for 80 francs from an antique dealer in the boulevard Montparnasse in 1907. Wilhelm Uhde, Paris; Sammlung Blun, Paris; E. Hartwich, Berlin; Galerie Alfred Flechtheim, Düsseldorf; Samuel Courtauld, London (1926); Courtauld Bequest (1948)

Bibliography: Uhde 1911, ill. 20; Uhde 1914, ill.; Uhde 1921, p. 21, ill.; Grey 1922, ill.; Scheffer 1926, pp. 292 f., ill.; Roh 1927, p. 111, ill.; Salmon 1927, p. 47; Soupault 1927, ill. 38; Zervos 1927, ill. 53; Grey 1943, ill. 70; Cooper 1951, ill.; Lo Duca 1951, p. 6, ill.; Wilenski 1953, pp. 8 f., ill. 3; Rousseau 1958, ill. 18; Bouret 1961, pp. 50, 95, ill. 18; Vallier 1961, p. 37, ill., pp. 119, 136 ; Salmon 1962, p. 33, ill.; Shattuck 1963, pp. 100, 105; Vallier 1969, p. 26, ill. X, pp. 87, 92 f., no. 39, ill., pp. 96, 101; Bihalji-Merin 1971, p. 106, ill. 6; Descargues 1972, p. 89, ill., p. 91, ill.; Bihalji-Merin 1976, p. 15, ill. 1; Keay 1976, pp. 10, 34, 77, ill. XV; Alley 1978, p. 29, ill. 19; Stabenow 1980, pp. 138, 156, 173, 184, 247; Le Pichon 1981, pp. 94 f., ill.; Vallier 1981, pp. 12, 17, ill.; Certigny 1984, pp. 160 ff., no. 84, ill., p. 348; exhibition catalogue Paris 1984–85, p. 47, ill.; New York 1985, p. 43, ill.; *Impressionist & Post-Impressionist Masterpieces: The Courtauld Collection*, New Haven & London 1987, no. 42, ill.; Werner 1987, no. 2, ill.; Stabenow 1994, pp. 14 ff., ill.; Schmalenbach 1998, p. 6, ill., p. 8

Exhibitions: Berlin 1926, no. 12, ill.; *Henri Rousseau*, XXV Venice Biennale, 1950, no. 4

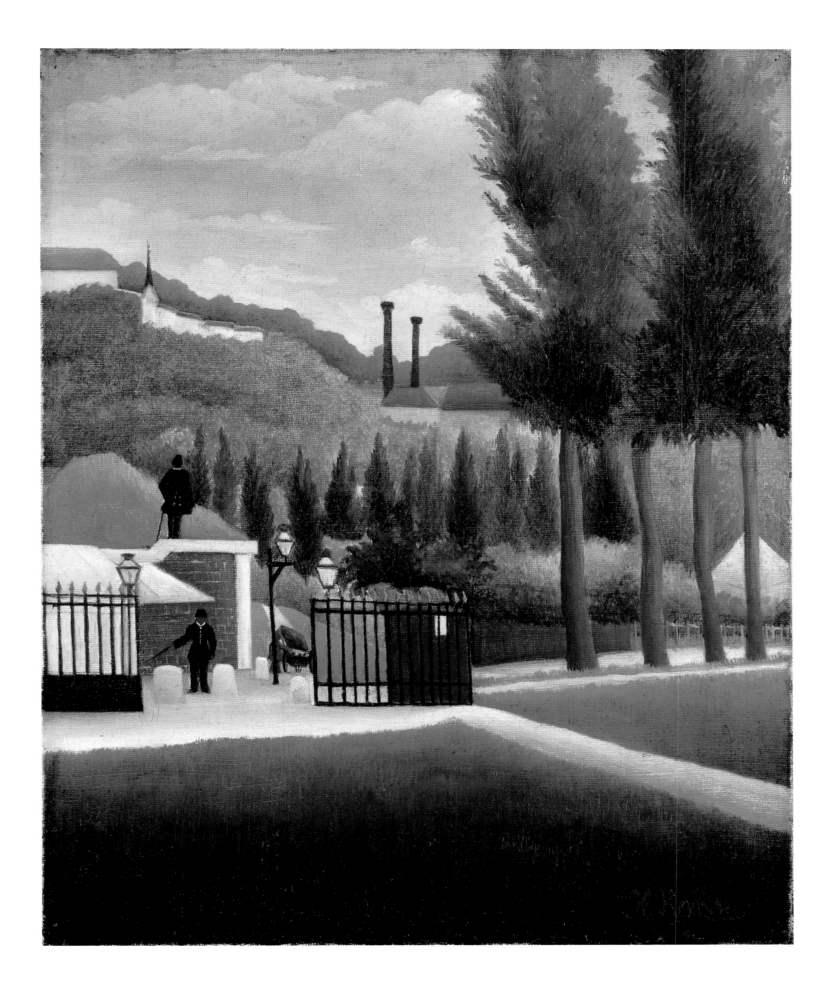

THE CUSTOMS HOUSE

Portrait of Frumence Biche in Uniform
Portrait de Frumence Biche en militaire

The portrait of Frumence Biche in the dress uniform of a Sergeant of the 35th Artillery Regiment was painted after the death of its subject in May 1892 (the decorated white wooden frame is original and also by Rousseau). It was based on a photograph probably provided by Biche's widow Marie, who is likely to have requested the portrait in remembrance of her husband, whom she had married only in 1891. After his own wife Clémence passed away in 1888, Rousseau wanted to marry Marie, then Mme Foucher, whom he had known for a long time (see p. 150). Frumence Biche was in the army from 1874 to 1886, achieving the rank of non-commissioned officer, and then in the Paris police. The photograph on which the portrait was based was probably taken at the latest in 1886, possibly to mark Biche's retirement from the army; he poses with dignity, his left hand on his sword hilt and his right holding a cigarette. In Rousseau's portrait, the over-large head contains strongly stylised features; the landscape may be based directly on the photographic studio backdrop. The painting is in poor condition, and it is not possible to deduce much about its original colouring, especially of the sky and green areas.[1]

It was exhibited at the ninth Salon des Indépendants in spring 1893, registered by the committee (which in that year included not only Signac but also Toulouse-Lautrec) with the title 'Portrait de M.B.', and given the exhibition number 1147. A critic in *Le Pays* for 21 March 1893 wrote of the exhibition that it was 'an affront to good taste', collected in a 'chamber of horrors' where 'gaudily coloured paintings hung framed in white'.[2] Rousseau, who continually tried the tolerance not only of art critics but also of his fellow artists, usually found his paintings condemned to the least prominent spot, in the basement; this year, Toulouse-Lautrec had to remind his co-committee members of the association's liberal articles to prevent them excluding Rousseau altogether.

1892–93
Oil on canvas
92 × 73 cm
Signed bottom right: H. Rousseau
Setagaya Art Museum, Tokyo

1 With the best will in the world, the date '1893' made out by Certigny below the signature cannot be confirmed. Certigny 1984, p. 154 .

2 Ibid., pp. 154, 156.

Provenance: Marie Biche-Foucher, Paris-Davrey; Cécile Biche, Paris-Davrey; Denis B., Neuilly-sur-Seine (1962); Marlborough Gallery, London (1966); C. Aberbach, New York

Bibliography: Certigny 1961, p. 124; Vallier 1969, pp. 93, 95, no. 66, ill.; Certigny 1971, ill. 18; Le Pichon 1981, p. 74, ill.; Certigny 1984, pp. 38, 82, 124, 132, 142, 146, 154 ff., no. 82, ill., pp. 158, 162, 186, 562; exhibition catalogue Paris 1984–85, p. 133; New York 1985, p. 124; Certigny 1990, p. 8; Certigny 1992, p. 6

Exhibitions: Paris 1893, no. 1147; Zürich–Munich 1975, no. H.4.; Setagaya 1996, p. 37, no. 2, ill.

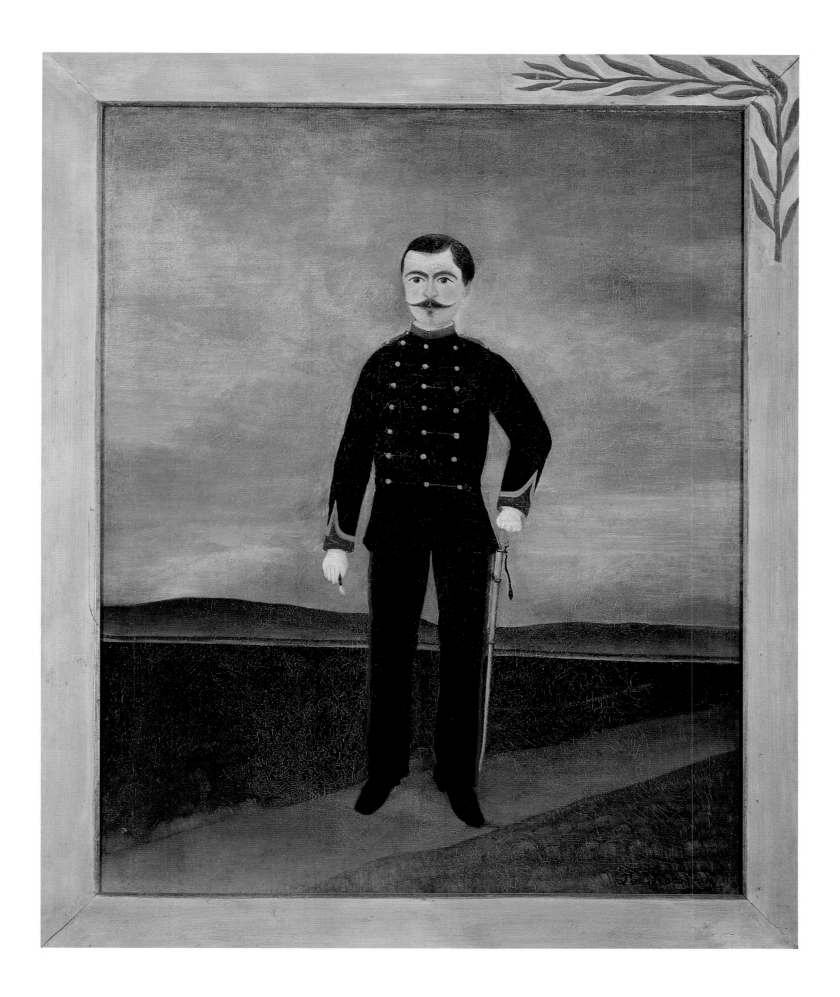

PORTRAIT OF FRUMENCE BICHE IN UNIFORM

The Artillerymen
Les Artilleurs

When Rousseau retired from the civil service to dedicate himself to painting, he was forced to look harder for contract work, and found a few suitable patrons among his acquaintances and neighbours. Like him they lived in Montparnasse, an artisans' quarter with a small-town containment somewhat apart from the life of the big city around it. Because they had neither the time nor inclination for lengthy sittings, Rousseau often had to depend on photographs – attractively retouched family heirlooms showing people singly, in pairs or in family groups, which were clearly important to their owners and subjects. But there would have been a sense of something finer, perhaps nobler, in being depicted by a real painter. Rousseau offered a range of paintings from exclusive individual works through small canvases to larger formats, with attractive colouring. To some extent they were mass produced, available at any time. Transferring the subjects from existing photographs helped him to conceal the difficulty he had with figure placement (no. 11).

c. 1893
Oil on canvas
79.1 × 98.9 cm
Signed bottom right: H. Rousseau
Solomon R. Guggenheim
Museum, New York.
Gift of Solomon R. Guggenheim,
1938 (Inv. No. 38.711)

Group portrait of artillerymen, postcard, c. 1900

Rousseau created a group of twelve men gathered around a cannon and their battery commander in a charming landscape of trees. The soldiers are in their dress uniforms, the guns are silent, the cannon is at rest; swords and weapons are placed haphazardly or guarded by one of the soldiers. Fourteen pairs of eyes peer motionless out of stereotypical faces. In contrast to the symbols of war, the machines and the hard black-and-white of the uniforms is a restful natural scene whose tone is set by a green balanced between blue and yellow. The arrangement of the painting, including the slyly rhythmic martial deportment of its subjects, is determined for the most part by the diagonal movement of the tree masses and the echelon-like placement of their tops. As with many of Rousseau's works, the feet are not well executed; here, they are seemingly stuck fast in the high grass (compare nos 27, 31, 32).

Rousseau extols the red and gold of the regimentals, witness to the affinity that he, as a customs officer, may have felt with the military. Two of

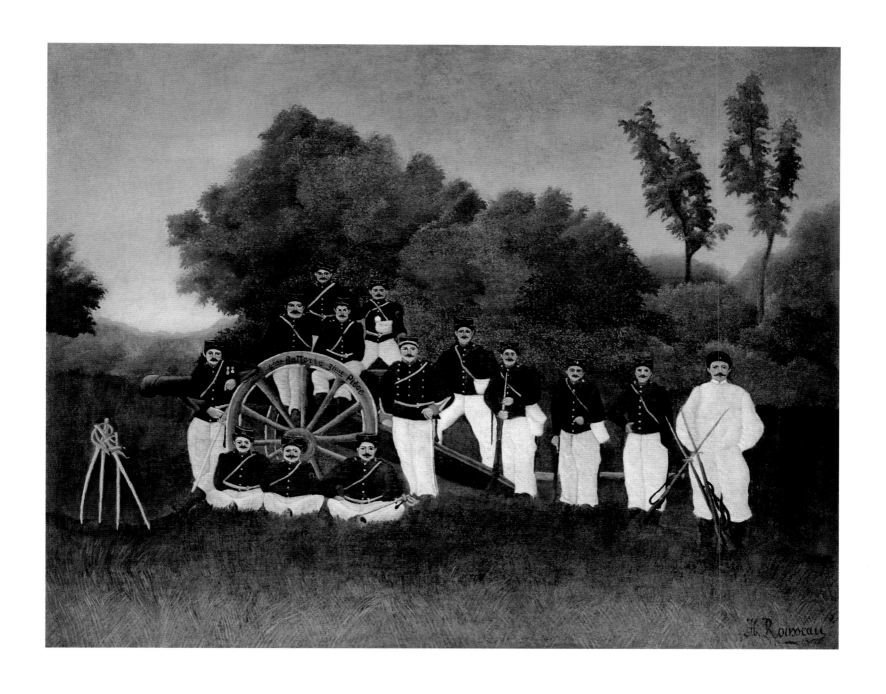

THE ARTILLERYMEN

the soldiers are farriers, designated by the horseshoe symbols on their sleeves; another poses with his service medals. The inscription on the wheel of the cannon, '4ème Batterie 3ème Piece', specifies which battery it belonged to. Rousseau was less concerned with detail in the natural setting, which reflects a formalist handling in the structured grass ground, and a Pointillist handling in the tree foliage.

The presentation here had nothing to do with Rousseau's own military experience between 1864 and 1868[1] or Apollinaire's improvement on it, nor with his short period of being drafted in 1870. It is more likely to be drawn from the life of Sergeant Biche whose wife was a friend (see no. 11); she might have lent him a photograph of artillery soldiers or even suggested it as a subject.

1 Apollinaire 1914, p. 8 (p. 628).

Provenance: Maurice Renon, Paris; Galerie Van Leer, Paris (before 1927); Knoedler Galleries, New York (1929); Roland Balaij, Paris (1937); Galerie Louis Carré, Paris; Solomon R. Guggenheim, New York (since 1938)

Bibliography: Basler 1927, pp. 31 f., ill. XIV; Bruno E. Werner, *Französische Malerei in Berlin*, in *Die Kunst*, 55, XXXXII, 1927, p. 225; Rich 1942, p. 29, ill.; Courthion 1944, p. 17, ill. XXX; Uhde 1948, ill. 7; Cooper 1951, p. 55, ill.; Lo Duca 1951, p. 4, ill.; Gauthier 1956, no. 30, ill.; *A Handbook to the Solomon R. Guggenheim Museum*, New York 1959, ill. 132; Bouret 1961, pp. 50, 190, ill. 86; Certigny 1961, p. 51; Vallier 1961, p. 51, ill.; Salmon 1962, pp. 44 f., ill.; Shattuck 1963, p. 106; Vallier 1969, p. 30, ill. XIV, p. 95, no. 65, ill.; Bihalji-Merin 1971, p. 132, ill. 32; Jakovsky 1971, p. 33, ill.; Descargues 1972, p. 94; Bihalji-Merin 1976, p. 110, ill. 33; Keay 1976, pp. 36, 120, ill. 7; Alley 1978, pp. 47 f., ill. 39; Stabenow 1980, pp. 198, 200; Le Pichon 1981, pp. 218, 225, ill.; Vallier 1981, p. 32, ill.; Certigny 1984, pp. 158 f., no. 83, ill.; Certigny 1992, p. 40; Stabenow 1994, pp. 63, 66, ill.; Schmalenbach 1998, pp. 26, 62, 74, ill.

Exhibitions: Galerie Hugo Perls, Berlin 1927; *75 Peintures du Musée Solomon R. Guggenheim*, Musée des Arts Décoratifs, Paris 1938; Chicago–New York 1942; New York 1963, no. 9, ill.; Paris 1964, no. 4 ill.; Zürich–Munich 1975, no. H. 6, ill. 57; Paris 1984–85, pp. 132 f., no. 11, ill. (not exhibited in Paris); New York 1985, pp. 124 f., no. 11, ill.

War, or Discord on Horseback
La Guerre, ou la chevauchée de la discorde

Rousseau painted this work during peacetime. After more or less noncommittal landscapes, portraits and genre scenes, this colossal metaphor is a triumphant and furious statement against war. Based on the perplexity of death, it shows a pestilential miasma of the Middle Ages riding into modern times: its symbolic roots, surely unknown to Rousseau, reach back to the fourteenth century with its Riders of the Apocalypse and allegories of the Black Death. Paolo Uccello transformed these themes into battle panoramas (see p. 204); Pieter Brueghel employed Death on horseback killing everything in its path as a protest against the Spanish occupation of The Netherlands (see p. 74).

What could have inspired Rousseau to paint this horrible vision, an allegory of war, at the end of the century that began with Goya's *The Disasters of War* (ill., p. 78)? Was it politics, or the colonial wars of the Third Republic? Did he want to influence the viewer politically, and to whom was the appeal directed? Or is the painting an expression of the artist's fears concerning social problems of the time, such as the increasingly subversive activities of French anarchists?

Whatever the case, nothing of contemporary history or politics can be read into the painting: no meaningfully historical date can be seen, and there is no indication of an actual war, with military struggle or its symbols and attributes. There are no weapons or uniforms. Besides the dying and the dead, the battlefield shows nothing – neither conqueror nor conquered. The

1894
Oil on canvas
114 × 195 cm
Signed bottom right:
Henri Rousseau
Musée d'Orsay, Paris
(Inv. No. RF. 1946-1)

Unknown master, *The Triumph of Death*, 15th century
Galleria Regionale della Sicilia, Palermo

things associated with war – fear, pain, weapons, dirt, blood-smeared bodies – have been removed, along with any indication of a specific battle or a geographical location. Although power and powerlessness meet head-on in a manner that is almost crass, the wailing of the victims is kept to a minimum. Out of the general agony, just one figure has an upraised arm with his hand clenched in a fist of defiance. The painting is without allusions to the potential for conflict between Germany and France that was growing in the 1890s, to patriotic heroism or the enthusiastic chant 'God with us' of Franco-German provenance.[1]

1 See Sigmar Holsten, *Allegorische Darstellungen des Krieges* 1870–1918, Munich 1976.

War is transformed into an anonymous power of fate. Horse and rider, cause and effect, have been stylised into a sudden, unavoidable destiny. The sharpness of the protest is lessened by the painting's compositional balance, which causes a neutralisation of its allegorical message. Rousseau avoided demonising his subject through a clear application of monumentality and aestheticism. He was not interested in presenting a battle, nor in the terror of spilling blood, nor in the detail of an historically correct military action complete with weaponry. Rather, in a mixture of horror and farce, he constructs an allegory of a helpless, hopeless world beyond time, place and history – the principals of war are shown to be catastrophe, destruction and death. Rousseau seems to say that victory is no guarantee of future peace but only of death, a view far from other, nationalistic, versions of the theme that were being created at the time. He completely smooths out the differences between perpetrator and victim, army and devastation.

Pieter Brueghel, *The Triumph of Death*, 1560–62 Museo del Prado, Madrid

No sign of life redeems Rousseau's apocalyptic vision – in the no man's land of the dead, nature itself has become barren. An almost infernal topography reveals no ways of escape; the smell of rotting flesh hangs in the air. The missing green of nature offers no future, no hope; sunrise red can be seen against a steel-blue sky. Soot-blackened cloud banks and ash-grey shards of trees dominate the stone-hard landscape. It was a vision that influenced later painters up to and including Joseph Beuys in his stone labyrinth, *The End of the Twentieth Century* (see p. 78).

The radical use of visual symbols, bequeathed to the Modern movement by the nineteenth century, is highly dramatic. This is Rousseau's only work with the dimensions of a historical painting in the vein of Ingres or Delacroix; he deployed intense moments of pain and suffering to justify his formal treatment of the subject and his coloration. No other work by

Lautrec has a young woman on a horse who seems to be at the whim of a man driving her around a circus ring with a whip. A detail of what seems to be a larger painting, it made a big impression on the public and earned a place of honour at the Moulin Rouge. And Seurat stylised one of those female acrobats on horseback who became an attraction in the circus rings of the late nineteenth century into a composition that caused a major stir

Henri de Toulouse-Lautrec,
In the Circus Fernando,
1888
The Art Institute of Chicago

in 1891 and 1892 at the Salon des Indépendants. Rousseau sought his visual stimulation elsewhere. There were many patriotically minded war allegories at the time, including an illustration in the socialist magazine *L'Egalité* of 6 October 1889, and another in *Le Courrier Français* of 27 October 1889 to accompany Pierre Andreiew's novel *Le Tzar*.[2] Rousseau may have saved such an illustration, and used it years later for details such as the way the rider is placed and the ravens follow the rushing horse. He was able to transform a propaganda drawing into his own confident handling of the subject, creating a war metaphor out of a Russian no man's land and the nihilism of the tsarist horseman, and converting it successfully to a large-format canvas, witness to his excellent visual inventiveness. Surely this work stands alone between Goya's *The Disasters of War* and Picasso's *Guernica* (ill., pp. 78, 81).

The painting, completed without private or public patronage in the winter of 1893–94, was exhibited from 7 April to 27 May at the Salon des

Illustration published in
L'Egalité, 6 October 1889

Indépendants as number 327, with an accompanying text that read: '*War* – wherever it marches forth it provokes horror, leaving despair, tears and destruction in its path.' By now a full-time artist, Rousseau had plenty of time to present himself in front of his paintings when they were on show and to respond to reactions from the public and press. Perhaps for this reason, reactions this time were a bit less negative than before.[3] We read, for instance, of Rousseau's 'symbolic painting that represents war', of his 'bitter satire' and of his autonomy 'even towards nature itself'. One critic was the 20-year-old poet Alfred Jarry; the two men, both from Laval, clearly established an immediate rapport – shortly afterwards Rousseau decided to paint a portrait of Jarry, while the younger man made it his goal to become the most extravagant of all Rousseau's advocates. In his discussions of the Salon exhibitions in

2 Forges 1964, pp. 360 ff.; the illustration has the caption: 'Everywhere where the mysterious black horse appears, a catastrophe occurs, a crime was committed.'

3 Müller 1993, pp. 19 f.

Eugène Delacroix, *Freedom Leads the People*, 1830
Musée du Louvre, Paris

image. The carpet of corpses of the defeated army of men has been put down before the victorious female to whom natural life itself, as well as social and moral order, has fallen victim. Ubiquitous death is for her the elixir of life.

The mass psychosis of yearning for war will be followed by mass death. The collective dead have done their duty, and the earth is longer able to receive them in the bosom of nature thus destroyed. The 'cleansing steel storm' of war has done its work efficiently. The heavy fallen bodies are without name and mostly without faces. Robbed of all their power and military insignia, their nakedness has become their new uniform, submissive to the hegemony of the 'weaker sex'. Only one protesting figure, peering out with a numb look of death, has been partly clothed, for reasons of decorum. The pale stiff cadavers, bound together in a single ornament of death, gave Rousseau the chance to vary figure placement and volume and contrast it with the flat, shadowy forms of the horse and rider. The men have been arranged in such a way as to personify a low-lying outcrop – but of backs and stomachs, not stones. Some of these 'stones' are soaked in blood and resemble glowing coals. The only victors in this war are the carrion birds of night who land on the rotting bodies and near the rivulets of blood.

The subject of man and woman is dealt with in a completely different way by Toulouse-Lautrec and Seurat. In *In the Circus Fernando*, Toulouse-

Rousseau is so completely based on polarities; no other work so completely and effectively realises movement and lifeless rigidity, individual figures and monumentality. The aggressive movement in the top half is separated from the lower part by sharply drawn horizontals. The apocalyptic rider passes, leaving executed men in her wake; the cries of war are silent. Her message is defeat and suffering, a rich harvest of blood in the horrific grey of morning, the complete victory of living death over dead life.

Joseph Beuys, *The End of the 20th Century*, 1983 Bayerische Staatsgemälde- sammlungen, Munich

Even though Rousseau employed the war-horse as a symbol of sovereignty and the main method for conducting battle, the horse here is also symbolic of ancient animalistic violence and the ubiquity of death itself. In a horizontally stretched gallop, it flies through the picture like the silhouette of a horse of deepest black. The attack of its silver-shod hooves allows no escape. To increase the impetus of this overwhelming creature of darkness, the rider – whose windswept hair was a precursor of Picasso's post-Cubic period – seems to be moving at a greater speed, seems to be not so much on the horse as moving in front of it, hunting without direction over the land of the dead. Her eyes are wide, looking for new victims, while her mouth is open in a grimacing cry. The figure, torn by furious movement, might be traced back to the Gorgon Medusa; instead of snakes, her head is made profane by a wild mane of hair. Clothed in the tight pleats of a girl's dress, she spreads fear and horror while shooting through the air, unaffected by the world represented by the field full of corpses below her. A raised blade and a burning tar-black torch are her trophies.

Francisco Goya, *Ravages of War*, from the series *The Disasters of War*, 1808–23

The tumultuous portent against the sky seems more monstrous in its subtlety and excessiveness. Behind the mask of a girl, whose white dress could have represented the purity of a guardian angel, is hidden the fearful talons of a horrible warning. While on the German side of the Rhine, war was represented as being masculine (whether in athletic nakedness or clad in full armour), on the French side war and death were represented as feminine. The connecting sequence of La Femme, La Guerre and La Mort is irrefutable: it is logical to allow a child-woman to become the incarnation of calamity. Nobody excapes the cruel reach of the adolescent *femme fatale*, at whose feet the world of men lies helpless. In Delacroix's beacon to democracy, the ultimate sacrifice for a just cause is being celebrated – the appealing barricade fighter makes the partnership of freedom and death a desirable possibility. There is nothing like that in Rousseau's requiem – no possibility here of a hero's death and its transfiguration through the visual

78

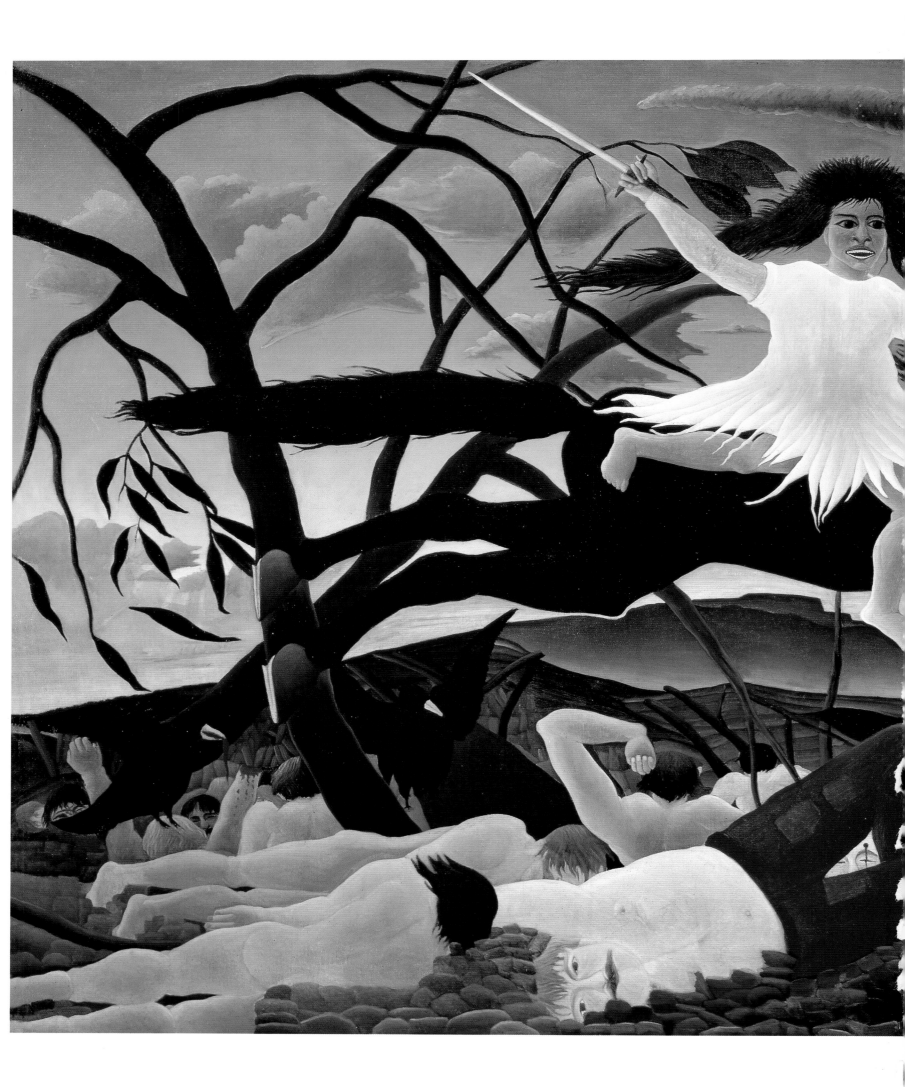

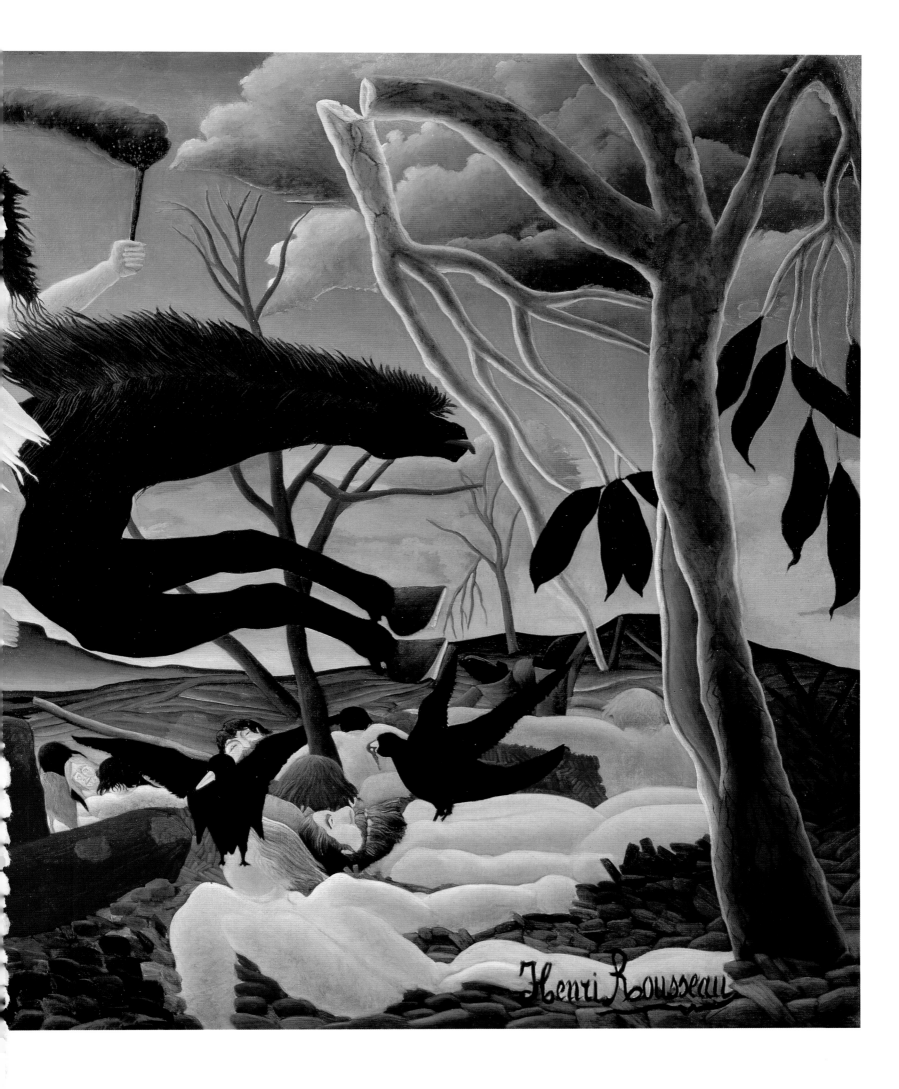

WAR, OR DISCORD ON HORSEBACK

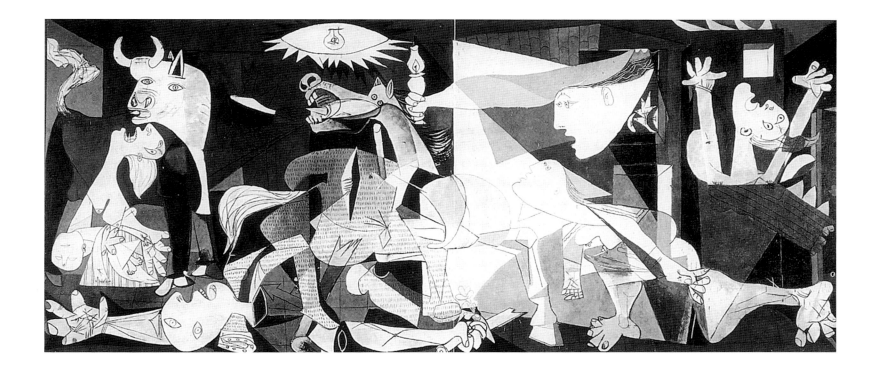

Pablo Picasso, *Guernica*, 1937
Museo Nacional Centro de Arte
Reina Sofia, Madrid

L'Art littéraire of May 1894 and in *Essais d'Art libre* of June, the precocious cynic expressed his preference for the eccentric and grotesque in art: 'of the curious H. Rousseau: *War [Discord on Horseback]*, above the dishevelled horizontality of his dread horse, below the confusion of amphibian cadavers . . .' Even more poetic was Jarry's second assessment: 'From H. Rousseau is, first to mention, *War* (it is fearful . . .). With outstretched legs held fast by dread, the warhorse stretches its neck with its rocking head, black leaves populate mauve clouds, and the pieces of ruin fall like pine cones under the translucent corpses of amphibians, attacked by crows with glowing beaks.'

At Jarry's instigation, the March 1895 issue of *Le Mercure de France*, a Symbolist magazine with which he had close contacts, published the only well-grounded article on Rousseau during the painter's lifetime.[4] Entitled *Un Isolé*, it was written by the art critic Louis Roy, a friend of Gauguin, who expressed his appreciation of this lone wolf and his painting: 'The most remarkable painting at the exhibition of the Artistes Indépendants from 1894 was surely *War* [*Discord on Horseback*] by Henri Rousseau. Although neither the way it is painted nor the painting itself is perfect, still the painting – even if it does not appeal to some – remains an audacious attempt to express the true meaning of the symbol. The artist who painted it is himself a singular personality. His picture seems strange only because it is reminiscent of nothing that we have seen before. Is this not a basic quality? Why should something not seen before be cause for ridicule? What right have we to laugh about an artistic effort? Even when the effort is not successful, which is not so in this case, ridicule is not appropriate and a sign of inferior intelligence . . . Henri Rousseau's fate has been the same as all new painters. He works all alone and possesses the characteristic, so seldom seen these days, of being absolutely self-reliant. His goal is a new

4 Ibid., pp. 22 ff.

Arnold Böcklin, *War*, 1896
Kunsthaus Zürich

kind of art. This painting, altogether a very interesting attempt, possesses some great qualities despite having some weaknesses. The accent of black, for example, is without a doubt very beautiful. The horizontality is also successfully handled. The large galloping black horse, which takes up the entire width of the canvas, is in no way banal, and is witness to a strong sense of style. On the back of the horse rides War. It wields a sword in its right hand and in the left hand is a burning torch. On the ground below lie ripped-up bodies, fat and thin, wretched and lamentable. They are dead or dying. Those who are still breathing express extreme horror. Nothing of nature remains except for two leafless trees, one grey, the other black, and ravens attracted by the smell of blood, which have flown down in order to feed upon the victims of war. The ground is covered in filth, the earth is without green, without even a single blade of grass. This painting expresses the hopelessness that an irreparable catastrophe causes in us all. Soon there will be nothing left alive here. The fire that the light on the horizon indicates will complete the work that iron began. In a moment, all will be dead. War rides on, however, untouched and relentlessly like a god, not yet satiated by the bloodbath. Nothing can stop it from its wild running. What single-mindedness! What a nightmare! How gripping the impression here of inconsolable bereavement! Only those with malicious intent can suggest that the man who gave us such a vision is not an artist.'[5]

Comment from the public came only in the context of the painting's exhibition at the Salon des Indépendants. Rousseau noted all the articles about him in the gazettes, and to document his growing reputation started a cuttings collection in 1885.[6] However, despite positive reviews, his work remained unsold; the young art dealer Ambroise Vollard, after an unsuc-

Giovanni Segantini, *Wicked Mothers*, 1894
Kunsthistorisches Museum, Vienna

5 Vallier 1961, pp. 56 f.

6 Ibid., p. 35.

82

Franz von Stuck, *War*, 1896
Bayerische Staatsgemäldesammlungen,
Neue Pinakothek, Munich

cessful effort to sell them, gave all of Rousseau's paintings back[7] (in the same year Vollard started another undertaking that did not look very promising, organising an exhibition for the almost-forgotten Cézanne in a Montmartre gallery).

What happened to this painting after the exhibition closed is not well documented. By 1895 it had disappeared. Certigny claimed that it had been in the possession of a farmer in Normandy, who later entrusted it to an antique dealer in Louviers, J. L. Angué (this was surely an assumption on his part).[8] By 1943 it had found its way to the Paris art dealer Etienne Bignou. A German officer, Ernst Jünger, hearing that a Rousseau had turned up, wrote in his diary for 19 October 1943: 'Again we have a report of a terrible air attack last night in Hanover . . . The city seems now to be completely in ruins. This afternoon I was at the art dealer's Etienne Bignou who, upon my request, had taken out of his bank safe a painting by the customs officer Rousseau, which has been lost for a long time. Rousseau called this work, painted in 1894, *War, or Discord on Horseback* and gave it the motto: 'Wherever it marches forth it provokes horror, leaving despair, tears and destruction in its path.' The colours stand out when you first see the picture: clouds seem to unfold like pink blossoms before a blue sky. In front of this is a black and warm grey tree, from whose branches tropical leaves hang down. The angel of discord gallops away on a black, eyeless horse over the battlefield. It wears a pleated shirt and in its right hand holds a raised sword, in the left a torch out of whose dark smoke sparks crackle. The ground over which this horrible extra-terrestrial flies is covered by naked or sparsely dressed

7 Viatte 1962, p. 331.

8 Certigny 1984, p. 176.

83

cadavers. Ravens are feasting upon them. To the corpse in the foreground which, by the way, is the only one scantily clad in a pair of trousers, Rousseau gave his own face; another in the background, whose liver is being eaten by a raven, has features like his wife's first husband . . . I see in this painting . . . one of the great visions of its time. It also presents a concept of necessary painting, in contrast to a kaleidoscope presentation of subject. The paintings of the early Impressionists corresponded to old daguerreotypes, while this one corresponds to a snapshot. The elementary impact of the subject is due to forceful contrast between a kind of spell of horror and decorative rigidity – one can contemplate this painting despite the fact that it somehow refuses to give up its secrets, whether that be accomplished through its own furtiveness created by the demonic being itself, or whether through its horrible speed. You can see that it was already very dangerous around that time. And then the Mexican atmosphere – thirty years earlier, Gallifet came back from this country. One source of our horrible world

Max Beckmann, *Apocalypse, 'And All the Birds Have their Fill of their Flesh'*, 1941/42

can be traced without a doubt to the planting of tropical seeds in European ground. Amazing, too, among the various qualities here, is the childlike quality – purity in fairy-tale horror, as in the novels of Emily Bronte.'[9]

After France was liberated, the Front National des Arts had a small retrospective in honour of the centenary of Rousseau's birth at the Musée d'Art Moderne de la Ville de Paris from 22 December 1944 to 21 January 1945. Fifty years after its first showing, *War, or Discord on Horseback* was seen again. We cannot disregard the possibility that Picasso, who drew many monstrous and destructive female images to personify war and violence, was reacting to the relentlessness of Rousseau's painting when he began *The Charnel House* at the end of 1944. Despite doubts concerning its authenticity, especially from André Breton, the painting was bought by the Musée du Louvre in 1946.[10]

9 Ernst Jünger, *Werke, Band 3, Tagebücher III*, Stuttgart 1962, pp. 184 f.

10 Bazin 1946, pp. 8 f.

Pablo Picasso, *The Charnel House*, 1945
The Museum of Modern Art, New York

Provenance: J. L. Angué, Louviers; Etienne Bignou, Paris.

Bibliography: A. Jarry, in *L'Art littéraire*, May–June 1894; A. Jarry, in *Essais d'Art libre*, May–July 1894; L. Roy, in *Mercure de France*, March 1895, pp. 350 f.; Soupault 1927, pp. 12, 39; Rich 1942, pp. 25, 29; Bazin 1946, pp. 8 f., ill. 4; T. Tzara, in *Labyrinthe, Genf*, 16 January 1946, ill.; Uhde 1947, p. 62; Uhde 1948, pp. 6, 13 ff., 24f., ill. 18; A. Breton, *Flagrant délit: Rimbaud devant la conjuration de l'imposture et du trucage*, Paris 1949, p. 170; Cooper 1951, p. 13, ill., pp. 53, 60; Lo Duca 1951, ill.; Wilenski 1953, pp. 4, 10 f., ill. 4; Gauthier 1956, ill. 13; Perruchot 1957, pp. 32, 36, 91; Rousseau 1958, pp. 24 f.; *Musée National du Louvre, Catalogue des peintures, pastels, sculptures impressionnistes*, Paris 1958, no. 383; Giedion-Welcker 1960, p. 91; Bouret 1961, pp. 14, 19, 24, 73, ill. 7; Certigny 1961, ill., pp. 131, 134, 137 f., 142, 147 ff., 156 f., 159, 210; Vallier 1961, pp. 7, 52, 54 ff., ill., pp. 60, 63, 134 f.; Salmon 1962, p. 15, ill., p. 40; Tzara 1962, p. 323; Viatte 1962, p. 331; Shattuck 1963, pp. 61 f., 94, 96, 235, 347; Forges 1964, pp. 360 f.; Vallier 1969, pp. 6, 8, 32 f., ill. XVI–XVII, pp. 84, 87, 95, no. 69, ill., pp. 98, 114; Vallier 1970, p. 96; Behalji-Merin 1971, pp. 8 ff., 45, 64 f., 73, 83, 145, ill. 46; Jakovsky 1971, p. 32, ill., p. 37; Descargues 1972, pp. 14, 38, 52 f., ill., pp. 58f., ill., pp. 114, 116, ill.; Gallego 1974, p. 4; Bihalji-Merin 1976, pp. 7, 17, 19, 107 f., 120, 130, 137, ill. 9; Keay 1976, pp. 12, 32, 61, ill. VII; Werner 1976, pp. 8, 28 f., ill.; Alley 1978, pp. 19, 22, 24 f., ill. 15, pp. 28, 42, 48; Stabenow 1980, pp. 90, 112, 147 ff., 150, 167, 174 ff., 196, 199 f., 204 ff., 211, 214 f., 226, 239, 245 f.; Le Pichon 1981, pp. 213 ff., 222 f., ill., pp. 257 f.; Vallier 1981, pp. 7, 55 ff., ill.; Certigny 1984, pp. 132, 134, 172 ff., no. 88, ill., pp. 182, 190, 234, 283 f., 292, 316 (with bibliography); Rousseau 1986, pp. 14 f., ill.; Werner 1987, no. 12, ill.; Certigny 1989, p. 4; Müller 1993, pp. 14, 19 f., 22 ff., 88 f., 168, 170, 185; Stabenow 1994, pp. 51 ff., ill.; Schmalenbach 1998, pp. 24 ff., ill., p. 166

Exhibitions: Paris 1894, no. 327; Paris 1944, no. 21, ill.; *Französische Kunst*, Kunsthalle, Bern 1949, no. 6; Paris 1964, no. 5, ill.; Paris 1984–85, pp. 40, 78, ill., pp. 104, 108, 126 ff., no. 9, ill., pp. 130, 180, 254; New York 1985, pp. 37, 70, ill., pp. 93, 98, 118 ff., no. 9, ill., pp. 122, 172, 231, 250

War
La Guerre

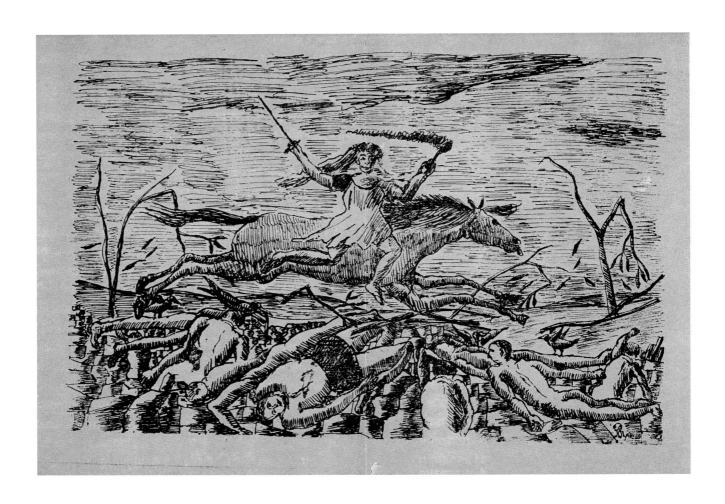

Alfred Jarry and Rousseau probably met for the first time at the exhibition of *War, or Discord on Horseback* (no. 13) in April 1894. Thereafter the elderly painter and the young poet were friends. Jarry was so impressed by Rousseau's allegory that he asked him to produce a pen-and-ink drawing of it so that he and his friend Rémy de Gourmont could make a lithograph to publish in their planned new quarterly magazine *L'Ymagier*.[1] Gourmont, the theorist of Symbolism, became the editor when the magazine began several months later in October 1894, dedicated to 'religious or legend-based pictures with a bit of clarifying text and nothing else . . .' The first issue contained an advance notification of the Rousseau lithograph, which was to be printed in the 15 January 1895 issue, in double-page format, with a special offer price of three francs.[2] The artist's only graphic work was trans-ferred to the stone and printed by the painter and critic Louis Ray, author of

1894
Printed lithograph of pen-and-ink drawing on red-brown vellum
22.2 × 33.1 cm
(paper size 27 × 38.7 cm)
Monogram bottom right: hR
Collection E. W. K., Bern

1 Apollinaire 1914, pp. 7 f (pp. 627 f); Müller 1993, pp. 22 ff.

2 '*Collection de L'Ymagier*, Henri Rousseau. *La Guerre*, lithographie originale, in – folio oblong, japon fr. rouge . . . 3 fr.'

the positive review of the original painting in *Le Mercure de France* (see no. 13). It is not known how many lithographs were produced; in 1914, Apollinaire wrote that it was very rare and that few people knew of it.[3]

Gourmont and Jarry had a falling out, and the magazine folded after only five issues. Jarry attempted to restart it in order to print all of Dürer's copper engravings – this expensive publication, called *Perhinderion* and published bi-monthly, lasted for only two issues before it ran out of money in summer 1896. In both these short-lived magazines Jarry expressed his support for popular French art, religious art and art from outside Europe, comparing these with the work of contemporary artists such as Emile Bernard and Gauguin. In Rousseau Jarry had found a 'modern folk artist', a forerunner of Fernand Léger, whom he could imagine designing and carrying out complete fresco cycles. Rousseau's sense of monumentality and his marvellous colouring directed him towards this rather than the colour-free medium of drawing. Indeed, one can see how the artist struggled to transfer the motifs of the large oil painting to ink on paper. Like all of his sketches, it is fussily drawn, contracted, clumsy and stiff. The line is unconfident, the hatching and shading formalised. Planning this for illustration, he eliminated the horrific character of most of the features.

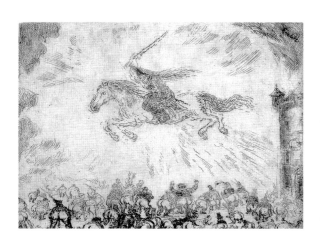

James Ensor, *The Angel of Destruction*, 1889

Bibliography: L. Roy, in *Le Mercure de France*, Paris, March 1895; Apollinaire 1914, p. 7 (p. 627); Basler 1927, pp. 8, 33, ill.; Soupault 1927, p. 9; Zervos 1927, p. 12; Rich 1942, p. 25, ill.; Weber 1942, p. 17, ill.; Courthion 1944, p. 24; Bazin 1946, pp. 8 f., ill. 3; Ch. Pérussaux, 'Commandée par Remy de Gourmont: L'Unique lithographie du Douanier Rousseau', in *Les Lettres françaises*, Paris, 30 August 1956, ill.; Perruchot 1957, p. 33; Rousseau 1958, ill.; Giedion-Welcker 1960, p. 91; Bouret 1961, p. 19; Certigny 1961, pp. 145 ff.; Jakovsky 1961, p. 7; Vallier 1961, pp. 52 ff., ill. 21; Tzara 1962, p. 323; Shattuck 1963, pp. 61, 188; Forges 1964, pp. 360 f., ill.; Vallier 1969, pp. 84, 95, ill.; Descargues 1972, p. 53; Bihalji-Merin 1976, p. 108; Bryars 1976, p. 312; Keay 1976, p. 14, ill.; Alley 1978, pp. 22 f., ill., pp. 30, 51; Le Pichon 1981, p. 222, ill.; Vallier 1981, pp. 55 f., ill.; Certigny 1984, pp. 175 ff., 180 ff., no. 89, ill.; exhibition catalogue Paris 1984–85, pp. 78, 104, 129 ff., no. 10, ill.; New York 1985, pp. 70, 93, 120, 122 f., no. 10, ill.; Müller 1993, pp. 22, 25, 89, 170, 185; Stabenow 1994, pp. 54 f., ill., p. 94; Pernoud 1997, pp. 61 f., ill. 3; Schmalenbach 1998, pp. 25, 66

Exhibitions: *Meisterwerke der Graphik von 1800 bis zur Gegenwart. Eine Schweizer Privatsammlung*, Kunstmuseum, Basel 1975–76, no. 98; *Von Goya bis Warhol, Meisterwerke der Graphik des 19. und 20. Jahrhunderts aus einer Schweizer Privatsammlung*, Kunstmuseum, Winterthur 1985, no. 97, ill.

3 'The first to encourage Rousseau in his attempt was without a doubt M. Remy de Gourmont. He even went so far as to order a lithograph of *The Horror of War* [*Discord on Horseback*], which was published in *L'Ymagier*. This lithograph print is very rare and hardly anyone knows it. Remy de Gourmont found out through Jarry that the customs officer painted with the purity, grace and conscientiousness of a primitive. He had seen some of his flower pieces, the ones he painted for the bakers in his neighbourhood." Apollinaire 1914, p. 7 (p. 627).

The Tiger Hunt
La Chasse au tigre

To link Rousseau with a movement or a tradition of any kind is difficult. Whereas to understand the development of Cézanne, Degas or Picasso requires a knowledge of their constant confrontations with the past, such an interpretation of Rousseau is insufficient. Although he applied for and received a permit to paint in the city museums (see p. 50) and supposedly enjoyed copying Uccello, Carpaccio, Watteau and Courbet,[1] his own visual references to these great masters is limited.[2] Academicians as well as those outside the Academy thrived on the study of the human body, whether using models or examples from past works of art. But the study materials that Degas relied on for *Dancers* and Cézanne for *Bathers* were not available to this self-taught painter. He was forced to learn the basics of figure painting, portraiture and landscape from popular handbooks.

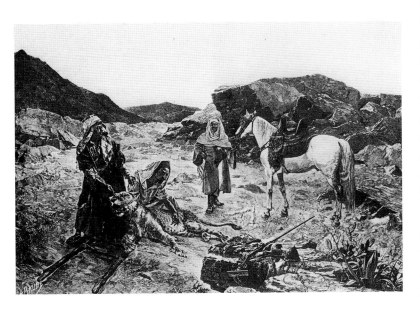

Rodolphe Ernst, *Triumphal Soirée*, illustration published in *Le Monde Illustré*, September 1895, p. 237

Rousseau regarded himself as a traditionalist painter, and never lost sight of the nineteenth century even as he was leaving it far behind him. Unlike other avant-garde painters of his time, Rousseau did not avoid unusual subject matter. His preferred source was popular ephemera – magazine illustrations, broadsheets, postcards and photographic portraits (see nos 2, 6–9, 11–13, 39–43, 58, 59). After transferring an image to canvas, apparently using a pantograph to get it as accurate as possible, he then shaped it to his unique style of painting.[3]

The Tiger Hunt is an interesting example of this method. The theme of the hunt – whether fishing in lakes or rivers, or with exotic settings for wild animals – takes a special place in Rousseau's work. This rocky desert scene with a dead tiger, three Berbers dressed in colourful attire and a white horse that has been led up to transport the kill is based on a painting by Rodolphe Ernst, *Soirée triomphale*, which had been a success at the official Salon in 1895 and was reproduced as a photo-engraving in the popular magazine *Le Monde Illustré* in September the same year. The Viennese Ernst lived in

1895–96
Oil on canvas
38 × 46 cm
Signed bottom right:
H. J. Rousseau
Columbus Museum of Art, Ohio
Gift of Ferdinand Howald
(Inv. No. 1931.091)

1 Perruchot 1957, pp. 79 f.

2 An illustration of a copy after Delacroix can be found in Certigny 1984, no. 10.

3 Vallier 1970, pp. 90 f

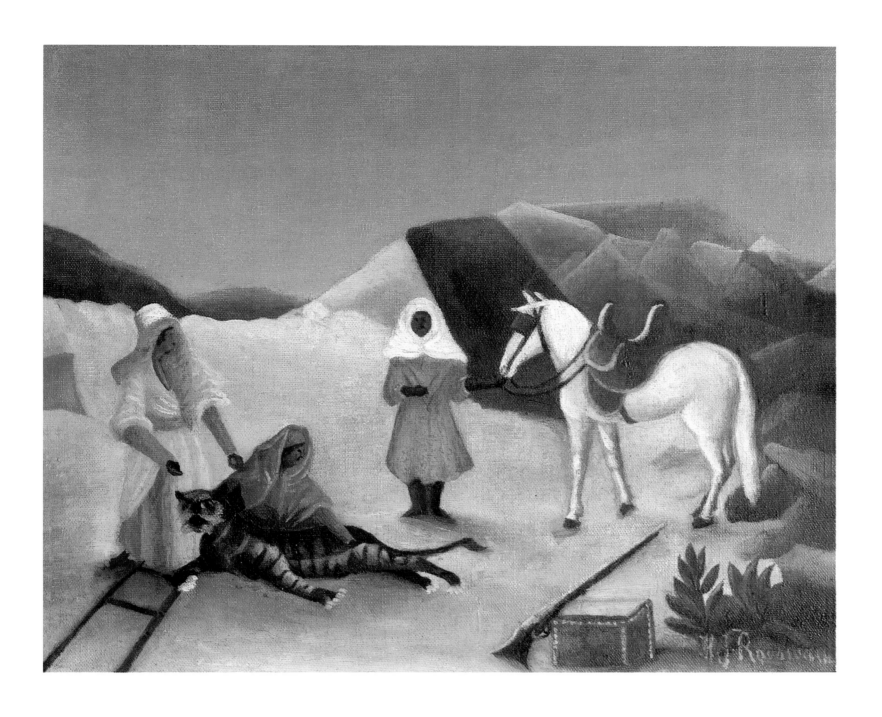

THE TIGER HUNT

Paris and was a painter of the oriental scenes that were so popular among Salon visitors.

Rousseau made an abstract interpretation of the engraving and transformed it into colour. A comparison with Ernst's work reveals what was important to him: he has distilled the exacting details into their fundamental forms, and replaced the lion with a tiger. He has changed the proportions and flattened out the spatial depth.

Provenance: Paul Guillaume, Paris; Ferdinand Howald, Columbus

Bibliography: Zervos 1927, ill. 21; Rich 1942, pp. 30 f., ill.; Lo Duca 1951, p. 11, ill.; Bouret 1961, p. 75, ill. 8; Vallier 1961, p. 141, ill. 135; Salmon 1962, p. 18, ill.; Vallier 1969, p. 101, no. 151, ill.; Vallier 1970, p. 94, ill. 96; Jakovsky 1971, p. 37, ill.; Descargues 1972, p. 70, ill.; Keay 1976, p. 33, ill., p. 123, ill. 11; Alley 1978, pp. 26 f., ill.; Stabenow 1980, p. 245; Le Pichon 1981, p. 159, ill.; Certigny 1984, p. 222, no. 111, ill., pp. 264, 422, 462, 486, 656 f.; Stabenow 1994, p. 50, ill., p. 57

Exhibitions: Chicago–New York 1942; Paris 1961, no. 8, ill.; New York 1963, no. 11, ill.

Antoine Watteau, *Gilles*,
c. 1719
Musée du Louvre, Paris

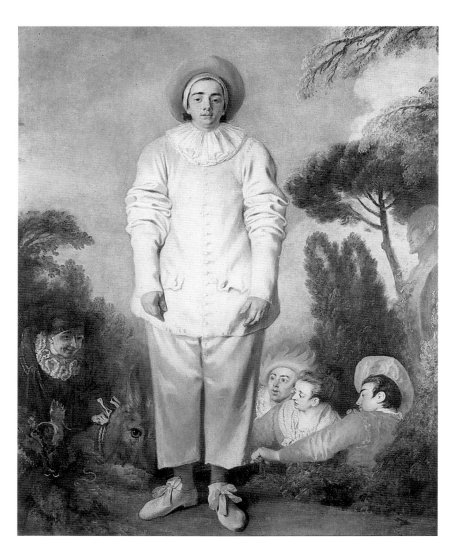

Portrait of a Woman
Portrait de femme

A good way to understand Rousseau's art is through his full-length, almost life-size portraits of individuals. By their size they proclaim his confidence and their derivation can be traced to full-length portraits from the past. This particular genre began in the sixteenth century with Jacob Seisenegger, Titian and others, and was originally reserved for the representation of emperors, kings and members of their families. But the style gradually became less restricted, and the interiors in which the figures were traditionally placed opened up to background landscapes. Even in the bourgeois society of the nineteenth century, only people of rank and reputation enjoyed the privilege of having themselves painted full-length by artists like Bonnat. Rousseau did not want to be outdone, and claimed the tradition, reserved until then for historically important people, for himself and for the models who would follow when, in 1890, he made a self-portrait called *I myself, Portrait – Landscape* (see p. 138). To Titian's and Velazquez's portraits of members of the House of Habsburg, Rousseau replied with this figure of a nameless young woman, posing her with the same majestic dignity and inaccessibility that had been the exclusive province of the nobility. Imperiously, she occupies most of the space, in front of a curtain handled in a way that had become symbolic of sovereign authority – Rousseau's Italian and Spanish predecessors could not have made it more pompous. The artist gave the deep black of her dress a place of honour on his palette, the black that Manet found in Velazquez and Goya, and that the Impressionists despised, even though it was a major colour for fashions at the time. The fashion began when Charles V put on black clothes of mourning after his Spanish mother passed away, and his son Philip II, mindful of this, decreed that only black might be worn at court in Spain. This influenced fashion at royal residences from Prague to Vienna and The Netherlands, until by the nineteenth century black was worn by all social classes.

c. 1895
Oil on canvas
160.5 × 105.5 cm
Musée Picasso, Paris
(Donation Picasso,
Inv. No. RF. 1973-90)

Diego Velazquez, *Isabella of Bourbon*, 1631–32
Private collection,
New York

Like Watteau before him in *Gilles* (ill. p. 90), which Rousseau was supposed to have admired at the Louvre,[1] the artist understood how to create a monumental portrait of mysterious forcefulness. This statue-like woman stands on a balcony or in front of an open window. The decoration of the curtain, bound with a thick cord, accentuates the vertical movement of the visual field. Except for a few details – such as the high-necked dress with the wide blue collar, which indicates the social class of the subject as well as a date in the late 1890s – hardly any value is placed on the characterisation of the subject. The powerful, architectural-like body and its placement between indoors and outdoors seem to suggest that she has just stepped in to our field of vision. Her head is turned slightly so that her eyes look beyond the viewer into the distance. The rigid frontality, the clear outlining, the emphasis on the woman's hands and the plant attributes – all give a pseudo-religious atmosphere to the figure, reminiscent of wall paintings or codex illustrations from the early Middle Ages.

The popular combination of a young woman and blossoms is inverted here: this figure is a metaphor for the transitoriness of life, as shown by the fuchsia held in one hand[2] and the branch with withered leaves held paradoxically upside down in the other. An unnatural-seeming group of plants – pansies, forget-me-nots and chrysanthemums close together in pots – seems to rot slowly away; they are overshadowed by the more lively colours of the curtain. Beyond the railings, the crags of a dead landscape of rocks have had every colour, every form of comforting green, distilled out. The hard white of a waterfall breaks across this waste land, while overhead a bird flies. This was described well by Jarry with the words: 'Stones, as cold as a trumpet blast'.[3] Instead of the hectic life of a big city beyond the balcony, as was favoured by Impressionists such as Caillebotte (see p. 94), Rousseau provides a lifeless nature, as though he wanted to remove communication between inside and out, sealing off one from the other.

It is not known who the woman is, or whether this was a commissioned portrait. The 27-year-old Picasso paid five francs for it in 1908 in a second-hand shop run by the art dealer Eugène Soulier, and it can claim to be the only woman Picasso kept beside him for almost his entire life, for 65 years until his death in 1973. An upholsterer by trade, Soulier also showed paintings and drawings in his shop, including some from Picasso's blue period. This portrait, showing aspects of life and death combined with a strong manipulation of form and colour, clearly appealed to the young Picasso, who had an ambivalent relationship with the opposite sex and had finished his seminal *Les Demoiselles d'Avignon* the previous year. He later recalled: 'The first work by the customs officer that I was able to buy awakened a persistent yearning in me. I walked through the rue des Martyrs. A second-hand shop had a group of paintings displayed in front. A head peered out, the face of a woman, hard eyes, a penetrating look, decisiveness and clarity. The canvas was huge. I enquired about the price. 'A hundred sous,' replied the dealer, 'You can paint over it.' It was one of the truest portraits ever of the French psyche.'[4]

We learn more about Picasso's dealings with Soulier from Fernande Olivier (see pp. 97 ff.): 'A new kind of buyer showed up one day at Picasso's.

1 Perruchot 1957, pp. 79 f.

2 The plant, discovered in Haiti, was given its name in the seventeenth century after the doctor and botanist Leonhart Fuchs, born in Tübingen in 1501.

3 Giedion-Welcker, p. 108. A similar rocky landscape with a view of water in the distance can be found in the portrait *L'Enfant aux roches;* Vallier 1969, no. 86; Certigny 1984, no. 94.

4 Fels 1925, p. 144.

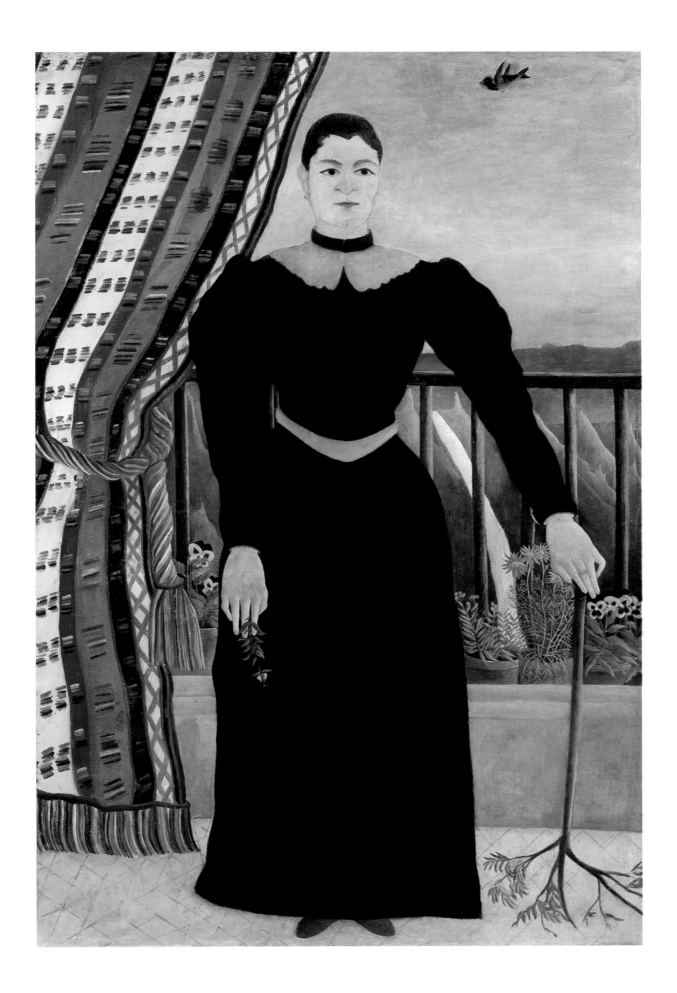

PORTRAIT OF A WOMAN

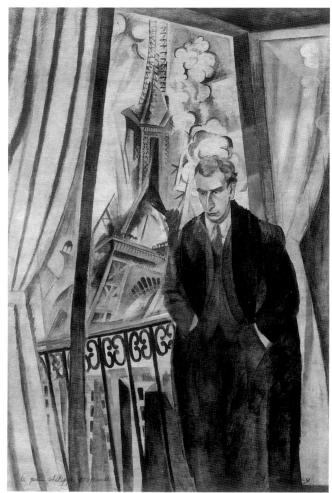

Gustave Caillebotte, *On the Balcony, Boulevard Haussmann*, 1880
Private collection

He was a shopkeeper from the rue des Martyrs across from the Circus Medrano. He sold bedlinen and second-hand goods. He was called Père Soulier. Why did this man need a Picasso? And he actually made numerous visits to the studio after that. He bought several drawings for a few francs . . . His dealings with Picasso were done at the bar of a local bistro . . . Picasso later bought a painting by the customs officer Rousseau for five francs: a life-sized female figure at a window that opens up to a landscape of a fortress.'[5] Elsewhere she recalled: 'I spoke one day with him [Rousseau] about the painting that Picasso had bought from Père Soulier, of a woman in front of a window; I have already mentioned it. Since I had always believed that window opens on to a Swiss mountain range, I said to Rousseau, "You were in Switzerland then, when you painted this picture?" He looked at me with an incriminating look, as if I was making fun of him. "But, but," he replied, "don't you recognise the fortifications of Paris? I painted this when I was still working at a gate as a customs officer." And I forgot which gate he said it was.'[6] Neither the assumption that Rousseau wanted to give the feeling of a Swiss mountain range, nor his insistence that it was meant to be the Paris fortifications clarify anything about this stage-like view of an unreal and inhospitable background.

Robert Delaunay, *The Poet Philippe Soupault*, 1922
Centre Georges Pompidou,
Musée national d'art moderne, Paris

5 Olivier 1933, pp. 63 f; Olivier 1982, p. 48.

6 Olivier 1933, pp. 82 f; Olivier 1982, p. 62.

Assuming that Picasso had attended Salon exhibitions from 1905, he was probably familiar with Rousseau's work by this time. He met the older artist personally through the American Max Weber in November 1908 (see no. 34). Weber visited Picasso's Montmartre studio in October or early November 1908, and 'with glowing eyes' Picasso showed his guest his recently acquired Rousseau, one of the first in what would eventually become a huge collection of paintings. 'As radiant as a Titian,' said the new owner proudly. 'I like it even more.'[7] Weber took Picasso to Rousseau's studio and apartment in rue Perrel in November, and Picasso's famous banquet in honour of Rousseau took place at the end of that month (see pp. 35 ff.). In the presence of a score of Picasso's friends, the banquet served not only to honour Rousseau but to celebrate Picasso's purchase. The older painter sat on an improvised throne. Draped in strands of green paper, the portrait was given a place of honour in the centre of Picasso's studio,[8] in the company of *Les Demoiselles d'Avignon* – a painting characterised by Wilhelm Uhde as 'somehow Assyrian'.

7 Leonard 1970, p. 32.

8 Salmon 1962, p. 75.

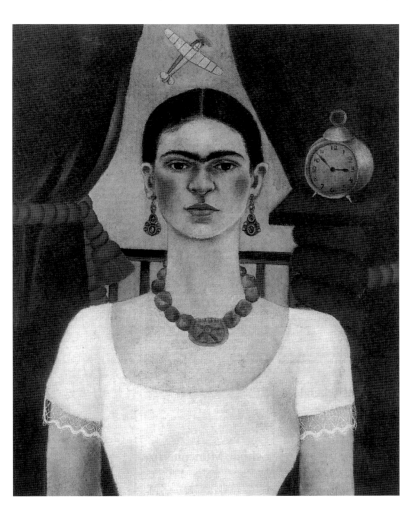

Frida Kahlo, *Self-portrait*, 1929
Private collection

The painting received the further accolade of being published in 1912 by Kandinsky and Marc in their almanac *Der Blaue Reiter* (see no. 26). It was the subject of a reflection by the poet Theodor Däubler in 1916: 'Rousseau sees his wonderful flowers from a botanical point of view. They are full of moisture, although he handles them as if they are branches. Leaf for leaf, they are held out to us by alabaster hands, softly drawn, clearly visualised. A nice, middle-class country girl has also brought home an overturned spring sapling, topped with green blossoming leaves. Her thoughts are secretly turned to a shop boy. But she has allowed herself to be painted next to a chintz curtain in clothes from Van Dyck. She stands in front of a latticework as she would before a local photographer from the most tasteful 1880s. The landscape behind the latticework is almost Chinese, coloured mystically. And she herself? How does she stand there? She remains the most important thing in the picture. Having become slightly plump before marriage, she will quietly have two to three children.'[9]

9 Däubler 1916, pp. 125 f.

Wilhelm Uhde looked Picasso up in rue La Boétie after the First World War: 'Well-known pictures greeted me from the walls. The large portrait by Rousseau, the black-clad woman with the upside-down branch. He had purchased it for fifteen francs [*sic*] from the same upholsterer where I had picked up my first Picasso for ten francs . . . the small sketch of a girl's head by Corot that I gave him for the portrait of me.'[10] It is not likely to have been by chance that when Picasso let Brassaï photograph him in 1932, it was in front of Rousseau's female idol.

10 Wilhelm Uhde, *Picasso et la tradition française*, Paris 1928, p. 56.

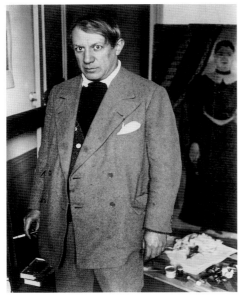

Brassaï, *Picasso, in the Rue la Boétie studio, Paris*, 1932
Musée Picasso, Paris
© Gilberte Brassaï

Provenance: Eugène Soulier, Paris; Pablo Picasso, Paris (from 1908)

Bibliography: Uhde 1911, pp. 47, 49, ill. 11; Kandinsky-Marc 1912, p. 76, ill.; A. Warnod, in *Comoedia*, 10 October 1912, ill.; M. Raynal, in *Les Soirées de Paris*, 20, 15 January 1914, p. 69; Uhde 1914, pp. 46, 48, ill.; Däubler 1916, pp. 125 f.; Uhde 1920, p. 54; Uhde 1921, pp. 54 ff., 70; Soupault 1922, p. 255; Fels 1925, p. 144; Basler 1927, p. 12; Adolphe Basler, 'Recollections of Henri Rousseau', in *The Arts*, XI, 6 June 1927, p. 318; Roh 1927, p. 112, ill.; Salmon 1927, pp. 46 f., ill. 6; Soupault 1927, p. 38, ill. 9; Zervos 1927, ill. 91; Olivier 1933, pp. 82 f.; Rich 1942, p. 50; Grey 1943, p. 47, ill. 14; Courthion 1944, p. 10; Uhde 1947, pp. 51 f.; Lo Duca 1951, p. 10, ill.; Wilenski 1953, p. 4; Salmon 1956, pp. 49 f.; Perruchot 1957, p. 56; Bouret 1961, p. 38, 193, ill. 94; Certigny 1961, pp. 170 f.; Vallier 1961, pp. 84, 138, ill. 69; Salmon 1962, p. 75; Shattuck 1963, p. 73; Brassaï 1964, pp. 32 ff., ill.; Vallier 1969, pp. 85, 97, no. 85, ill.; Bihalji-Merin 1971, pp. 56 f.; Descargues 1972, p. 16; Bihalji-Merin 1976, pp. 96 ff., ill. 30; Keay 1976, pp. 18, 127, ill. 18; Warnod 1976, pp. 48 f., 124, ill.; Werner 1976, p. 10; Alley 1978, p. 33, ill. 24, p. 65; Stabenow 1980, p. 247; Stein 1980, p. 111; Le Pichon 1981, pp. 80 f., ill.; Vallier 1981, pp. 82 f., ill.; Jacob, *Lettres à René Rimbert*, Mortemart 1983, pp. 57 f.; Certigny 1984, pp. 140 f., no. 75, ill.; Werner 1987, p. 11; Müller 1993, pp. 5, 105, 115, 121 f., 128 f., 133, 140, 188; Stabenow 1994, p. 24, ill., pp. 28, 80; Schmalenbach 1998, pp. 25, 78, ill.

Exhibitions: Paris 1912, no. 2; Berlin 1926, no. 3, ill.; Paris 1984–85, pp. 51, 60, 65, ill., pp. 94 f., ill., pp. 106, 134, no. 12, ill., pp. 144, 269; New York 1985, pp. 46, 54, 58, ill., p. 84, ill., pp. 94, 126 f., no. 12, ill., pp. 136, 263; Munich 1998, pp. 13, 31, 43, 48, 51, 212 ff., no. 73, ill.

Assuming that Picasso had attended Salon exhibitions from 1905, he was probably familiar with Rousseau's work by this time. He met the older artist personally through the American Max Weber in November 1908 (see no. 34). Weber visited Picasso's Montmartre studio in October or early November 1908, and 'with glowing eyes' Picasso showed his guest his recently acquired Rousseau, one of the first in what would eventually become a huge collection of paintings. 'As radiant as a Titian,' said the new owner proudly. 'I like it even more.'[7] Weber took Picasso to Rousseau's studio and apartment in rue Perrel in November, and Picasso's famous banquet in honour of Rousseau took place at the end of that month (see pp. 35 ff.). In the presence of a score of Picasso's friends, the banquet served not only to honour Rousseau but to celebrate Picasso's purchase. The older painter sat on an improvised throne. Draped in strands of green paper, the portrait was given a place of honour in the centre of Picasso's studio,[8] in the company of *Les Demoiselles d'Avignon* – a painting characterised by Wilhelm Uhde as 'somehow Assyrian'.

7 Leonard 1970, p. 32.

8 Salmon 1962, p. 75.

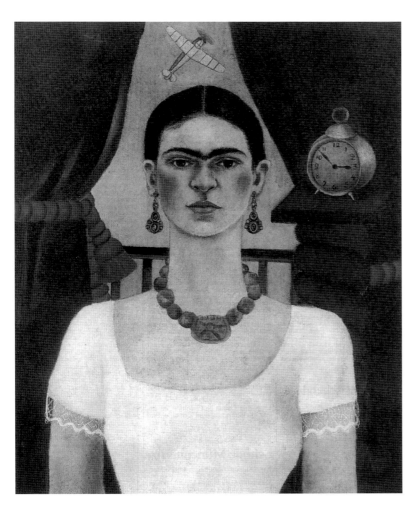

Frida Kahlo, *Self-portrait*, 1929
Private collection

The painting received the further accolade of being published in 1912 by Kandinsky and Marc in their almanac *Der Blaue Reiter* (see no. 26). It was the subject of a reflection by the poet Theodor Däubler in 1916: 'Rousseau sees his wonderful flowers from a botanical point of view. They are full of moisture, although he handles them as if they are branches. Leaf for leaf, they are held out to us by alabaster hands, softly drawn, clearly visualised. A nice, middle-class country girl has also brought home an overturned spring sapling, topped with green blossoming leaves. Her thoughts are secretly turned to a shop boy. But she has allowed herself to be painted next to a chintz curtain in clothes from Van Dyck. She stands in front of a latticework as she would before a local photographer from the most tasteful 1880s. The landscape behind the latticework is almost Chinese, coloured mystically. And she herself? How does she stand there? She remains the most important thing in the picture. Having become slightly plump before marriage, she will quietly have two to three children.'[9]

9 Däubler 1916, pp. 125 f.

Wilhelm Uhde looked Picasso up in rue La Boétie after the First World War: 'Well-known pictures greeted me from the walls. The large portrait by Rousseau, the black-clad woman with the upside-down branch. He had purchased it for fifteen francs [*sic*] from the same upholsterer where I had picked up my first Picasso for ten francs . . . the small sketch of a girl's head by Corot that I gave him for the portrait of me.'[10] It is not likely to have been by chance that when Picasso let Brassaï photograph him in 1932, it was in front of Rousseau's female idol.

Brassaï, *Picasso, in the Rue la Boétie studio, Paris*, 1932
Musée Picasso, Paris
© Gilberte Brassaï

10 Wilhelm Uhde, *Picasso et la tradition française*, Paris 1928, p. 56.

Provenance: Eugène Soulier, Paris; Pablo Picasso, Paris (from 1908)

Bibliography: Uhde 1911, pp. 47, 49, ill. 11; Kandinsky–Marc 1912, p. 76, ill.; A. Warnod, in *Comoedia*, 10 October 1912, ill.; M. Raynal, in *Les Soirées de Paris*, 20, 15 January 1914, p. 69; Uhde 1914, pp. 46, 48, ill.; Däubler 1916, pp. 125 f.; Uhde 1920, p. 54; Uhde 1921, pp. 54 ff., 70; Soupault 1922, p. 255; Fels 1925, p. 144; Basler 1927, p. 12; Adolphe Basler, 'Recollections of Henri Rousseau', in *The Arts*, XI, 6 June 1927, p. 318; Roh 1927, p. 112, ill.; Salmon 1927, pp. 46 f., ill. 6; Soupault 1927, p. 38, ill. 9; Zervos 1927, ill. 91; Olivier 1933, pp. 82 f.; Rich 1942, p. 50; Grey 1943, p. 47, ill. 14; Courthion 1944, p. 10; Uhde 1947, pp. 51 f.; Lo Duca 1951, p. 10, ill.; Wilenski 1953, p. 4; Salmon 1956, pp. 49 f.; Perruchot 1957, p. 56; Bouret 1961, p. 38, 193, ill. 94; Certigny 1961, pp. 170 f.; Vallier 1961, pp. 84, 138, ill. 69; Salmon 1962, p. 75; Shattuck 1963, p. 73; Brassaï 1964, pp. 32 ff., ill.; Vallier 1969, pp. 85, 97, no. 85, ill.; Bihalji-Merin 1971, pp. 56 f.; Descargues 1972, p. 16; Bihalji-Merin 1976, pp. 96 ff., ill. 30; Keay 1976, pp. 18, 127, ill. 18; Warnod 1976, pp. 48 f., 124, ill.; Werner 1976, p. 10; Alley 1978, p. 33, ill. 24, p. 65; Stabenow 1980, p. 247; Stein 1980, p. 111; Le Pichon 1981, pp. 80 f., ill.; Vallier 1981, pp. 82 f., ill.; Jacob, *Lettres à René Rimbert*, Mortemart 1983, pp. 57 f.; Certigny 1984, pp. 140 f., no. 75, ill.; Werner 1987, p. 11; Müller 1993, pp. 5, 105, 115, 121 f., 128 f., 133, 140, 188; Stabenow 1994, p. 24, ill., pp. 28, 80; Schmalenbach 1998, pp. 25, 78, ill.

Exhibitions: Paris 1912, no. 2; Berlin 1926, no. 3, ill.; Paris 1984–85, pp. 51, 60, 65, ill., pp. 94 f., ill., pp. 106, 134, no. 12, ill., pp. 144, 269; New York 1985, pp. 46, 54, 58, ill., p. 84, ill., pp. 94, 126 f., no. 12, ill., pp. 136, 263; Munich 1998, pp. 13, 31, 43, 48, 51, 212 ff., no. 73, ill.

Pablo Picasso
Portrait of Fernande

Picasso painted this bust portrait of Fernande Olivier during the summer of 1909 in Horta de Ebro in Spain.[1] He had moved to Paris in April 1904 and was living in his studio at 13 rue Ravignan when he met his model at the end of the year. They lived together in the studio for five years; on their return from the trip to Spain they moved to more comfortable quarters at 11 boulevard de Clichy. The resolute Fernande was constantly by Picasso's side during the most creative and productive phase of his career. She experienced the pink period between 1904 and 1906, the acrobats, the families of jugglers, the actors and the harlequins. She was witness to the most revolutionary time in Picasso's life when, after struggling for months, he finally finished *Les Demoiselles d'Avignon* in July 1907. She was there between 1908 and 1910 when the artist, not yet 30, put into effect those ideas that, as analytical Cubism, would make history. She was certainly involved in Picasso's decision to purchase Rousseau's *Portrait of a Woman* (no. 16) in the autumn of 1908, and she supervised the subsequent banquet in Rousseau's honour (cf. pp. 35 ff.).

Picasso probably first took notice of Rousseau in 1905, when the press made the older painter 'fetish and mascot' of the younger generation after the autumn exhibition of *The Hungry Lion* (no. 33). The art dealer Vollard, who had organised Picasso's first Paris exhibition in June 1901 and in 1906 had bought a large part of his works produced during the previous two years, purchased Rousseau's large-format *Lion* for 200 francs on 31 March 1906. Picasso certainly had the opportunity of seeing this major work at Vollard's, who would later purchase his portrait of Fernande. But it was not until 1908 that, as Picasso's friend Uhde stated: 'Picasso is one of the few people who understood and loved Rousseau. They shared a common interest in that they both loved objects and things as the prerequisite of painting.'[2]

Picasso's interest in Rousseau became more intense when, at the end of his blue and pink periods, he painted *Les Demoiselles d'Avignon* and began to experiment with Cubism. He found himself an outsider up against a misunderstanding public, a position that Rousseau had been in for years.

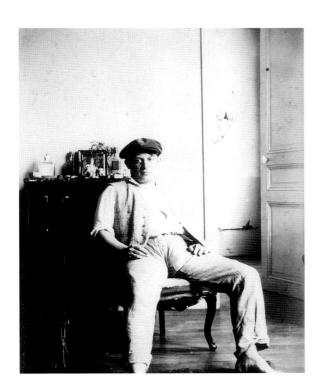

Pablo Picasso, *Self-portrait*, Horta de Ebro 1909
Musée Picasso, Paris

1909
Oil on canvas
61.8 × 42.8 cm
Signed top left: Picasso
Kunstsammlung Nordrhein-Westfalen, Düsseldorf
(Inv. No. 133)

1 Werner Schmalenbach, *Bilder des 20. Jahrhunderts. Die Kunstsammlung Nordrhein-Westfalen, Düsseldorf*, Munich 1986, pp. 20 f.

2 Uhde 1921, p. 7

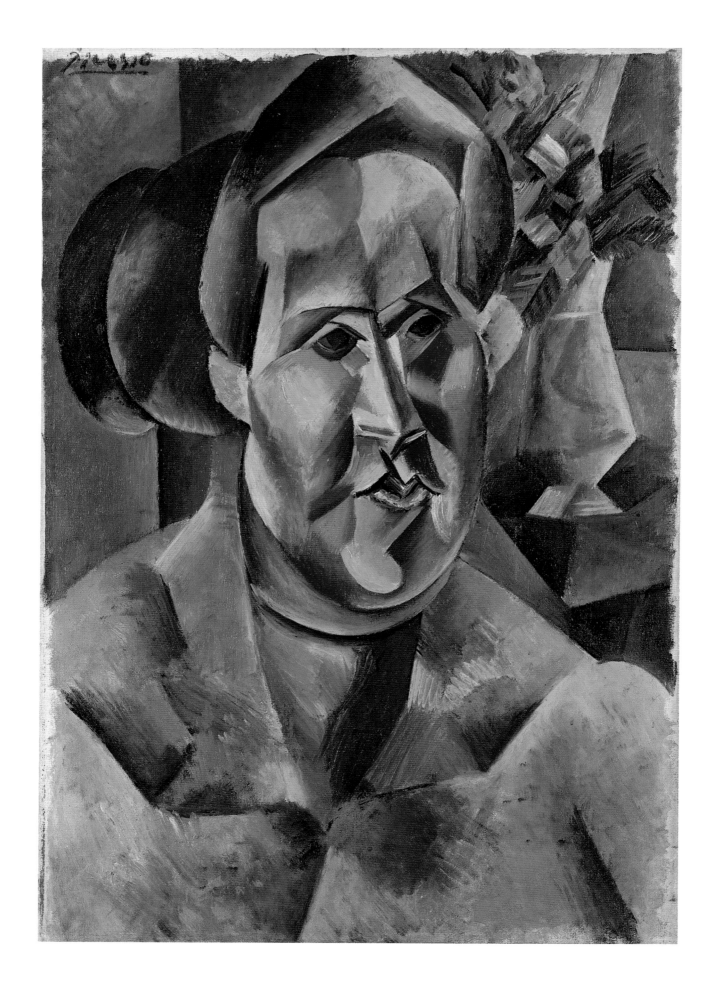

PABLO PICASSO PORTRAIT OF FERNANDE

Picasso discovered Rousseau at the point in his career when he departed from the symbolically loaded, somewhat flamboyant early works and, under the influence of Iberian sculpture, African and Oceanic tribal art, had turned to a new kind of Primitivism. Picasso must have found it an attractive quality in Rousseau that he seemed to draw his strength from being untrained and non-professional; between 1906 and 1907 Picasso had put his own career on the line when he radically changed style and sought to put the professionalism of his early years behind him. In the light of this, his acquisition of the Rousseau portrait is significant and highlights the important role the older artist played as a mentor to the budding Cubist movement. In Rousseau's paintings, Picasso – along with Delaunay, Kandinsky and Léger after him – saw a confirmation of his own abstract impulses, impulses that were especially evident in the landscapes he painted at rue de Bois in the late summer of 1908.[3] After these landscapes, which imitate the jungle paintings of Rousseau, and before the portrait of Fernande came his acquisition of the Rousseau portrait. During this year Picasso seems to have reflected much on Rousseau's distillation of style, his simplified palette of colours and his powerful sense of subject, even when working in a small format. For Picasso the archaic massiveness must have been important, as well as the blocky compactness in Rousseau, along with a sense of disillusionary realism that creates things and spaces in a flattened visual field without bringing their contingency into question.

3 Rubin 1984, pp. 295, 298, 300.

Pablo Picasso, *House in a Garden*, August 1908
State Hermitage Museum, St Petersburg

The high esteem in which Picasso held Rousseau for his entire life was expressed in his purchase of four other major works (nos 16, 29, 30, 41). Once in his possession, they were like fetishes from which he was never parted and which always remained near him. Statements he made are witness to the respect he had for the older artist, for example: 'It is simply wrong to speak of "Rousseau's case". Quite simply, the works of Rousseau represent the complete realisation of a kind of art that saw and expressed itself in a specific way.'[4] Picasso's judgement of Rousseau's works was always sought after. Brassaï reports that Picasso once sat across from an editor, fuming with anger as he thumbed through a new Rousseau monograph,[5] saying, 'This is a forgery . . . this one too. Here we have forgery number three and number four . . . Rousseau would never have painted like this. Not in his whole life.'[6]

4 Fels 1925, p. 144.

5 This was probably the 1943 edition by Roch Grey (pseudonym of the Baroness d'Oettingen), in which several forgeries were published.

6 Brassaï 1964, p. 144.

View of the Bois de Boulogne
Vue du Bois de Boulogne

From a flowery meadow, which functions in a similar way to the field in Rousseau's earlier group picture of artillerymen (no. 12), we look down into an open space to a lake surrounded by a landscape of trees. Fore-, middle- and background elements are placed one after the other, as in a set design. At the far end of the lake – whose surface reflects both the sky and the forest scenery – the horizontal line of the bank area, on which there are two people, blocks any further extension of depth. The leaning tree-trunks at left and right contrast the thickness of the leaves as a mass and the softness of each individual leaf. Paintings by Rousseau presenting a landscape with barely noticeable figures and in which nature is so completely idealised as this one are rare.

Wilhelm Uhde published this landscape in a book of 1914, naming the owner as Hans Siemsen, who came from the German town of Osnabrück and was living with his family in Berlin. He owned other paintings by Rousseau; he relates that his 'student flat in Munich had three pretty pictures by Henri Rousseau'.[1] The painting was given the German title *Im Bois de Boulogne* at a Rousseau exhibition at the Gallery Flechtheim in Berlin in 1926, the catalogue of which contains a sympathetic text by Siemsen. After Zervos repeated the title in French the following year, the name stuck. In the spring 1896 exhibition of the Indépendants, one of the ten submitted works by Rousseau had the name 'Vues [*sic*] du Bois de Boulogne', but it is not known if it was this painting.

After receiving his first positive reviews in 1894 and 1895, Rousseau's Salon des Indépendants exhibits for 1896 earned reviews with a strongly ironic tone once again.[2] He was called the most independent of the independents. Thadée Natanson, a friend of Toulouse-Lautrec, wrote in *La Revue blanche* that Rousseau was not the only painting civil servant, and that there must have been other gendarmes and concierges who would love to use their brushes with complete naivety, too.

1895-96
Oil on canvas
33 × 41 cm
Signed bottom left:
Henri Rousseau
Museum Charlotte Zander,
Schloß Bönnigheim

1 'I've never had such a beautiful flat in my life! And I'll never have such a beautiful flat in my life again. The pictures from Rousseau are not just pictures, like other pictures. They are living beings, friends that you expect to see when you come home. Three friends were waiting for me when I came home.' Exhibition catalogue, Berlin 1926, p. 14.

2 Müller 1993, pp. 26 ff.

Provenance: Hans Siemsen, Berlin; sold at auction, Stuttgarter Kunstauktionshaus Dr Fritz Nagel, Stuttgart 29 October 1994, no. 2029, ill.

Bibliography: Uhde 1914, ill.; Grey 1922, ill.; Roh 1927, p. 114, ill.; Soupault 1927, ill. 14; Zervos 1927, ill. 88; Grey 1943, ill. 49; Courthion 1944, ill. XII; Lo Duca 1951, p. 9, ill.; Bouret 1961, no. 194, ill. 95; Vallier 1961, ill. 68; Vallier 1969, pp. 98 f., no. 114, ill.; Certigny 1984, pp. 68, 122, 258 f., no. 130, ill., p. 320; Eva Karcher, *Die Maler des heiligen Herzens*, Bönnigheim 1996, pp. 63, 164, no. 52, ill.; Susanne Pfliger, *Henri Rousseau, Traumreise in den Dschungel*, Munich-New York 1997, p. 8, ill.

Exhibitions: Berlin 1926, no. 20, ill.

VIEW OF THE BOIS DE BOULOGNE

View of the Fortifications
Vue des fortifications

An afternoon quiet has settled over this park landscape consisting of heaped-up walls with paths leading to the top, and the walls of the former Paris fortifications system. Built around the city as a line of defence and often fought over, these served peaceful purposes in the end. The use of this bastion for defence is counteracted by an overgrowth of trees and bushes. The fortifications were relatively young to be out of use, having served as a line of defence in the Franco-Prussian war of 1870–71. A quarter of a century later, mothers and their children have taken control of the entrenchments. Steadfastly planted in the landscape, they embody both an existence far removed from danger, and the stillness and intimacy of a location that was once filled with the noise of masses of people. A zone of nature and of life has taken the place of a once-important strategic line where soldiers died, a site at which the German poet Theodor Däubler found an air of melancholy.[1]

Certigny wrote that this painting came from the Kullmann Collection, from which three Rousseaus were put up for auction at the Hôtel Drouot in Paris in 1914. The catalogue description for one runs: 'On the left half of the picture sit five persons on folding chairs or on the grass. One of them, a woman, is sewing. Various trees on different levels. 1896 exhibited at the Salon de la Société des Artistes Indépendants.'[2] Among the ten Rousseaus exhibited in 1896, one bearing the number 988 was listed with the title *Vue des fortifications (Boulevard Gouvion Saint-Cyr)*;[3] the fortifications here once defended the western part of the city.

Eugène Atget, *On the Paris fortifications*, c. 1908

1896
Oil on canvas
38 × 46 cm
Signed bottom right:
Henri Rousseau
Private collection, Switzerland

1 'The fortified ramparts before Paris: the silvery greenish grey of the inviolate precincts near the capital. Inside, in front of the thin grey, the short April green. Especially fresh in front of the metropolis: since very quickly it will revert to the bareness of the tree skeletons. Loneliness before the ramparts: even beauty. In fact perpetually rather March-like. And melancholy with it.' – Däubler 1916, pp. 123 f.

2 Certigny 1984, p. 256.

3 Uhde 1911, p. 62.

Provenance: Herbert Kullmann, Manchester; sold at auction, Hôtel Drouot, Paris, 16 May 1914, no. 12; Galerie Alfred Flechtheim, Berlin; Paul and Lotte von Mendelssohn-Bartholdy, Berlin; Lotte Duchess Kesselstadt-Mendelssohn, Vaduz; Emil G. Bührle, Zurich (since 1947)

Bibliography: W. Uhde, 'An Henri Rousseau', in *Genius* 1919, p. 190, ill.; Basler 1927, ill. XVII; Grey 1943, ill. 58; Cooper 1951, pp. 38 f., ill.; Lo Duca 1951, p. 11, ill.; *Sammlung Emil G. Bührle. Festschrift zu Ehren von Emil G. Bührle*, Kunsthaus Zürich 1958, p. 145, no. 255; Bouret 1961, p. 218, ill. 157; Vallier 1961, ill. 73; Vallier 1969, p. 101, no. 141, ill., p. 103; Le Pichon 1981, p. 55, ill.; Certigny 1984, pp. 254, 256 f., no. 129, ill. (with bibliography)

Exhibitions: Paris 1896, no. 988; *Moderne primitive Malerei*, Kunsthalle Bern 1949, no. 5; *Henri Rousseau*, XXV Venice Biennale, 1950, no. 12

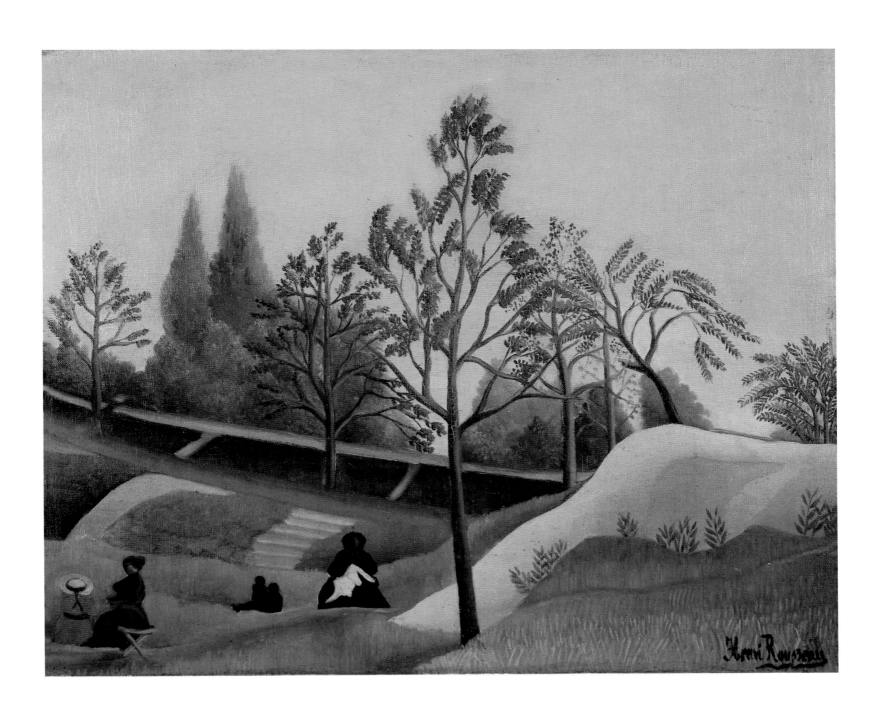

VIEW OF THE FORTIFICATIONS

Landscape with Church Spire
Paysage au clocher

Rousseau loved the countryside around Paris, the suburbs and the parks where maids, butlers and gardeners from the city would picnic on Sundays. He enriched them with his trees. He placed figures and architecture in them. Here he could determine the direction of rivers and roads, and from here he eventually glimpsed tropical virgin territory. He took as a subject a comprehensible area he could reach by foot. In 1910 he told the art critic Arsène Alexandre: 'Nothing makes me happier than to observe and to paint nature. You can imagine that, when I go out into the country and I see sun everywhere and green and blossoms, that I say to myself, "Truth to tell, all this belongs to me."'[1]

With no illusion of centralised perspective, the depth of a hilly landscape is achieved here solely through a combination of three horizontal planes. A wide curving street populated by pedestrians divides the foreground area of grass and trees from the buildings of a village with a pointed steeple at the deepest part of the visual field. The landscape idyll is disturbed by technology, however, in the form of a gas lamp that cannot be missed at the edge of the street, indicating that a municipal gasworks must have been close at hand.

1895–97
Oil on canvas
22 × 27 cm
Signed bottom left:
Henri Rousseau
Private collection

1 Alexandre 1910, p. 701.

Provenance: Hans R. Hahnloser, Bern

Bibliography: Zervos 1927, ill. 69; Grey 1943, ill. 55; Lo Duca 1951, ill.; Bouret 1961, p. 194, ill. 97; Vallier 1961, ill. 140; Vallier 1969, pp. 104 f., no. 178, ill.; Keay 1976, p. 126, ill. 16; Le Pichon 1981, p. 112, ill.; Certigny 1984, pp. 98 f., no. 54, ill.

Exhibitions: *Hauptwerke der Sammlung Hahnloser, Winterthur,* Kunstmuseum Luzern 1940, no. 120; Paris 1964, no. 6, ill.

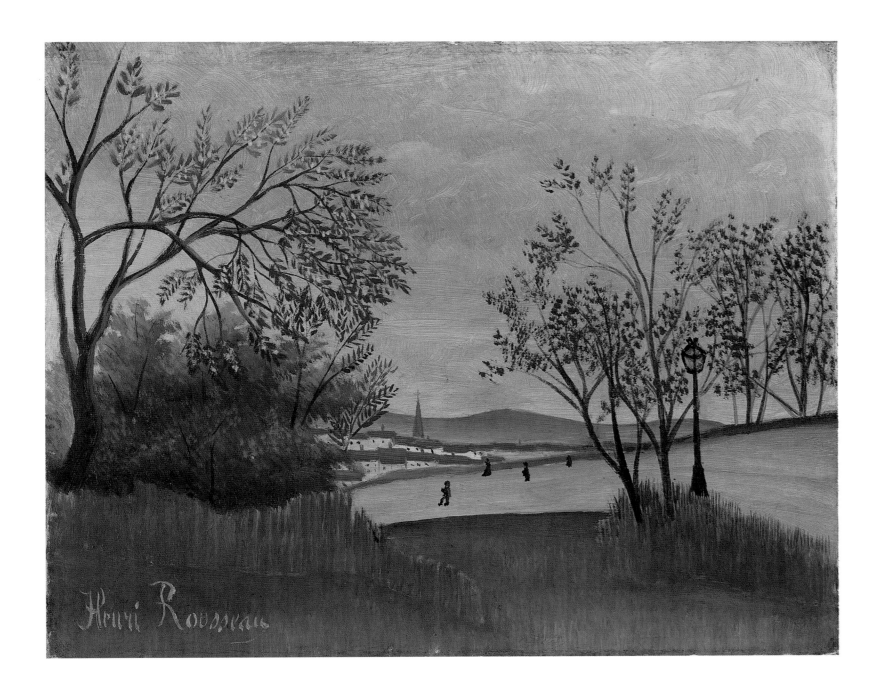

LANDSCAPE WITH CHURCH SPIRE

Suburban Scene
Banlieue

Rousseau's Paris was not one of speed and movement, nor of horse-drawn carriages and motor-cars. Crowds in the streets and squares, lighted boulevards with their lines of lamps – these did not interest him. He was more concerned with the plain parts of Paris – the Seine bridges and quayside walls, and the suburbs with people there dressed in their Sunday best.

Apartment blocks, warehouses and factory chimneys could also enrich his paintings. Here is another view of his Paris suburbs, one woven with a combination of wide horizontals and finely drawn vertical elements. Between the turquoise of the stationary water and the cloudy sky is a zone enriched by colours, consisting of a variety of cubic architectural constituents placed in terse relationship to each other. Their front and side views are freely combined, outside the rules of perspective. A single red roof nicely complements the dominating cool blue and grey tones, appropriate to the winter season. The silhouettes of trees and fog banks contrast with the slate grey and zinc of the remaining roofs. The painter's addiction to serialisation can be seen in the simplified windows. The picket fence runs through the painting in a single line, dividing the riverbank promenade from the factory.

A frosty melancholy lies over this picture. Nobody seems to be living in the apartments, no one is shown working. The structures are an example of the hasty erection of many buildings during the advent of industrialisation at the end of the nineteenth century. Here, they are limited to architectural motifs that separate water from sky, against which rise the filigree branches of near-leafless trees. The person taking a walk and the people fishing next to each other do not partake in their surroundings. Analogous to the man painting them from across the river, they are distant observers, who function only as tiny shadows of people. The anachronistic-seeming alienation between place and the elements and figures that make it up is characteristic.

Various dates have been suggested for *Suburban Scene*, ranging from around 1896 to before 1905, based on its horizontal format. The location is as yet unidentified. A painting in the 1896 exhibition at the Salon des Indépendants showing a view of Charenton Canal at sunset may possibly be identified with this work.

c. 1896
Oil on canvas
50 × 65 cm
Signed bottom right:
Henri Rousseau
Private collection, Switzerland

Provenance: Galerie Bing, Paris; Albert D. Lasker, New York; Paul Hänggi, Vaduz; sold at auction, Christie's London, 27 June 1994, no. 12, ill.

Bibliography: Gauthier 1949, ill. XVII; Lo Duca 1951, p. 8, ill.; Bouret 1961, p. 105, ill. 23; Vallier 1961, ill. 80; Vallier 1969, pp. 101, 103, no. 166, ill.; Bihalji-Merin 1971, pp. 14, 107, ill. 7; Bihalji-Merin 1976, pp. 23 f., ill. 2; Keay 1976, p. 135, ill. 32; Le Pichon 1981, p. 116, ill.; Certigny 1984, pp. 248 f., no. 124, ill.

Exhibitions: Paris 1944–45, no. 14; New York 1951, no. 2

LANDSCAPE WITH CHURCH SPIRE

Suburban Scene
Banlieue

Rousseau's Paris was not one of speed and movement, nor of horse-drawn carriages and motor-cars. Crowds in the streets and squares, lighted boulevards with their lines of lamps – these did not interest him. He was more concerned with the plain parts of Paris – the Seine bridges and quayside walls, and the suburbs with people there dressed in their Sunday best.

Apartment blocks, warehouses and factory chimneys could also enrich his paintings. Here is another view of his Paris suburbs, one woven with a combination of wide horizontals and finely drawn vertical elements. Between the turquoise of the stationary water and the cloudy sky is a zone enriched by colours, consisting of a variety of cubic architectural constituents placed in terse relationship to each other. Their front and side views are freely combined, outside the rules of perspective. A single red roof nicely complements the dominating cool blue and grey tones, appropriate to the winter season. The silhouettes of trees and fog banks contrast with the slate grey and zinc of the remaining roofs. The painter's addiction to serialisation can be seen in the simplified windows. The picket fence runs through the painting in a single line, dividing the riverbank promenade from the factory.

A frosty melancholy lies over this picture. Nobody seems to be living in the apartments, no one is shown working. The structures are an example of the hasty erection of many buildings during the advent of industrialisation at the end of the nineteenth century. Here, they are limited to architectural motifs that separate water from sky, against which rise the filigree branches of near-leafless trees. The person taking a walk and the people fishing next to each other do not partake in their surroundings. Analogous to the man painting them from across the river, they are distant observers, who function only as tiny shadows of people. The anachronistic-seeming alienation between place and the elements and figures that make it up is characteristic.

Various dates have been suggested for *Suburban Scene*, ranging from around 1896 to before 1905, based on its horizontal format. The location is as yet unidentified. A painting in the 1896 exhibition at the Salon des Indépendants showing a view of Charenton Canal at sunset may possibly be identified with this work.

c. 1896
Oil on canvas
50 × 65 cm
Signed bottom right:
Henri Rousseau
Private collection, Switzerland

Provenance: Galerie Bing, Paris; Albert D. Lasker, New York; Paul Hänggi, Vaduz; sold at auction, Christie's London, 27 June 1994, no. 12, ill.

Bibliography: Gauthier 1949, ill. XVII; Lo Duca 1951, p. 8, ill.; Bouret 1961, p. 105, ill. 23; Vallier 1961, ill. 80; Vallier 1969, pp. 101, 103, no. 166, ill.; Bihalji-Merin 1971, pp. 14, 107, ill. 7; Bihalji-Merin 1976, pp. 23 f., ill. 2; Keay 1976, p. 135, ill. 32; Le Pichon 1981, p. 116, ill.; Certigny 1984, pp. 248 f., no. 124, ill.

Exhibitions: Paris 1944–45, no. 14; New York 1951, no. 2

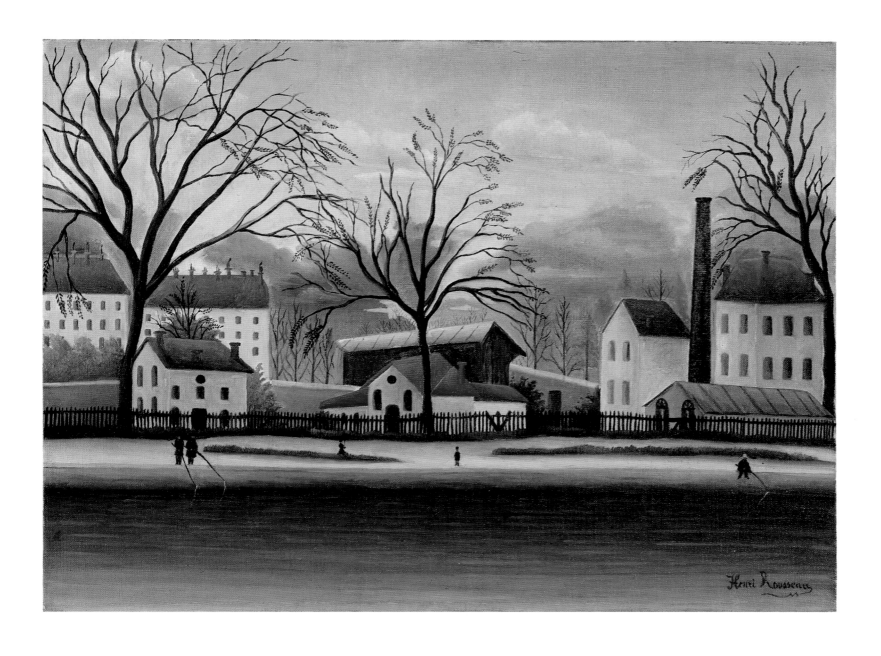

SUBURBAN SCENE

Landscape with Farmer
Paysage avec paysan

Rousseau invented his own urban landscapes, with multi-level residential blocks and industrial buildings, tree-covered parks or meadows and fields bordering the roads into Paris. This provincial boy who grew up in Laval and Angers preferred country panoramas populated with individuals in country attire, presented as if seen from the outer precincts of the city. Views of the grands boulevards, cafés and cabarets, circus and brothel, preferred by the Impressionists and those who followed them, were not of interest to Rousseau.

The garden wall in *Landscape with Farmer* is one of those images characteristic of some of Rousseau's landscapes composed from the middle of the 1890s (see no. 20); it seems to be closer to the viewer on the right side of the visual field. It divides a park area from the foreground sloping down to the road. Behind and above it, a white church tower and two other buildings rise out of a compact variation of light greens. Between the row of thin-leafed trees in the immediate foreground and the thick, autumn leaves behind the wall, a single element of movement is included – a farmer with a spade on his shoulder walking down the road. Communication with the dark cloudy sky is established by the chimneys and, on a more symbolic level, the over-large cross on the bell tower.

c. 1896
Oil on canvas
38 × 56 cm
Signed bottom left:
Henri Rousseau
Harmo Museum, Shimosuwa,
Nagano

Provenance: Galerie Pierre, Paris (1935); Georges Renand, Paris; Maurice Renand, Paris

Bibliography: Uhde 1948, ill. 28; Lo Duca 1951, p. 8, ill.; Bouret 1961, p. 200, ill. 111; Vallier 1961, p. 116, ill. 31; Vallier 1969, pp. 90 f., no. 16, ill.; Certigny 1984, pp. 276 f., no. 138, ill.

Exhibitions: Paris 1937, no. 9.

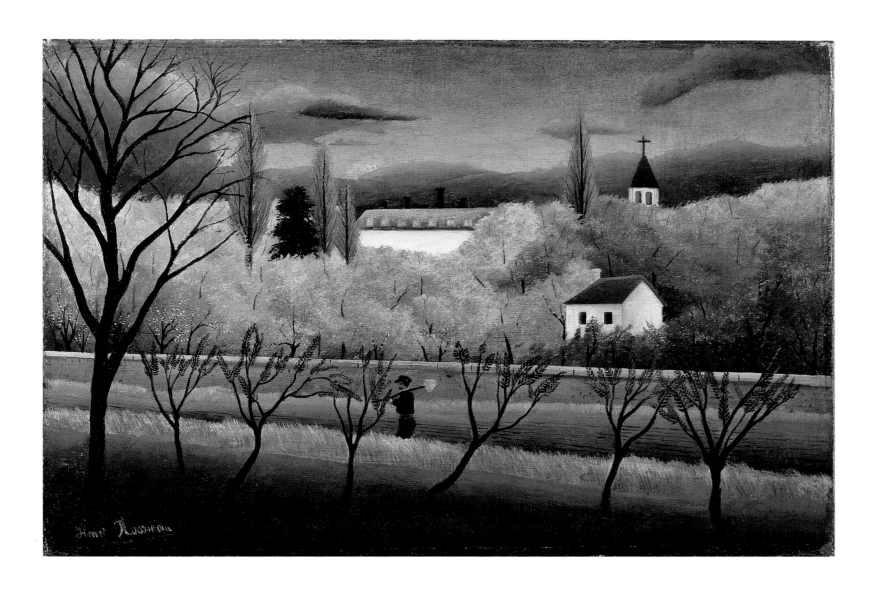

LANDSCAPE WITH FARMER

View of the Outskirts of Paris
Vue des environs de Paris

By the middle of the 1890s Rousseau was struggling with large formats and more challenging subjects, but he always came back to unspectacular scenes in and around Paris that he treated with uniform objectivity. He felt drawn to the periphery of the metropolis, seeing its centre in small sections and then only from a distance (see no. 52). In contrast to the Impressionists, who took rural places on the Seine such as Grenouillère, Chatou or Bougival and made them into locations full of life where people had weekend picnics, twenty-five years later Rousseau preferred to paint urban river banks that were almost devoid of people.

In this balanced composition, a view from a bridge on to the Seine and its steep riverbank, are two motifs that are among those most frequently found in Rousseau's paintings – a river and factory chimneys. The many horizontal elements in the painting – the bridge, the row of houses and the jetty for barges or passenger boats – are nicely balanced by the strongly drawn verticals of the towering pair of chimneys.

c. 1896
Oil on canvas
46.36 × 53.58 cm
Signed bottom left:
Henri Rousseau
The Detroit Institute of Arts,
Bequest of Robert H. Tannahill
(Inv. No. 70.182)

Provenance: Valentine Gallery, New York; Robert Tannahill, Detroit

Bibliography: Vallier 1969, p. 114, no. 258, ill.; Vallier 1981, ill. back jacket

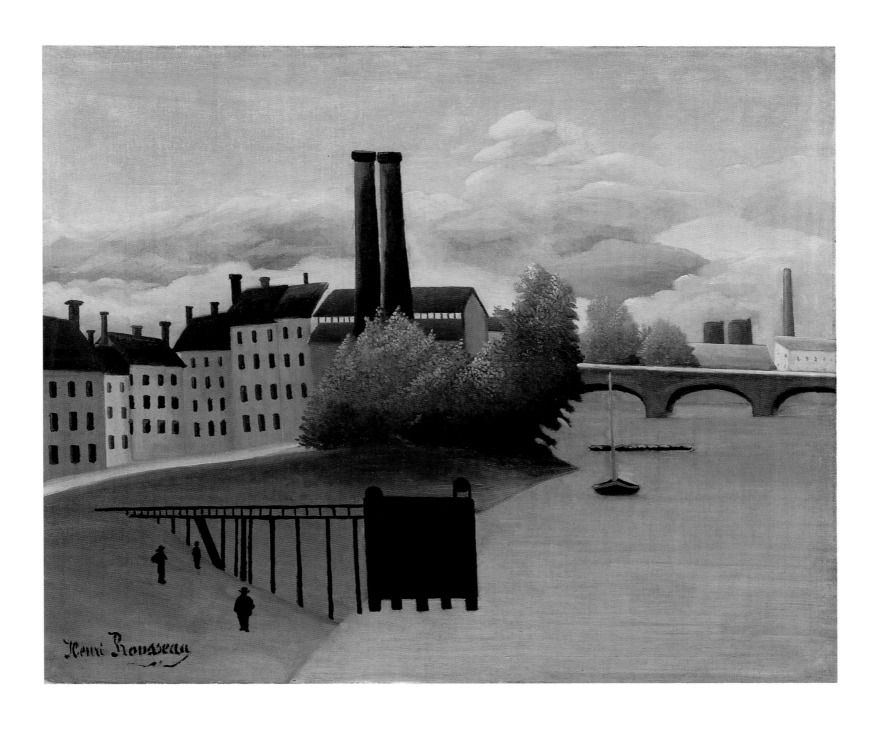

VIEW OF THE OUTSKIRTS OF PARIS

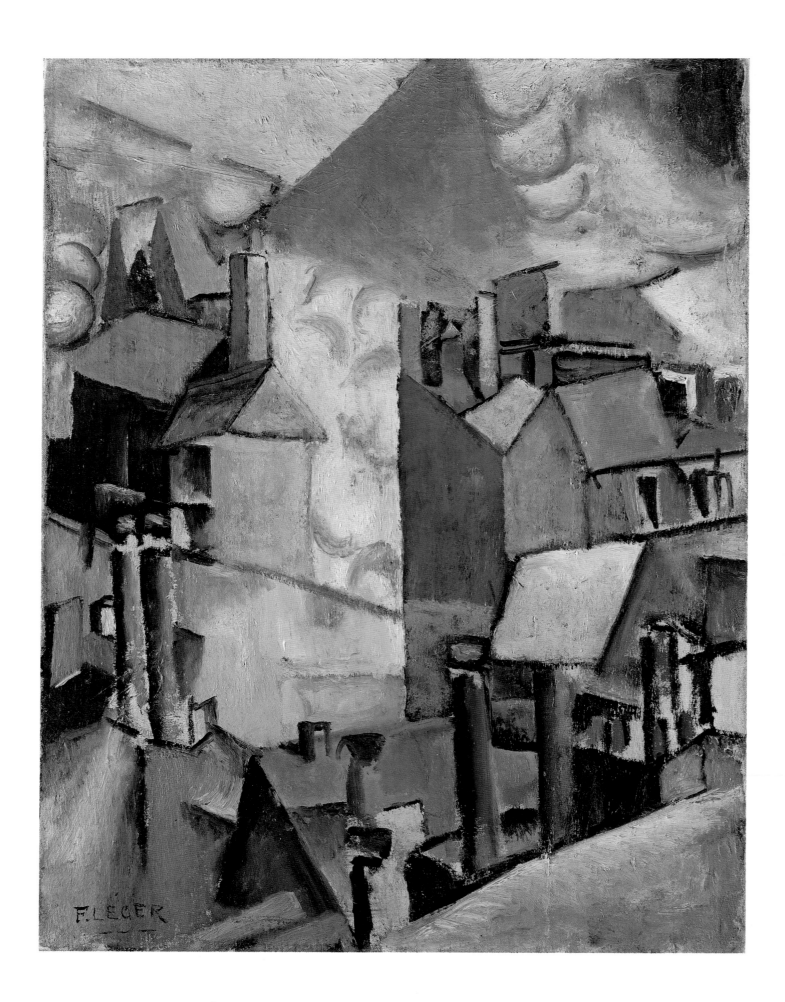

FERNAND LÉGER SMOKE OVER THE ROOFS

Fernand Léger
Smoke over the Roofs

Among artists of the early twentieth century, Rousseau was of great importance for Fernand Léger.[1] Léger searched for a national idiom in which to express the lives of the proletariat on a symbolic level, and Rousseau was of influence for two reasons: first, he belonged to that social class in which Léger assumed truthfulness to abide; secondly, he worked, according to Léger, 'as point-blank, as sincerely, as the Biblical David did, far removed from the fine handwork of Impressionism and its superficial play of light and colour.'[2] Léger met Rousseau through Delaunay in 1909 and was full of respect for him. 'I immediately liked his direct way of painting and how he comprehended things. His primitive enthusiasm, a purist! I think of him often and of the primitive Italians.'[3]

Under Rousseau's influence, a confident and robust Léger presented himself in 1911–12 as a 'new primitive' who had broken with the refined Cubism of Picasso and Braque. This painting was done at the start of Léger's series *Les Fumées sur les toits.* It shows a view from a studio window on to the roofs and chimneys around the rue de L'Ancienne Comédie, using simple cubic and cylindrical forms thrust into motion by curving trails of smoke that perforate them.[4] Rousseau was similarly concise in the way he made the autonomous structures of his urban landscapes from strongly contrasting forms, lines and colours. What was important to Léger, and what influenced his work up to and including the series *Contrastes de formes,* was the projection of tightly packed groups of buildings across the surface of the canvas and blending between them thick formations of smoke and cloud.

Léger offered a great deal of information on all subjects, but one particular statement he made about Rousseau is worth quoting: 'An amazing guy, complicated . . . In order to make ends meet, he gave violin lessons to the children from his neighbourhood. Every Sunday, bakers, butchers and milkmaids and the like gathered at his studio [see pp. 33 ff.] and Rousseau had the children play for their parents. Once our group barged into one of these recitals. The customs officer didn't know what to do, he was so confused. He said over and over again, gentlemen, gentlemen, I don't have any chairs left. It wasn't a studio but a small apartment. Still, we could see how he worked. He often used picture postcards. When he had drawn his picture, he began with the colours, from the top down . . . Rousseau knew exactly when he began, and knew exactly when he was finished . . .'[5]

1912
Oil on canvas
68 × 47 cm
Signed bottom left: F. LÉGER
Dated on back: 1912
Private collection, Courtesy
Galerie Nathan, Zürich

1 Lanchner–Rubin 1984–85, pp. 71 ff.; see also pp. 62 ff.

2 Descargues 1972, p. 41.

3 Verdet 1955, p. 12.

4 Georges Bauquier, *Fernand Léger. Catalogue raisonné de l'œuvre peint 1903–1919*, Paris 1990, pp. 58 f., no. 32.

5 Verdet 1955, pp. 63 f.

Study, View of Montsouris Park
Esquisse, vue du parc Montsouris

In order to make clear the function of some of Rousseau's studies in a quasi-Impressionistic manner (cf. nos 24, 25, 50, 51), we must again refer to his reserved attitude towards the stylistic principles of the Impressionists. Of course, he was familiar with their goals and the techniques they used to achieve them. However, he was not willing to accept these as his own – his respect for his subject matter was too great to subtract from its purity through tonal influences or the changing immediacies of light and time.

Although he came from a generation of painters who worked out of doors, Rousseau remained a studio painter. Since light was of secondary importance for him, he was in the habit of completing his ideas indoors. For a painter of his stamp, the liberties that the Impressionists took with reality, the sketch-like quality practised by Toulouse-Lautrec, and the specific kind of openness that the elderly Cézanne discovered for himself were not enough. The fullness of his visual organisms allows for no empty spaces. In the light of this, it is no surprise that he offered to complete the unfinished canvases of Cézanne, exhibited at a Cézanne retrospective at the autumn Salon exhibition of 1907.[1] A strange notion: paintings that Cézanne did not dare to bring to an end, completed by Rousseau who was not aware of the latter's scruples to begin with.

For Rousseau, a work was valid only when it was completed into every single corner of the canvas, the entire design process remaining hidden behind the end product. The dictates of the brush should not be hindered; every suggestion of spontaneity had to be smoothed out and the hard contours of the subject's form, along with the often unbroken colour of the location, had to be brought into line. Neither the *procedere* nor the *non-fini*, long acceptable in the Salons, came to expression with Rousseau. After the failure of the Impressionists to gain popularity, Rousseau wanted to win the approval of the art-going public by a precise handling of subject, a complete realisation of visual form and challenging content. The fundamentals of Impressionism he transported into colours. Their freely improvised signature he answered with a visual language that was descriptive and clearly articulated. Their disintegration of light and hue permeating subjects based on water was answered by his fullness of realisation and a strongly standardised view of nature. To the dynamic movement and openness of Impressionism he replied with the form and stability of tectonic structures.

From the mid 1890s Rousseau made sketches during his often arduous preparatory processes.[2] In his eyes, these – along with his unimportant studies[3] – were little more than by-products of the methods he employed while painting. Meant as a basis for work in the studio, they were intended

1894
Oil on paperboard
21.5 × 16 cm
Harmo Museum, Shimosuwa, Nagano

1 'Vous savez, je pourrais finir toutes ces toiles.' Rich 1942, p. 47; Certigny 1961, p. 279.

2 Apollinaire 1914, p. 27 (p. 639); Eichmann 1938, pp. 302 ff.

3 Of the finished sketches made by Rousseau from 1885, which in 1895 he estimated to number about 200, only 19 small, awkward-seeming study sheets have survived. Certigny 1984, nos 9, 12, 13, 32, 42, 107, 128, 177, 188–98.

STUDY, VIEW OF MONTSOURIS PARK

to give an overall impression, noting what was to be accented for surface value and for contrast. When Rousseau was asked about his sketches, 'he nodded with a smile and said, "But they are only preparatory sketches. They are only there to help me design my paintings."'[4] On other occasions, he left no doubt about what he used his sketches for: 'Concerning landscapes, I make little drawings outdoors in natural settings, but I always work them over in larger format at home.'[5]

Small-format preliminary sketches, also typical for contemporary Academicians, have been linked, wrongly, with the transitory goals of the Impressionists. Such superficial analogies with *plein air* painting fail to recognise that the tempestuous studies that preceded the painting were intended only to contribute to the accuracy of the visual forms. However, it was in the studies that preliminary colour patterns became precisely formulated, and that structures were created from free compositions planned down to the smallest detail. Certigny presented eighteen of such sketch 'ideas' by Rousseau;[6] although the artist did not regard them as autonomous works, he none the less signed the majority of them after he discovered that younger artists had a keen appreciation of their 'bravura' quality. Painted on canvas, paperboard or wood, they are all landscape designs conceived and put down in front of the motif. They did not, however, determine the realisation of the final paintings; Rousseau used them only sporadically to assist him when he painted urban landscapes. Evidently, he did not find it necessary to make preliminary studies for the complicated jungle paintings, the historical–allegorical 'creations', the portraits or the still-lifes.

Montsouris Park on the edge of Paris, realised by the engineer J.-C. Alphaud, was one of the projects built by Napoleon III to improve the quality of life in the city by surrounding it with a network of open spaces. At the southernmost end of the Parc des Buttes-Chaumont north-east of the city (see no. 47), it was built between 1867 and 1878 over a former stone quarry. Since it was not far from Plaisance, Rousseau was surely able to visit it often (no. 48).

His study combines the trimmed trunk of a fir tree, deciduous trees standing on a flowery meadow and a path bordering rue Gazan. A painting that he made shortly after this also shows a view of Mountsouris Park, and might be the one mentioned in the catalogue of the 1895 exhibition of the Salon des Indépendants.[7] Robert Delaunay purchased the study at Rousseau's studio auction after his death (see no. 50); had he bought it directly from the painter, it would surely have been signed.

Provenance: Robert Delaunay, Paris

Bibliography: Uhde 1921, p. 60; Kolle 1922, ill. 27; Zervos 1927, ill. 96; Grey 1943, ill. 88; Bouret 1961, p. 224, ill. 177; Vallier 1961, p. 137, ill.; Vallier 1969, p. 111, no. 244B, ill.; Certigny 1984, pp. 210 f., no. 105, ill.

Exhibitions: Berlin 1913 (?); Paris 1961, no. 47; Tokyo 1985, no. 15, ill.

4 Soupault 1927, p. 43.

5 Vallier 1979, p. 22.

6 Certigny 1984, nos 55, 86, 105, 112, 136, 160, 164, 165, 219, 238, 257, 261, 272, 278, 282, 284, 296, 298.

7 Ibid., no. 106.

Study, View of the Eiffel Tower and Trocadéro

Esquisse, vue de la Tour Eiffel et du Trocadéro

In one of the loveliest of these light improvisations made by Rousseau for study purposes, which initially and in fact were diametrically opposed to their supposed outcome (cf. no. 23), one looks out over the Seine, traversed by a barge, to the four arches of the Pont des Invalides under a rainy sky full of dark clouds. The outlines of the Eiffel Tower, built in a mere 26 months and opened for the Paris World Exhibition of 1889, tower above the horizontal lines of the bridge. Further to the right one can make out a sketchily rendered round building on the other side of the Seine; this is the Palais du Trocadéro, erected by Davioud for the 1878 World Exhibition. Since the stone parapets and street lamps of the Pont des Invalides were replaced for the third World Exhibition of 1900 by elegant balustrades and different lighting, this gives us an *ante quem* date of between 1889 and 1900 for the period of the picture's creation and also a *post quem* date because of the presence of the Eiffel Tower.

1896–98
Oil on canvas
19.5 × 25.5 cm
Signed bottom right: H Rousseau
Courtesy of Galerie Vömel,
Düsseldorf

Luis Jiménez y Aranda,
*A Visitor at the World
Exhibition*, 1889
Meadows Museum and
Gallery, Dallas

Certigny located the painter's viewpoint as not far from Pont Alexandre III on the right bank of the Seine. Construction of this bridge started in October 1896. Anticipating the orgies of wrapping of a Christo, the building work made it necessary to cover a sculpture which in this temporary state, together with the obligatory figure in rear view (cf. nos 51, 52), takes up the foreground of the picture. On the left stand trees that were planted on the Champ de Mars in 1889. Their height and growth here permit the conclusion that they are already a few years old. The sketch and corresponding painting could accordingly have been produced between 1896 and 1898.[1]

In 1889 the cartoonist Jules Draner used the Trocadéro and Eiffel Tower to complain about the expense of the budget for the World Exhibition, which could barely be balanced (ill. p. 118). Rousseau on the other hand in 1890 celebrated the Eiffel Tower in his self-portrait (ill. p. 138) as a monument to engineering skills. Just like Seurat and the Salon painter Luis Jiménez y Aranda shortly before, he

1 Vallier 1969, no. 157A; Certigny 1984, no. 137.

Jules Draner, cartoon published in *Le Charivari*, 17 April 1889, p. 74

declared himself in favour of the vertical cluster of energy bridging earth and sky and made the highest ever achieved viewpoint into an object for contemplation. The symbol of the spectacle of the 1889 exhibition, not uncontroversial among artists and intellectuals, symbolised the successful era of the Third Republic. And, a hundred years after the social revolution, the republican Rousseau did not let slip this opportunity to record his belief in the marvel of the industrial revolution. But it would be Robert Delauney, his greatest admirer, who first made the Eiffel Tower a cipher of the modern era (pp. 120 f., 218 ff.).

Provenance: Wilhelm Uhde, Paris (?); Edwin Suermondt, Aachen; Martha Suermondt, Drove; Alex Vömel, Düsseldorf.

Bibliography: Uhde 1911, p. 54, ill. 18; Uhde 1914, p. 53, ill.; Uhde 1921, p. 60; Salmon 1927, ill. 7; Uhde 1947, p. 55; Bouret 1961, p. 244, ill. 227; Vallier 1961, ill. 89; Shattuck 1963, pp. 101, 103; Vallier 1969, p. 102, no. 157B, ill.; Stabenow 1980, pp. 157 f., 243; Certigny 1984, pp. 270 ff., no. 136, ill., p. 274.

Exhibitions: Basel 1933, no. 54.

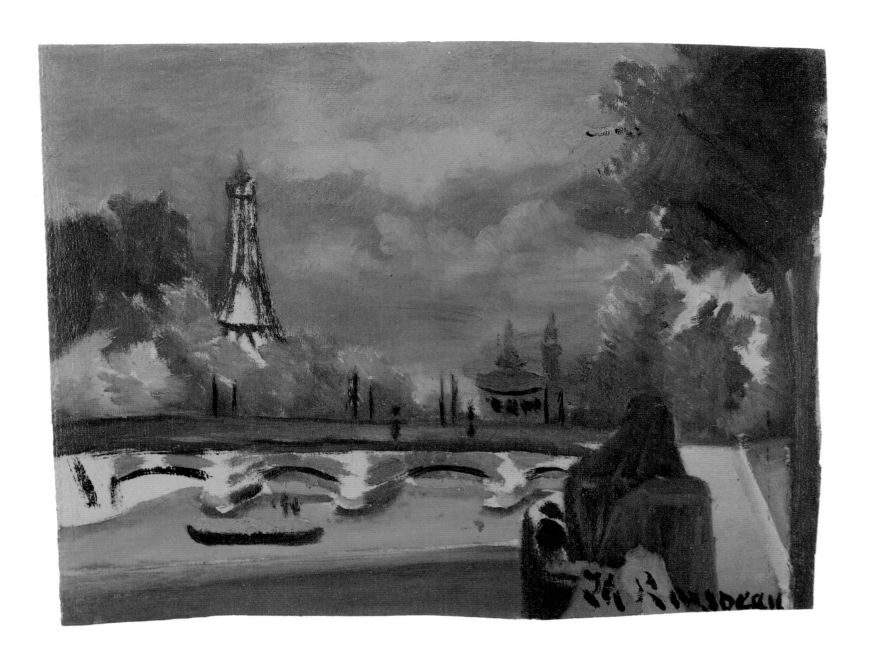

STUDY, VIEW OF THE EIFFEL TOWER AND TROCADÉRO

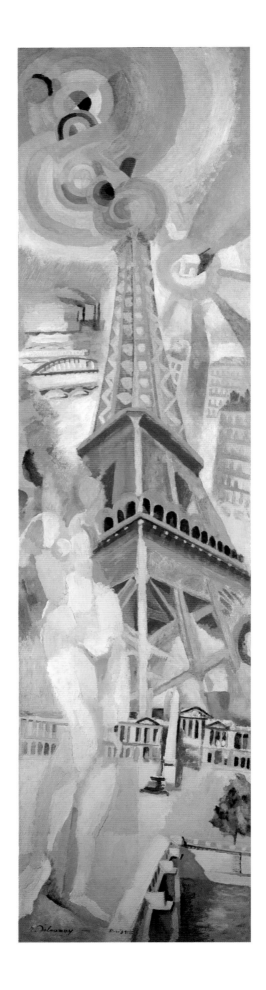

ROBERT DELAUNAY THE CITY OF PARIS. THE WOMAN AND THE TOWER

Robert Delaunay
The City of Paris. The Woman and the Tower

Without exploring Rousseau's creative peculiarities more closely, the content of his pictures – Eiffel Tower and aircraft, Seine quaysides, industrial complexes, bridge constructions and rows of houses – remained of central importance to Delaunay for many years. This is also the case, for example, in this preliminary study for a mural decoration more than four and a half metres high, which was intended for a pavilion at the Exposition Internationale des Arts Décoratifs in Paris in 1925.[1] Completely outside the existing topography and any familiar pictorial logic, motifs of Parisian architecture are assembled simultaneously into a montage and piled high in a vertical format that is topped by the radiating Place de L'Etoile and by abstract circular forms. Prominent emblems of the city – the obelisk for old Paris, the Eiffel Tower for the modern city, the Pont and Place de la Concorde for its architectural beauty and smoking chimney stacks for its prospering industry – are put together to form an allegory on the world's metropolises. The female nude, which may stand for the charm of Parisian life, is taken from the artist's own composition *The City of Paris*, dating from 1912, which formed a résumé of his early work and where, apart from the central group of the Graces, passages from Rousseau's full-length self-portrait (ill. p. 138) were also cited as homage to the artist.[2]

The large composition serves as an example of the fact that Delaunay constantly went back to his beginnings and emphasised this appropriately in order to keep faith with himself. This is what he missed in Picasso, whom he criticised harshly in the mid 1920s, holding Rousseau up as a shining example: 'Individualism taken to extremes leads to plundering. The need to glorify oneself rapidly prevents certain artists from spontaneously drawing the form of their art from the fundamental laws and tempts them . . . to seek the expedient genre . . . in the work of other artists . . . Example: P [icasso] with his periods. Steinlein [*sic*], Lautrec, Van Gogh, Daumier, Corot, Negro art, Braque, Derain, Cézanne, Renoir, Ingres etc., etc., etc. . . . These influences show a lack of seriousness with regard to the structure and the sureness of an artist; he changes in order to grasp means that have been employed by another personality. I give as an example Douanier Rousseau, who until the end of his work made professional progress, but who always remained Rousseau, which testifies to his great personality, his continuity and sureness by comparison with the superficialities of the other and his habitual snobbishness.'[3]

1925
Oil on canvas
207.5 × 52.5 cm
Signed and dated at bottom left:
r.delaunay Paris 1925
Staatsgalerie Stuttgart
(Inv. No. 2795)

1 *Staatsgalerie Stuttgart. Malerei und Plastik des 20. Jahrhunderts*, edited by Karin v. Maur and Gudrun Inboden, Stuttgart 1982, p. 112.

2 Michel Hoog, 'La Ville de Paris de Robert Delaunay. Sources et développement', in *La Revue du Louvre*, 15, 1965, pp. 29 ff.

3 Delaunay 1957, p. 101.

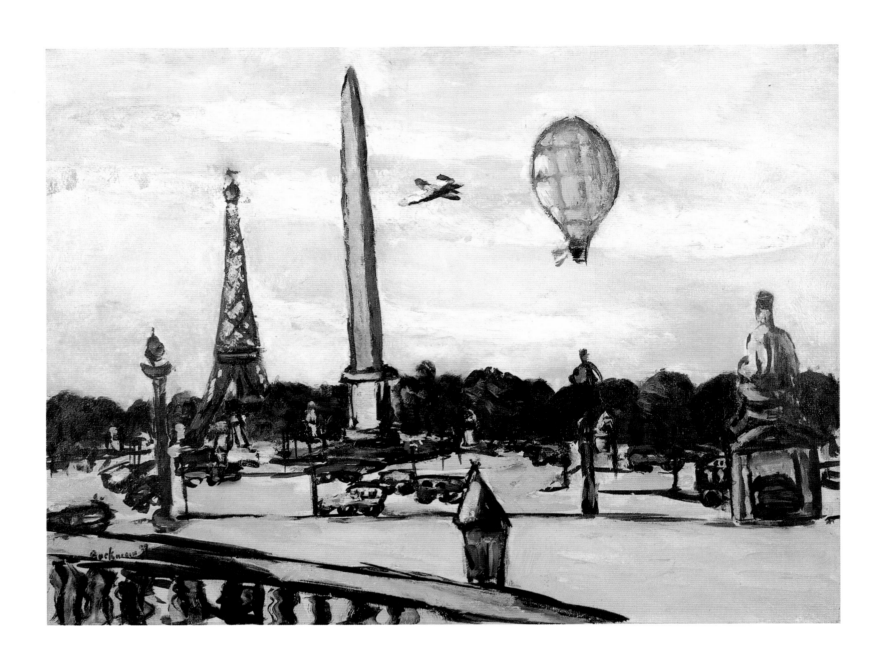

MAX BECKMANN PLACE DE LA CONCORDE BY DAY

Max Beckmann
Place de la Concorde by Day

Beckmann, defamed in Germany as 'entartet' (degenerate), stayed in Paris in 1939 and decided that summer to move to Amsterdam because of the threat of war. Only a few pictures from that time are as untroubled by the oppressive political situation and by the artist's personal situation immediately before the outbreak of war as the *Place de la Concorde* with its inventory, familiar since Rousseau, of hot-air balloon, aircraft and Eiffel Tower.[1] The previous year, in a speech given in London on the occasion of the exhibition '20th Century German Art' at the New Burlington Galleries, Beckmann had expressly acknowledged his 'great old friend Henri Rousseau' (cf. p. 175). According to Quappi Beckmann, her husband was 'simply enchanted' by Rousseau's 'imagination and pictorial composition . . . and by his way of painting'.[2]

1939
Oil on canvas
46.2 × 61 cm
Signed and dated at bottom left:
Beckmann 39
Private collection

1 Erhard and Barbara Göpel, *Max Beckmann. Katalog der Gemälde*, Berne 1976, no. 524.

2 Mathilde Q. Beckmann, *Mein Leben mit Max Beckmann*, Munich - Zurich 1983, p. 152.

Study, Avenue de l'Observatoire
Esquisse, Avenue de l'Observatoire

Wilhelm Uhde published this study in 1921 under the title *Avenue de l'Observatoire, Skizze*. Although the location cannot be identified precisely, the author, familiar with the artist's work, will have had his reasons to refer to the multi-lane system leading from the Jardin du Luxembourg to the Boulevard du Montparnasse.

The artist, who occasionally made heavy weather of his paintings (cf. no. 23), found that sketches flowed easily from his hand. The road leading through rows of trees is sketched in a cursory structure of strokes and light dabs of colour on a piece of cardboard whose brown forms the basis for the airy painting manner. A few black, white and red accents, backed by a tender spring green, sufficed to hint at what was perceived in passing.

The fact that no finished painting based on the study has survived, and perhaps indeed none ever existed, may have something to do with the subject. A building site with little activity taking place was not sufficiently weighty for further development. Meticulously heaped piles of earth and stones block the roadway and pavement. Two roadmenders, one of whom is sitting down on a beam and warning passers-by of the approaching steamroller by means of a red flag, act as supernumeraries.

Certigny referred to a photo by Eugène Atget dating from 1898 which shows road workers carrying out repairs in the Avenue de l'Observatoire. It is possible that there was some connection between the roadworks of that time and the idea for a picture.

1896–98
Oil on cardboard
(mounted on wood)
21 × 15 cm
Courtesy of Galerie Vömel,
Düsseldorf

Provenance: Edwin Suermondt, Aachen; Martha Suermondt, Drove; Alex Vömel, Düsseldorf.

Bibliography: Uhde 1921, p. 71, ill.; Bouret 1961, p. 206, ill. 125; Vallier 1961, ill. 106; Vallier 1969, p. 104, no. 179, ill.; Stabenow 1980, p. 243; Certigny 1984, pp. 328 f., no. 160, ill.

Exhibitions: Basel 1933, no. 21.

STUDY, AVENUE DE L'OBSERVATOIRE

The Poultry Yard
La Basse-Cour

The backyard scene must have been little more than a favour done for an acquaintance who wished to have a picture of his poultry yard. By no means well versed in questions of perspective and figural proportions, Rousseau laid out the rectangular space according to the peepshow principle (cf. no. 17). Directed towards the middle of the picture, the buildings, fences and hedges are lines of demarcation from the neighbouring plots of land. The partially verdant surface of the yard is animated by poultry that are exceptionally large by comparison with the human figures. Light falls on the right from a dark, cloudy sky, and the cut-off wooden fence at the bottom hints at the elevated viewpoint of the painter. The narrowly bounded tranquillity of the locality, which limits nature to its gardening function and tailors the architecture to the needs of the suburbanite, conceals any desire for atmospheric distance. Required instead are closeness, clarity and security. The symbolic image of the garden as *hortus conclusus* has been secularised as an open-air poultry run serving a practical purpose.

This casual work signed with large letters has nevertheless achieved art-historical standing through its owner, Wassily Kandinsky. The latter discovered his liking for Rousseau early on and knew his works ever since his stay in Paris with Gabriele Münter in 1906–1907. Over the years his admiration for the 'Douanier' indeed took such concrete form that in his writings on art theory he derived the 'spiritual in art' from the 'great realism' – diametrically opposed to 'great abstraction' – of Henri Rousseau and Arnold Schönberg (cf. pp. 227 ff.). The extent to which Kandinsky was interested in Rousseau during his Blaue Reiter activities of 1911–12 and how keen he was to own one of Rousseau's works is clear from extensive correspondence between Kandinsky, Franz Marc and Robert Delaunay. Delaunay had been in close contact with Rousseau from 1906 onwards and, after the latter's death, would play a special role as intermediary for his fellow artists in Germany (cf. pp. 221 ff.). Kandinsky had been referred to Delaunay and his Russian wife Sonia Terk – who had married Delaunay in November 1910 after her divorce from Wilhelm Uhde – by one of his Munich students, the painter Elisabeth Epstein, also of Russian origin, who had lived in Paris from 1904.

On 28 October 1911 Kandinsky wrote from Murnau to Delaunay in Paris:[1] 'Today I received Uhde's book on Henri Rousseau [the first monograph on Rousseau, which had appeared in Paris in September 1911]. Once again I was struck by the expressive power of this great poet. And what lovely works you have in your possession! I have always sought an opportunity to acquire a Rousseau. Would you be so kind as to tell me whether this is still possible? I mean, I cannot pay much. How high are the prices for

1896–98
Oil on canvas
24.6 × 32.9 cm
Signed bottom left:
Henri Rousseau
Centre Georges Pompidou, Paris
Musée national d'art moderne
Centre de création industrielle
(Bequest of Nina Kandinsky,
Inv. No. AM 81-65-860)

1 The following extracts from letters are cited after Meißner 1985, pp. 483 ff.

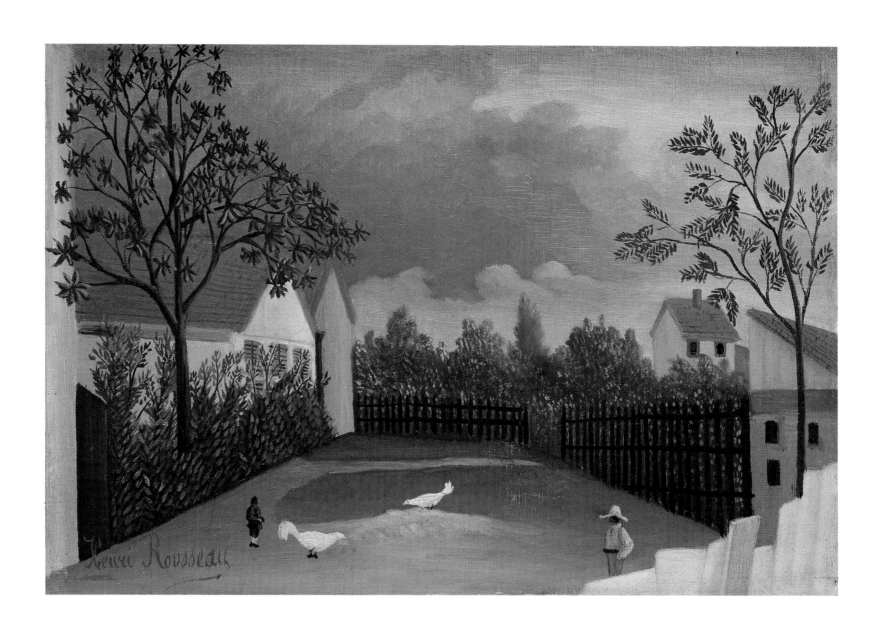

THE POULTRY YARD

Rousseau now? Oh, if only for example one could have the landscape with the large cow and the small woman on the left! Or the Eiffel Tower seen from Malakoff! I would be extremely grateful to you for some advice on how to get a Rousseau without having to pay a high price. To whom do the unsold pictures belong? Would you kindly inform me of Mr Uhde's address: I would like to ask him about Rousseau plates for the Blaue Reiter.' And a day later to Franz Marc: 'Piper [Reinhard Piper, a Munich publisher] sent me Uhde's Rousseau, which I forward to you . . . What a wonderful person this Rousseau was! And naturally in contact with the "other world". And what depth there is in the pictures! Just a few days ago I thought: No. 1 of the "B.R." [the first number of the *Blaue Reiter* almanac] and no Rousseau! The editors should go crimson! And now I felt as if whipped, quite shaken. Oh God! There is the very root of realism, the new realism! This still-life! And the last one – this cigar-box painting! Yesterday I wrote at once to Delonnay [*sic*] and asked whether he thought that Uhde would give us plates.

Gabriele Münter, photograph of the 'memorial corner' to Rousseau at the Blaue Reiter exhibition, Munich 1911–12

Have given Piper hints (twice already) that he should publish the book in German . . . I find that Rousseau belongs to the company: Kahler, Kubin, Epstein, Schönberg, Münter. My exact opposites!' Marc replied promptly on 1 November 1911 from Sindelsdorf: '. . . many thanks . . . especially for the wonderful Henri Rousseau, which struck Sindelsdorf like a flash of lightning.' Kandinsky answered Marc the following day: 'Girieud firmly promised to send me some Rousseaus on approval. I sent the same request to Le Fauconnier. Unfortunately just as unsuccessfully. I have now written to Delaunay and once again to Le Fauconnier . . . Today I wrote to Uhde (circular enclosed) and asked him for 5 plates: cow, self-portrait [no. 29], child's portrait, Malakoff [no. 45] and the narrow Seine. I got the address from Piper, who does not want to publish the Uhde [book] since "the artist is still as good as unknown in Germany". I also asked Uhde whether we can take quite a bit from his book. Something must be written about Rousseau.' On 5 November Kandinsky lamented to Delaunay: 'I am sad that I am unable to buy a Rousseau. To buy from Vollard etc. . . . you need a different purse for that.'

In November and December 1911 Kandinsky and Marc were completely taken up with preparations for the first exhibition of the 'Redaktion Der Blaue Reiter' at the Moderne Galerie Heinrich Thannhauser, Theatinerstraße 7, Munich, as well as with publication of the *Blaue Reiter* almanac. Marc noted on an undated card to Kandinsky: '. . . obtained our own room

128

for second half of December at Thannhauser, in which we 2 should exhibit what we want. So come on, let's get serious about this. My programme: Burljuk, Campendonk, August [Macke], [my] own glass pictures, Schönberg, Bloch, and if at all possible a Rousseau (not too big). Then Delaunay and perhaps two or three old things (rice paintings, glass pictures, votives). It must become something splendid!' Kandinsky responded on 8 December: 'Delaunay is taking part. His pictures are probably coming very soon. But he won't give a Rousseau. I have written again to Mrs Epstein and held out the prospect of a possible sale.' Since Delaunay was unwilling to loan any of the Rousseau paintings in his possession for the Blaue Reiter exhibition, Kandinsky hoped to obtain some through Elisabeth Epstein. This was obviously successful at short notice, for eight days later Kandinsky expressed his thanks to Delaunay: 'Thank you so very much for your obliging assistance in despatching the Rousseau, as well as for sending your pictures.' And on 18 December Delaunay heard from Kandinsky in Munich: '. . . thankfully everything is alright: we are hanging today – your 4 pictures have just arrived today. One crate is still at Customs. Perhaps with the Rousseau and your two drawings. They are going to be delivered to me in 2–3 hours. Many thanks for sending this Rousseau. I will probably buy it, since I have just sold one of my pictures to a Berlin patron [Bernhard Koehler] who is here, and who would also like to acquire a Rousseau [nos 36, 37].'

Piper Verlag prospectus for the almanac *Der Blaue Reiter*, March 1912

In the crate that Delaunay sent from Paris was Rousseau's *The Poultry Yard*, which matched Kandinsky's idea of price and which he bought. The picture arrived in Munich just in time to be displayed as number one, under the title *Die Straße* (The Street), in the Blaue Reiter exhibition at Galerie Thannhauser. It hung reverently, provided with a laurel wreath in memory of Rousseau, who had died the previous year, from 19 December 1911 to 3 January 1912 in the Munich exhibition (ill. p. 128).[2] The exhibition was subsequently seen in a somewhat different form from 20 to 31 January 1912 at the Gereonsklub in Cologne, then at Herwarth Walden's Sturm-Galerie in Berlin, at the Vereinigte Werkstätten in Bremen and – without the Rousseau loan – in Hagen, in Frankfurt am Main and until the end of October 1912 in Hamburg. Replying to Delaunay's request for a photo of *The Poultry Yard*, Kandinsky wrote him on 23 January 1912: 'Unfortunately I do not have a photo of my small Rousseau because the plate was made direct from the picture. The picture is now also in Cologne and will perhaps be travelling until the summer. As soon as I have a photo I will send it on to you.' In the spring of 1912 *The Poultry Yard* was one of seven Rousseau works reproduced in the almanac

2 How Werner Schmalenbach arrived at the assertion that seven Rousseau works 'owned by Wilhelm Uhde figured in the memorable "Blaue Reiter" exhibition in Munich', remains his secret – Schmalenbach 1998, p. 68.

129

Der Blaue Reiter, edited by Kandinsky and Marc (nos 16, 26, 29, 30, 45). It also adorned the Piper Verlag's advertising leaflet (ill. p. 129) for the publication, which was intended to be the most spectacular programme text on twentieth-century art in the German language.

Kandinsky's second purchase of a Rousseau work (no. 27), which he initiated in the spring of 1912, must also have happened through the agency of Elisabeth Epstein and Robert Delaunay. It is hardly likely that Kandinsky, who had to leave Germany on the outbreak of war in 1914, took his two

Kandinsky's apartment in Dessau, with the painting *The Poultry Yard* next to the wall clock, c. 1928

Rousseaus with him to Russia. After his stops in Berlin in 1922 and at the Bauhaus in Weimar, they reappeared in Dessau in the Meisterhaus, built in 1926 by Walter Gropius, which the Kandinskys shared with Paul Klee's family. In Kandinsky's apartment, decked out with furniture from the Ainmillerstraße flat in Munich in a style that was anything but Bauhaus in manner, the pictures hung to right and left of a Rococo-style wall clock, close to Klee's painting *Der Schmied* (The Blacksmith). Kandinsky also took the Rousseau paintings with him to Paris, where he was forced to emigrate in 1933 having been declared 'entartet' (degenerate). There they were published again by Christian Zervos in 1934. Finally, following the murder of Kandinsky's widow in 1981, they entered the Centre Georges Pompidou, Musée national d'art moderne, together with the artist's estate.

Provenance: Wassily Kandinsky, Munich, Dessau, Paris; Nina Kandinsky, Neuilly-sur-Seine.

Bibliography: Kandinsky - Marc 1912, p. 81, ill.; C. Zervos, in: Cahiers d'Art, 9–10, 1934, p. 269; Uhde 1948, ill. 23; Lo Duca 1951, p. 7, ill.; Bouret 1961, p. 234, ill. 203; Vallier 1961, ill. 67; Vallier 1969, p. 99, no. 113, ill., p. 101; Keay 1976, p. 156, ill. 64; Vallier 1981, p. 35, ill.; Certigny 1984, pp. 104 f., no. 57, ill.; Derouet - Boissel 1985, p. 470, no. 845, ill.; Meißner 1985, pp. 484 f.; Stabenow 1985, p. 313, ill. 5; Hopfengart 2000, p. 217, ill.

Exhibitions: *Die erste Ausstellung der Redaktion DER BLAUE REITER*, Moderne Galerie Heinrich Thannhauser, Munich, 19 December 1911–3 January 1912, p. 3, no. 1 (*Die Straße*), ill.; Gereonsklub, Cologne, 20–31 January 1912; Berlin 1912, no. 105; Berlin 1913, no. 17; Paris 1937, no. 21; *Paris - Berlin. 1900–1933,* Centre National d'Art et de Culture Georges Pompidou, Paris, 12 July–6 November 1978, p. 56, ill.; *Blauer Reiter*, Städtische Galerie im Lenbachhaus, Munich 1999, no. 247, ill. 170.

The Painter and his Wife
Le Peintre et sa femme

The painting, which is among the few on which Rousseau did not assert his authorship by means of his signature, has previously been called *Rousseau Paints his Wife's Portrait* or *The Painter and his Model*. If the artist was indeed

1899
Oil on canvas
46.5 × 55.5 cm
Centre Georges Pompidou, Paris
Musée national d'art moderne
Centre de création industrielle
(Bequest of Nina Kandinsky,
Inv. No. AM 81-65-861)

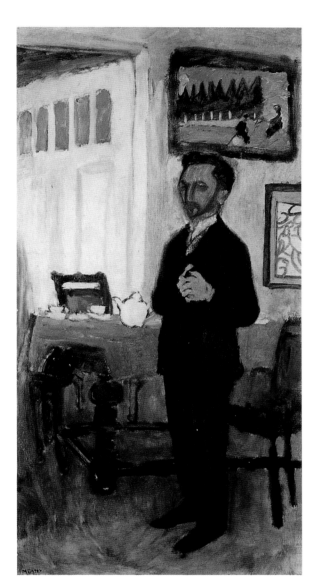

painting his wife's portrait, on the easel we would not see a green landscape but at least some suggestion of the model. Possibly Rousseau was thinking of a sort of wedding picture in which he and his second wife Joséphine Noury, whom he had married in early September 1899, were to be immortalised in a Garden of Eden (cf. nos 29, 30).[1] The easel set to one side, he poses as an expert in his field who, in the dress of a city-dweller, adorns himself with the insignia of the open-air painter. The couple, dressed in black, have made themselves comfortable on folding chairs on the semicircular bank of a lake. The compositional lines of the paths, fence and trees parading in a line slope down from right to left from the elevated standpoint of Madame Rousseau, who sits in state on a bank. The area is opened up at the back by an unusual gateway which leads to a shining white nothingness.

1 Cf. the wedding picture painted over for this reason – Vallier 1969, no. 87; Certigny 1984, no. 117.

Rousseau's self-portrayal with his wife was the second, more important Rousseau painting that Kandinsky was able to buy for himself thanks to the intervention of Elisabeth Epstein and Robert Delaunay in the spring of 1912 (cf. no. 26). Disregarding the coincidence of the offer, it is clear that Kandinsky took particular pleasure in having two subjects that emphasise the enclosed realm of the garden as a symbol of a precisely ordered world. This may have been due to the structures, straightened geometri-

Gabriele Münter, *Portrait of Kandinsky*, spring 1912
Private collection

cally and serially, but perhaps also to the fact that two contrasting possibilities of a garden – the practical function of the poultry yard and the park used for relaxation – were specified.

The Painter and his Wife hangs prominently over the subject in a portrait of Kandinsky in bourgeois dress and setting that Gabriele Münter

painted in their flat at Ainmillerstraße 36, Munich, in April or May 1912. A rather more extensive view of the general living and eating area showing Kandinsky, the Goltzes and Gabriele Münter also includes the latest Rousseau purchase on the right, above Kandinsky's head.

The picture survived Kandinsky's moves to the Bauhaus in Dessau in 1925 and to Paris in 1933 unscathed, but in mid 1943, as a result of financial difficulties caused by the war situation, the émigré found himself forced to think about selling, although it never actually came to that. In view of his intention to sell the painting he drew a pencil sketch which straightens out Rousseau's composition and bears a descriptive accompanying text (p. 134). This states that Rousseau is shown in the middle in front of a small easel and his wife is sitting on the right. The trees, which Kandinsky recorded as 'poplars' with 'autumn bushes', can hardly be identified as such, admittedly.

Provenance: Wassily Kandinsky, Munich, Dessau, Paris; Nina Kandinsky, Neuilly-sur-Seine.

Bibliography: C. Zervos, in: Cahiers d'Art, 9–10, 1934, p. 269; Lo Duca 1951, p. 11, ill.; Bouret 1961, p. 208, ill. 130; Vallier 1961, p. 120, ill. 74; Vallier 1969, p. 38, ill. XXII, p. 101, no. 142, ill., p. 103; Bihalji-Merin 1971, p. 127, ill. 27; Descargues 1972, p. 90, ill., p. 93, ill.; Bihalji-Merin 1976, p. 32, ill.; Le Pichon 1981, p. 41, ill.; Vallier 1981, p. 35, ill.; Certigny 1984, pp. 266 f., no. 134, ill.; Derouet - Boissel 1985, p. 471, no. 846, ill.

Exhibitions: Paris 1944–1945, no. 12; Henri Rousseau, XXV Biennale, Venice 1950, no. 17; Les Sources du XX^me Siècle, Musée Nationale d'Art Moderne, Paris 1960, no. 620; Paris 1964, no. 17; Tokyo 1966, no. 21; Munich - Zurich 1974–1975, no. h.11, ill. 63.

Gabriele Münter, *After Tea II*, spring 1912
Private collection

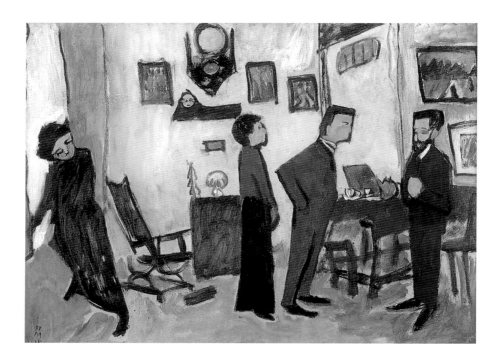

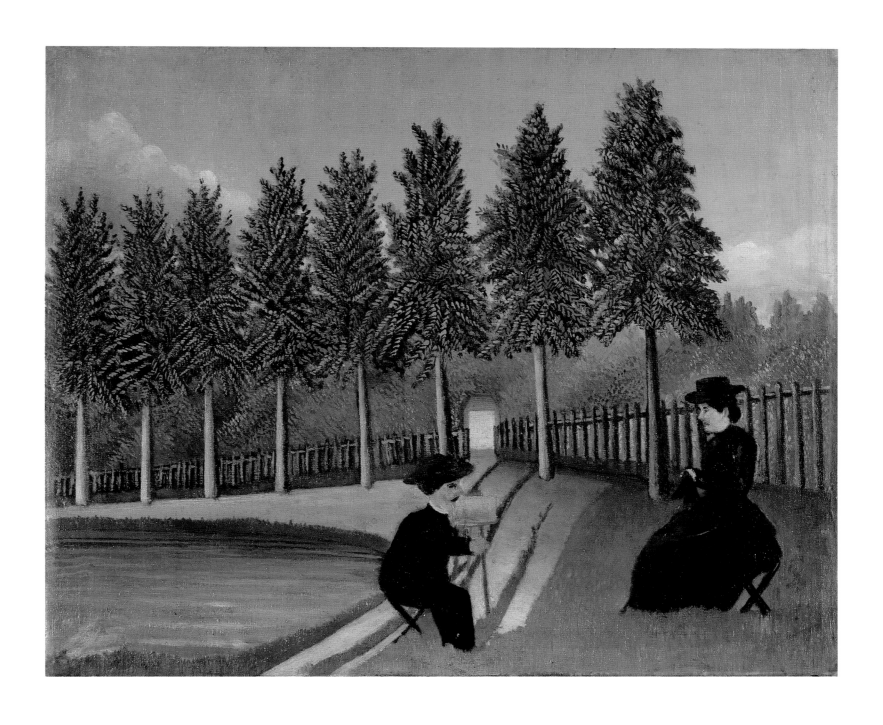

THE PAINTER AND HIS WIFE

Wassily Kandinsky
The Painter and his Wife

1943
Pencil on paper
12.5 × 13.5 cm
Inscribed at top and bottom:
<u>Henri Rousseau</u> -10 F. (55 × 46) /
Sa femme assise (à droite) et /
lui-même (au centre) devant /
un petit chevalet. Au fond /
peuplier +. Reproduction aux /
"Cahiers d'art" 1934, N° 9-10./
Prix: 500 mille <u>net</u>. + et buissons
d'automne.
Centre Georges Pompidou, Paris
Musée national d'art moderne
Centre de création industrielle
(Bequest of Nina Kandinsky,
Inv. No. AM 81-65-862)

In 1943, as a German émigré in Paris, Kandinsky thought about selling the Rousseau painting *The Painter and his Wife* (no. 27), which had been in his possession since 1912. In connection with this plan, which in the end was never carried out, he made this sketch as a reminder with the appropriate accompanying text:[1] <u>Henri Rousseau</u> - 10 F. (55 × 46) / His wife seated (on the right) and / he himself (in the middle) in front of / a small easel. In the background / poplars. + Reproduced in / "Cahiers d'art" 1934, no. 9-10. / Price: 500 thousand <u>net</u>. + and autumnal bushes.

1 Derouet - Boissel 1985, no. 847.

Portrait of a Woman (detail), c. 1895, no. 16

A Corner of the Plateau of Bellevue
Un coin du plateau de Bellevue

Rousseau gave this landscape the comprehensive title: *A Corner of the Plateau of Bellevue. Autumn, Sunset*. One can assume that the description on the back of the picture corresponds to that listed under number 1544 in the exhibition catalogue for the Salon des Indépendants of 1902: *Un coin de Bellevue (Soir)*. The painting was on sale at the exhibition for ninety francs.[1]

The artist defined his landscapes as precisely as possible with regard to the location. He rarely related them to the season or time of day. In this case, however, the long shadows indicate the evening light of the setting sun, while the colouring of the delicately chased foliage and the rising mist in the background fit the autumnal atmosphere. The linear structures of the tree-trunks and branches as well as the decorative patterns of the leaves, as though cut from coloured glass, convey the impression of a luxurious Gobelin tapestry. A figure standing on a narrow path is inserted into the latticework of branches hung with foliage that are gathered into an overarching arabesque.

1901–2
Oil on canvas
31.5 × 27.5 cm
Signed bottom left:
Henri Rousseau
Inscribed on back: Un coin
du plateau de Bellevue.
Automne, Soleil couchant,
Henri Rousseau.
Museum of Art, Rhode Island
School of Design, Providence
Gift of Mrs Henry D. Sharpe
(Inv. No. 77.114)

1 Certigny 1984, p. 376.

Provenance: Galerie Paul Rosenberg, Paris; Galerie Paul Guillaume, Paris; Henry D. Sharpe, Providence; Mrs Henry D. Sharpe, Providence.

Bibliography: Salmon 1927, ill. 21; Zervos 1927, ill. 15; Lo Duca 1951, p. 5, ill.; Bouret 1961, p. 208, ill. 131; Certigny 1961, p. 212; Vallier 1961, ill. 143; Vallier 1969, pp. 102, 108 f., no. 223, ill.; Certigny 1984, pp. 376 f., no. 184, ill.

Exhibitions: Paris 1902, no. 1544; Paris 1923, no. 23; New York 1931; Basel 1933, no. 30; Paris 1961, no. 70, ill.; New York 1963, no. 60, ill.; Tokyo 1966, no. 43.

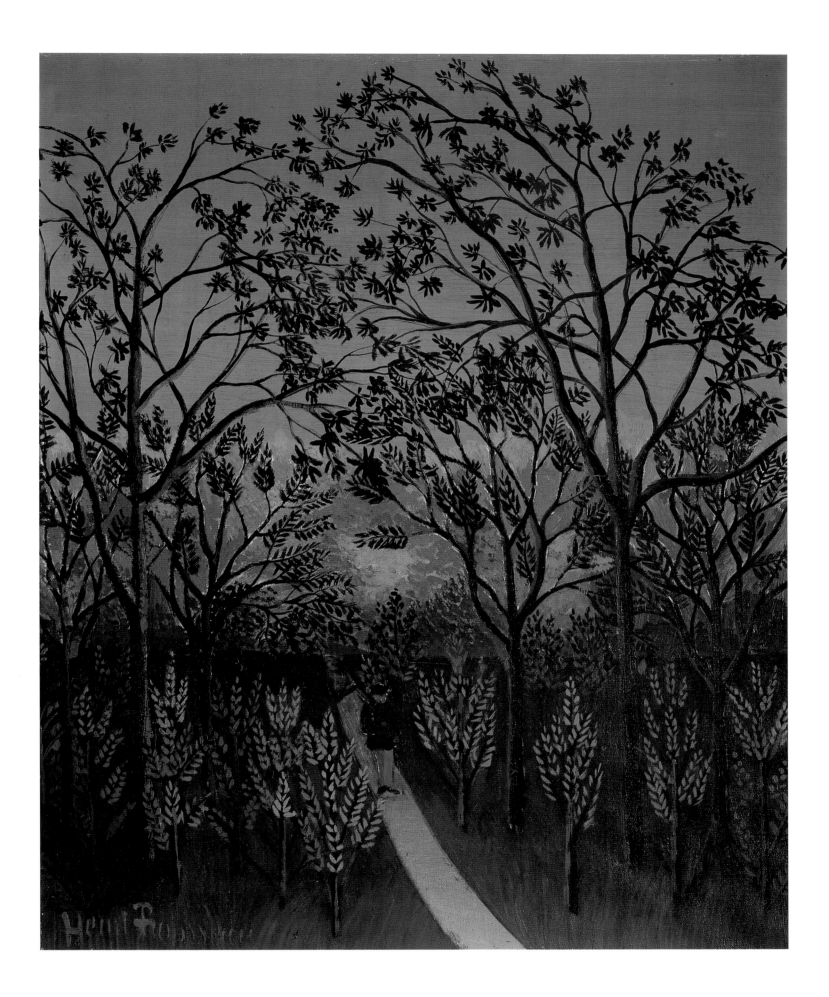

A CORNER OF THE PLATEAU OF BELLEVUE

Self-portrait of the Artist with a Lamp
Portrait de l'artiste par lui-même à la lampe

1903
Oil on canvas
23 × 19 cm
Musée Picasso, Paris
(Donation Picasso, Inv. No. RF. 1973-88)

As a memento of their marriage, which only lasted for a few years, Rousseau created a double portrait of great impact on two equal-sized canvases shortly before the death of his second wife on 14 March 1903 (see also no. 30). It was intended specifically to honour the memory of Joséphine Noury, widow of a hackney cab driver, who had married the artist on 2 September 1899 and contributed to their joint upkeep by opening a stationer's shop (cf. no. 27).

The portrait busts of the married couple are closely related to one another in the manner of a diptych. Although the stoical composure of their gaze is strangely remote, they are directed towards each other by a slight turn of the body, in front of a gathered curtain. The fact that the portraits form a pair is emphasised not least by the almost identical backgrounds as well as by the oil lamps on round white and blue pedestals. Despite the different lamp models, the mirror-image placing of the bases and the cut-off shape of the lamps refer in a metaphorical sense to a conjoined flame of life that is gradually growing weaker. The lamplight throws white highlights on to the physiognomies of the couple. The facial features are sharply delineated and develop a particular inner dynamic through the strong modelling. In the network of brushstrokes laden with pigment the flesh, alternating between zones of light and shadow, appears refracted in crystalline fashion.

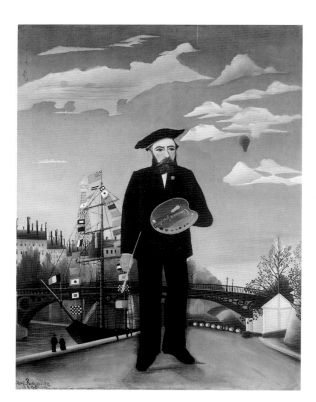

Henri Rousseau, *I Myself, Portrait-landscape*, 1890 Národni Gallery, Prague

Rousseau had already taken stock of himself in a self-assured manner in 1890, when he presented himself as a personality whose reputation as a successful *artiste-peintre* preceded him. The 'inventor' of the *Portrait-landscape* painted himself then with all the symbols of his status and position. The *I Myself* of his self-portrayal aimed to emphasise the artist as a heroic figure of the nineteenth century and – against the optimistic backdrop of Paris – as a link between dependable traditions and the achievements of the technological age. With the purple 'Palmes académiques' medal in his buttonhole – and who more competent to decorate himself with this award than the creator of enchanting palm groves? – he felt himself the equal of the great and good of art history.

Nothing of this pretension remained when, 13 years later, Rousseau showed himself in his true light, more modestly and without any sign of his profession. The ambitious, wishful, ideal image of earlier times was reduced to the usual bust-length portrait, the self-glorifying pose to conventional reality. Even the full beard which, in his younger days, may have been an expression of masculinity and republican convictions has gone. What remains is a moustache with upward-twirling ends, of the type for which Parisian waiters had gone on strike, a smooth-shaven, forceful chin and – above eyes accentuated with black – a furrowed, self-willed forehead set off by his remaining hair. The aging painter presents himself in dignified fashion in a dark jacket with immaculately starched shirt-front and a blue bow tie, whereas the careworn face of his muse, who is decked out with brooch and earrings and wears a black and red dress, points towards her approaching demise.

There is no doubt about the identity of the subjects, since Uhde mentioned them in 1911 and 1914: 'There are two small portraits in which Rousseau depicts himself and his wife; they are both no longer young; the heads stand out against the background without decoration, without symbols, but a lamp set simply beside them arouses the impression of quiet domesticity and secure happiness in a more suggestive way than an interior with all the details could have done.'[1] Certigny dated the counterparts 1886–1888 since he believed it was Clémence Boitard, the artist's first wife, who was represented. In view of the age of Rousseau, who is shown here not as in his early forties but with the wrinkles and heavy bags under the eyes of somebody in his late fifties, Vallier's suggested date of 1902–1903 is convincing.

Fortunately, the portraits of the couple have never been separated. In 1911 they were already in the possession of Robert Delaunay, who at the end of that year obtained the plates for Kandinsky so that they could be reproduced in the latter's *Blaue Reiter* almanac, which appeared in 1912 (cf. no. 26). Having been sold by Delaunay, the portraits reached the Galerie Paul Rosenberg in 1938, where they were bought by Picasso (cf. nos 16, 41) who, as the proud owner, had himself photographed with them in various poses (ill. p. 142). They hung in his otherwise plain bedroom at the Villa La Galloise in Vallauris, where he lived with Françoise Gilot from the summer of 1948.

1 Uhde 1911, p. 46; Uhde 1914, p. 45.

Provenance: Robert Delaunay, Paris (from 1911); Galerie Bing, Paris; Louis Neumann, Zürich; Galerie Paul Rosenberg, Paris (end of 1938); Pablo Picasso, Paris (after 1938).

Bibliography: Uhde 1911, p. 46, ill. 4; Kandinsky - Marc 1912, p. 94, ill.; A.J. Eddy, *Cubism and Post Impressionism*, Chicago 1914, pp. 12 f., ill.; Uhde 1914, p. 45, ill.; Uhde 1921, p. 54; Grey 1922, ill.; Kolle 1922, ill. 1; Scheffer 1926, p. 292; Basler 1927, p. 32; Salmon 1927, ill. 4; Soupault 1927, ill. frontispiece; Zervos 1927, ill. 66; Grey 1943, ill. 18; Courthion 1944, ill. I; Uhde 1947, p. 50; Gauthier 1949, ill. IV; Cooper 1951, ill.; Lo Duca 1951, p. 13, ill.; Perruchot 1957, p. 99; Rousseau 1958, ill. 2; Bouret 1961, p. 204, ill. 118; Certigny 1961, p. 96; Vallier 1961, p. 144, ill. 83; Salmon 1962, p. 59; Tzara 1962, p. 326; Shattuck 1963, pp. 86, 88 f.; Vallier 1969, pp. 100 f., no. 140 A, ill.; Bihalji-Merin 1971, pp. 20, 180, ill.; Descargues 1972, p. 64, ill.; Bihalji-Merin 1976, pp. 31 f.; Keay 1976, p. 129, ill. 23; Werner 1976, ill. back cover; Alley 1978, p. 50, ill. 41; Le Pichon 1981, p. 42, ill., p. 221; Vallier 1981, ill. frontispiece; Certigny 1984, pp. 46, 48 f., no. 25, ill., p. 234; Meißner 1985, pp. 483, 486; Stabenow 1985, pp. 313 f., ill. 6; Stabenow 1994, pp. 62 f., ill.; Schmalenbach 1998, p. 91, ill.

Exhibitions: Paris 1911, no. 36; Berlin 1913, no. 3; Berlin 1926, no. 1, ill.; Paris 1984–85, pp. 59, 79, ill., pp. 81, 159 ff., no. 23, ill., p. 269; New York 1985, p. 53, ill., pp. 71 f., ill., pp. 151 ff., no. 23, ill., p. 263; Munich 1998, pp. 11, 31, 44, 49 f., 216, no. 74, ill., pp. 218 f.

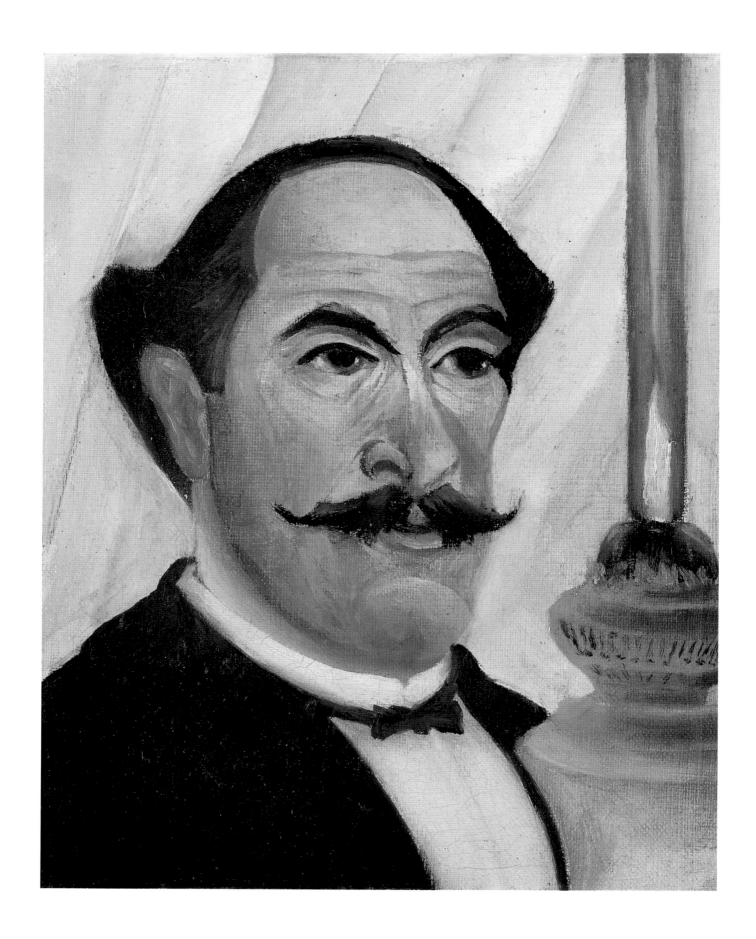

SELF-PORTRAIT OF THE ARTIST WITH A LAMP

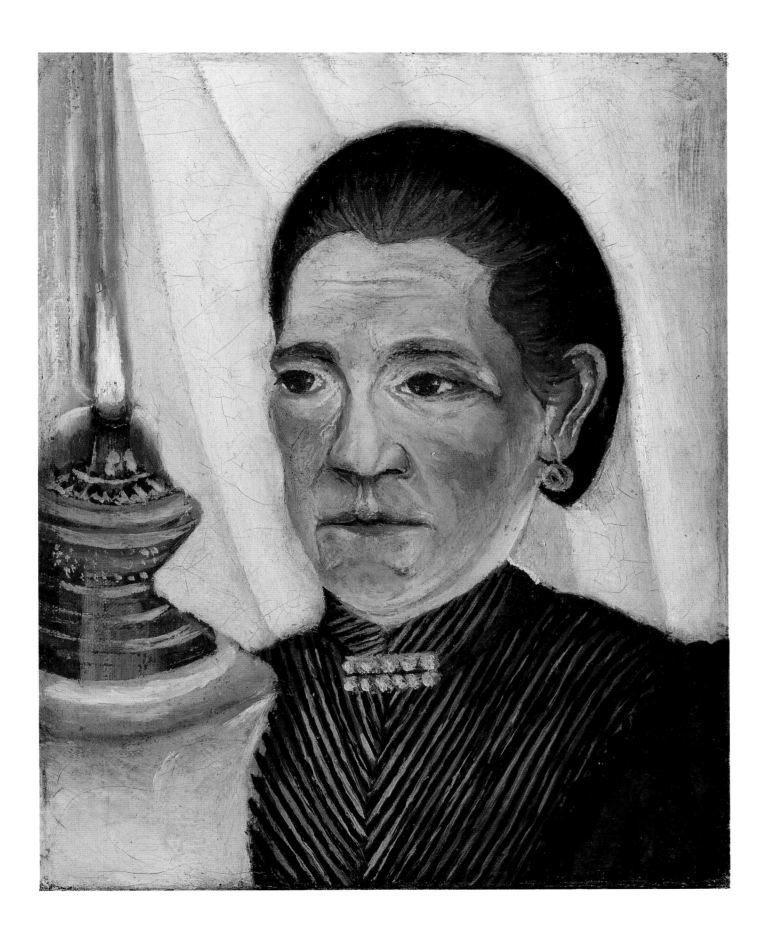

PORTRAIT OF THE ARTIST'S SECOND WIFE WITH A LAMP

Portrait of the Artist's Second Wife with a Lamp

Portrait de la seconde femme de l'artiste à la lampe

See no. 29.

1903
Oil on canvas
23 × 19 cm
Musée Picasso, Paris
(Donation Picasso, Inv. No. RF. 1973-89)

Provenance: Robert Delaunay, Paris (from 1911); Galerie Bing, Paris; Louis Neumann, Zürich; Galerie Paul Rosenberg, Paris (end of 1938); Pablo Picasso, Paris (after 1938).

Bibliography: Uhde 1911, p. 46; Kandinsky - Marc 1912, ill.; Uhde 1914, p. 45; Uhde 1921, p. 54; Grey 1922, ill.; Scheffer 1926, p. 292; Salmon 1927, ill. 3; Soupault 1927, ill. 3; Zervos 1927, ill. 67; Grey 1943, ill. 19; Uhde 1947, p. 50; Gauthier 1949, ill. V; Lo Duca 1951, p. 13, ill.; Bouret 1961, p. 204, ill. 119; Certigny 1961, pp. 96, 102; Vallier 1961, p. 144, ill. 84; Shattuck 1963, pp. 88 f.; Vallier 1969, pp. 100 f., no. 140 B, ill.; Bihalji-Merin 1971, p. 20; Bihalji-Merin 1976, pp. 31 f.; Keay 1976, pp. 9, 129, ill. 24; Alley 1978, p. 51, ill. 42; Le Pichon 1981, p. 43, ill.; Vallier 1981, p. 34, ill.; Certigny 1984, pp. 46 ff., no. 24, ill.; Meißner 1985, p. 486; Apollinaire 1991, p. 37; Stabenow 1994, p. 63, ill.; Schmalenbach 1998, p. 91, ill.; Hopfengart 2000, pp. 220 f., ill.

Exhibitions: Paris 1911, no. 37; Berlin 1913, no. 4; Berlin 1926, no. 2, ill.; Paris 1984–85, pp. 81, 159 ff., no. 24, ill., p. 269; New York 1985, pp. 73, 151 ff., no. 24, ill., p. 263; Munich 1998, pp. 11, 31, 44, 49 f., 217 ff., no. 75, ill.

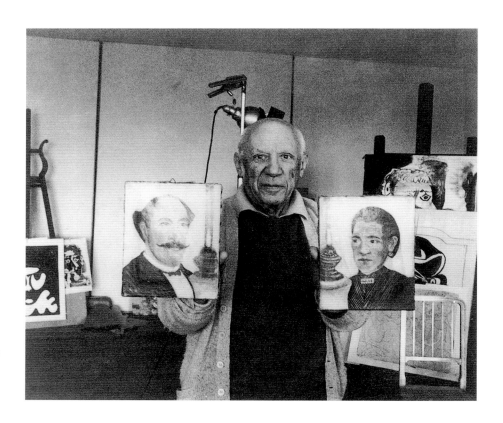

André Gomés, *Picasso in his studio in the country house Notre Dame de Vie with the portraits of the Rousseaus*, 1965
Musée Picasso, Paris

Liberty Inviting Artists to Take Part in the 22nd Exhibition of the Société des Artistes Indépendants (detail), 1905–6, no. 40

Les Valton, Signac, Carrière, Willette Luce, Jenrat, Otton Pissaro Jau din, Henri Rousseau, etc. sont tes émules.

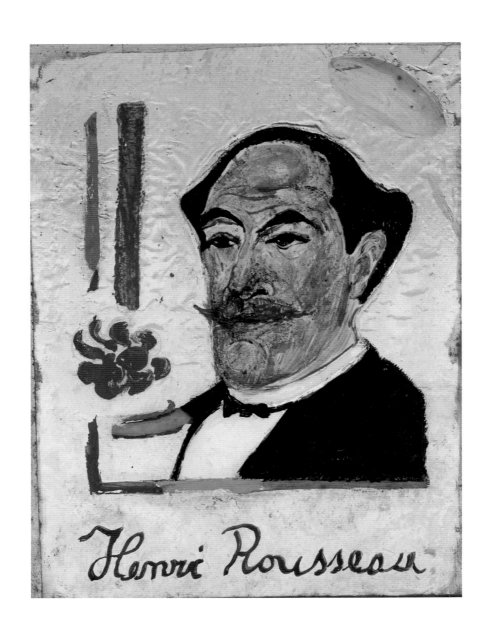

FRANZ MARC PORTRAIT OF HENRI ROUSSEAU

Franz Marc
Portrait of Henri Rousseau

Franz Marc expressed his reverence for Rousseau in the form of a *verre églomisé* picture that paraphrases the latter's *Self-portrait of the Artist with a Lamp* (no. 29).[1] He used the reproduction given in Wilhelm Uhde's Rousseau monograph, which had appeared in Paris on 22 September 1911, as the model for his Upper Bavarian homage. Kandinsky received the Uhde book from the Munich publisher Reinhard Piper as soon as 28 October and forwarded it immediately from Murnau on the 29th of that month to Franz Marc in Sindelsdorf (cf. no. 26). On 1 November 1911 Marc replied in euphoric terms: '. . . many thanks . . . especially for the wonderful Henri Rousseau, which struck Sindelsdorf like a flash of lightning'.[2]

The 'lightning flash' quickly resulted in the *verre églomisé* picture, which from 19 December 1911 hung beside Rousseau's *Poultry Yard* (no. 26) in the Rousseau 'corner of remembrance' of the Blaue Reiter exhibition organised by Kandinsky and Marc at the Galerie Thannhauser in Munich (ill. p. 128).[3] In accordance with the *verre églomisé* technique, the representation is a smaller mirror image of the original picture. Instead of the oil lamp, Marc's portrait is distinguished by a flower, provided with a wedge of colour and inscribed with a signature which is a copy of Rousseau's. The silver gleam of the foil and the golden yellow of the radiant halo contribute to make the subject of the portrait an icon of Bavarian piousness. As the rustic *verre églomisé* painting of the eighteenth and nineteenth centuries was in vogue in the Murnau environment of Kandinsky and Gabriele Münter – people collected it and tried out the technique for themselves – it seemed reasonable for Marc to give his Rousseau interpretation to Kandinsky as a Christmas present in 1911.

When Kandinsky acquired the *Poultry Yard*, Marc wrote to him that he 'envied him this little picture'.[4] After visiting Delaunay in Paris in the autumn of 1912 and admiring the 'lovely Rousseau's' there,[5] Marc himself made efforts to buy a Rousseau painting. He talks about this in a postcard to Delaunay sent from Bonn on 18 October 1912:[6] 'As regards the Rousseau picture – do you know the price? Is it dear? I ask this for myself. Have you got a photo of it? Please ask Mr Apollinaire. I would be very, very happy to own a work by Rousseau, but the financial aspect!! I don't think this would be something for Mr Koehler; after all he already has two portraits [nos 35, 36] and he would like to have a large one like yours [ill. p. 219]; but they are very expensive at present, I believe; in short, I would be very grateful to find out something more precise about it, especially to have a photograph.' Marc supported Delaunay's attempts to find a German publisher for a Rousseau book that he had planned (cf. pp. 220 ff.). On 28 November 1912 he wrote in

1911
Verre églomisé picture
(backed with silver foil)
15.3 × 11.4 cm
Inscribed below: Henri Rousseau
Signed on back: Franz Marc fec.
Städtische Galerie im Lenbach-
haus, Munich
(Inv. No. GMS 723)

1 Rosel Gollek, *Der Blaue Reiter im Lenbachhaus München*, Munich 1982, no. 335.

2 Meißner 1985, p. 483.

3 Instead of the 'ca. six Rousseau's' that Marc, according to his letter to Macke of 7 December 1911 (*August Macke – Franz Marc, Briefwechsel*, published by Wolfgang Macke, Cologne 1964, p. 87), was expecting for the Blaue Reiter exhibition, in the end only the *Poultry Yard* was seen in the exhibition.

4 Hopfengart 2000, p. 217.

5 Meißner 1985, p. 495.

6 This and the following extracts from letters are quoted after Meißner 1985, pp. 486, 495 ff.

this connection to Paris: 'A few words in haste; I still don't understand the publishing business with the Rousseau book: Do you have a French publisher to share the costs of publication, and what will be the conditions under which the French publisher will waive the German publishing rights? Or do you think that the German publisher (Piper) should do the whole thing for both countries. One must also look closely at the financial side of all of this. I will happily write a short article in order to show how Rousseau is 'seen' in Germany and what importance he has for us; in other words, the German point of view (If you could supply the necessary photos for the album, Piper would certainly have the plates made from them and [do] everything connected with both the texts, French and German.). As regards the title, H. Rousseau dit le douanier, maître de Plaisance, I agree with you. But if the publication by Piper is to be produced in German, then the term "maître de plaisance" will barely be translatable; the thing is, there is no suitable word in our language, the French expression will not be comprehensible here. For a French edition it is very good.' But Marc's efforts were in vain, as he revealed in a postcard to Delaunay of 3 December: 'Thanks for your card, which puts me in the picture regarding your plans. I have already spoken to Piper about it – he refuses! Fears he will not sell enough! I go round and round, I wrote again, but in vain. I immediately made contact with a different publisher and am awaiting a reply. On 10 December I am going to Berlin with my wife for three weeks and will talk to publishers there as well [Herwarth Walden].'

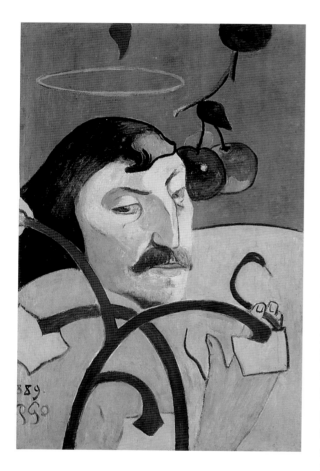

Paul Gauguin, *Self-portrait with Halo*, 1889
National Gallery of Art, Washington

In a letter to Kandinsky on 23 December 1911 Marc mentions the 'complex of feelings' that they both associate 'with the name of Rousseau'. This is a reference to that fanciful attitude for which the Cartesian-schooled Frenchman Delaunay had no understanding. Kandinsky and Marc's mysticism was not to his taste, as he clearly gave Marc to understand in early 1913: 'I find that one does not need mysticism for art, for movement in art, neither Christian nor Jewish nor any other kind . . . What distinguishes my art from what I have seen a bit, I say a bit and this is true, in your country, among the most interesting of the young Germans, is this mystical predilection or, better, numbing which paralyses and hinders life. You know how much I love Rousseau. I was the first to pay homage to Rousseau the great painter, and my love for him can only become greater. But nor do I deceive myself about the snobbishness of those who proclaim him as friend, as their friend, and speculate with the pictures in your beloved country, who do not see the truth about things and work against all of you (ask Walden). I am

speaking about R. the mystic. R. is full of mystery, but not a slave to mysticism. He is mysterious because of [his] life, circumstances, because of his love taken as far as the intellectual which, for my own feeling, I find too exaggerated; in this respect he is the last of the so-called classical painters.' And in a draft letter to Marc dated 11 January 1913 Delaunay adds: 'My friend Rousseau in his time sang in the right way for his environment. His melody is now generally acknowledged, in the big newspapers in New York there are advocates, prophets, proclaiming his genius. They have spoken with firm belief amid all the laughter. I have reminded myself repeatedly of his words, his sweetness, his enthusiasm, his richness, and I never had difficulties in loving his strong imagination: his [manner of] expression is anti-descriptive, his deep sensitivity put him on the same level as most of the great Impressionists; outside their artistic advance, he succeeded in painting pictures, and in this sense he is the only true representative of objectivity . . . Moreover Rousseau also had the old artistic conception (perspective, certain manner of geometry of colour etc.) but, cutting across these antiquated means of expression, what freedom of vision. What a good craftsman. That is the entire sublime expression of his world, stronger, less light, less bourgeois than that of Cézanne. It was not the psychologists who saw these things in Rousseau, but the painters; in general the people who like to see, saw it.' Marc again emphasised his view of Rousseau in March 1913: 'Henri Rousseau, the customs officer, is the only one whose art often troubles me. Again and again I try to imagine how he painted his magnificent pictures, try to put myself into the inner state of this admirable painter, I mean to say: in the state of a great love.'[7] And Delaunay closed the discussion on 4 May 1913 in conciliatory fashion with the remark: 'But I do not believe in this one-after-the-other, on the contrary I believe that we agree with one another because we both love Rousseau.'[8]

7 Hopfengart 2000, p. 217.

8 Meißner 1985, p. 506.

Attributed to Rousseau
Portrait of a Child

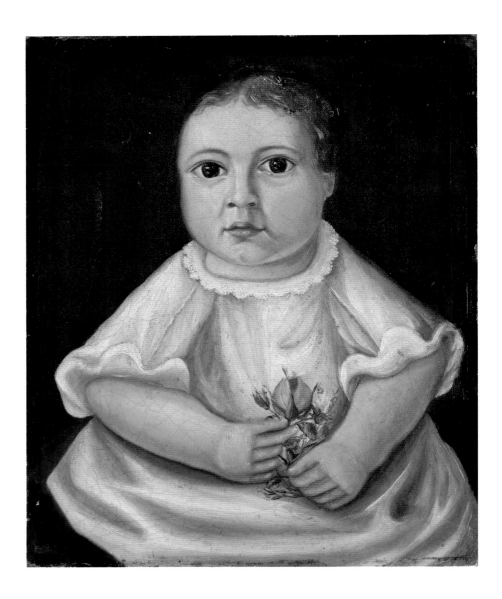

In her detailed report of 7 July 1983 the Rousseau expert Dora Vallier attributed this portrait of a child set against a dark background to Rousseau. If one follows her hypothesis, then this small picture is an example of how the artist complied with the wishes of those who commissioned paintings from him.

1900–06
Oil on canvas
28 × 23 cm
Private collection

Provenance: Private collection, Switzerland.

Bibliography: Susanne Grimm, *Authentische Naive*, Stuttgart 1991, p. 76, ill.

Exhibitions: Tokyo 1985, no. 6, ill.

Rousseau's portrait *To Celebrate the Baby* can certainly hold its own when set beside child portraits of Spanish provenance such as those created by Velazquez, Goya and Picasso (ill. p. 152), as well as beside Philipp Otto Runge's particular German version. Like these artists, Rousseau too shows an individual immersed completely in his or her own world. The viewer stands face to face with the child. One is forced to adopt the child's viewpoint and fit into its universe, where the trees are suited to the figural presence and the string puppet becomes an over-sized partner. Admittedly, it was a long way from the regally outfitted Infante of a Velazquez to Rousseau's child, full of energy and self-confidence, from a very different social environment.

1903
Oil on canvas
100 × 81 cm
Signed bottom right:
Henri Rousseau
Kunstmuseum Winterthur,
Winterthur
Gift of the heirs of Olga Reinhart-Schwarzenbach, 1970 (Inv. No. 1103)

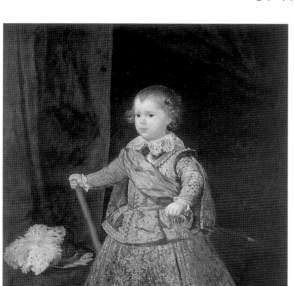

Diego Velazquez, *Prince Baltasar Carlos*, 1632 Hertford House, Wallace Collection, London

One feels here that all the positive attributes that make up the charm of a child's portrait have been taken into account, every single cliché has been satisfied. The plump, blond-curled apparition is clothed in a white shift with its front pulled up to hold a freshly picked bunch of flowers. The well-nourished child, whose chubby-cheeked face with big eyes and full red mouth is absolutely bursting with health, has found its way on to a flowery meadow studded with trees under a cloudless sky. However, if you look more closely, you discover odd notes of discord. These may come from the fact that, although Rousseau brought seven children into the world, their ways nevertheless remained strange to him. According to Theodor Däubler, Rousseau had 'the look of hatred of a child caught, so to speak, at play by an adult, when by play it means romantic fact, innermost truth'.[1] The old man, who was said to have childlike traits, has painted an old child without any emotionality. The gigantic baby raised into a monument to itself is not atmospherically incorporated into its surroundings, intersected by a path, but stands out sharply against them. Figure and nature are only related to each other fictitiously. The head and limbs are disproportionate, the expression of the face is confusingly masklike. In order to avoid an all too flat juncture with the ground, the painter has here again dodged an exact depiction of the feet. By covering them with grass, he leaves the figure without any definite conclusion at the bottom (cf. nos 12, 27, 32).

1 Däubler continues: 'He also painted a large, fat child. It stands with its jumping jack in the most cheerful green. In the freshest of fresh air: one sees this from the leaves and flowers. The baby is drastic. It has naked calves and naked arms. A fantastic experience and already a strong stylistic expression. Rousseau was like that.' – Däubler 1916, pp. 121, 128.

149

The dangling marionette attached to five cords appears as *alter ego* of the *putto* placed heavily in the landscape, who could be either boy or girl. Corresponding to the mechanically activated jumping jack, the child is facing a life spoon-fed by invisible forces. He or she will one day function similarly and be kept in motion by an unknown hand, just like the puppet. The developing individual and the artificial figure that can be taken apart are assigned to one another. Geometrised daintiness is added to clumsy fullness of life. Childhood and age, subject and mass product, pure white and brilliant colour form an unequal pair.

The back-to-front dignity of the large child and the small man is a reminder that Alfred Jarry, Rousseau's youthful poet friend (cf. pp. 30 ff.), was a fan of puppet theatre and produced a series of puppet plays. To entertain guests he even built a stage for this purpose in his Boulevard Saint-Germain flat which he probably also used after moving into Rousseau's home. Perhaps the painter had his house-guest in mind when he made this sturdy model, whose defiant energy stands plain in his face, into a childish *Ubu roi* who makes the doll dance. Henri Rousseau evidently distrusted the 'origin and innocence' topos of the child that was inspired by Jean-Jacques Rousseau. The return to childhood as a Romantic metaphor for longing, echoes of which are also heard in Heinrich von Kleist's text *Über das Marionettentheater*, was not the Douanier's theme. His child is long since past the uninhibited state.

In early 1903 Marie Foucher, widow of Frumence Biche (cf. no. 11), and her daughter Cécile visited Rousseau and his already severely ill wife in the Rue Gassendi.[2] The painter showed the just-finished child portrait to his old acquaintance, whose daughter recalled half a century later: 'This work pleased my mother very much, but as she was very prudish she found fault with the fact that the child was showing its thighs.'[3] The portrait, given the number 2140 and the description *Pour fêter le bébé*, was exhibited at the Salon des Indépendants from 20 March to 25 April 1903 and declared to be not for sale. It seems hardly credible that an unknown customer is said to have paid three hundred francs for it – in other words, that some employee, manual worker or labourer from the 14th *arrondissement* laid out

2 Certigny 1961, pp. 223 f.

3 Certigny 1984, p. 408.

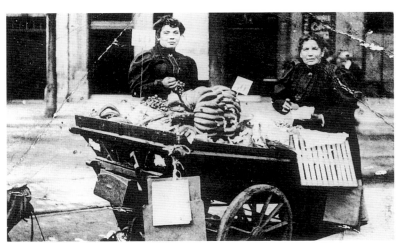

Marie Biche-Foucher and her daughter Cécile as fruit sellers, Paris c. 1910

this enormous sum for a portrait of his child. The customary price at that time, depending on size and subject, ranged between thirty and seventy francs per picture. Probably Uhde's memory had faded when he reported: 'He earns a little money through small landscapes, which the citizens of Plaisance buy off him, and now and again through a commission for a

150

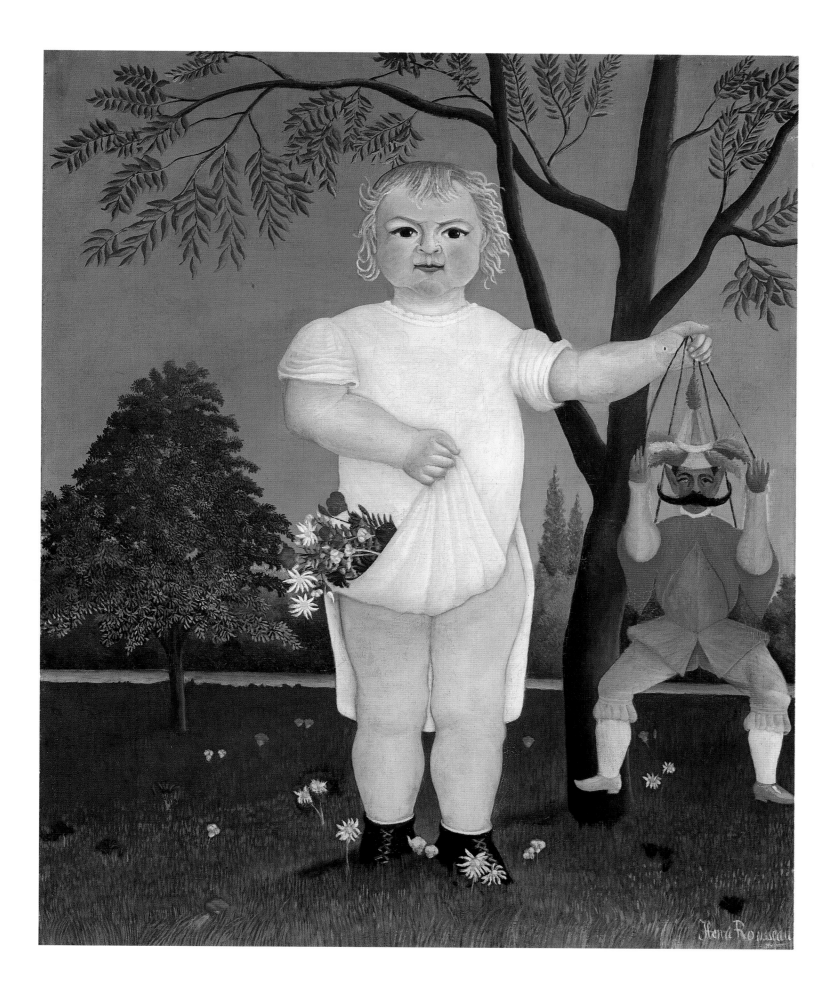

TO CELEBRATE THE BABY

portrait. But all this is poorly paid. There exists a child's portrait by him that is among the most beautiful of his pictures. The child stands in the open air, has flowers in its little shirt, whose tail it is holding up with one hand with a Harlequin in the other. He is being paid three hundred francs for this portrait, and I believe he has never received this much money for a portrait in his life before. But the child's parents have ruined themselves with this order and are being forced to give the picture away to settle a small laundry bill. Incidentally, with this picture, as with many others, one can make the comment that the best pictures that Rousseau paints are those for which he is paid the most.'[4]

4 Uhde 1911 and 1914, pp. 20 f.

The painting – according to Uhde given by its owner in lieu of payment of a laundry bill – was discovered by the German in a junk shop on the Boulevard du Montparnasse and bought for less than ten francs.[5] He sold it to the German painter Eduard von Freyhold, who was active in Paris, before the appearance of his Rousseau monograph in 1911.

5 Kieser 1913, p. 220.

Pablo Picasso, *Maya with Horse and Doll*, 1938
Private collection

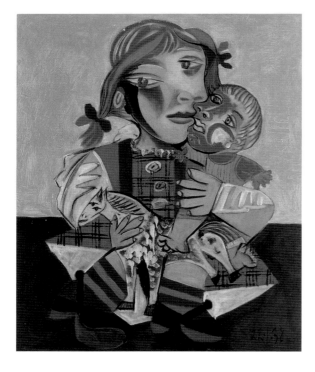

Provenance: Wilhelm Uhde, Paris (before 1910); K.F. Eduard von Freyhold, Paris (before 1911), Baden, Freiburg im Breisgau; Werner Reinhart, Winterthur (1944); Georg Reinhart, Winterthur (1951); Olga Reinhart-Schwarzenbach, Winterthur (1955).

Bibliography: Uhde 1911, pp. 20 f., 49, ill. 23; Kieser 1913, p. 220; Uhde 1914, pp. 20, 48, ill., cover; Däubler 1916, p. 128; Uhde 1921, pp. 31 ff., ill., p. 56; Grey 1922, ill.; Basler 1927, ill. X; Salmon 1927, ill. 35; Soupault 1927, ill. 13; Grey 1943, ill. 13; Courthion 1944, ill. VII; Uhde 1947, pp. 37, 52, 59; Uhde 1948, p. 16, ill. 16; Cooper 1951, p. 33, ill.; Lo Duca 1951, p. 9, ill.; Perruchot 1957, p. 38; Rousseau 1958, ill. 17; Bouret 1961, pp. 45, 109, ill. 25; Certigny 1961, pp. 223 f., 226; Vallier 1961, p. 73, ill., pp. 91, 141, 143 f.; Salmon 1962, p. 39, ill.; Shattuck 1963, p. 91, ill. 22; Vallier 1969, p. 39, ill. XXIII, pp. 85, 88, 101, no. 145, ill.; Bihalji-Merin 1971, pp. 22, 128, ill. 28; Descargues 1972, p. 18, p. 103, ill.; Bihalji-Merin 1976, pp. 35 f., ill. 6; Keay 1976, pp. 29 f., 136, ill. 34; Werner 1976, ill. cover; Alley 1978, pp. 53 f., ill. 44; Stabenow 1980, pp. 25, 137, 150, 180 f., 247; Le Pichon 1981, p. 62 f., ill., p. 264; Vallier 1981, p. 44, ill.; Certigny 1984, pp. 330, 406, 408 ff., no. 200, ill. (with further literature references); Rousseau 1986, p. 35, ill.; Stabenow 1994, pp. 62, 92 f., ill.; exhibition catalogue *Die Sammlung Georg Reinhart*, Kunstmuseum Winterthur, Winterthur 1998, p. 258.

Exhibitions: Paris 1903, no. 2140; Basel 1933, no. 26, ill.; Munich – Zurich 1974–75, H. 13, ill.; Paris 1984–85, p. 98, ill., pp. 162 f., no. 25, ill., p. 184; New York 1985, p. 87, ill., pp. 154 f., no. 25, ill. p. 176 (not exhibited in New York).

Eve and the Serpent
Eve et le serpent

The paradoxical situation of a female nude in a jungle setting represents a double exception within Rousseau's œuvre, since the nude remained as much a phenomenon of marginal importance in his repertoire as did religious themes. The fact that just such a theme is involved here is not difficult to recognise. Eve, turned to the left and seen in profile, accepts with pleasure the apple held out to her by the serpent of temptation in a Garden of Eden transplanted to the tropics. The symbolic figure of the female stands awkwardly in front of the elegantly entwined snake, whose momentous offer looks more like an orange than an apple.

1904–05
Oil on canvas
61 × 46 cm
Signed bottom right:
Henri Rousseau
Hamburger Kunsthalle, Hamburg
Property of the Stiftung zur
Förderung der Hamburgischen
Kunstsammlungen
(Inv. No. 2992)

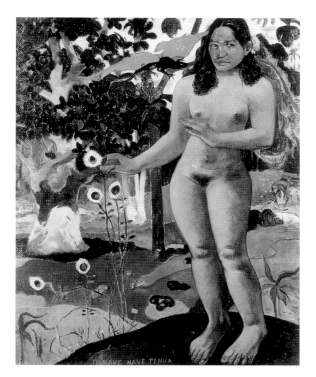

Paul Gauguin, *Te nave nave fenna*, 1892
Ohara Museum of Art, Kurashiki

The forbidden fruits on the tree of knowledge are orange-red, the snake's skin is patterned with light red, and the sun emerges red above the green depths of the jungle. While Eve threatens to become the henchwoman of fate, there is no trace of Adam, the future object of her desire. Her radiant body is not yet aware of its nakedness, although the phallically erect snake body already has its sex firmly in its sights. In the compactly put-together nude and the doll-like movements of her limbs one remarks the fear of touch of her interpreter, who was unversed in anatomical matters. The ground seems to have been removed from under Eve, her pronounced *contrapposto* seems to have lost its basis. Barely visible feet stand on the fluctuating green of the leaves. Her floating state may indicate that the heavenly dream will be followed by an earthly awakening. Already in 1892 Gauguin had interpreted the old theme, close to Symbolist thinking on guilt and atonement, in an *Eve exotique* with an exotic gloss for the modern consciousness. And the kinship of Picasso's ungainly female nudes of 1906 with the Douanier's archaically black-haired version of the previous year is obvious.

The trickiest phase of becoming human, directly before the Fall, is taking place here. Out of a virginal Elysium Rousseau has made a mature jungle labyrinth filled with vegetation except for a narrow strip of sky. A wilderness of ferns, agaves, banana plants, palm fronds and rubber plants, dominated by their burgeoning growth, creates a decorative background for the figure accentuated against the thicket of plant life. No path leads out into the wide, civilised landscape from this space that arouses feelings of claustrophobia. The refuge in

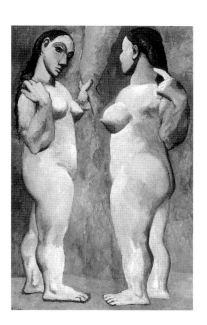

Pablo Picasso, *Two Female Nudes*, autumn 1906
The Museum of Modern Art, New York

three levels, leading upward step by step and differentiated both in terms of colour as well as in precision of execution, is shown to be inaccessible. In its hermetical impermeability it has lost its paradisiacal innocence. Become ambivalent, it displays menacing features with fateful consequences.

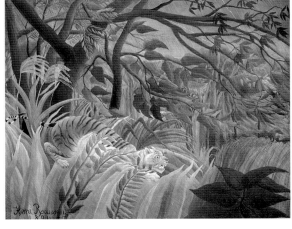

Henri Rousseau, *Surprise!*,
1891
The Trustees of the National
Gallery, London

This questioning of paradise was followed between 1904 and 1910 by an imposing series of further jungle scenes, 26 of which are known and have become synonymous with the inventive power of their creator (cf. nos 33, 42, 43, 58, 59). With his *Eve* or the jungle attraction *Surprise!*, which truly landed a surprise coup at the Salon des Indépendants of 1891,[1] Rousseau was laying down a pattern for his very own pictorial genre, which over the years was enriched, systematised and provided with dramatic effects in sundry ways. During the course of this process landscape views, frequently held at a distance from an elevated viewpoint, changed into forced close-ups comparable to those which had already been conceived in the mid 1880s (cf. nos 6–8). As anti-naturalistic and therefore utopian alternatives to both the immediacy of Impressionism and the overblown floral designs of Art Nouveau, the symbols of a perpetual, evergreen natural state were exceptions that deviated from the norms of artistic skill and aimed at radical simplification – and this in an age which made it its task to reproduce the everyday as well as work from the subject. The nineteenth century produced an excess of the exotic. But only Gauguin and Rousseau understood how to wring out its attractions from a jaded *fin de siècle* and keep it fruitful for a modern sort of primitivism. They pulled the already played-out dream of the primeval back into the consciousness, although Rousseau's exoticism was very much at second hand. His Tahiti took place in a musty working-class quarter of Paris and was thought up at home on a red-upholstered settee. On the wide expanse of his canvases the explorer responded to the paradisiacal promises of technical progress,

1 Vallier 1969, no. 47; Certigny 1984, no. 63.

Eve, fragment on the north
portal of Autun Cathedral,
c. 1120

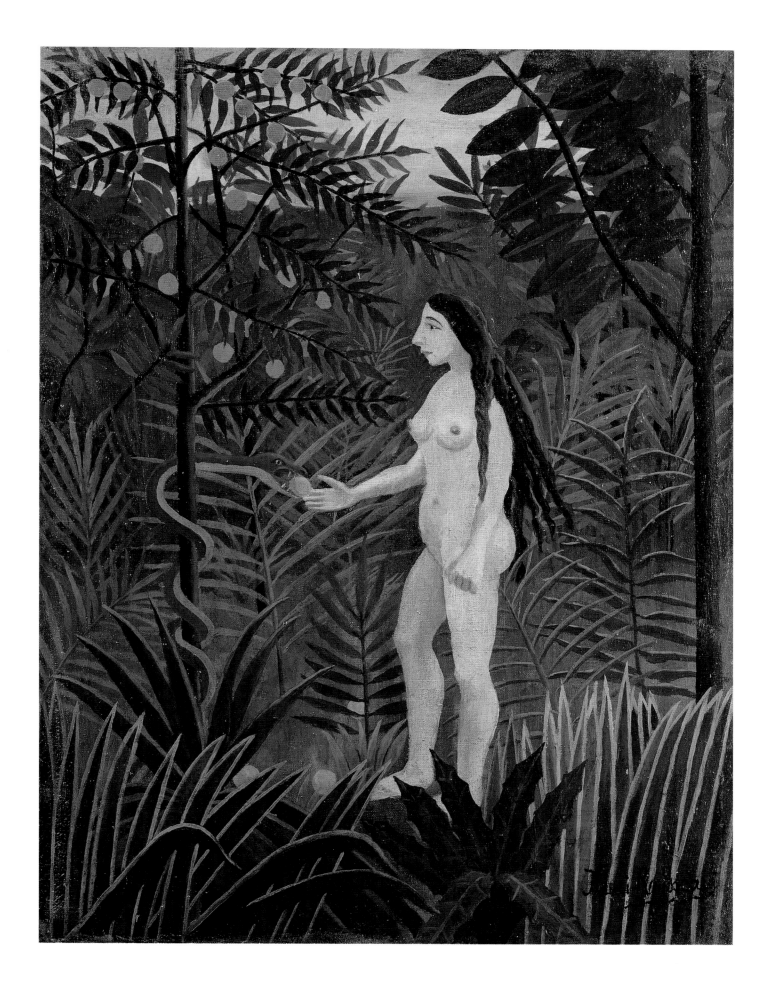

EVE AND THE SERPENT

foreign cultures and tropical vegetation with ideal images of an unspoilt, hypertrophic nature. Alone in his modest dwelling in the Rue Perrel, used both as a studio and for sleeping and living, he interpreted his visions of inaccessible animal and plant worlds, restricted neither by location nor by time. He was doing this at a time when Cézanne too, with his forest motifs in the countryside around Aix-en-Provence, and Monet in his garden in Giverny were becoming increasingly isolated.

Henri-Pierre-Leon-Pharamond Blanchard,
A Tropical Landscape with Paul and Virginia, 1844
The New Orleans Museum of Art, New Orleans

But what induced Rousseau to take his pioneering spirit into unexplored, utopian realms and produce stylised, fictitious jungles that were anything but critical of civilisation? And why was he only ready in 1904 to continue a pictorial genre that had already caused a stir in 1891 and was intended to help him achieve success? We do not know. There have been more attempts at explanations than answers for the sudden emergence of the jungle genre and its further development at a later date. For example, from Apollinaire we learn that Rousseau took part in Napoleon III's unsuccessful Mexico campaign in 1866/1867 as a young soldier assigned to the 51st Infantry Regiment and, four decades later, was inspired to paint his jungle pictures by a region of Central America where – *nota bene* – there are no tropical forests. This legend could be straightened out since his jungles were never entered, in other words, they represent no reminiscences of putative expeditions and have no Mexican provenance. Although the artist himself initially stuck to the story, he did finally admit that he had 'never travelled further than to the hothouses in the Botanical Garden' in Paris. 'I don't know whether it's the same for you as for me', he confessed to Arsène Alexandre, 'but when I am in the greenhouses and see the strange plants from exotic countries, it is as though I am experiencing a dream. I feel myself to be a completely different person.'[2]

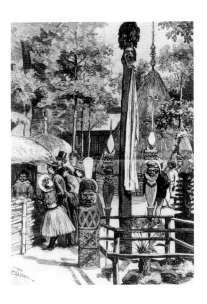

Paris World Exhibition, illustration published in *Le Monde Illustré*, 27 June 1889

Accordingly, Rousseau's jungles are hothouse fantasies fed by the most diverse of sources. Apart from his visits to the botanical and zoological gardens, the palm houses, orangeries and menageries of the city, there is no doubt that the world exhibitions of 1889 and 1900 also made a contribution.[3] The sudden development in French colonialism in the 1880s provided the excuse to present a brief overview of a world defined in colonial terms. Through reconstructions of settlements

2 Alexandre 1910 (p. 700).

3 Vallier 1961, pp. 38 ff.

Auguste Michel Nobillet,
In the Greenhouse
Private collection

and their inhabitants, visitors received *en passant* insights into the life of colonial peoples from Indochina, Tonkin, Senegal and Tahiti or could amuse themselves with the attractive panoramas of stuffed animals displayed in the exhibition grounds. Moreover the interested person could read about these exotic pleasures at home in the pages of illustrated magazines such as the *Magasin pittoresque* or the *Journal des voyages et des aventures de terre et de*

mer. Rousseau too drew his stereotyped knowledge from the relevant magazines and popular ethnographic journals. Thus, among his estate was found *Bêtes sauvages*, published for promotional purposes by the Grands Magasins 'Aux Galeries Lafayette'. It contains around 200 illustrations of terrifying beasts of prey, including snakes, tigers, lions, jaguars, apes and buffalos, which the artist employed as models for his jungle combat scenes (ill. pp. 209, 262).

Jungle collages set in the geographical nowhere and everywhere of the imagination were assembled from the above-mentioned ingredients. With the

addition of animal and human staffage, they are subtle derivatives of the artificial arrangements seen in Parisian hothouses and palm houses. The painter was successful with this because he touched the nerve of a middle class in love with decoration, in touch with nature primarily in synthetic terms: through flowered wallpaper and tapestries, through selected decorative plants in drawing rooms and stairways, through pompous winter gardens or Métro stations with floral designs. With his jungles Rousseau gave appropriate artistic expression to the *horror vacui* of his epoch.

M. von Munkácsy, *The Little Sugar Thief*, exhibited at the Salon des Artistes Françaises, Paris 1895

Provenance: Wilhelm Uhde, Paris; Paul and Lotte von Mendelssohn-Bartholdy, Berlin; Lotte Gräfin Kesselstadt-Mendelssohn, Vaduz; Galerie Nathan, Zurich.

Bibliography: Uhde 1914, ill.; Kolle 1922, p. 14, ill. 9; Basler 1927, p. 31, ill. XLVIII; P. Courthion, *Panorama de la peinture française contemporaine,* Paris 1927, p. 161bis, ill.; Soupault 1927, ill. 33; Zervos 1927, ill. 63; Grey 1943, ill. 103; Courthion 1944, ill. XIX; André Lejard, *Le Nu dans la peinture française,* Paris 1947, no. 56, ill.; Cooper 1951, p. 37, ill., p. 58; Lo Duca 1951, p. 13, ill.; Bouret 1961, p. 225, ill. 180; Vallier 1961, ill. 132; Vallier 1969, pp. 6, 41, ill. XXV, pp. 102 f., no. 164, ill.; Bihalji-Merin 1971, pp. 41, 147, ill. 48, p. 164, ill. 77; Descargues 1972, p. 121, ill.; Bihalji-Merin 1976, pp. 79, 138, ill. 10; Keay 1976, p. 149, ill. 51; Stabenow 1980, p. 231; Le Pichon 1981, p. 201, ill.; Certigny 1984, pp. 464 f., no. 229, ill.; Certigny 1989, p. 13; Stabenow 1994, p. 79, ill.; Schmalenbach 1998, p. 41, ill.

Exhibitions: Paris 1912, no. 7; Berlin 1926, no. 6; Paris 1984–85, pp. 45, 67, 85, 156, 170 f., no. 29, ill., p. 255; New York 1985, pp. 41, 59, 75, 148, 162 f., no. 29, ill., p. 251.

The Hungry Lion Throws itself on the Antelope
Le Lion, ayant faim, se jette sur l'antilope

Rousseau's jungle pictures quickly grew into fantastical realities (cf. no. 32). The largest of them was created in 1905. On a canvas of six square metres it depicts a hunting lion which holds its prey, collapsing under its assault, firmly in its grip. With teeth and claws buried deep in the neck of the so-called antelope, it is in the process of killing the creature, portrayed with gaping wounds. The hunting scene, which in reality would have taken place out on the open savannah, was transposed without concern to the depths of an exotic forest. Appropriately alien to the location are the other beasts that lurk all around the scene. On a branch on the right a panther is preparing to leap down in order to snatch its share of the fatally wounded antelope. Two birds of prey in the trees at the top with blood-soaked scraps of flesh dangling from their beaks have already helped themselves. And a mysteriously eerie hybrid being – human-ape and bird-man – that could hardly have been bettered in inventiveness by Max Ernst is emerging from behind a curtain of leaves on the left. The ritual tearing of flesh culminating in the wide-open, glassy button eyes seems to have been frozen for a fraction of a second in the harsh glare of a flashlight.

1905
Oil on canvas
201.5 × 301.5 cm
Signed bottom right:
Henri Rousseau
Fondation Beyeler, Riehen/Basel
(Inv. No. 88.4)

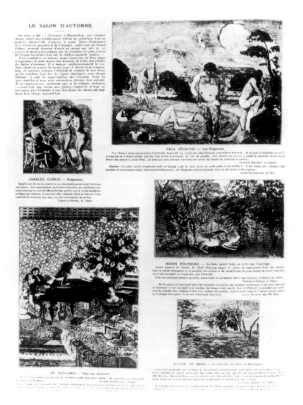

Double spread, published in
L'Illustration, 4 November 1905

Like a collage, the fauna are associated with flora that can only be identified with difficulty. Above a thickly grown strip of grass rises an opulent backdrop of trees, shrubs and gigantic foliage. A portent of the deadly struggle, the glowing red orb of the sun is sinking behind the expansive splendour of the myriad shades of green. Dense and open structures alternate with light and dark zones of light. The excessive size of the forest and of the animals, never before seen in this combination, is handled magnificently.

On a broad front the predator's attack introduced the sensational into Rousseau's iconography. An aggressive scene of destruction was inserted into the jungle décor, the sudden pounce making life a question of survival. The evenly distributed all-over design of the plant ornamentation is charged with the drama of the brutal assault. The forest as a passive, peaceful factor of order simultaneously becomes a place of action for the dangerous aspect of nature, in which life and death are brought into an unsettling equilibrium.

A compositional layout already conceived in the mid 1880s and realised in other contexts (cf. nos 6–8) winds through all these jungle paintings like Ariadne's thread. The action is usually pressed right forward in the middle of the picture in front of high plant walls that are open at the top. The painter was not very bothered about the natural proportions as regards size, but he was obviously concerned to get the details as exact as possible, to train his ability to visualise things by studying zoological and botanical models and, if necessary, transferring their outlines to the canvas with the aid of a mechanical magnifying instrument.[1] But in the end, the extent to which the observed and the invented agree is meaningless. It is unimportant whether the lavish vegetation that makes gigantic shrubberies out of plants and combines excessively tall ferns with excessively low deciduous trees corresponded in size, form and colour to what Rousseau saw in the Jardin des Plantes, and whether the proportions of the living things are reproduced correctly in relation to their surroundings. What is decisive is rather that Rousseau convincingly translated the inaccessible and perpetual boundlessness of nature into the large format according to his imagination.

To clarify the central fight scene the artist provided stage directions which in their detail – completely normal at the end of the nineteenth century – provided a sentimental counter-check to the down-to-earth comprehensibility of the picture: 'The hungry lion throws itself on the antelope, it tears it to pieces; the panther waits anxiously for the moment when it too will get its share. Birds of prey at the top have torn a piece of flesh from the poor animal, which sheds a tear. Sunset.' With this commentary Rousseau presented his composition to the public, together with two smaller Oise landscapes (no. 34), at the Salon d'Automne in the Grand Palais which opened on 17 October 1905. This event had been inaugurated two years earlier. From 1886 to 1910 the Salon des Indépendants was Rousseau's major and indeed, except for the years 1899 and 1900, almost his only exhibition forum. However, in 1905, 1906 and 1907 he also entered eight paintings in the groupings of the Salon d'Automne, which at that time was considered the most active and the most argumentative. The jury of the 1905 Salon placed Rousseau's main work prominently in Room II, adorned with a statue by Maillol, 'in the middle of a

1 Vallier 1970, pp. 90 ff.

159

large wall, in an infinitely elaborate décor of leaves and foliage plants!', as was stated in *Les Nouvelles* of 10 January 1910. In the immediate vicinity hung works by Matisse, Derain, Braque, Rouault, Vlaminck, Dufy, Marquet and others. The critic Louis Vauxcelles called this constellation a 'cage aux fauves' (cage of wild beasts) in view of the young, fearless colourists and possibly also in association with the idea of Rousseau's powerful *Hungry Lion*. As we know, this was not the only time that a deprecatory word has become a stylistic term. Examples range from Gothic via Baroque to Impressionism and Cubism. In the case of the so-called 'Fauves', too, the catchword became the official terminology for a wild, colour-intensive manner of painting which made its scandalous début at the Salon d'Automne of 1905.[2] It created a furore and Rousseau, who had a sceptical attitude towards the younger artists, particularly Matisse, profited from this. Even in an environment in which the avant-garde strove by every means to qualify as such, his entry was felt to be something out of the ordinary. On 4 November 1905 the spectacular work was even illustrated in the conservative magazine *L'Illustration* in a double column alongside Salon examples by Cézanne, Guérin, Vuillard, Matisse, Rouault and Derain (ill. p. 158). This was the first time a work by Rousseau had been reproduced, and in the accompanying text it was noted that the artist who had been ridiculed at the Salon des Indépendants had been accorded a place of honour at the Salon d'Automne.[3]

The press criticism was altogether more benevolent than in earlier days. The tables had turned when the chairman of the jury, Guillaumin, voted to admit Rousseau to the Salon d'Automne and the critics, out of respect for the jury's decision, treated entries in a more discriminating way than in the case of the juryless Salon des Indépendants.[4] For example, the archaic planar style was emphasised and comparisons were drawn that ranged from cave painting to the ancient East.[5] A few days before the private view, the newspaper *Le Paris* of 13 October 1905 commented: 'Room 2 contains a bizarre entry which falls somewhere in the middle between terracotta and fresco: a fleetingly painted lion which is devouring a rudimentary antelope, in a quasi-prehistoric landscape, which incidentally is the best part of M. Rousseau's composition. The author of this painting, which will be one of the highlights of the Salon d'Automne, is obviously as assured as he is independent. Heaven gave him a specific mentality, that of the primitive artists who drew profiles of aurochses on the rock walls of caves. We sincerely hope that he does not become the accepted thing, but let us do justice to his loyalty and his feel for pure colour, which is quite commendable . . .' On 17 October, the opening day, several newspapers carried reports on the 'Douanier'. In *Le Gaulois* Fourcaud, in fact a professor at the Ecole des Beaux-Arts, wrote: 'In the *Fight of the Lion and the Antelope* by M. Rousseau we see an old oriental theme that reached the Persians from the Chaldaeans and was not ignored even by our own Middle Ages. How everything difficult changes and becomes diversified! But one would wish a livelier and more personal accent for this great attempt at landscape . . .' And from Furetières in *Le Soleil* we learn: 'The small room in which we now find ourselves is not the least visited. It belongs to M. Rousseau, the excellent retired customs

2 Cf. Martin Schieder, '"Aucun rapport avec la peinture" – Die Fauves im Salon d'Automne von 1905 und die Kunstkritik', in Fleckner – Gaehtgens 1999, pp. 406 ff.

3 The magazine admittedly felt obliged to warn its readers: 'If some readers should be surprised by our choice, we ask you to read the text printed under each reproduction. These lines represent the judgements of the most famous art critics, behind whose authority we take cover. We would just comment as follows: if, in the past, criticism reserved all its incense for generally acknowledged celebrities and its sarcasm for beginners and for those still finding their way, then things today really have changed a lot.'

4 Müller 1993, pp. 36 ff.

5 The following reports are cited after Certigny 1984, pp. 314 f.

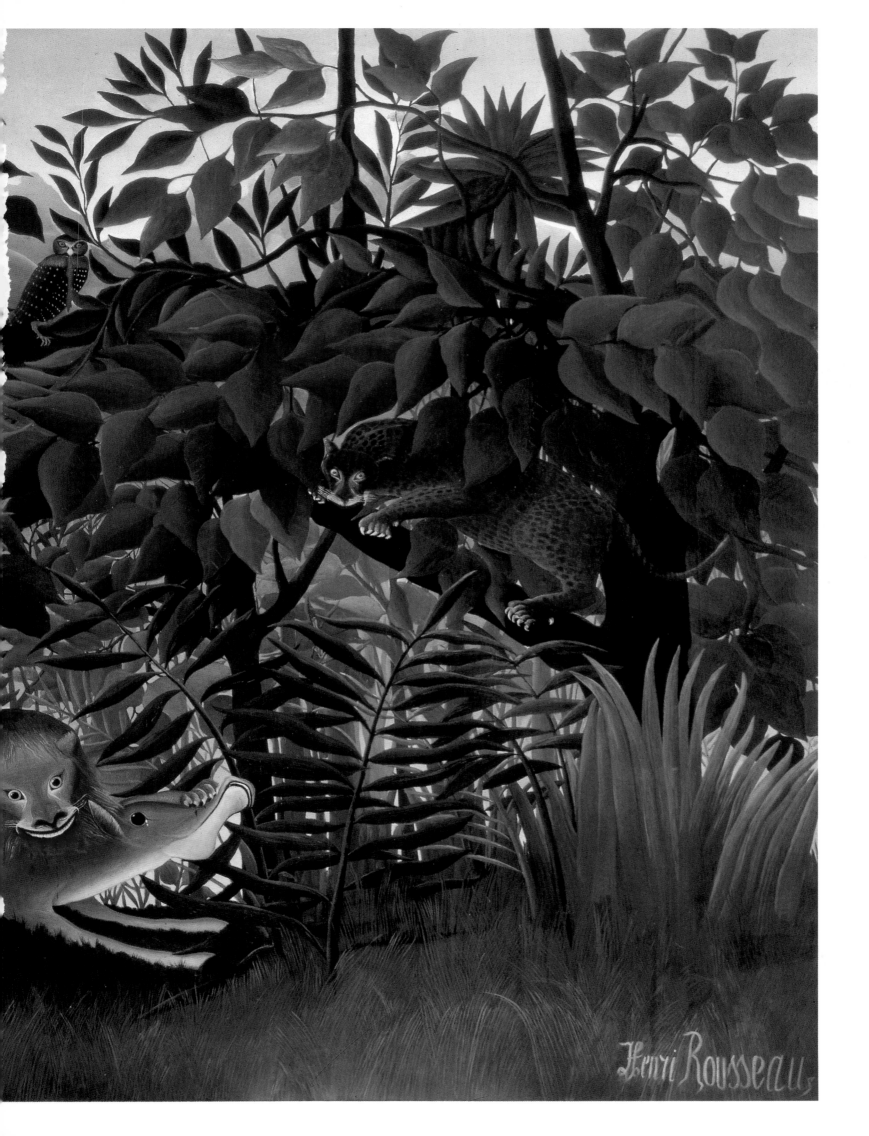

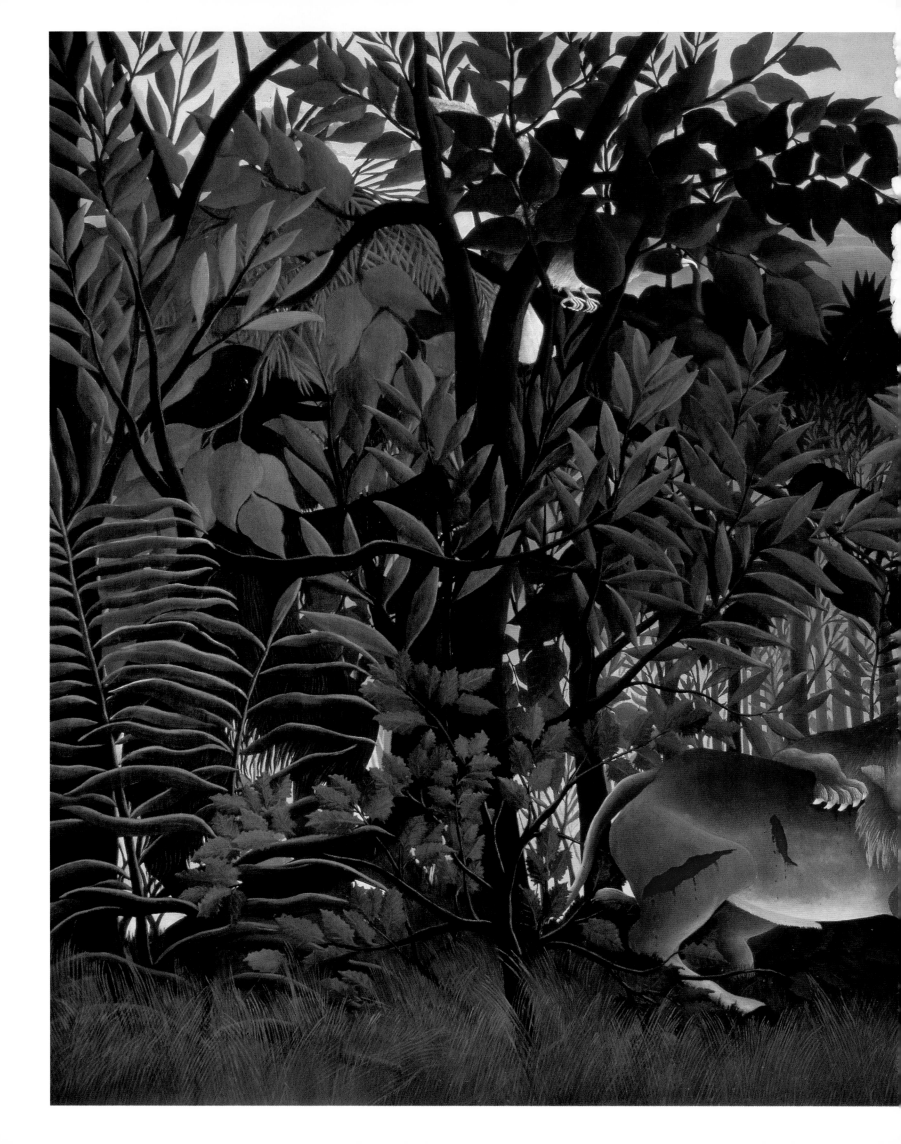

officer, who paints pictures in order to keep busy in his spare time. And here he is in his naivety in the process of becoming an interior decorator, with his manner which inclines towards the Japanese masters. Ah! This tiger, which holds an antelope in its claws, what success I predict for it! And if one were to say that this piece came from Persia or India, it would cost ridiculous sums!' On the other hand, Monet's friend Thiébaut-Sisson represented Rousseau in *Le Temps* as totally naive: ' . . . all the falsely naive . . . are delighted by a newcomer who calls himself Rousseau. They are not wrong, in fact, since this newcomer . . . is characterised by the happiest of all clumsinesses. Every year at the Salon des Indépendants this enthusiastic novice exhibited landscapes with figures whose naivety is only comparable to that of those peasant sculptors in the Black Forest who fabricate Noah's Arks for thirteen sous. No Ecole des Beaux-Arts, no Louvre have left their lasting impressions on Douanier Rousseau. Free to interpret nature and life as his eye sees them, the hand of the late artist translated his vision with a childlike execution that delights all these boys who seek their models among the primitives . . . It is an enlarged Persian miniature, transformed into an enormous décor, incidentally not without merit, that Rousseau is exhibiting at the Salon d'Automne. He has performed a masterly throw for his début in a genuine Salon. In the room where the painting has a place of honour the committee had . . . the delicate task of placing only pictures in subdued tones, coordinating with the main piece . . . the sole sculpture allocated to this room of brightness comes from an artist [Maillol] who, in order to find his formula, has gone back as far as those sources from which Rousseau too, instinctively, has drawn. As you see, the harmony is complete among the inhabitants of this shadowy corner.' The critic of the *Journal des Débats* wrote: 'Must one speak about M. Henri Rousseau, concerning whom the jury, it seems, have made themselves look a bit silly? He is a famous man at the Indépendants on account of his childlike imagination and his plumber's painting. You will see the large painting that is in this room. I admit that he has never produced anything more stirring than this lion devouring an antelope! . . . M. Henri Rousseau is, as has been confirmed to me, a dignified and very honest man. He is the only honest one among all these modern painters, one might add! . . . Laughter aside, his naivety has some attraction. It astonishes us, as though it has taken us back to prehistoric times . . . But I am worried: there is style – yes, truly there is – in the decorative arrangement of this picture! Who is deceived by this? . . .' The chronicler of the *Siècle*, Henry Eon, also reported on the 'Douanier': 'There is a great deal of talk about a painting by M. Henri Rousseau, the appearance of which, first of all, is prehistoric . . . a scene of slaughter. A lion throws a hind to the ground under the jealous gaze of a jaguar as well as of a screech owl and a pheasant perched high up on very carefully painted trees. His work is not unpleasing to look at because of the neutrality of the greens, and it blends effortlessly with the plants with which it has been surrounded.' In *Gil Blas*, finally, Louis Vauxcelles took the opportunity to state: 'M. Rousseau has the strict disposition of the Byzantine mosaicists, of the tapestry weavers of Bayeux. It is regrettable that his technique is not equal to his innocence. His fresco is

The Hungry Lion Throws itself on the Antelope (detail), 1905, no. 33

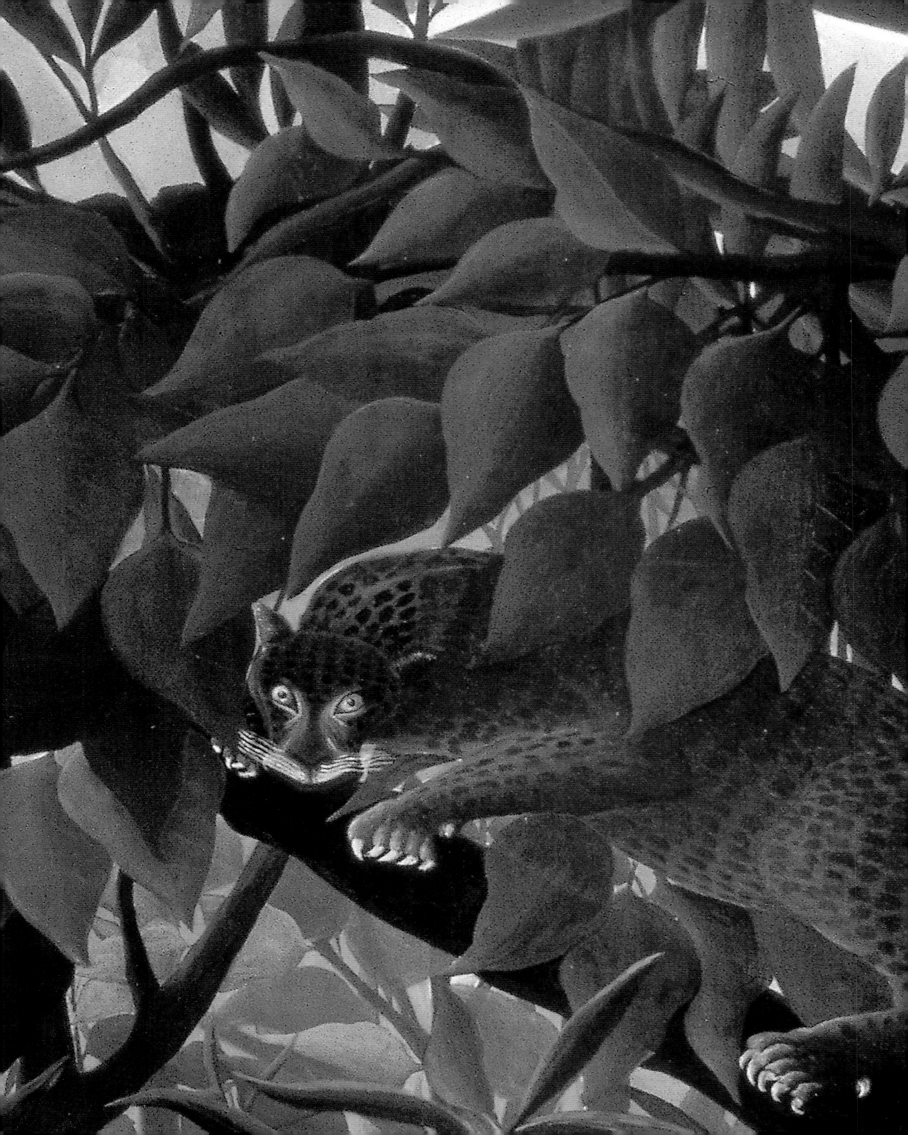

not indifferent. I concede that the antelope in the foreground is adorned with the mouth of a pike, but the red sun and the bird that appears between the leaves testify to a rare decorative power of imagination.' Only the critic of *La Liberté* mentioned 'the presence of a hidden ape in the trees', whose dark entrance was otherwise overlooked.

It can be assumed that not only the participants at the Salon d'Automne but also other representatives of the art scene such as Picasso and his friends became aware of the 'Douanier' at that time. The art dealer Ambroise Vollard, who rediscovered Cézanne for Paris in 1895 and supported the young Picasso, bought the *Hungry Lion* for 200 francs on 31 March 1906. The artist made out the following receipt: 'Received from Monsieur Vollard the sum of two hundred francs for a painting with the title: *The Hungry Lion*, which I have sold to him and which was exhibited at the Salon d'Automne. Paris 31 March 1906 Rousseau 2bis rue Peyrel [*sic*].'[6] It was the first Rousseau picture to enter the art market and, eventually withdrawing again from the art market, today holds an appropriate place of honour at the Fondation Beyeler.

6 Viatte 1962, p. 331; regarding Vollard's memories of Rousseau cf. Ambroise Vollard, *Erinnerungen eines Kunsthändlers*, Zurich 1980, pp. 229 ff.

Certigny put forward the daring theory that the hit of the 1905 Salon d'Automne had already been exhibited at the Salon des Indépendants in 1898 under the title *La Lutte pour la vie* (The Fight for Life). He bases this on newspaper reports of 1898 in which there is talk of a 'lion which devours a gazelle', of a 'sort of jaguar, which lurks on a laurel branch', or of 'tropical flora in which a lion overcomes a water hog, while an owl is present at the slaughter without being involved'.[7] Even if there are similarities in the descriptions, it is unlikely that one and the same picture, which in Certigny's opinion was retouched between 1898 and 1905, is meant. Nor is there any indication by the reporters, some of whom had commented on the previous exhibition, that Rousseau's masterpiece of 1905 had already been seen seven years earlier at the Salon des Indépendants.

7 Certigny 1984, pp. 308, 310 f.

Provenance: Ambroise Vollard, Paris (1906–1933); Franz Meyer senior, Zurich; Erbengemeinschaft Franz Meyer, Zurich; on permanent loan in the Kunstmuseum, Basel (1969–1997).

Bibliography: Uhde 1911, p. 22; Kieser 1913, p. 220; Uhde 1914, p. 22; Uhde 1921, pp. 33 f.; Soupault 1927, p. 40; Rich 1942, pp. 38 f., ill. (detail), p. 60; Grey 1943, p. 51, ill. 126; Courthion 1944, p. 14, ill. XIII; Uhde 1947, p. 38; Uhde 1948, pp. 15 f., ill. 35; Gauthier 1949, pp. 17, 22; Lo Duca 1951, p. 9, ill.; André Malraux, *Les Voix du silence*, Paris 1951, p. 507, ill.; Maurice Raynal, *Histoire de la peinture moderne de Picasso au Surréalisme. Du Cubisme à Paul Klee*, Geneva 1951, p. 27, ill.; Wilenski 1953, p. 4; Perruchot 1957, pp. 39, 89; Rousseau 1958, pp. 26 f.; Bouret 1961, pp. 37, 111, ill. 26; Certigny 1961, pp. 248, 250 ff.; Vallier 1961, p. 25, ill. 11, pp. 72, 74 f., ill., p. 142; Viatte 1962, p. 331; Shattuck 1963, pp. 68, 94 f., 108, 346; Vallier 1969, p. 46, ill. XXX, pp. 85, 88, 95, 103, no. 172, ill., pp. 105, 113; Vallier 1970, pp. 95 f., ill. 13; Bihalji-Merin 1971, pp. 44, 71, 146, ill. 47; Descargues 1972, pp. 19, 112, ill., p. 119, ill., pp. 127 f., ill.; Koella 1974, p. 124; Bihalji-Merin 1976, p. 50, ill. 2, pp. 82 f., 117; Keay 1976, pp. 16, 142 f., ill. 42; Warnod 1976, p. 77; Alley 1978, p. 47, ill. 38, p. 60; Stabenow 1980, pp. 44 f., 93, 104; Le Pichon 1981, pp. 152 f., ill., p. 266; Vallier 1981, pp. 85, 91, ill.; Certigny 1984, pp. IV, 283, 308 ff., no. 153, ill., pp. 322, 348, 422, 468, 486, 550, 560, 657, 664, 682 (with further bibliography); Rubin 1984, p. 295; Rousseau 1986, pp. 26 f., ill.; Werner 1987, no. 22, ill.; Certigny 1989, pp. 1 f., ill.; Certigny 1992, pp. 21, 24; Müller 1993, pp. 36 ff., 83, 117, 174; Stabenow 1994, pp. 78 f., 90 f., ill., p. 95; *Fondation Beyeler*, Munich – New York 1997, pp. 72 f., ill. 12, p. 333, no. 157; Schmalenbach 1998, ill. cover, pp. 28 ff., ill., p. 59.

Exhibitions: Paris 1905, no. 1365; Paris 1912, no. 25; Basel 1933, no. 32, ill.; Paris 1937, no. 6; Zurich 1937, no. 6; Munich – Zurich 1974–1975, no. 68, ill.; Paris 1984–85, pp. 18, 49, 52 f., 93, 174 ff., no. 31, ill., pp. 181, 218, 254 f.; New York 1985, pp. 17, 45, 47 f., 82, 93 f., 166 ff., no. 31, ill., pp. 173, 210, 250 f.; *Colleccion Beyeler*, Centro de Arte Reina Sofia, Madrid 24 May–24 July 1989, p. 39, ill.; *Wege der Moderne. Die Sammlung Beyeler*, Nationalgalerie, Berlin 30 April–1 August 1993, no. 119, ill.

Landscape on the Banks of the Oise, Area of Chaponval

Paysage pris sur les bords de l'Oise, territoire de Chaponval

On 21 August 1908 Rousseau wrote to the young American painter Max Weber, with whom he had become friendly: 'I am hoping for a pleasant visit from you and that we will agree about the painting you like. I also have another one than the one you know, it is its counterpart, both these paintings were made in the same place. It is the area of Champoval [*sic*], on the banks of the Oise. As I am in a bit of a fix at the moment, I would let you have the two for 35 francs, framed if you wish. You see, that is not expensive; they are catalogued, were at the Salon d'Automne [1905]. We will always agree about pictures.'[1] Weber was obviously unable to take up the offer to buy both pieces for the special price to a friend of 35 francs. He owned only one of the landscapes mentioned, to which he gave the title *The House, Suburb of Paris*. Equally non-committal is the caption *A Villa in the Environs of Paris*, which was added to a reproduction of the painting in the magazine *Comoedia* of 19 March 1910.

From the letter it would appear that the pair of pictures were painted on the bank of the Oise in the 'Champoval' area and had been exhibited at the Salon d'Automne. In the catalogue of the 1905 Salon d'Automne – in addition to the large jungle scene (no. 33) – two landscapes are listed with the identical title: *Landscape on the Banks of the Oise (Area of Champoval)*. The place cited by Rousseau is actually called Chaponval and lies between Auvers-sur-Oise and Pontoise in a region that was earlier frequented by the Impressionists. Here, beside the river, Rousseau sketched the view of the stately country house and the bridge over the Oise on a board.[2] Back in his studio he then meticulously copied the locality on to a larger canvas, down to the architectural details of roof construction, shutters and chimneys. The simple pictorial structure confronts the lines of the road and river, as well as the architecture reduced to cubes, with the organic green of nature. Light and shadow complexes are effectively harmonised, and additional tension is provided by the bridge – complete with two pedestrians – which, like a ski-jump, takes off from the lower edge of the picture and stretches out vertically into the distance. The straight, horizontal line of the river past the villa is carved out of a landscape the special intensity of which derives not least from the luminosity of the complementary contrasts of green and red, white and black, blue and yellowish beige.

Rousseau's display of two landscape subjects from the environs of Paris alongside his massive jungle picture at the Salon d'Automne shows that he never lost sight of the relationship with reality in work in front of and on the subject. The spectacular evocation of nature's elemental force was totally in accord with an entirely unspectacular local landscape view.

1905
Oil on canvas
33.02 × 46.36 cm
Signed bottom right:
H. Rousseau
Carnegie Museum of Art,
Pittsburgh
Acquired through the generosity
of the Sarah Mellon Scaife Family,
1969 (Inv. No. 69.10)

1 Certigny 1984, p. 446.

2 Vallier 1969, no. 137B; Certigny 1984, no. 219.

Max Weber, owner of the painting for many years, had arrived in Paris from New York in December 1905 in order to study painting at the Académie Julian.[3] Having made the acquaintance of representatives of the Parisian avant-garde through the brother and sister Gertrude and Leo Stein (also from the USA), the 26-year-old American was introduced to the 63-year-old Rousseau in the drawing room of Comtesse Berthe de Rose, mother of Robert Delaunay, in October 1907. And in the autumn of 1908 it was Weber who took Picasso, whom he had met at the Steins, along to visit Rousseau at the latter's flat in the Rue Perrel. Just before Weber left to return to the USA on 21 December 1908, Rousseau held a soirée in his studio 'in honour of the departure of Monsieur Weber' on 19 December, to which numerous friends, including Picasso, Apollinaire and Marie Laurencin, were invited.[4] Back in New York, Weber acknowledged Rousseau's work by making it known in America. Thus, in the year of the artist's death, he organised an initial commemorative exhibition with paintings and drawings that he had brought back from Paris in Alfred Stieglitz's 291 Gallery – the major bridgehead for European modern art on the East Coast – in New York from 18 November to 8 December 1910. In February 1913 Weber loaned the *Oise Landscape*, among other pieces, for the legendary Armory Show held in the barracks of the 69th Infantry Regiment, which brought the ideas of the Parisian avant-garde to the attention of the New York public.

3 Gail Levin, 'Amerikanische Kunst', in *Primitivismus in der Kunst des zwanzigsten Jahrhunderts*, Munich 1984, pp. 464 ff.; Alfred Werner, *Max Weber*, New York 1975, pp. 36 f.

4 Apollinaire 1914, pp. 15 f. (pp. 632 f.).

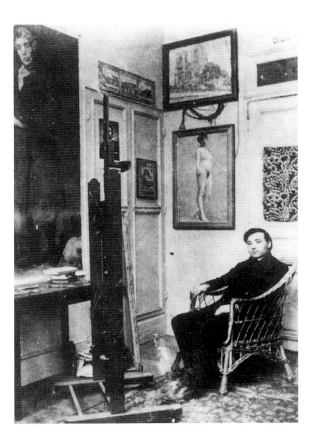

Max Weber in his studio at rue Belloni 7, Paris, c. 1907

Provenance: Max Weber, Great Neck, NY (from 1908); Mrs Max Weber, Great Neck, NY.

Bibliography: Alexandre 1910, ill.; Uhde 1911, ill. 3; Uhde 1914, ill.; Kolle 1922, ill. 16; Eichmann 1938, p. 307; J. O'Connor, 'Henri Rousseau', *Carnegie Magazine*, December 1942, p. 221; Rich 1942, pp. 39, 44, ill.; Bouret 1961, pp. 37, 216, ill. 153; Certigny 1961, p. 251; Vallier 1961, ill. 82; Vallier 1969, p. 100, no. 137A, ill.; Leonards 1970, pp. 66 f., ill.; Descargues 1972, p. 19; Alley 1978, pp. 40 f., ill. 33; Stabenow 1980, pp. 158, 243; Le Pichon 1981, p. 117, ill., p. 266; Vallier 1981, p. 38, ill.; Certigny 1984, pp. 444, 446 f., no. 220, ill., p. 470.

Exhibitions: Paris 1905, no. 1367; New York 1910; New York 1913; Chicago – New York 1942; New York 1951, no. 11; Paris 1984–85, pp. 164 f., no. 26, ill., p. 270; New York 1985, pp. 156 f., no. 26, ill., p. 264.

LANDSCAPE ON THE BANKS OF THE OISE. AREA OF CHAPONVAL

MAX BECKMANN WENDELSWEG

Max Beckmann
Wendelsweg

In his work of the early 1920s Beckmann was clearly coming closer to Rousseau (cf. pp. 174 f.). In the course of a new approach to landscape the Rousseau admirer, who shared this particular liking with his adversary Picasso (cf. nos 16, 29, 30, 41), assumed the legacy of that 'great realism' that Kandinsky had once ascribed to Rousseau (cf. p. 227). Its opposite pole, Kandinsky's 'great abstraction', was however succinctly qualified by Beckmann in his first letter to a female painter in 1948 with the remark that 'every form of important art, from Bellini to Henri Rousseau, was ultimately abstract'.[1]

Beckmann's close affinity with Rousseau is also reflected in the picture *Wendelsweg*, one of the last of his Frankfurt subjects.[2] This road was close to Beckmann's flat at that time in Frankfurt's Sachsenhausen district.[3] The steep section of roadway in a narrow, vertical format clearly differs from the actual topography as preserved in a photograph by Quappi Beckmann. On the other hand the composition completed in October 1928 is similar, even as regards the human 'extras', to the road layout that Rousseau used in the *Landscape on the Banks of the Oise* . . . (no. 34). An illustration of the Rousseau painting was available to Beckmann at the latest in April 1928, when the art dealer Günther Franke sent him a copy of Uhde's Rousseau monograph of 1914. Moreover Beckmann had had the opportunity of getting to know the Frenchman's stylistic characteristics since 1926 through the painting *The Avenue in the Park of Saint-Cloud* (no. 46), which hung in the Städtische Galerie in Frankfurt.

1928
Oil on canvas
70.5 × 44.5 cm
Signed and dated bottom right:
Beckmann / F.28
Kunsthalle zu Kiel
(Inv. No. 685)

1 Beckmann 1984, p. 181.

2 Erhard and Barbara Göpel, *Max Beckmann. Katalog der Gemälde*, Bern 1976, no. 294.

3 Nina Peter, 'Déjà vu. Die Bildquellen der Landschaften von Max Beckmann', in the exhibition catalogue *Max Beckmann. Landschaft als Fremde*, Hamburger Kunsthalle, Hamburg 1998, pp. 47 f.

View of the Banks of the Oise
Vue des bords de l'Oise

According to Rousseau, the preceding view of the Oise (no. 34) had a counterpart. The same is true of this river landscape, a somewhat larger second version of which exists with two sailing boats traversing the two inlets.[1] It was shown at the Salon des Indépendants in 1906 and received the title *Vue des bords de l'Oise*.

In the present painting, slightly varying in the detail, Rousseau was at pains to reproduce the characteristics of the riverbank area densely grown with deciduous trees in emulation of his Impressionist colleagues who decades earlier had sought out the Oise as *plein-air* painters. He picked up the curve of the bank in the tree heights and cloud formations and replaced the figural or architectural 'props' that are otherwise customary in his landscapes by seven haystacks in a meadow. Their massed arrangement, admittedly, is rather more reminiscent of an African kraal than of the hayricks that Monet made into a famous series of pictures in 1891.

Wilhelm Uhde published the river landscape in 1920 as *Waldlandschaft* (Forest Landscape), and Bouret in 1961 even gave it the title *Wege im Wald* (Paths in the Wood).

1905–6
Oil on canvas
38 × 46.5 cm
Signed bottom right: H. Rousseau
Private collection, Switzerland

1 Vallier 1969, no. 173; Certigny 1984, no. 231. Regarding repetitions of subjects and variations, cf. ibid., nos 3–7, 51, 52, 69, 77, 88, 89, 145, 146, 186, 234, 240, 244, 258, 264, 274, 276, 277, 279, 280, 287–90, 311–14.

Provenance: Galerie Alfred Flechtheim, Berlin; Paul and Lotte von Mendelssohn-Bartholdy, Berlin; Lotte Gräfin Kesselstadt-Mendelssohn, Vaduz; Emil G. Bührle, Zurich (from 1947).

Bibliography: W. Uhde, 'Henri Rousseau', in *Deutsche Kunst und Dekoration*, 47, 1920, pp. 16 ff.; Kolle 1922, ill. 25; Lo Duca 1951, p. 7, ill.; *Sammlung Emil G. Bührle. Festschrift zu Ehren von Emil G. Bührle*, Kunsthaus Zürich, Zurich 1958, p. 145, no. 256; Bouret 1961, p. 215, ill. 151; Vallier 1969, p. 117, no. L 36, ill.; Le Pichon 1981, p. 129, ill.; Certigny 1984, pp. 472 f., no. 232, ill.

Exhibitions: *Moderne primitive Maler,* Kunsthalle Bern, 1949, no. 4; *Henri Rousseau*, XXV Biennale, Venice 1950, no. 11.

VIEW OF THE BANKS OF THE OISE

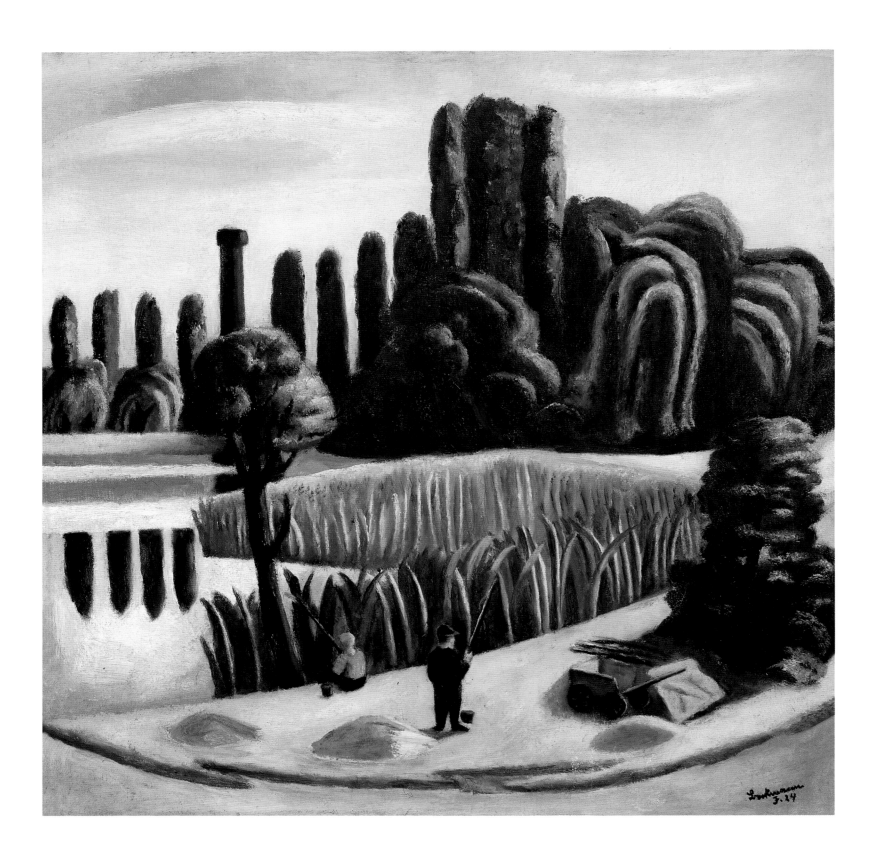

MAX BECKMANN LAKE LANDSCAPE WITH POPLARS

Max Beckmann
Lake Landscape with Poplars

Lake Landscape with Poplars is one of the most striking examples of Beckmann's closeness to Rousseau (cf. pp. 122 f., 170 f.).[1] The idyllic landscape in which peace and calm predominate had left behind the thematic claims and expressiveness of previous years. In the spirit of Rousseau, objectivity and stillness – turning their back on Expressionism, Cubism and abstraction – have returned to the picture. Just two anglers monopolise the lake surrounded by reeds in Frankfurt's Ostpark. The fishermen, the serial motif of the rows of poplars reflected in the water and the chimney unobtrusively included among them could come from Rousseau. The shortening of form too, as well as the generous use of black, suggests the comparison with Rousseau.[2] In July 1938, in his famous speech in London on 'My theory of painting', in which he set out his artistic motivations, Beckmann paid homage to Rousseau in the form of a vision: 'Again and again painting appeared before my eyes as the sole possible way to realise the power of imagination. I thought of my great old friend Henri Rousseau, this Homer in the porter's lodge, whose dreams of the jungle had sometimes brought me closer to the gods . . . and I greeted him respectfully in my dream.'[3]

1924
Oil on canvas
60×60.5 cm
Signed and dated at bottom right:
Beckmann / F. 24
Kunsthalle Bielefeld
(Inv. No. B 294)

1 Erhard and Barbara Göpel, *Max Beckmann. Katalog der Gemälde*, Bern 1976, no. 232; Nina Peter, 'Déjà vu. Die Bildquellen der Landschaften von Max Beckmann', in the exhibition catalogue *Max Beckmann. Landschaft als Fremde*, Hamburger Kunsthalle, Hamburg 1998, pp. 46 f.

2 Hans Belting, *Max Beckmann. Die Tradition als Problem in der Kunst der Moderne*, Berlin 1984, pp. 20, 28.

3 Beckmann 1984, p. 141.

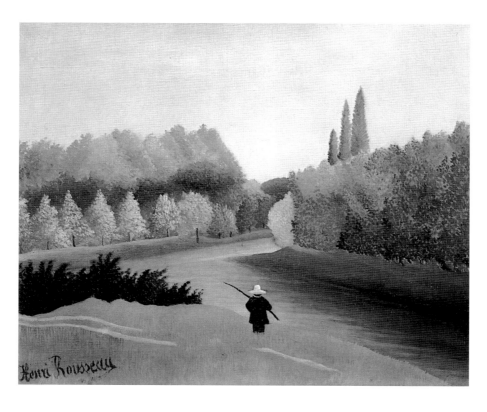

Henri Rousseau, *The Angler*, 1909
Private collection

Portrait d'homme

Since Rousseau's portraits portray a particular social stratum, his subjects all seem to belong to the same family. In formally arranged group or individual portraits the painter satisfied the pictorial requirements of his neighbours, firmly rooted in their class, in the working-class and artisanal district of Plaisance. He would make a portrait of them and their relatives for a small fee, or he might settle outstanding accounts, according to necessity, by offering a portrait, a small landscape or a floral painting.

Rousseau's portraits must have seemed clumsy to the sort of people who frequented the Salon exhibitions since they in no way corresponded to what one was accustomed to see with this genre in terms of elegance, recognition effects, expression of emotion and sentiment. And people searched in vain in Rousseau's work for the angles aiming at spontaneity, the details and fragmentation that Degas or Toulouse-Lautrec had introduced for their clientele. On the other hand, the frontal poses based on the products of contemporary photography, like the masklike faces which resemble one another because of the large eyes outlined with black, the thick eyebrows and the broad noses, met the representational needs of Rousseau's own circle of customers. Despite or indeed because of their stereotypical nature, they convey an impression of enormous presence, especially since the painter attached maximum importance to building up the faces – as vehicles of meaning – almost three-dimensionally by means of thick application of paint. According to hearsay he even compared the tubes of paint with the flesh tones of his sitter in order to achieve the greatest possible authenticity of tone.[1]

The power of his figures is also seen in the portraits of a married couple (see also no. 37), whose pride in being able to have their uprightness and respectability depicted by the painter is obvious. In the classical bust format, the dark, heavy bodies are set against a cloudy sky whose airily abstract expanse ends in the concrete narrowness of the austerely sculpted features. The red-cheeked dignitaries of the suburban bourgeoisie are represented in their festive finery. The black of Spanish royalty had definitively become the Sunday black of the Parisian petty bourgeois that Heinrich Heine had already subjected to mockery in his Salon report of 1831: 'Our modern black jacket really has something so fundamentally prosaic about it that it could only be used in a painting in the sense of parody.'[2] Adorned with side whiskers and well-preserved, the couple have been stylised as the epitome of those intrinsically middle-class virtues which Alfred Jarry too denounced sarcastically: '. . . these moralisers in their correct black clothing, hung with white side whiskers, their heads as bald as their conscience . . .'[3] Not least Theodor Däubler would come to speak of Rousseau's customers in a similarly

c. 1905
Oil on canvas
41 × 36 cm
Signed bottom right:
Henri Rousseau
Private collection

1 Uhde 1911, p. 48; Uhde 1914, p. 47.

2 Jean René Derré – Christiane Giesen, *Heinrich Heine, Gesamtausgabe*, 12/1, Hamburg 1980, p. 30.

3 Shattuck 1963, p. 234.

disrespectful way: 'What sort of people live in the suburbs? Worthy citizens with their family dog. Witchlike women with their pet cat. Brides who for the first time are ugly in their white bridal rig . . . Petty bourgeois to be photographed. All done up in old-fashioned elegance . . . Proper, decent. The Sunday tie small and correct, laid on the starched shirt. The moustache twirled, not waxed, into shape . . . The hair combed in a rather romantic manner; but tidy. The men are often a bit like shop dummies, the women slightly malicious. Doggedly old-maidish: if it is possible to portray that . . .'[4]

The provenance of both the portraits can be documented with some certainty through the following correspondence. On 18 December 1911, the day before the opening of the Blaue Reiter exhibition in Munich, Kandinsky wrote to Robert Delaunay in Paris: 'Many thanks for sending this Rousseau [cf. no. 26]. I have just sold one of my pictures [*Impression 2, Moscow*] to a Berlin patron who is here, and who would also like to acquire a Rousseau. Do you perhaps know of a very attractive Rousseau that is for sale? It is a good collection in Berlin, and one would have to take the trouble to get hold of a really very lovely R. It would be the first collection in Germany with an R.! Could you help me with this? I would be infinitely grateful to you. I am waiting with great impatience for the Rousseau photos you told me were coming: already the Blaue Reiter is almost all at the printer's.'[5]

He was referring to Bernhard Koehler, the Berlin industrialist, collector and generous patron of the Blaue Reiter exhibition and almanac (ill. p. 181). Shortly before the turn of the century Koehler had started to build up a collection, in particular of contemporary art from Munich. On the advice of August Macke, who was married to one of Koehler's nieces, the 60-year-old Koehler gained access to the French Impressionists and Neo-impressionists, whose works he then acquired together with works by Macke and Marc as well as their friends in the Blaue Reiter circle. Thus before the First World War he developed an important collection covering all the essential movements in modern art from Impressionism to Futurism.[6]

To return to the above-mentioned correspondence,[7] in a letter to Franz Marc on 22 December 1911 Kandinsky mentioned two portraits in the possession of Delaunay which, with a probability that verges on certainty, must be the present *Portrait of a Man* and its female counterpart (no. 37): 'Delaunay wants to sell 2 portraits (by) Rousseau, definitely together – 1500 fr. He praises these pictures highly and only wishes to part with them in order to bring poor R. out of the "fosse commune" [paupers' grave] into a grave of his own. Otherwise Rousseaus are only still available from dealers (Uhde!) and they demand a lot. Please write to Köhler about this. After all it isn't much money, they are two good pictures, and one will be doing a good deed.' Rousseau had died in Paris on 2 September 1910 and been buried in a pauper's grave. By selling the two portraits Delaunay hoped to be able to finance a grave for him with a thirty-year concession in the cemetery of Bagneux. In this connection Marc replied on 23 December: 'I wish to write about Rousseau, but only that we first ensure that he gets something. 2 portraits at 1500 fr. together; but I know that Köhler is unhappy about buying a pig in a poke . . . Also he cannot comprehend the complex of feelings that we associate with the name of Henri Rousseau. Could not Delaunay send

4 Däubler 1916, p. 124.

5 Meißner 1985, pp. 484 f.

6 Schmidt 1988, pp. 76 ff. As opposed to the 150 works by 28 artists listed there for the Koehler Collection, current research runs to over 360 works by more than 80 artists.

7 The following extracts from letters are cited after Meißner 1985, pp. 486 ff.

PORTRAIT OF A MAN

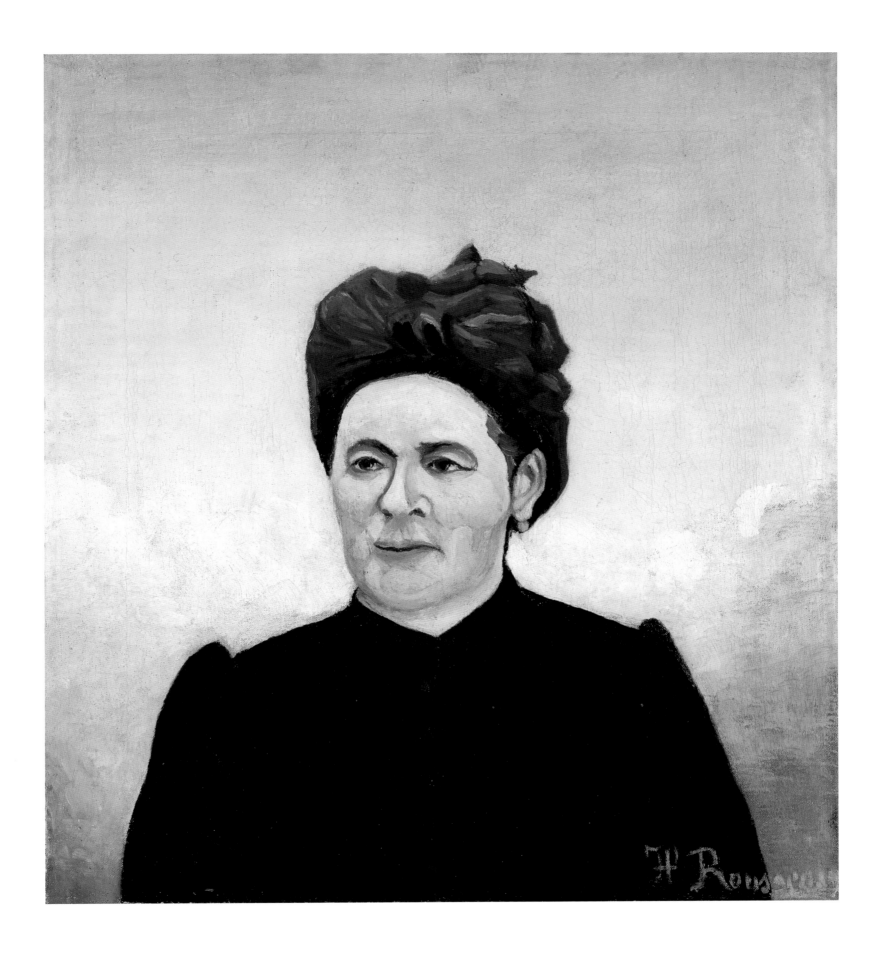

PORTRAIT OF A WOMAN

us some photographs, small amateur photos, so that Köhler can get some idea in advance?' On Christmas Day Kandinsky asked Delaunay for both the photos: 'Many thanks for the Rousseau photos [for the *Blaue Reiter* almanac]! Would you be so kind as to also send me the photos of the 2 portraits that are for sale? These are presumably not the two you already sent me: the self-portrait of Rousseau and a lady [nos 29, 30]?' Three days later Kandinsky again contacted Delaunay: 'I have just received a letter from K. [Koehler]. He entreats you to send him the two Rousseaus, and at once. He will assume the costs of transportation. He is almost certain he will buy. He has a high opinion of the judgement of Mr Marc, who is travelling to Berlin today. I am certain he will buy. Otherwise he will send the pictures back to you and pay the return transport. In addition I could show your pictures (in the case of non-purchase) at Mr Thannhauser's (Moderne Galerie) in Munich. I would be very grateful if you could make this despatch to K. as soon as possible. R. will be exhibited in a beautiful collection. The address is: – Mr Bernhard Koehler – Berlin S 42 – Brandenburgerstraße 34 – Very urgent, perhaps. In the case of purchase Mr Koehler wishes to loan me these pictures for the Blaue Reiter exhibition, which gives me great pleasure.'

The purchase of the two portraits from Robert Delaunay's collection was finalised at the start of the new year. Asked for his assessment, Kandinsky reported to Delaunay on 10 January 1912: 'Mr Koehler sent me the 2 portraits by Rousseau in order to hear my opinion. They are very beautiful.' And two days later: 'Mr Koehler has bought the 2 Rousseaus from you – he is transferring the money in the next few days (he may perhaps already have done this). Thank you very much for these Rousseaus. They are in a lovely collection, which may help you to get over the sadness at having sold them, even for such a humane and beautiful purpose.' On 21 January 1912, finally, Delaunay received Koehler's confirmation of payment: 'I am sending you 1500 frs. drawn on Crédit Lyonnais for the two portrait-pictures by Rousseau and would ask you to acknowledge your receipt of this sum.'

The pictures had their exhibition première as loans from Bernhard Koehler at Herwarth Walden's gallery Der Sturm when the slightly altered Blaue Reiter exhibition stopped off in Berlin from 12 March to 10 April 1912. Apart from them, the other Rousseau work shown in Walden's gallery at Tiergartenstraße 34a was Kandinsky's *Poultry Yard* (no. 26), here entitled *Straße* (Street).

For a long time the portraits belonged to the art dealer Hugo Perls, who had a gallery in Berlin in the 1920s and presumably took them over during the financial crisis suffered by Bernhard Koehler junior. And when, under the Nazis, Perls was forced to emigrate to the USA and settled in New York, the portraits remained in his possession.

Provenance: Robert Delaunay, Paris; Bernhard Koehler, Berlin (1912); Hugo Perls, Berlin, New York.

Bibliography: Bouret 1961, p. 205, ill. 122; Vallier 1961, p. 144, ill. 100; Vallier 1969, pp. 101, 103, no. 175a, ill.; Bihalji-Merin 1976, p. 33; Keay 1976, p. 132, ill. 27; Meißner 1985, pp. 486 f.; Stabenow 1985, p. 314; Schmidt 1988, pp. 80, 86 f., 91; Susanne Grimm, *Authentische Naive*, Stuttgart 1991, p. 74, ill.

Exhibitions: Berlin 1912, no. 106; Berlin 1913, no. 14; Baden-Baden 1961, no. 164, ill.; Paris 1961, no. 30; New York 1963, no. 25, ill.

Portrait of a Woman
Portrait de femme

See no. 36.

c. 1905
Oil on canvas
41 × 36 cm
Signed bottom right: H. Rousseau
Private collection

Provenance: Robert Delaunay, Paris; Bernhard Koehler, Berlin (1912); Hugo Perls, Berlin, New York.

Bibliography: Bouret 1961, p. 205, ill. 123; Vallier 1961, p. 144, ill. 101; Vallier 1969, pp. 101, 103, no. 175 b, ill.; Bihalji-Merin 1976, p. 33; Keay 1976, p. 132, ill. 28; Meißner 1985, pp. 486 f.; Stabenow 1985, p. 314; Schmidt 1988, pp. 80, 86 f., 91; Susanne Grimm, *Authentische Naive*, Stuttgart 1991, p. 75, ill.

Exhibitions: Berlin 1912, no. 107; Berlin 1913, no. 15; Baden-Baden 1961, no. 165, ill.; Paris 1961, no. 31; New York 1963, no. 26, ill.

Gabriele Münter, *On the balcony at Ainmillerstraße 36*, Munich 1911.
From left: Maria and Franz Marc, Bernhard Koehler, Heinrich Campendonk, Thomas von Hartmann, with Kandinsky seated
Gabriele Münter- und Johannes-Eichner-Stiftung, Munich

Portrait of a Woman
Portrait de femme

Like the previous portraits, this depiction of an unknown woman represents the female half of a double portrait set against a dark red curtain that is gathered towards the middle.[1] Even if this pair did not have the luck to be kept together, there is no doubt that they belong together for reasons of colour and style. The *Portrait of a Woman* exhibits the classic colour combination of black, white and red. The red of the background, in particular, emphasises the 'status symbol' character of the portrait. The matron decked out with gold earrings, brooch and necklace is distinguished by her large-planed face, which emerges heavily from the white blouse trimmed with black. Her eyes, set deep in their sockets, stare past the viewer as though in expectation of a camera click. A slight lift at the corners of the mouth softens the hard-edged features somewhat. The undifferentiated black of the close-fitting dress, corresponding to that of her hair, and the propped-up arm give the composition dignity and balance.

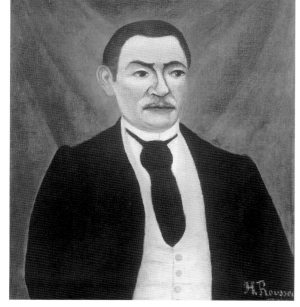

Henri Rousseau, *Portrait of a Man*, c. 1906
Private collection

The art dealer Paul Rosenberg, who organised a Rousseau retrospective in his Paris gallery as early as July 1923, worked closely with Picasso and in the late 1930s sold him Rousseau's *Self-Portrait of the Artist* together with the portrait of his second wife (nos 29, 30). After the war, by then based in New York, he once again turned to Picasso, whose penchant for Rousseau was known to him, and offered him the two portraits with the red curtain as backdrop. Evidently however Picasso's need for works by Rousseau had been satisfied (cf. nos 16, 41), as no sale took place.[2]

c. 1906
Oil on canvas
45.5 × 35.5 cm
Signed bottom right: H. Rousseau
Stiftung Insel Hombroich

1 Cf. the male counterpart – Vallier 1969, no. 190a.

2 Exhibition catalogue Munich 1998, pp. 219 f.

Provenance: Galerie Paul Rosenberg and Co., New York; private collection, New York; Gallery Sun Motoyama, Tokyo.

Bibliography: Bouret 1961, p. 93, ill. 17; Vallier 1961, ill. 103; Vallier 1969, p. 51, ill. XXXV, pp. 103, 105, no. 190 b, ill.; Keay 1976, p. 73, ill. XIII; Le Pichon 1981, p. 43, ill.; Certigny 1992, p. 25; exhibition catalogue Munich 1998, p. 220.

Exhibitions: Paris 1961, no. 24, ill.

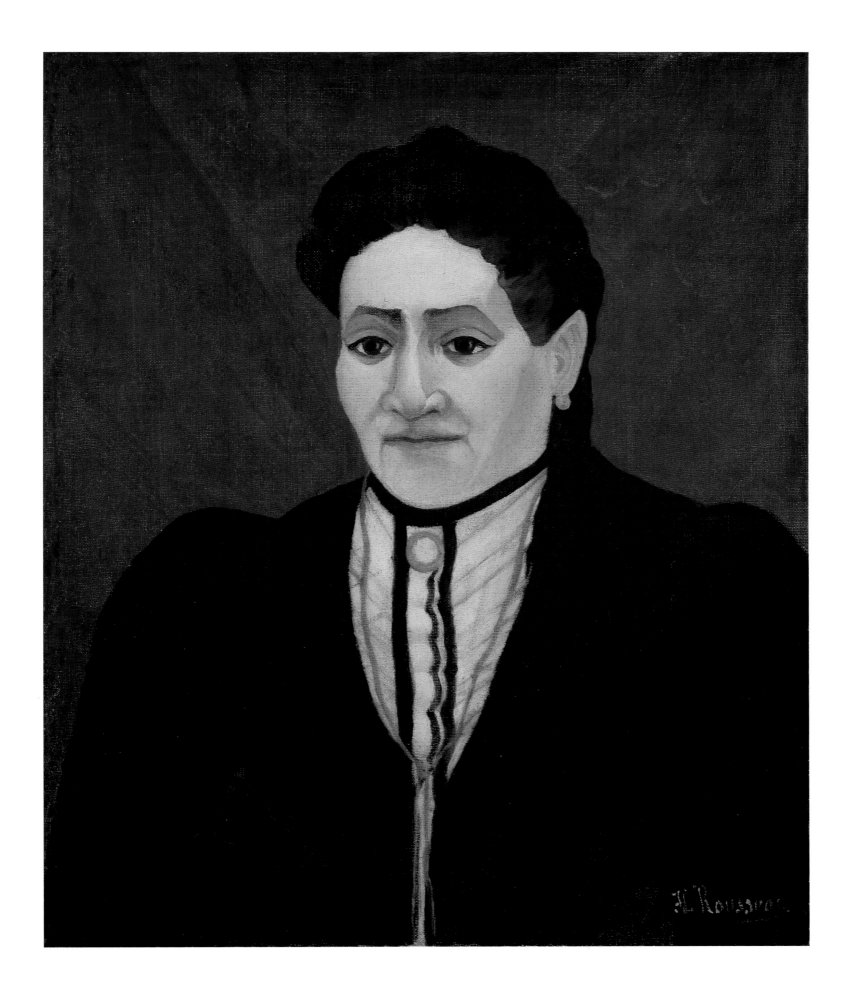

PORTRAIT OF A WOMAN

Portrait of Mr X (Pierre Loti)
Portrait de Monsieur X (Pierre Loti)

Based on the pattern of the half-figure portrait customary since the early Renaissance, the figure is set like a playing-card character in front of the landscape. The person, who appears to be of a Mediterranean type, wears North African dress with a red fez and a black mantle similar to a burnous. The almost magical intensity of his personality is concentrated in the oversized head and the face set in pre-Cubist faceted forms. Distinguishing attributes, apart from the pale complexion and neat, dark hair, are the statuesque cat sitting on a red pedestal and the burning cigarette held between the fingers of the right hand, adorned with a ring. The hand seems to have taken on an independent life of its own against the black background. The stripes of the cat's fur and the alternating *chiaroscuro* of the landscape backdrop contribute to the spatial tension, as does the diagonal relationship between the smouldering cigarette and the smoking chimney in the epaulette of chimney stacks, arranged in a row like organ pipes, that occupies the shoulder. The monumental physical impact and small, regimented lines of houses, the green foliage and inevitable factory smokestacks – also employed by Degas, Cézanne and Seurat – combine to produce a memorable symbiosis. Man and animal, nature and industry, Orient and Occident are laid out deliberately in relation to each other on the picture surface, like still-life elements on a table. The picture is rich in analogies which provide a mutual commentary and definitely also contributed to the parallel-surface body idiom being picked up by Fernand Léger, Max Beckmann and others (cf. pp. 186, 188 f.).[1]

Wilhelm Uhde published the bust portrait in 1914 in the German edition of his Rousseau monograph under the title *Portrait des Herrn X (Pierre Loti)*. He named the consul general Paul von Mendelssohn-Bartholdy of Berlin as the owner. A partner in the banking house of Mendelssohn & Co., which went into liquidation in 1939, the latter was a member of the Prussian upper chamber and came from an old Jewish banking family to which the philosopher Moses Mendelssohn and the composer Felix Mendelssohn-Bartholdy also belonged. As a financial expert in the circle of Kaiser Wilhelm II, he and his wife Lotte collected in grand style the works of Degas, Van Gogh,

Edgar Degas, *Henri Rouart in Front of his Factory*, c. 1875 Museum of Modern Art, Carnegie Institute, Pittsburgh

1905–06

Oil on canvas

61 × 50 cm

Signed bottom right: H. Rousseau

Kunsthaus Zürich, Zurich

(Inv. No. 2508)

1 Cf. Lanchner – Rubin 1984–85, pp. 72 ff. and 64 ff.

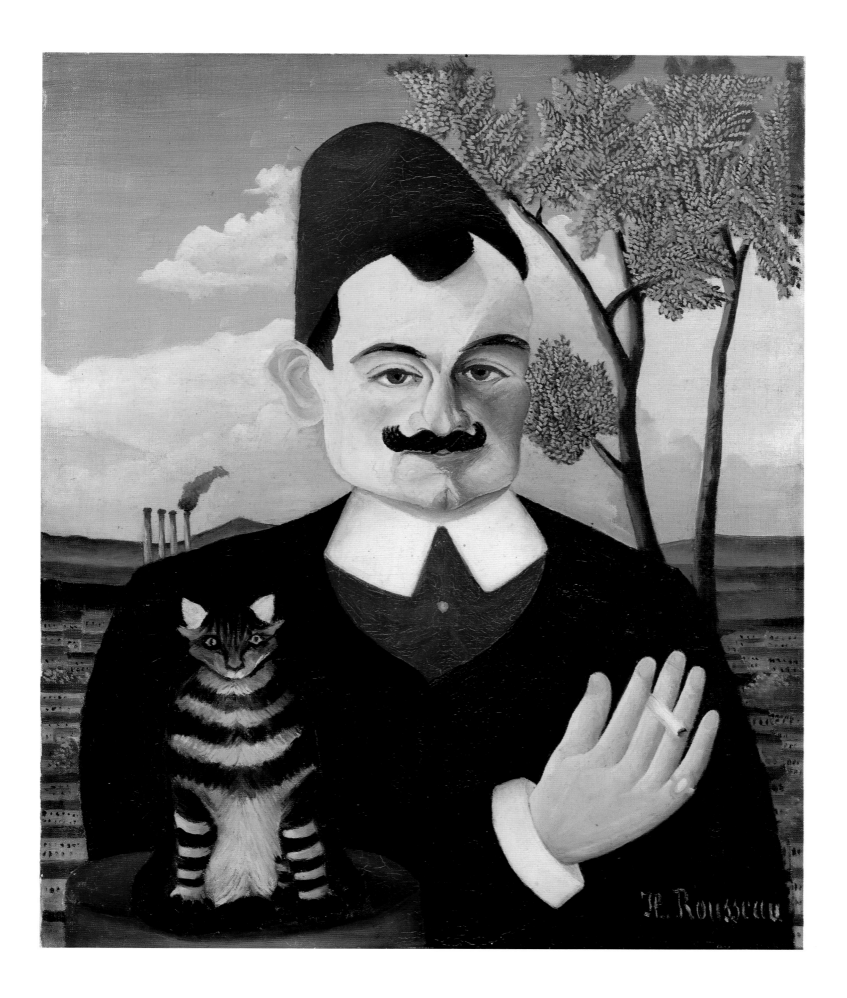

PORTRAIT OF MR X (PIERRE LOTI)

Cézanne and Picasso, in other words those French artists whom his Teutonic majesty deigned to describe as gutter art. Within only a few years the couple, advised by the architect Bruno Paul, had also succeeded in putting together one of the most important collections of Rousseau's works (cf. nos 18, 32, 35, 40, 42, 58, 59).[2] These were housed in a palace built near the Reichstag by Bruno Paul in 1913 to 1915 which – minus its 'degenerate contents' – degenerated into being the official residence of Albert Speer after its owners' family emigrated in 1933.[3]

If we trace back the provenance of *Mr X*, which is said to have cost the Berlin collector 6000 francs, we encounter the Parisian art dealer Paul Rosenberg.[4] The latter bought the portrait together with the allegory on Liberty (no. 40) from Georges Courteline, satirist and writer of popular stage farces, for 10,000 francs in 1913. He in turn had acquired the portrait from the artist in 1906 for his 'Musée des Horreurs'. By this Courteline meant a true cabinet of horrors, a conglomeration of drolleries, amateur art and Sunday painters' daubs, for which a room in his flat was specially reserved. Uhde correctly emphasised in retrospect that for a long time Rousseau's pictures were 'not taken seriously by anybody and were not bought by anybody – apart from Vollard, Picasso and myself. If this did occasionally happen, then it was as in the case of Courteline, who bought the lovely portrait of Pierre Loti in order to be able to hang a grotesque curiosity in his "Museum of Horrors".'[5]

The idendification of Mr X as the writer Pierre Loti, put somewhat cautiously in parentheses by Uhde in 1914, quickly became accepted as fact; the portrait was identified with another by Roussseau of a 'Monsieur L.', which had been exhibited at the Salon des Indépendants in 1891. Pierre Loti was the pseudonym of a naval officer, Julien Viaud, who wrote travel books and popular novels from 1879 onwards and was an authority on the French colonies in North Africa, the Middle East and the Far East. Because of his success as a novelist he was elected to the Académie Française in 1891, and his collected works appeared in Paris from 1903 to 1911. In them the best-selling author, an escapee from civilisation, made topical and popularised the myth of the exotic. Gauguin is said to have read the novel *Le Mariage de Loti* before setting out for Tahiti, and Rousseau too must have been familiar with Loti's adventure stories. His portrait, possibly inspired by the photographer Atget's picture of Loti (ill. p. 187), might even have been intended as homage to the prominent writer and his special liking for dressing up in oriental costume and for cats.

Thus far the facts. Who actually was portrayed and when, however, became a matter of controversy when the portrait was included in the exhibition *Cent Portraits d'Hommes* at the Galerie Charpentier, Paris, in 1952 and the journalist Edmond Achille Frank spoke up. With reference to a magazine illustration, he explained in a comprehensive statement that it was not a portrait of Pierre Loti but the replica of a portrait of himself that Rousseau had painted in his (Frank's) flat at rue Girardon 13 between 1909 and 1910.[6] It was displayed at that time at the Salon des Indépendants and he had destroyed it in 1911. Furthermore, Frank added, he as the model had worn a fez and the background landscape with the large acacia in the neighbouring

2 Wilhelm Uhde made the point: 'In Germany Rousseau's significance was grasped relatively early . . . It was Bruno Paul who showed an interest in Rousseau in Germany and saw to it that Mr von Mendelssohn-Bartholdy bought a large number of his pictures. Very important and beautiful pieces are therefore to be found in the Suermondt Collection [nos 1, 24, 25]. Thus it happens that one gets to know Henri Rousseau almost better from these two collections than from the scattered pictures belonging to French artists.' – Uhde 1921, p. 74.

3 Thanks to Sven Kuhrau and Robert Alexander Bohnke for references.

4 In this connection Uhde recalled: 'The portrait of Pierre Loti was on display one day in the Galerie Rosenberg's window in the Avenue de l'Opéra and, if I am not mistaken, cost six thousand francs. It had belonged to the comedy writer Courteline, who had formerly incorporated it in his famous "Musée d'horreur" and could not comprehend that this picture, which he found ridiculous but which in reality was magnificent, had brought him so much money.' – Uhde 1947, p. 58.

5 Uhde 1948, pp. 22 f.

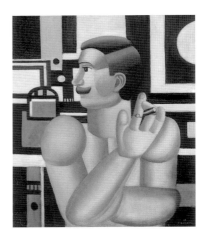

Fernand Léger, *The Mechanic*, 1918
Musée d'Art Moderne, Villeneuve d'Ascq

6 The letter is published in Certigny 1961, pp. 477 f.

garden reproduces the view over Montmartre from the dining room of his flat. Rousseau had borrowed the picture for a month prior to the Salon exhibition in order to do some retouching. In reality, however, the journalist said, the artist copied the original for commercial purposes.

Quite apart from the fact that Frank suspected Rousseau of dishonest manipulation, his reasoning and Certigny's attempts at explanation based on this are not exactly plausible. For it can hardly be believed that Frank in 1911 destroyed a portrait that, according to his statements, was created by somebody in 1909 or 1910 who was already well known at that time in artistic circles, not least in Montmartre. It makes no sense to destroy a painting 'unsuspectingly', when the painting had previously been exhibited with great public success – as Frank himself emphasised – and, following the artist's death in 1910, when prices rose rapidly, would have brought a relatively high profit. It makes the destruction theory entirely unbelievable.

Whoever the sinisterly portrayed person is – Pierre Loti, Edmond Frank or some unknown third person – one thing is certain: the portrait must be assigned to the painter's last years for stylistic reasons. Nor is there any doubt that there are overpaintings in the area of the tree in leaf that were carried out when the canvas was already framed, and that part of the black hair was covered by the fez in a second work process. It is also certain that Rousseau, notwithstanding Edmond Frank's testimony, was only represented at the Salon des Indépendants in 1909 and 1910 by the portrait of Joseph Brummer. However, in 1906 he exhibited the portrait of a Monsieur F., a literary figure who, judging by the picture title, wished to remain incognito. The critic Louis Vauxcelles noted on 20 March 1906 that the portrait had 'its rightful place in Courteline's collection'.[7] Accordingly Georges Courteline acquired the portrait of a literary figure at the private view of the Salon exhibition on 20 March and years later, probably because of certain similarities but also to enhance its value, offloaded it to Rosenberg as a representation of the famous Pierre Loti.

Eugène Atget, *Pierre Loti*

7 Certigny 1984, p. 476.

Provenance: Georges Courteline, Paris (probably 1906); Paul Rosenberg, Paris (1913-1914); Paul and Lotte Mendelssohn-Bartholdy, Berlin; Lotte Gräfin Kesselstadt-Mendelssohn, Vaduz.

Bibliography: Uhde 1914, ill.; Kolle 1922, p. 14, ill. 6; Basler 1927, ill. VIII; Roh 1927, p. 105; Soupault 1927, pp. 38 f., ill. 4; Zervos 1927, ill. 49; Rich 1942, p. 25; Grey 1943, p. 46, ill. 24; Courthion 1944, p. 10, ill. IV; Uhde 1947, p. 58; Uhde 1948, p. 23, ill. 9; Gauthier 1949, ill. III; Cooper 1951, p. 9, ill.; Lo Duca 1951, p. 4, ill.; Wilenski 1953, pp. 2, 6 f., ill. 2; Perruchot 1957, pp. 25 f., 29 f., 99, ill.; Bouret 1961, pp. 21 f., 119, ill. 30; Certigny 1961, p. 116, ill., pp. 255 ff., 261, 477 f.; Vallier 1961, pp. 46 f., 123, ill. 48; Salmon 1962, p. 47, ill., p. 62; Tzara 1962, p. 326; Shattuck 1963, pp. 90 f., 101; Vallier 1969, p. 28, ill. XII, pp. 93 f., no. 48, ill., pp. 103, 119; Bihalji-Merin 1971, pp. 25, 41, 84, 95, 125, ill. 25, p. 162, ill. 70; Jakovsky 1971, p. 32; Descargues 1972, p. 3, ill., pp. 20, 81, ill.; Rubin 1972, p. 128; Bihalji-Merin 1976, pp. 40, 42, 75 f., 130, 142, ill. 14; Keay 1976, pp. 14, 33, 148, ill. 49; Werner 1976, pp. 11, 24 f., ill.; Alley 1978, pp. 26, 59 f., ill. 51; Stabenow 1980, pp. 180 f.; Le Pichon 1981, p. 78, ill., p. 267; Certigny 1984, pp. 132, 468, 474 ff., no. 233, ill., p. 519 (with further bibliography); Rousseau 1986, p. 9, ill.; Werner 1987, p. 8, no. 7, ill.; Certigny 1992, p. 41; Müller 1993, pp. 128, 194; Stabenow 1994, pp. 68, 73, ill.; Schmalenbach 1998, pp. 25, 27, ill., p. 88, ill.; Hopfengart 2000, p. 221, ill.; exhibition catalogue *Max Beckmann Selbstbildnisse*, Bayerische Staatsgemäldesammlungen, Munich, 17 November 2000-28 January 2001, p. 200, ill.

Exhibitions: Paris 1906; Berlin 1926, no. 4; *Cent Portraits d'Hommes*, Galerie Charpentier, Paris 1952, no. 20; Paris 1961, no. 80, ill.; Paris 1964, no. 14; Munich - Zurich 1974-1975, no. H28; Paris 1984-85, pp. 62, 72, ill., pp. 74, 81, ill., pp. 87, 122 ff., no. 7, ill., p. 232; New York 1985, pp. 56, 64, ill., pp. 66, 72 f., ill., pp. 77 f., 112 ff., no. 7, ill., p. 228.

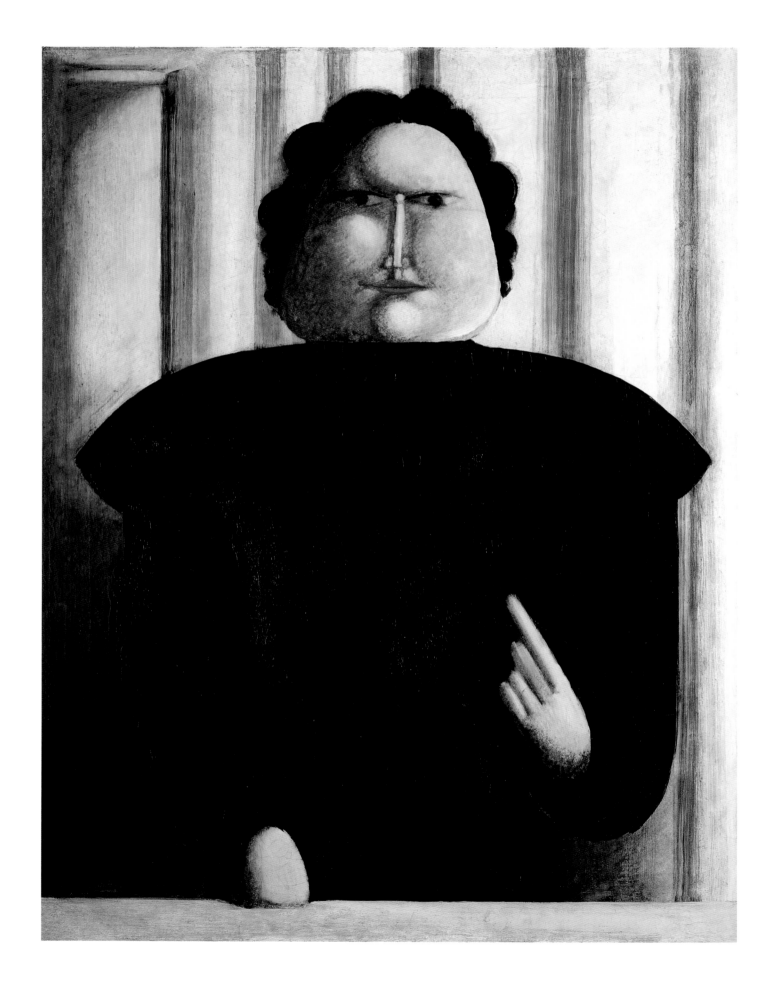

OSKAR SCHLEMMER PARACELSUS. THE GIVER OF LAWS

Oskar Schlemmer
Paracelsus. The Giver of Laws

On 27 April 1915 Oskar Schlemmer noted in his diary: 'I have come full circle yet again. I am back with Henri Rousseau. This means a return to the possible, to the lyrical, to the hermit. To the amalgamation of everything acquired. Simple themes. But inward; inward. No manner, no brush technique, not modern. More like Thoma, Haider; away from the essence of industrial art. "Colourful Cubism"!!! Folksy! Folk painter. Draw strength from the local . . . The fir, the acacia, the house. The same too with the human being. The type. Rousseau – venetian-blind colours. The fantastic still-lifes, certainly, but the spirit of Rousseau should make me look inward. I wish to paint a strangely beautiful portrait, figural picture, landscape.'[1]

Schlemmer painted one of these 'strangely beautiful portraits' in 1923 as a fictitious likeness of the physician, teacher and natural philosopher Theophrastus Bombastus von Hohenheim, known as Paracelsus.[2] The link with Rousseau's *Portrait of Mr X (Pierre Loti)* (no. 39), which Schlemmer must have known from Wilhelm Uhde's German version of the 1914 Rousseau monograph, is evident. The reference is signalised both by the uncompromising, massive frontality of the half-length figure and by the succinct gesture of the hand pointing upwards against the unbroken black of the gown. The mask-like, stylised, sharply punched-out features, the imperious expression as well as the distinct shading may also be derived from the Rousseau portrait, which Max Beckmann too had tackled a short time previously in order to incorporate hands and fingers into the scene in an expressive way like no other. Schlemmer's understanding for Rousseau could hardly be more powerfully shown than in the ideal image of the humanist natural scientist.

1923
Oil and lacquer on canvas
99 × 74 cm
Inscribed, dated and signed on the back: Paracelsus 1923 – Oskar Schlemmer / Weimar/ Staatl. Bauhaus – the Giver of Laws 192 . . .
Staatsgalerie Stuttgart
(Inv. No. 2694)

1 Oskar Schlemmer. *Briefe und Tagebücher*, edited by Tut Schlemmer, Munich 1958, p. 38.

2 Karin von Maur, *Oskar Schlemmer. Œuvrekatalog der Gemälde, Aquarelle, Pastelle und Plastiken*, Munich 1979, no. G120.

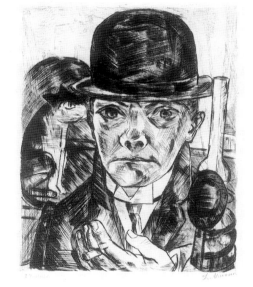

Max Beckmann, *Self-portrait with Homburg*, 1921 Staatsgalerie Stuttgart, Graphische Sammlung

Liberty Inviting Artists to Take Part in the 22nd Exhibition of the Société des Artistes Indépendants

La Liberté invitant les artistes à prendre part à la 22e exposition des artistes indépendants

In the exhibitions of the Société des Artistes Indépendants, founded on 4 June 1884 and provided with statutes by Albert Dubois-Pillet, Redon and Jaudin, anybody who so wished could exhibit his or her works for a handling fee of 15 francs. There was no need to be vetted by a jury, or selection committee, in order to participate. These events were initially housed in temporary premises on the Place du Carrousel, but then from 1901 also in the greenhouses of the World Exhibition or in the Palais de Horticulture built by Charles Albert Gautier, an exhibition hall (no longer in existence) on the Cours la Reine, east of the Pont des Invalides. Since Rousseau had no chance of being accepted into the Mount Olympus of the pompous, in other words the official, jury-regulated Salon exhibitions, for him membership of the Société des Indépendants and participation in its exhibitions was the most important, and until 1905 indeed the only, platform he had to make himself known to the Parisian public. From 1886 to 1898 and from 1901 to 1910 he had the opportunity on 23 occasions to show a total of 125 paintings and numerous drawings. The annual exhibitions, usually held in the spring, became the fixed points around which his activities concentrated. He worked towards them in order to have himself judged among his peers in company with Seurat, Signac, Toulouse-Lautrec, Van Gogh, Bonnard, Matisse and others.[1] And he always entered his most recent works, many of which can no longer be traced. Rousseau painted this exceptional tribute in honour of the exhibitions which made him famous, since they brought him not only ridicule from the public and malice from the critics but also recognition from many of his colleagues.[2] With it he showed his reverence for an institution to which he ultimately owed his existence as an artist, especially since through the yearly change it had become his actual 'patron'. He made it his memorial to the artistic freedom that was guaranteed only at the jury-free Salon des Indépendants in which, as we can see, female artists also participated.

After Rousseau had exhibited in the spring of 1905 at the Salon des Indépendants and in the autumn at the Salon d'Automne, it must have been clear to him that he owed his breakthrough among young painters not just to

'Why weren't the Sculpture Salon and the horticultural exhibition combined, which after all would have brought completely new impressions?', cartoon published in *Le Charivari*, 23 May 1888

1905–6
Oil on canvas
175 × 118 cm
Signed bottom left:
Henri Rousseau
The National Museum of
Modern Art, Tokyo

1 Cf. Coquiot 1920, pp. 130 ff.

2 Koella 1974, pp. 115 ff. Theodor Däubler described the picture in the following terms: 'A really long procession of painters is moving through the avenue: they are going to the Indépendants. No jury here can dent hopes after a heavy winter's work. The most respectable of the "freest" artists perform their duty: in their best black clothes they proceed in rows towards the exhibition building. Some of them even with hand-carts, so many are the pictures they wish to hang. After all, they have paid the wall fee of 25 francs [*sic*]. That is a touching picture by Rousseau: he himself is likewise among the pilgrims.' – Däubler 1916, p. 128.

190

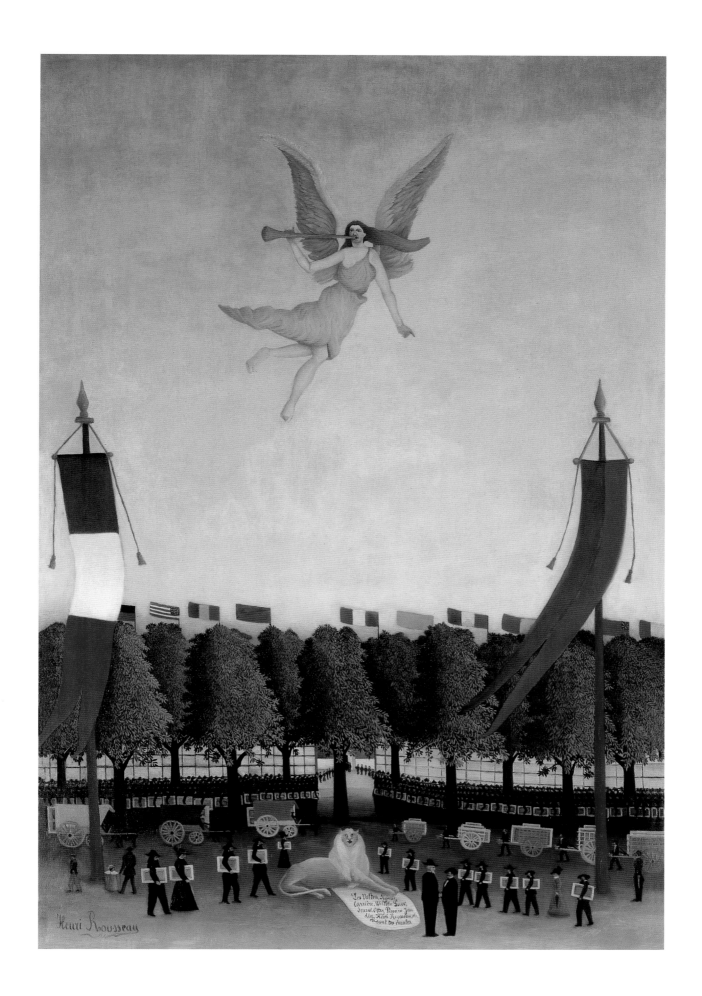

LIBERTY INVITING ARTISTS . . .

his principal work (no. 33), exhibited at the Autumn Salon, but also to his two decades among the independent artists, with whose liberal goals he felt completely in agreement. It was for friends and defenders from this circle that he formulated this picture of thanks, whose declaratory character also makes clear the extent to which he identified with the liberal operation of these exhibitions. Painted in the late autumn or winter of 1905–6, this manifestation of a body of artists answerable to itself alone, which had finally prevailed over academic conventions, admittedly also reminds us somewhat of La Fontaine's fable of the fox and the sour grapes. Because, like Cézanne, Rousseau would have considered himself fortunate to have found acceptance and recognition among the circle of Academicians, in other words the masters of the official Salon.

The title of the picture permits the conclusion that this is one of Rousseau's rare allegories (cf. nos 13, 41). The lightly clad, angel-like being hovering in the sky who, as a personification of Liberty and Fame, broadcasts the triumph of the independent artists is issuing an invitation to the 22nd exhibition of the Société des Indépendants and an army of members is responding to her call. Although the stream of participants offered a contemporary occasion, the allegorical dimension is dominant in the picture. Rousseau imagined something that did not of course take place in this ritualised form. The centring, both in form and content, stages a reality that has nothing to do with what actually happened in the run-up to an exhibition. While a large number of painters dressed in black, with two female painters among their ranks, all still with their canvases clasped under their arms or loaded on horse-drawn wagons and hand-carts, advance towards the entrance to the exhibition hall, the flags glorifying the internationalism of the event already signal the ceremonial opening. This took place on 20 March 1906 in the presence of the painter of battle scenes, Undersecretary of State and co-founder of the society Etienne Dujardin-Beaumetz, the Inspector General Guillemet, as well as the society's president Valton. The host role of country and city is conspicuously documented by the tricolour on the left and by the blue and red of the city's banner and the artists' society on the right.

Rousseau, who positioned his allegories exclusively in the secular realm, celebrated the arts as a substitute religion under the Gloria in Excelsis on the pattern of an altarpiece. The exhibition building decorated with flags and the lines of approaching artists form an appropriate framework for a representation with exceedingly ceremonial, indeed liturgical features. A row of expectant figures flanks the Via Triumphalis leading to the remote inner sanctum, the radiantly lit hall of fame of the arts. The Palais de Horticulture is wide open, and all the hopeful – prominent and less prominent – are streaming in. The exhibition venue, of whose excesses dating from the era of massive industrial expansion only the functional grid of its glass front remain, has become a church of the aesthetic in Hölderlin's meaning of the term. The religious community gathered for a festive procession, who have made independence their creed, offer their icons up on the altar of public opinion. Alternating between people and convoys of carts, the

parade turns into a triumphal procession of the producers and their carried and carted products. With the exception of a few passers-by dressed in different colours, Rousseau forced the Indépendants, distinguished by their uniform black, their broad-rimmed hats and canvases, into dependence on a dress code and on marching in step. Their equality of status may be taken as an expression of the democratic structure of an assembly of geniuses which, in the painter's opinion, is entitled to a self-important context equipped with signs and symbols.

M. von Munkácsy, *Apotheosis of the Renaissance*, exhibited at the Salon des Artistes Françaises, Paris 1890

With his programmatic picture for an independent artisthood Rousseau finally put an end to the prestigious nineteenth-century glorification of artists in France, which began with Ingres's *Apotheosis of Homer* of 1827, went via Courbet's *Painter's Studio* of 1855 and ended in 1894 with Cézanne's *Apotheosis of Delacroix*. His 'allégorie réelle' took the claim of the artist active in the service of the general public out of Courbet's private studio sphere and into the public eye. In the democratic juxtaposition, the artist – as part of an aesthetically ordered society – reports to a 'world exhibition' accessible to everyone to present proof of his ability. He is the guarantor of a society in which, despite the threat of stereotyping of the profession and exhibitions of gigantic dimensions (in the catalogue for the 22nd exhibition the allegory on Liberty was listed under number 4367!), the individual can hold his own.

Thus the elevated allegorical tone did not prevent Rousseau from presenting himself with due prominence in the foreground of the picture and advertising his authority as one of the great representatives of French painting in the eyes of heaven. He is being welcomed in person by the society's white-haired president, Edmond Valton. Both names also adorn the cartouche on which the guild's celebrities are immortalised (see p. 143). Rather like the equivalent of a red carpet, it lies at the feet of a mighty lion which represents an earthly counterpart to the celestial Fama. While the angelic figure sounding a fanfare is probably based on Antoine Coysevox's Baroque marble sculpture at the entrance to the Jardin des Tuileries, Rousseau

Frédéric-Auguste Bartholdi, *The Lion of Belfort*, postcard, c. 1900

borrowed the other prop from Frédéric-Auguste Bartholdi, creator of the *Statue of Liberty* and of the *Lion of Belfort*, made in 1878. A memorial to the heroic defence of the city during the Franco-German War of 1870–71, the latter has risen from its pedestal in the Place Denfert Rochereau in order

here to protect the inviolability of artistic freedom. On the roll of honour in front of Rousseau's lion we read: 'Les Valton, Signac, Carrière, Willette Luce, Seurat, Ottoz Pissaro [*sic*] Jaudin, Henri Rousseau, etc etc sont tes émules'. The artists listed were representatives of the contemporary Neo-Impressionist and Symbolist movements and, with the exception of Carrière and

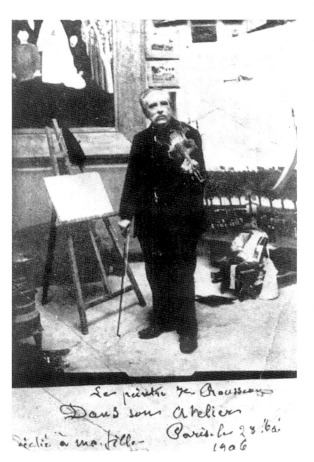

Le peintre de Rousseau
Dans son atelier
Paris le 28 ·bei
1906
Dédié à ma fille—

Henri Rousseau in his studio in front of the painting *Liberty Inviting Artists . . .*, Paris, May 1906

the graphic artist Willette, had been officers of the Société des Indépendants for many years. Valton and Seurat were founder members of the society, Rousseau, Signac and Pissarro joined it in 1886 and Luce the following year. Valton had been president of the exhibition committee since 1889 and Signac was its vice-president. The latter, together with Luce, Ottoz and Jaudin, on several occasions served as a member of the selection committee. Seurat and Pissarro were already dead at the time the allegory caused a sensation at the Salon des Indépendants.

Unlike the previous year, when the press had assessed Rousseau's contribution to the Salon d'Automne fairly positively (cf. no. 33), in 1906 they again reacted with the old prejudices. The Indépendants were divided into two groups: 'The cunning and crafty ones like M. Matisse, and the naive ones like M. Rousseau.'[3] The alienation between artists, critics and the public that had existed since Courbet and the Impressionists reached a new peak. The smugness of a bourgeois society sneered at the demands of a modern art that it misunderstood and reacted to the irritations of an artist such as Rousseau with extreme amusement. *Le Siècle* reported on 20 March 1906 regarding the opening of the exhibition: 'In the left greenhouse M. Henri Rousseau, whom the Salon d'Automne assured of talent, as always holds the record for merriment with a few portraits and a winged Fama who hovers above a deployment of uniformed artists – Indépendants!' And Vauxcelles in *Gil Blas* on the same day spoke of '. . . the illustrious Henri Rousseau . . . I wonder whether he is still so guileless. I have my doubts. He is turning into an old master . . . his *Liberty* . . . is of less guileless inspiration. In particular there is a devilish inscription which makes me prick up my ears. Might our happy ex-customs man not be touched by the demon of arrogance? Whatever the case, the lion and the naked woman (there is always a lion and a naked woman in Rousseau's pictures) are very gentle.' On 31 March 1906 the picture was reproduced in *Le Monde Illustré* and accompanied by the following text: 'We still need to address the curious success that M. H. Rousseau has had with the painting, in front of which visitors lingered for a long time. M. Rousseau reinforces his faith in the Indépendants with the composition: The *Liberty* . . . Our readers can form their own judgement about it as we print an

3 Müller 1993, pp. 41 f.

194

illustration of this eminently personal and masterfully independent aspect.'

None the less, the allegory on freedom was sold in 1906 to Georges Courteline, the humorist, author and playwright, who bought the most eccentric possible works of art for his 'Musée des Horreurs'. Courteline, who also acquired Rousseau's *Portrait of Mr X (Pierre Loti)* (no. 39) for his gallery as the epitome of the grotesque, disposed of both the Rousseau paintings in 1913 to the art dealer Paul Rosenberg, in connection with whose visit he later recalled: 'One day a gentleman came to visit me and asked if he could take a look at my museum. "Fine," I tell him, "it's here." – "Would you sell me these two pictures?" he asks. – "You must be joking! For the insignificant sum you would give me for them – since you could only offer a low price for them – I do not wish to disturb this collection, which shows the extent to which . . ." – "I'm offering you ten thousand francs," says the gentleman . . . Now, I don't like it when people make fun of me – I showed him the door. But the visitor pulled a bundle of banknotes out of his pocket. "No, that you won't do!" I say to him. "Even if you are just as stupid as the originator of these daubs, I am not the man to take advantage of such a thing." – "But there can be no talk of taking advantage, quite the opposite!" My visitor persisted in his wish. In the end I would ultimately have been dumber than all of the paintings put together. That could not be allowed to happen. "OK, I accept," I say, in order to catch this joker in his own trap. But he pays out a bundle of banknotes into my hand. "Please excuse me," he says, "I only have seven thousand francs on me; but if you will trust me . . ." – "My dear sir," I say, "if anybody is enough of an idiot to buy such things, then one can also expect from such a twirp that he will keep going to the bitter end. Here, take the hideous things, and many thanks for your blue notes." But what beats everything is that he sent round the three thousand francs that very same evening. And what is even funnier about the story is that it appears that the pictures are worth a great deal more.'[4]

4 Michel Georges-Michel, *De Renoir à Picasso*, Paris 1954; Perruchot 1957, pp. 29 f.

Provenance: Georges Courteline, Paris (from 1906); Galerie Paul Rosenberg, Paris (1913/1914); Paul and Lotte von Mendelssohn-Bartholdy, Berlin; Lotte Gräfin Kesselstadt-Mendelssohn, Vaduz; Marian von Castelberg; Franz Meyer senior, Zurich; on loan in The Museum of Modern Art, New York, and in the Kunsthaus Zürich, Zurich.

Bibliography: Uhde 1914, ill.; Däubler 1916, p. 128; Kolle 1922, ill. 8; Soupault 1927, pp. 30, 40, ill. 20; Zervos 1927, p. 21, ill. 41; Grey 1943, ill. 29; Courthion 1944, p. 24; Uhde 1948, ill. 26; Cooper 1951, p. 60; Lo Duca 1951, p. 10, ill.; Wilenski 1953, p. 5; Perruchot 1957, pp. 29 f., ill. VIII; Bouret 1961, pp. 22, 38, 117, ill. 29; Certigny 1961, ill., pp. 260 f., 460; Vallier 1961, pp. 76, 89, ill., p. 135; Shattuck 1963, pp. 97 f., 100; Vallier 1969, pp. 49, 85, ill. XXXIII, p. 104, no. 185, ill.; Vallier 1970, pp. 95 f., ill. 15; Bihalji-Merin 1971, pp. 21, 139, ill. 39; Boime 1971, p. 25; Jakovsky 1971, p. 30, ill., p. 32; Descargues 1972, pp. 20, 54, ill., p. 60, ill., pp. 107 f., ill.; Koella 1974, pp. 115 ff., ill.; Bihalji-Merin 1976, pp. 32, 57, 89 f., ill. 29; Keay 1976, pp. 16, 83, ill. XVIII; Werner 1976, pp. 34 f., ill.; Alley 1978, pp. 58 f., ill. 49; Stabenow 1980, pp. 214, 236; Le Pichon 1981, pp. 187 f., 196 f., ill., pp. 266 f.; Vallier 1981, p. 67, ill.; Certigny 1984, pp. 164, 466 ff., no. 230, ill., pp. 474, 476 f., 501, 594 (with further literature references); Rousseau 1986, p. 19, ill.; Werner 1987, no. 19, ill.; Müller 1993, pp. 41 f.; Stabenow 1994, p. 19, ill., p. 22, ill.; *Gallery Guide to the Collection of the National Museum of Modern Art*, Tokyo, Tokyo 1997, p. 23, no. 10, ill.; Schmalenbach 1998, pp. 18, 61, 64, ill.

Exhibitions: Paris 1906, no. 4367; Berlin 1926, no. 10, ill.; New York 1931, no. 14; New York 1951, no. 14, ill.; Baden-Baden 1961, no. 167, ill.; Paris 1961, no. 44, ill.; New York 1963, no. 43, ill.; Paris 1964, no. 16, ill.; Munich – Zurich 1974–1975, no. H20, ill. 72; Paris 1984–85, pp. 128, 149, 174, 178 ff., no. 32, ill., p. 266; New York 1985, pp. 120, 141, 166, 170 ff., no. 32, ill., p. 260.

The Representatives of Foreign Powers Coming to Greet the Republic as a Sign of Peace

Les Représentants des puissances étrangères venant saluer la République en signe de paix

The ideal image of Peace, completed in the spring of 1907, is another of Rousseau's allegories on War and Freedom (cf nos 9, 13, 40). A few months before the second conference on the settlement of international disputes which took place in The Hague from 15 June to 18 October 1907 and brought together 44 countries at the instigation of the American president Theodore Roosevelt, Rousseau painted an imaginary meeting in Paris, far from the political reality. The representatives of foreign powers have gathered with their French hosts for the ritual of the group portrait, under a dark red canopy, on a platform in the Place Maubert near the Boulevard Saint-Germain. Although the rival countries' representatives never actually met in this particular constellation, the artist – a supposed eye-witness of the pseudo-historical state occasion – dreamt up an apotheosis of international understanding. His faith in the power of the powerful and their diplomatic capabilities, spiced with a pinch of irony, produced a proclamation of an alliance linking the peoples, a symbol of friendship between nations. Marianne, the personification of the République Française, clad in red and wearing the Phrygian cap of the Revolution (cf. no. 9), has taken the champions of the monarchies, the republic and the colonial peoples under her wing. As peacemaker, she towers above the isocephalic row of potentates turned into static supernumeraries in this homage to the *grande nation*. With her right hand Marianne points to the blue shield representing the unifying power of the people that bears the inscription 'Union des Peuples'. The olive branch in her left hand indicates the monument opposite, erected in 1886 to honour the memory of the humanist Etienne Dolet (burnt for heresy in the Place Maubert in the sixteenth century) after a design by Ernest Guilbert. On its pedestal, a personification of the city of Paris – executed in low relief – functions as a protector of the freedom of thought with upraised arm waving a martyr's palm. Across the years, therefore, Rousseau established a connection between the humanistic traditions of France, which fell victim to religious intolerance, and the republican achievements of the Revolution, bought at a huge toll in lives, for the defence of which there was again need of a heraldic lion baring its fangs, the emblem of courage and heroism (cf. no. 40).

Ordinary people are only marginally involved in the peace meeting between the heads of state lined up like figures in a waxworks or as though for a photo call. The older gentlemen's classless society keeps to itself. Unmoved, facing forward, they turn their backs on the young people from

1907
Oil on canvas
130 × 161 cm
Signed and dated bottom right:
Henri J. Rousseau/1907
Musée Picasso, Paris
(Donation Picasso, Inv. No. RF. 1973-91)

Ernest Guilbert, *Memorial to Etienne Dolet*, 1886, postcard, c. 1910

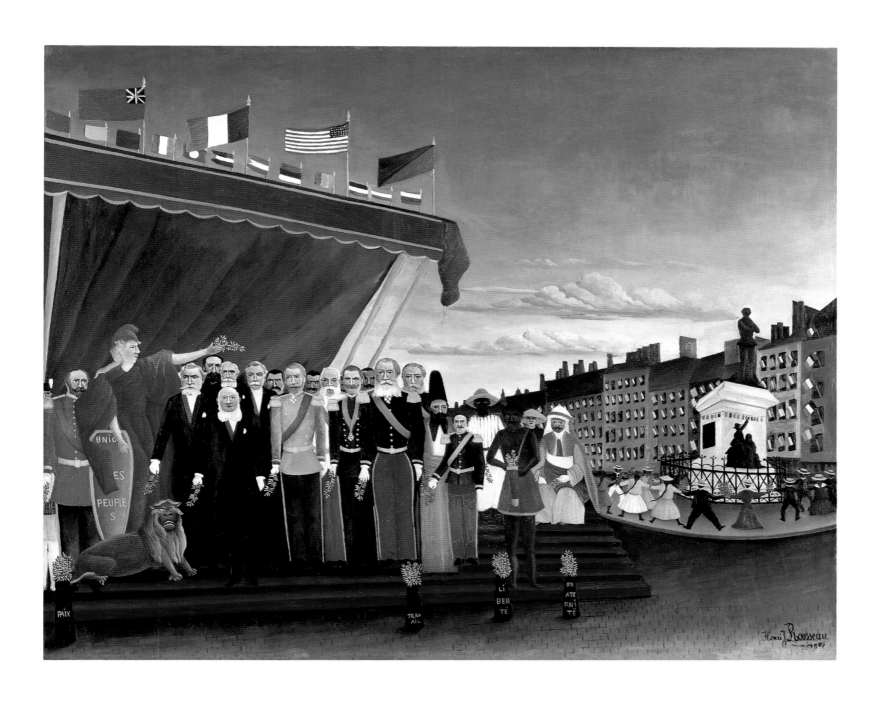

THE REPRESENTATIVES OF FOREIGN POWERS . . .

the four corners of the earth who are tripping the light fantastic in patriotic exuberance. It is no accident that the term 'égalité' (equality) was omitted from the vases filled with olive branches that stand in front of the open steps of the platform. The revolutionary maxims of 'liberty' and 'fraternity' are instead supplemented by the words 'work' and 'peace'.

Whereas *War* (no. 13) divested heroes of every sign of fame and dignity, '*Peace*' shows the identifying figures of Europe at that time, characterised by height, facial features and hair, in serious black or in the colourful adornment of uniforms, ribbons and decorations. Each of them holds an olive branch as a sign of peace. The main figure of Marianne is flanked by those who are particularly in sympathy with her. On one side, accompanied by a Scotsman in a kilt, is the Francophile English king Edward VII; when he was Prince of Wales, Paris was his second home and he later devised the Anglo-French Entente Cordiale, directed against his German nephew Wilhelm II. On the other side, a black-coated group of no less than six French presidents shelters under Marianne's strong arm. The presidencies of Grévy, Carnot, Perier, Faure, Loubet and Fallières covered that period from 1879 onwards that was also available to Rousseau for his artistic development. The fact that he placed Fallières, in office from 1906 to 1913, next to Marianne is a reference to the picture having been produced in that period; also, it was under Fallières in 1884 that Rousseau was granted a copyist's permit for the state-run museums (ill. p. 50).

The elected are joined by a phalanx of crowned heads, beginning with Tsar Nicholas II of Russia, who had not exactly shown himself to be a prince of peace with the suppression of the Duma rebellion in 1905. He is followed by King Peter I of Serbia and the Austrian emperor Franz Joseph I, the elderly man with white side-whiskers, little esteemed in France. Alongside poses an unpopular German guest, Kaiser Wilhelm II, with martial stare and moustaches twirled high, plainly distanced from his Uncle Edward. The impression given by Leopold II of Belgium, behind whom the heads of the Ethiopian ruler Menelik II and George I of Greece peek out, inspires more confidence. The Shah of Persia, Muzaffar-ed-Din, wears a hat. The smallest among the great ones is the delicate Victor Emmanuel III of Italy, the only one who succeeded in keeping his position through the two world wars until 1946. The personifications of Madagascar, Equatorial Africa, Indochina and North Africa are also present on the platform to represent France's colonial power.

The international parade of flags on the canopy and in every window of the houses round about, sporting the colours of Belgium, Italy, Germany, Austria, etc., is headed by the tricolour, the blue and red of the city of Paris and the Union Jack of England. The fact that Rousseau did not just include Europe and the neighbouring regions in his peace efforts but also thought of the far-off USA is revealed by the central position of the Stars and Stripes above the majesties of the old continent. It was presumably hoisted in honour of the American president, holder of the Nobel Peace Prize, in anticipation of the peace conference in The Hague. Rousseau's aesthetic sense was stimulated by the unbroken, heraldically correct, harmonised colour sequences which have lost nothing of their fascination, down to Jasper

Johns' flag pictures or Gerhard Richter's *Schwarz Rot Gold* (Black Red Gold) for the Reichstag in Berlin. Rousseau needed these flags, waving in the breeze, as a colour-intensive counterbalance for his composition, which otherwise was built up from a strictly hieratic point of view (cf. nos 9, 40).

In an interview three years later the painter recalled the public's enthusiastic reaction to his entry for the Salon des Indépendants in spring 1907: 'When I painted the *Meeting of the Peoples*, in which the representatives of foreign powers pay homage to the Republic as a sign of peace, I could not even leave the exhibition because of the people who pressed around me, shook my hand and wanted to congratulate me. And why was all this? Because it was right at the time of the conference in The Hague, and I hadn't even thought about it. But that was what happened. And the letters I received from all over the world, from Belgium, Germany, Russia, really from all over.'[1] The following reports must admittedly have been rather closer to the truth: 'The show-stopper of the Indépendants', one could read in *Fantasia* on 15 April 1907, 'is the painting by M. Henri Rousseau which bears the number 4284 and the simple title: *The Representatives* . . . This painting is the funniest thing in the world. Because M. Henri Rousseau, retired custom's officer, has no idea at all about drawing or painting. And his success is solely to make everybody laugh. Solely? No . . . Because Douanier Rousseau gives lessons . . . drawing lessons! He teaches at the Association philotechnique and also at home: he has students, followers, he is the head of the school!' What this 'school' actually looked like was mocked by Paul Gsell in *La Revue* of 15 October 1907: 'In the footsteps of Cézanne, Van Gogh, Gauguin and Douanier Rousseau marches the glorious phalanx of the Matisses [Matisse exhibited his famous *Blue Nude* at the Salon des Indépendants in 1907], the Rouaults, the Frieszes, the Vlamincks, etc., etc. The rooms in which they show their products have the appearance of a shop for bungled jobs . . .' Wilhelm Uhde too later described the *succès de scandale* of the picture on Peace: 'The "Indépendants" is the exhibition to which Rousseau has been sending his pictures for many years. He has become known through it, and the "Indépendants" has acquired some of its character from him. Rousseau's pictures are the great attraction. Hundreds stand before them and laugh. They have the effect of a comical accident on the Boulevards, but lasting for two months; one group replaces the other. People get to know one another in front of them because of the shared funny atmosphere and thereafter greet each other when they meet. I have never experienced such laughter at any comedy, at any circus, as in front of Rousseau's picture *Les souverains* [*The Representatives*]. They would have carted one off to Charenton if one had talked of qualities. But now and again you see a few young people looking at these pictures very seriously and very thoughtfully.'[2]

The ovation to the République Française's services to peace remained unsold, especially as the government did not lift a finger. After two and a half years, on 26 September 1909 Rousseau turned to the art dealer Vollard with the information that he could offer two paintings for sale: *Fight between a Tiger and a Buffalo* (no. 43) and this one. A receipt dated 14 December

1 Alexandre 1910 (p. 700).

2 Uhde 1911 and 1914, pp. 21 f. Not least Gertrude Stein spoke of the scandal caused by the picture. – Stein 1980, p. 23.

199

confirms the receipt of 'ten francs for a painting and 200 francs for "The Fight between a Tiger and an American Buffalo".'[3] This means that, disappointed by the fact that the government was making no preparations to buy *The Representatives*, the painter flogged off one of his state-centred 'creations' to Vollard in a barter deal for only ten francs.

In the summer of 1913 Picasso discovered his affection for the group portrait and bought it from Vollard (cf. nos 16, 29, 30). On 19 August he informed his Swabian promoter and dealer Daniel-Henry Kahnweiler: 'We have found a large and very sunny studio with living accommodation quite close to us at rue Schoelcher no. 5, and I have bought a Rousseau, that's the news to date.'[4] That he was referring to the peace conference picture is confirmed by the memoirs of Ilja Ehrenburg, who remembered seeing a 'Peace Conference' by Douanier Rousseau in Picasso's studio in the rue Schoelcher when he visited him there in early 1915.[5] Philippe Soupault, in fact a member of the Surrealist group around André Breton (ill. p. 94), wrote in 1922 about the picture that it was 'one of those dreams that paper the rooms of labourers and minor employees; one can smile about it without hurting anyone. Even Rousseau could not restrain himself when he gave each of the figures a little laurel twig.'[6] Picasso himself 'turned to Rousseau with loving admiration', we learn from Hélène Parmelin.[7] 'He laughed when he described *The Representatives of Foreign Powers Coming to Greet the Republic as a Sign of Peace*. It was a loving laugh. And the painting is indeed astonishing, amusing, permeated by a naive feeling for the world that may touch or irritate one. But at the same time it is Rousseau, in other words: painterly expression of a

3 Viatte 1962, p. 333.

4 Cited after the exhibition catalogue *Donation Louise et Michel Leiris*, Centre Georges Pompidou, Musée nationale d'art moderne, Paris 22 November 1984–28 January 1985, p. 170.

5 J. Ehrenburg, 'Souvenirs sur Pablo Picasso', *La Nouvelle Critique*, 130, November 1961, p. 53.

6 Soupault 1922, pp. 255 f.

7 Hélène Parmelin, 'Picasso ou le collectionneur qui n'en est pas un', *L'Oeil*, 230, September 1974, p. 9. Françoise Gilot remembered a remarkable dream in connection with the birth of her son Claude on 15 May

Brassaï, *Picasso's studio in the rue de la Boétie*, Paris 1932
© Gilberte Brassaï

being with belief and imagination. When Picasso looked at it – I was only present once – he seemed to be amusedly delighting in the Douanier's masterly achievement. And to be seeing him before him as he sat under his canopy in the bateau-lavoir on the day of the famous great party [see pp. 35 ff.], and how the painters and poets performed the great comedy in praise of Rousseau between the wine flowing all too generously and the non-arrival of the food. Through their arguing and craziness, their boisterousness and the apotheosis of the Douanier they made the latter a very happy man and enjoyed their own mockery . . . This was the background against which Picasso looked at Rousseau's *The Representatives of Foreign Powers*. Between Apollinaire and Salmon. And at the same time quite dissolved with joy at the heavenly imagination of this painter, whom after all he liked so very much that for years he had nothing hanging in his bedroom except two small paintings by him [nos 29, 30].' Following the death of Picasso, who had owned the painting for sixty years, it did, after all, end up in the keeping of the State as its creator had wished, thanks to the 'Donation Picasso' in 1973.

Provenance: Ambroise Vollard, Paris (end of 1909); Pablo Picasso, Paris (from August 1913).

Bibliography: Uhde 1911, p. 22; Uhde 1914, p. 21; Uhde 1921, p. 33; Soupault 1922, pp. 255 ff.; Zervos 1926, p. 229, ill.; Soupault 1927, p. 40, ill. 23; Zervos 1927, p. 21, ill. 89; Grey 1943, ill. 28; Uhde 1947, pp. 37 f.; Uhde 1948, p. 12; Cooper 1951, p. 60, ill.; Lo Duca 1951, p. 10, ill.; Wilenski 1953, p. 5; Bouret 1961, p. 222, ill. 171; Certigny 1961, pp. 268 f.; Vallier 1961, p. 77, ill. 99; Tzara 1962, p. 325; Viatte 1962, p. 333; Shattuck 1963, pp. 97 f.; Vallier 1969, pp. 85, 105, no. 194, ill.; Bihalji-Merin 1971, p. 65; Boime 1971, p. 25; Descargues 1972, p. 20; Koella 1974, pp. 115, 120 f., 125; Bihalji-Merin 1976, pp. 108 ff.; Keay 1976, p. 149, ill. 50; Werner 1976, pp. 6, 8; Alley 1978, p. 59, ill. 50; Marie-Thérèse de Forges, *Catalogue Donation Picasso*, Paris 1978, p. 84, no. 36; Le Pichon 1981, pp. 16, 187 ff., 198 ff., ill., p. 267; Vallier 1981, p. 40, ill.; Certigny 1984, pp. 498 ff., no. 241, ill. (with further literature references); Rousseau 1986, p. 13, ill.; Werner 1987, p. 10, no. 13, ill.; Müller 1993, pp. 42 f., 175; Stabenow 1994, pp. 20 ff., ill.; Schmalenbach 1998, p. 62, ill.

Exhibitions: Paris 1907, no. 4284; Paris 1911, no. 111; Paris 1984-1985, pp. 35, 52, 174, 186 ff., no. 35 ill., p. 269; New York 1985, pp. 33, 47, 112, 166, 178 ff., no. 35, ill., p. 263; Geneva 1997, p. 8, ill.; Munich 1998, pp. 13, 23, 31, 44, 48 f., 215, 218 f., no. 76, ill.

1947: 'I had started writing down the details of unusual dreams a year or two before I met Pablo. Shortly before we got to know each other, I dreamed one night that I was participating in one of those bus trips that are organised for tourists wishing to visit famous sites. In my dream we halted in front of a museum. When we got out, we were pushed into a goat-shed. Although it was black as pitch inside, I could see there were no goats there. I was just asking myself why we had been taken there when in the middle of the shed I saw a pram with two pictures: Ingres' portrait of *Mademoiselle Rivière* and a small picture by Douanier Rousseau, *Les Représentants des puissances étrangères venant saluer la République en signe de paix*. Both were smaller than in the original; the Ingres hung down from the pram handle, while the Rousseau lay inside the pram. A few months after meeting Pablo I showed him the notebook in which I had recorded my dreams. He found this dream in particular very interesting, especially since the Rousseau picture of which I had dreamed belonged to him, which I could not have known at that time. When I arrived at the hospital, Dr Lamaze was not yet there, and instead a nurse and a midwife were waiting for me. One of them was called Mademoiselle Ingres, the other Madame Rousseau.' – Gilot – Lake 1987, pp. 138 f.

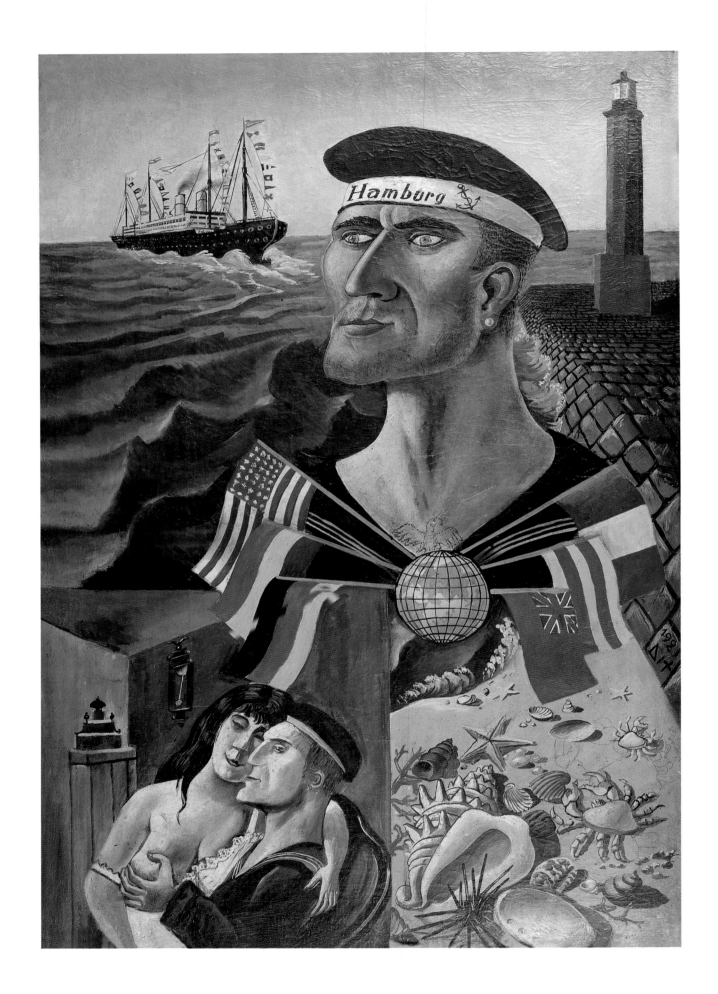

OTTO DIX FAREWELL TO HAMBURG

Otto Dix
Farewell to Hamburg

Expressionism in Germany had exhausted itself with the activities of the Dadaists and the emergence of a new objectivity after the First World War. In his book *Nach-Expressionismus. Magischer Realismus* the art critic Franz Roh in 1925 made Rousseau one of the identifying figures for those artists who at the beginning of the 1920s went back to a more down-to-earth, object-based outlook and manner of painting. 'But even more it was Henri Rousseau who, in secret association with anonymous Biedermeier painting, perhaps also with reception of Eastern miniature art, found the incredible late style of his jungle paintings, standing gently aloof but keenly opposed to his time which, ever more daringly, had advanced to abstract gestures as well as to increasing excitation. He ought to become the leader of the latest generation because of that total calm and that unmoving devotion with which here a solitary person was immersed in the sight of eternally silent nature, in mere existence. Cézanne had become the founder of modern dynamism in abstract form. Rousseau became the father of modern statics in concrete form.'[1]

From 1920 onwards Otto Dix left a lasting stamp on the turn towards a new objectivity for which Rousseau was invoked as guarantor. Something between satire and rational stock-taking, Dix's *Farewell to Hamburg* is an outright declaration of realism 'à la Rousseau', its core represented by the globe studded with flags.[2] The folksy attributes assembled in the form of a painted collage – from the seabed, via the brothel scene on land, to the harbour mole with the ocean liner sailing out at full speed over the foaming crests whipped up like meringue – are indicators to the profession of the Hamburg lad with the steel-blue gaze.

Incidentally, George Grosz and the 'monteurdada' John Heartfield also cited Rousseau when, in the catalogue for the major event of Berlin Dadaism, the 'First International Dada Fair' in June 1920, they used his self-portrait (ill. p. 138) in a collage to make a Dada-type travesty under 'picture no. 73'. They 'corrected' the 'master image' by modernising the figure of Rousseau, by providing the whole thing with a ruched edging as a canopy at the top, and by making it sail under the 'da-da' flag.[3]

Development in Italy was also going in the direction of a new concreteness. Following Futurism the representatives of Pittura Metafisica (metaphysical painting) – Giorgio De Chirico, Carlo Carrà and others – orientated

1. Henri Rousseau - Selbstbildnis
Grosz-Heartfield mont.

George Grosz and John Heartfield, *Henri Rousseau. Self-portrait*, published in the catalogue of the First International Dada Fair, Berlin 1920

1921
Oil on canvas
85 × 59 cm
Dated and signed right: 1921/DIX
Inscribed, signed and dated on the back:
Abschied von Hamburg Dix 1921
Private collection

1 Roh 1925, p. 105.

2 Fritz Löffler, *Otto Dix 1891-1969, Œuvre der Gemälde*, Recklinghausen 1981, no. 1921/1.

3 Lachner - Rubin 1984-85, pp. 89, 79.

themselves towards the painters of the early Renaissance and also to Rousseau, whose work was known in Italy through Ardengo Soffici.[4] 'The Douanier meant as much to artists in post-futuristic Italy as his great predecessors of the fourteenth and fifteenth centuries', Carlo Carrà recalled in 1951. 'His art seemed to us to be not incompatible with theirs, but even more than them he belonged to the glorious past to which we, after years of experiments, wished to return . . . for me he deserves to be treated separately. He is a unique case and perhaps not repeatable . . In my book *Pittura metafisica* of 1919 I devoted a chapter to Henri Rousseau: those were the years in which we were trying to lead Italian painting back to its comprehensive elements after the experiments of Futurism, and in the "Douanier" we saw a rather meaningful reference . . . more than any other, Henri Rousseau had the merit . . ., of taking painting back to its essential, primary purposes. Apollinaire and Soffici declared him to be the Paolo Uccello of our century . . . The softness of his tones, the richness of the light, and the naive and elementary joy in his pictures carry the viewer off into the imagination. To see that in our way is the judgement that one has to formulate about the painting of Henri Rousseau; certainly he does not rank among the greatest, but what is important is that a painter creates his own world, large or small. And Rousseau's is a world that is limited, but completely his own, and therefore essential.'[5]

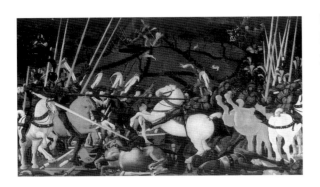

Paolo Uccello, *The Battle of San Romano*, 1456 Galleria degli Uffizi, Florence

In his poetical obituary on Apollinaire, published in late 1918 in the magazine *Ars nova*, De Chirico also referred to 'pictures by the painting customs officer': 'When his coin-like profile, which I stamped on the Veronese sky of one of my metaphysical paintings, surfaces in my memory, I think of the melancholy gravity of a Roman centurion who steps on to the bridge of a ship going over to the shores of vanquished lands, far from the consoling warmth of his hearth and the soil of his ploughed fields . . . As in a dream, I see a six-storeyed grey building before me and at the very top, under the roof, two rooms. The curtain rises and an image of wonderful intensity forms in silence: between the tragic innocence of the varnish-covered pictures of the painting custom's officer and the metaphysical architecture of the undersigned, I see the light of a paraffin lamp, a cheap pipe stained yellow by nicotine, long bookcases of white wood, pregnant with books, and friends who sit silently in the shadows . . . There, as in the beam of light from a magic lantern, the fateful-sombre rectangle of a Veronese sky stands out against the wall, and on that sky appears once again the curved outline of the sad centurion's profile . . . It is Apollinaire, the returning Apollinaire; he is the poet's friend who defended me on earth and whom I will never see again.'[6]

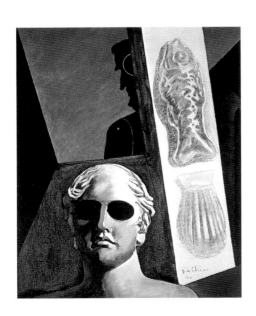

Giorgio De Chirico, *Portrait of Guillaume Apollinaire*, 1914 Centre Georges Pompidou, Musée national d'art moderne, Paris

4 Müller 1993, pp. 102 f.; Michael Zimmermann, 'Kritik und Theorie des Kubismus', in Fleckner – Gaehtgens 1999, pp. 444 f.

5 Carlo Carrà, 'Il doganiere Rousseau e la tradizione italiana', in *Carlo Carrà, Tutti gli scritti*, edited by Massimo Carrà, Milan 1978, pp. 595 ff.

6 Maurizio Fagiolo dell'Arco, 'De Chirico in Paris 1911–1915', in the exhibition catalogue *Giorgio De Chirico der Metaphysiker*, Haus der Kunst, Munich 17 November 1982– 30 January 1983, p. 35.

The Flamingoes (detail), 1907, no. 42

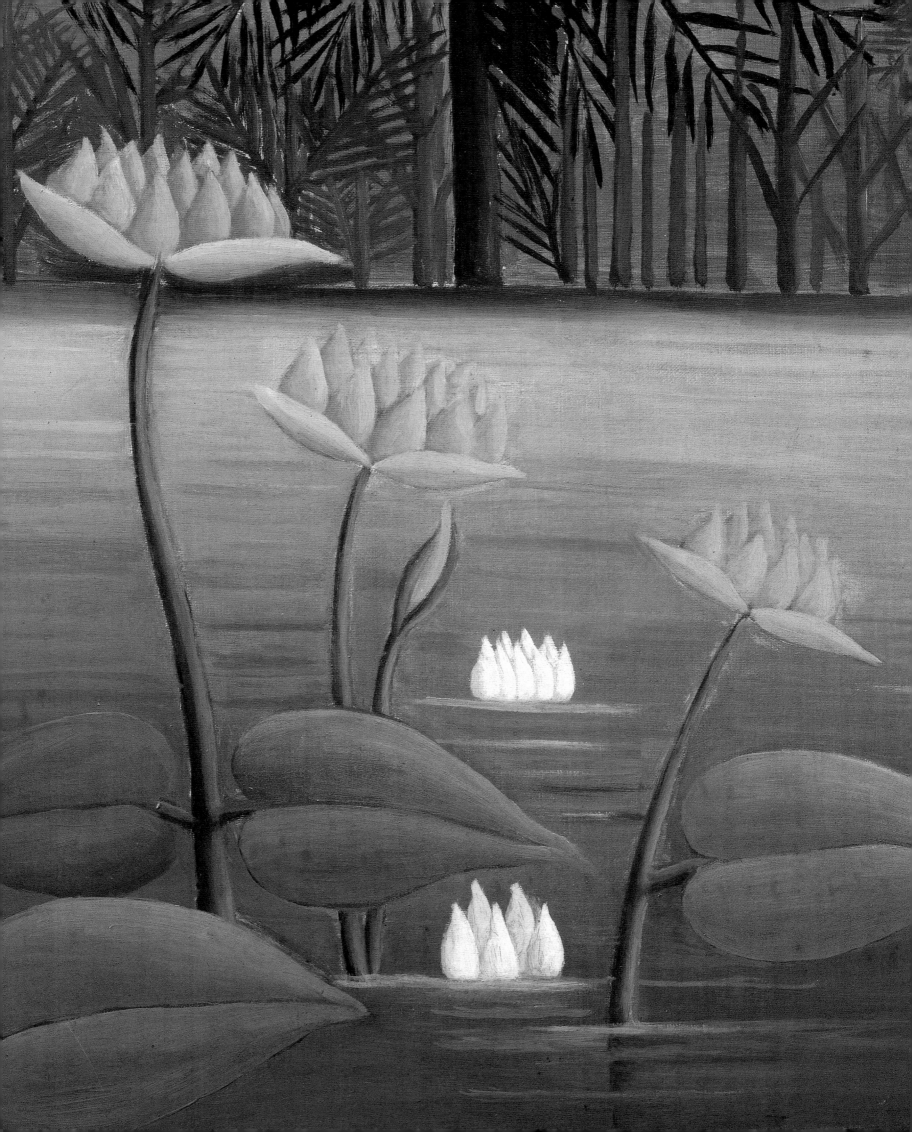

The Flamingoes
Les Flamants

Between 1891 and 1910 Rousseau showed four of the jungle pictures at the Salon des Indépendants[1] and a further five at the Salon d'Automne.[2] At the latter venue in 1907 the large-format painting *The Snake Charmer* (ill. p. 219) was exhibited together with two exotic landscapes that were not more precisely identified. Whether one of these was *The Flamingoes* can only be suspected because of a particular relationship with the *Snake Charmer*.

1907
Oil on canvas
114 x 163.3 cm
Signed bottom left: Henri Rousseau
Collection of Joan Whitney Payson

Probably conceived at the same time, both compositions clearly diverge from the otherwise customary pattern of the jungle pictures (cf. nos 32, 33, 43, 58, 59). In both cases the landscapes are set beside a broad river and both are enlivened by large, exotic birds. Thus the snake charmer is accompanied by a spoonbill, while here the four pink-plumaged flamingoes preen against the luminous blue of the river. For a model the painter made use of one of around two hundred photographs of animals, taken in the zoological gardens, that were published by the Parisian department store Galeries Lafayette in the album *Bêtes sauvages*. Rousseau owned a copy of this book, printed in large numbers, from which one learns in connection with flamingoes 'that their varied and picturesque attitudes have frequently caused painters to include them in order to lend an exotic flair to certain landscapes'.

Cover of the album *Bêtes sauvages*, Grands Magasins aux Galeries Lafayette, Paris c. 1900

1 1891 *Surpris* (ill. p. 154); 1904 *Eclaireurs attaqués par un tigre*; 1908 *Combat de tigre et de buffle* (no. 43); 1910 *Le Rêve*.

2 1905 *Le Lion ayant faim* (no. 33); 1906 *Joyeux farceurs*; 1907 *Charmeuse de serpents* (ill. p. 219), *Paysage exotique, Paysage exotique*.

The division of earth, water and sky into roughly equal compartments was transposed from the local river landscapes (nos 20, 22) to the tropics. The olive green of a palm grove is inserted between the deep turquoise-blue of the water and the blue of the sky. Rousseau's sure feel for decoration required a reversal of the proportions, in other words a minimising of animals and humans in favour of the uninhibited growth of leaves and the lotus-like plants which, rising out of the water on long stems, are reminiscent of the arabesques of Art Nouveau. From their white, yellow and pink blossoms down to the slender-legged elegance of the birds and the natives in white loincloths, no topos is omitted that might convey the beauty of the overseas colonies to a Central European. And yet the artist's look at the idyll of a secularised, colonial Garden of Eden remains distant. There is nothing effusive about it, the laconic approach excludes any sense of longing. The tropical scenario disciplined into a dreamlike natural image appears in all indifferent, lacking an atmospheric connection.

Illustration from *Bêtes sauvages*, p. 171

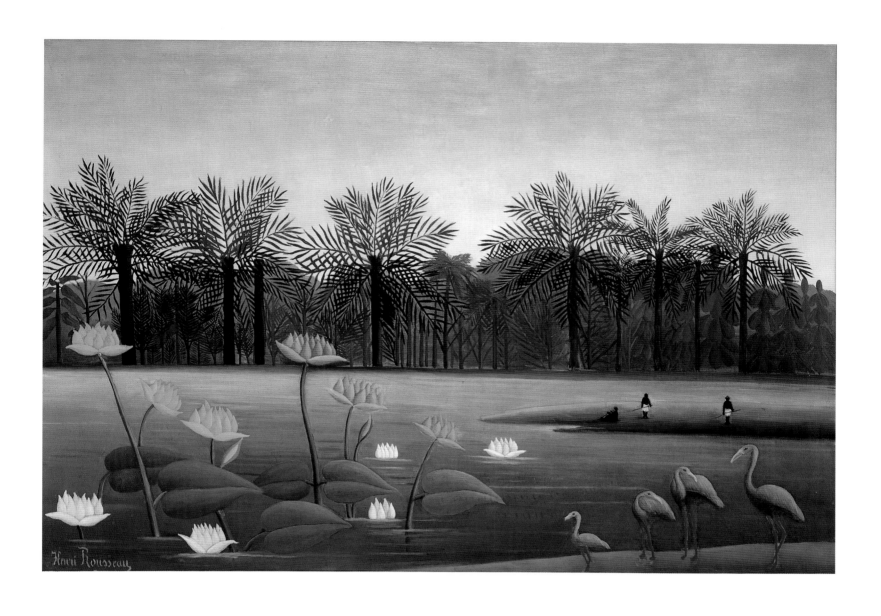

THE FLAMINGOES

On the occasion of the Rousseau retrospective at the Galerie Bernheim Jeune in 1912 the exhibition's organiser, Uhde, gave the picture the title *La Forêt Vierge – Der Urwald*, and André Warnod described it on 30 October that year in the magazine *Comoedia*: 'Pink flamingoes dream on the bank of a river close to large waterlilies, with the forest stretching out behind, and on an island there are two small negroes, completely in black.'

Max Ernst, *Flamingi*, 1920
Private collection

The heyday of the Surrealism movement brought not just a flamingo paraphrase by Max Ernst but also a redis-covery of the Baroque 'Rousseau precursor' Frans Post. In the magazine *L'Amour de l'art* in December 1931 J. Combe published the article 'Un Douanier Rousseau au XII siècle: Franz [*sic*] Post (1612–1680)'. It is not documented whether Rousseau in Paris ever saw pictures by the Dutchman, who made paintings in Brazil from 1637 to 1644 on behalf of the Dutch West India Company and, once back in Haarlem, continued to produce Brazilian subjects following the Dutch landscape painting style of the 1640s for another quarter of a century. The comparative possibilities hardly go beyond the fact that both of them dealt with tropical landscapes and the appropriate plant life.

Provenance: Wilhelm Uhde, Paris (?); Paul and Lotte von Mendelssohn-Bartholdy, Berlin; Lotte Gräfin Kesselstadt-Mendelssohn, Vaduz; Charles S. Payson, New York (from 1961); Mrs Charles S. Payson, New York.

Bibliography: Basler 1927, ill. XLI; Salmon 1927, ill. 32; Soupault 1927, ill. 30; Zervos 1927, ill. 64; Grey 1943, ill. 127; Cooper 1951, p. 58; Lo Duca 1951, p. 12, ill.; Bouret 1961, p. 227, ill. 185; Vallier 1961, ill. 151; Vallier 1969, p. 52, ill. XXXVI, pp. 105 f., no. 196, ill.; Bihalji-Merin 1971, pp. 44, 149, ill. 50; Keay 1976, p. 35; Alley 1978, p. 71, ill. 60; Stabenow 1980, pp. 27, 101, 105, 194, 200, 236; Le Pichon 1981, pp. 168 f., ill.; Certigny 1984, pp. 648, 690 f., no. 318, ill.; Certigny 1991, p. 4; Schmalenbach 1998, p. 40, ill.

Exhibitions: Paris 1912, no. 10; Berlin 1926, no. 29, ill.; New York 1931, no. 13; Paris 1961, no. 54, ill.; Paris 1984–85, pp. 93, 189, 192 f., no. 37, ill.; New York 1985, pp. 81, 181, 184 f., no. 37, ill.

Fight between a Tiger and a Buffalo

Combat de tigre et de buffle

In his late period Rousseau handled his pictorial creations with a sureness of touch that can best be compared with that of those anonymous master builders of the Middle Ages, with their stock of handed-down knowledge, who dealt with materials, dimensions and proportions self-confidently without differentiating between craft work and work of art. His power of imagination resulted in growth zones of considerable originality. Leaf and plant forms, as well as splendid floral motifs and types of fruit, are grouped and combined variously according to ever stricter criteria.

The perpetual mystery of the Rousseauesque trees of which Theodor Däubler spoke, the 'mystical veining with invigorating heart-shaped leaves' and the 'foliate plants with verdant lungs',[1] is powerfully set in the jungle here with tiger and buffalo. Just a few weeks' work in the constricted living, sleeping and studio space of the rue Perrel flat sufficed to complete the opulent masses of plant life in this major work. The leaf forms used which, duplicated as though with a stencil, are cut sharp-edged as if from a peculiarly robust material, vary widely: they range from the thin blades of grass looking as though they have been stroked with a comb, via the fleshy leaves of rubber plants and the tall ferns and agaves, to the expansive, light-storing leafy surfaces of the banana plants with their imposing clusters of fruit. The bunches of bananas hanging from the tree like festive illuminations as well as the oranges contribute accents of colour that enliven the shades of green in which everything is enveloped.

The painter who never ventured far beyond the Paris city limits incorporated a deadly battle scene into this ensemble of plant life absolutely bursting with fertility. Dying is suggested amid the flourishing. A leaping tiger has forced a huge buffalo to its knees by biting its neck. The fallen fruit and broken twigs mark the jungle clearing out as a place of combat. In order to make clear the leaping predator's intensity of movement, the diagonal of its body is continued downwards in a leafstalk bent below the buffalo. The bulk of the vanquished animal's body rears up in vain against the weight of this oblique line that runs across the picture.

However, it remains Rousseau's secret why, according to his statement, an 'American buffalo'[2] is being attacked in the jungle by a Bengal tiger from India. This cannot have been anything to do with the model for the picture, as this shows the buffalo being surprised by the tiger at a waterhole surrounded by reeds. Although the painter turned the scene the other way round, strongly schematised the tiger's coat and set the whole thing in the jungle, one can assume that the etching by Eugène Pirodon was available as Rousseau's model for the scene.[3] It reproduces a painting by the Belgian

1908
Oil on cloth
170 × 189.5 cm
Signed and dated bottom right:
Henri Rousseau /1908
The Cleveland Museum of Art
Gift of the Hanna Fund 1949.186

1 Däubler 1916, p. 124.

2 Rousseau described the animal as an American buffalo in a letter to Vollard. – Viatte 1962, p. 332.

3 Certigny 1984, p. 552.

animal painter Charles Verlat, whom Van Gogh admired, and was published in the magazine *L'Art* in March 1883 and again in March 1906. Its use is an example of Rousseau's compilatory method, feeding the flow of his compositions from the most diverse sources.

The painter needed at least two months to complete a painting of this size. This emerges from a petition that he wrote to the judge on 28 December 1907 from prison, where he was serving a short sentence for his complicity in a cheque fraud. In it he expressed his fear that he would not be able to finish his painting in time for the opening of the Salon des Indépendants on 20 March the following year: 'I again ask you to be lenient . . . and hope, Your Honour . . . that you will approve my release so that I can continue to work on the two by two metre painting that I have started for the Salon and for which I need at least two months in view of the composition.'[4] Already in the last weeks of 1907 he made a start on the canvas and then worked on it further after his provisional release on 31 December. Despite the delay caused by his imprisonment the picture was ready in time for the exhibition opening on 20 March 1908.

Charles Verlat, *Bengal Tiger Attacks Buffalo*, illustration published in *L'Art*, March 1906

4 Certigny 1961, p. 311.

Although Rousseau was still able to exhibit at the Salon des Indépendants, the jury of the Salon d'Automne feared a scandal because of his involvement in criminal doings and his brief imprisonment and refused him any further entries. Also, yet again, there was a scornful and condescending reaction from the press, not least because of the charge that had been preferred. In *Le Matin* of 20 March Rousseau was apostrophised mockingly as a 'modern Giotto', and on the following day in *La République Française* the talk was of 'bits of plumbing painted green', an 'outstretched cat skin' and a 'blackish heap that emerges from a horn . . . All this amid a metallic tree structure the din of which is extraordinary'. The budding correspondent of the magazine *La Revue des lettres et des arts*, Guillaume Apollinaire, also took a reserved view on 1 May 1908 in his report on Rousseau and his exhibition entry. The fact that the critic would become Rousseau's friend and most inventive champion is not yet in evidence: 'M. Rousseau's contribution to the exhibition is simultaneously touching and pleasant. This self-taught painter has undeniable natural qualities, and Gauguin apparently admired the black tones of Rousseau. But on the other hand the Douanier is too lacking in general culture. One cannot rely on his naturalness. One has too great a sense of what it contains that is accidental and also ridiculous. Henri Rousseau knows neither what he wants nor where he is going . . . And how Rousseau's calm gets on one's nerves. There is no restlessness, he is content, but without arrogance. Rousseau should have been just a craftsman.'[5]

5 Apollinaire 1991, p. 108.

The painter, who was in constant financial straits, hoped in vain for a sale of his large jungle picture. When in late September 1909 he informed the art dealer Vollard that he had an interested party who was prepared to

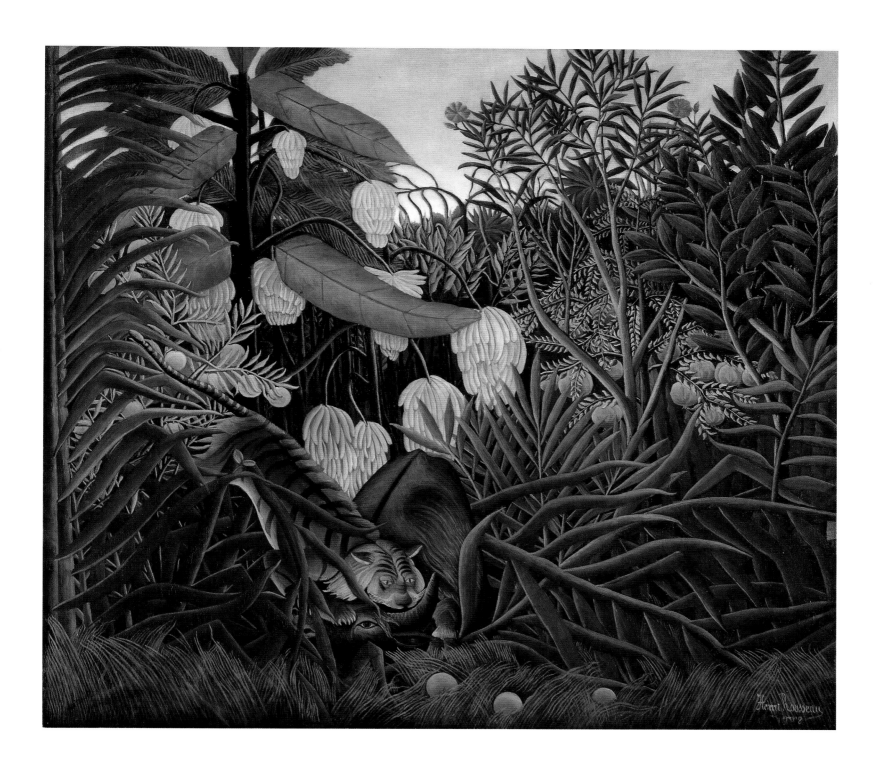

FIGHT BETWEEN A TIGER AND A BUFFALO

offer a fabulous 5000 francs, this was probably merely a subterfuge to drive up the price. A few weeks later he had to content himself with the 200 francs offered by Vollard and on 14 December 1909 acknowledged receipt of '200 francs for "The Fight between a Tiger and an American Buffalo"' (cf. no. 41).[6] Vollard too had to wait many years – until 1923 – before he was able to sell the Rousseau picture together with four of Picasso's paintings for 10,215 dollars to John Quinn of New York. Despite the fact that a regular clientele had become established with Delaunay, Picasso, Uhde, Jastrebzoff, Weber and others, from 1906 – when Vollard bought the first jungle painting (no. 33) – until 1909 there had been no change in the prices for the meticulous compositions with their ambitious content. If twenty to thirty francs came into consideration for the smaller land-scapes, the prices for paintings that were set apart by their size and execution lay at 200 to a maximum 400 francs. The price situation in Rousseau's late period is known because the artist kept a record of proceeds in 1909 and 1910. Apart from the exercise books in which he collected newspaper cuttings, he now also recorded income and outgoings as well as the number of pictures sold. According to this, his income must have been relatively high. In 1909 Vollard alone bought works to an overall value of 1,040 francs, Uhde 221 francs and the art dealer Brummer 76 francs. In 1910 Rousseau's available income was 2,150 francs for 13 pictures from Vollard, 3,950 francs from the Italian painter Soffici, 1,170 francs from the Baroness d'Oettingen, 510 francs from Uhde and 840 francs from the German sculptor Bernhard Hoetger,[7] as well as his pension entitlement and his teaching fees.

Rousseau's jungle picture *Jungle Scene with Indian and Gorilla* in Bernhard Hoetger's studio, c. 1910

6 Viatte 1962, p. 333.

7 Paula Modersohn-Becker and Bernhard Hoetger called on Rousseau in Paris, and Hoetger bought the *Jungle Scene with Indian and Gorilla*. – Vallier 1969, no. 247; Certigny 1984, no. 320 (ill. opposite). I am indebted to Wolfgang Werner for the reference.

Provenance: Ambroise Vollard, Paris (from 1909); John Quinn, New York (from 1923); Mrs John Alden Carpenter, Chicago; Valentine Gallery, New York; Mrs Patrick J. Hill, Washington DC; Pierre Matisse Gallery, New York (1948).

Bibliography: Uhde 1911 and 1914, p. 65; Uhde 1921, p. 88; Forbes Watson, *The John Quinn Collection of Paintings, Watercolors, Drawings and Sculpture*, Huntington NY 1926, pp. 14, 108, ill.; Basler 1927, ill. XXXIX; *Kunst und Künstler*, 29, 1931, p. 32, ill.; Rich 1942, p. 49, ill., p. 64; Grey 1943, ill. 110; Uhde 1948, ill. 43; H. S. Francis, 'The Jungle by Henri-Julien Rousseau', *The Cleveland Museum of Art Bulletin*, 36, November 1949, pp. 165, 170 ff., ill., and 37, June 1950, p. 125, ill., p. 129; Gauthier 1949, p. 17; Lo Duca 1951, ill.; Wilenski 1953, pp. 2 f., ill., p. 24; Perruchot 1957, p. 14; Bouret 1961, pp. 44, 231, ill. 195; Certigny 1961, p. 315; Vallier 1961, p. 142, ill. 152; Salmon 1962, p. 13; Viatte 1962, pp. 332 f.; Vallier 1969, p. 61, ill. XLV, pp. 103, 107, no. 211A, ill.; Vallier 1970, pp. 95 f., ill. 14; Bihalji-Merin 1971, pp. 87, 152 f., ill. 53, 54; Descargues 1972, p. 21; Bihalji-Merin 1976, p. 76, ill. 22, p. 134; Keay 1976, p. 155, ill. 61; Alley 1978, pp. 74 f., ill. 63; Stabenow 1980, p. 249; Le Pichon 1981, pp. 146 f., ill., pp. 268, 270; Vallier 1981, p. 90, ill.; Certigny 1984, pp. V, 222, 550, 552 ff., no. 264, ill., pp. 590, 652, 664, 682 (with further literature references); exhibition catalogue Paris 1984–85, pp. 52, 220, 234; Certigny 1989, p. 12; Certigny 1992, p. 11; Müller 1993, pp. 45, 85, 176; Stabenow 1994, p. 87, ill.; exhibition catalogue Munich 1998, p. 215; Schmalenbach 1998, pp. 42 f., ill.; Louise d'Argencourt et al., *The Cleveland Museum of Art, Catalogue of Paintings: Part Four, European Paintings of the 19th Century*, The Cleveland Museum of Art, Cleveland 1999, pp. 555 ff., no. 196, ill. (with bibliography).

Exhibitions: Paris 1908, no. 5260; Chicago 1931, no. 7; Chicago – New York 1942; *Henri Rousseau*, XXV Biennale, Venice 1950, no. 14, ill. 59; New York 1963, no. 46, ill.; Paris 1964, no. 20, ill.; Rotterdam 1964, no. 20, ill.; New York 1985, pp. 47, 212 ff., no. 50, ill., p. 230.

Fight between a Tiger and a Buffalo (detail), 1908, no. 43

212

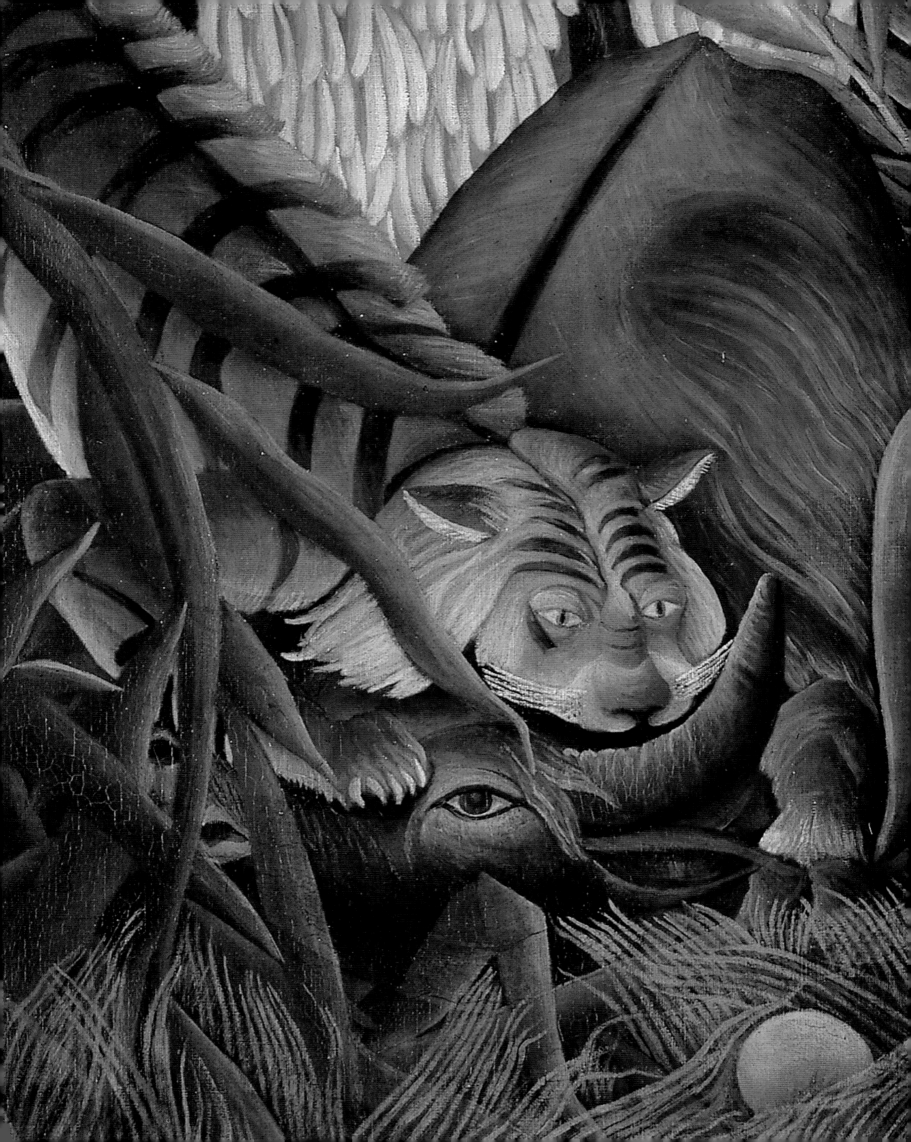

View of the Quai d'Ivry

Vue du Quai d'Ivry

In the nineteenth century, as never before, prospects of progress became the basic pattern for society. Urban life was decisively stamped by developments in the fields of heavy industry and electrical industry, mechanical engineering and civil-engineering works. Technical appliances for more rapid movement on land, sea and air, for writing and for sewing revolutionised the concepts of speed and productivity that had remained the same within living memory. New sources of light as well as new communication and reproduction forms contributed to the modernisation of life.

Among the artists who were first to react to the promising technical instruments and objects was Rousseau. In contrast to the Impressionists, but especially to Cézanne, who was vehemently opposed to the projects of a new age,[1] Rousseau expressed his modernity less in the conceptual realm of the picturesque than by incorporating up-to-date innovations into his pictures. Yet the thought of becoming that 'painter of modern life' whom Baudelaire had written about years earlier was far from his mind. The rapid pulse of the metropolis as the epitome of the modern age remained alien to his nature. His enthusiasm for progress was limited to the set pieces of technological advancement, which he tried to bring into harmony with the contemplativeness of his view of nature. In order to make the poetic appeal of his townscapes topical, it was only natural for Rousseau to deck them out with the latest technical achievements and to introduce much of what had previously not been considered picture-worthy – such as factory buildings and their chimneystacks, tenement houses and iron bridges, sundry flying machines and telegraph poles complete with wiring – into the pictorial context as fresh motifs (nos 20, 22, 39, 45).

The view from Ivry over to Alfortville on the other side of the Seine is an example of how gently, indeed almost idyllically, Rousseau interpreted the invasion of the industrial age, and how its contemporary signals are put forward in a narrative manner that would like to appear completely uncontemporary. Thus an airship, noiseless and fabulous, appears for the first time in Rousseau's sky. Almost half the picture is reserved for it and its airy environment. The artist seems to have adopted the bird's-eye perspective of the aeronauts, since his wide-angle view too looks down from above over the steep road, as well as the brimful, watery olive green of the bend in the Seine and the clearer green of the mouth of the Marne.

Paris celebrated with enthusiasm the products of the aeronautical industry, constructed on the basis of cycle and automobile manufacturing, which increasingly took flight over the city. Their names were known and postcards of them were printed. One of the latter must have formed the

1907
Oil on canvas
46.1 × 55 cm
Signed bottom left:
Henri Rousseau
Bridgestone Museum of Art,
Ishibashi Foundation, Tokyo
(Inv. No. Gaiyo 43)

1 Cf. no. 45.

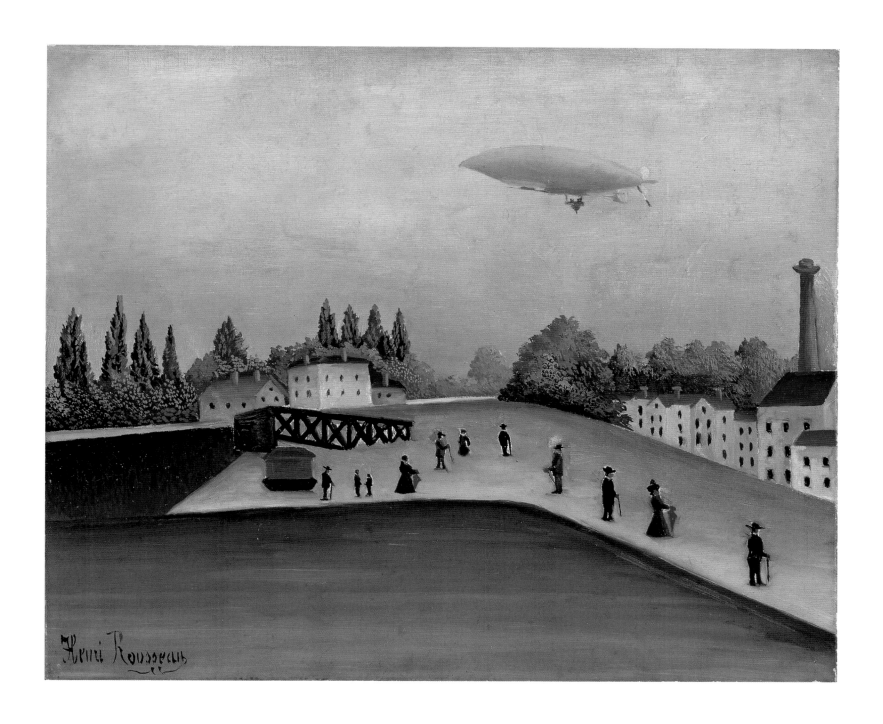

VIEW OF THE QUAI D'IVRY

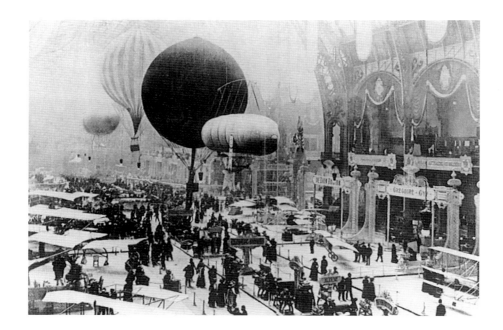

International air show, Paris 1909

basis for the representation of the brothers Pierre and Paul Lebaudy's airship *Patrie*, equipped with a 50hp Daimler petrol engine with finned stern, manned gondola and tricolour on the rudder, which Rousseau set in the sky of his picture. Constructed in Moisson, the *Patrie* was put into service in the autumn of 1906 and stationed at Verdun (ill. p. 217).[2] On the national holiday in 1907 it was still the main attraction of the military parade at Longchamps and was illustrated several times in the weekly magazine *L'Illustration*. But this showpiece of the French army tore itself loose from its mooring ropes on 30 November that year and disappeared, never to be seen again. Thus airship construction in France came to an end and Count Zeppelin's success story commenced in Germany.

The high-altitude flight of the *Patrie*, moving along in stately fashion in a boundless top stratum which makes what is below seem small, appears not to affect the figures scattered here and there like isolated super-numeraries on an open-air stage. Unconcerned, they turn their backs on the rivers empty of boat traffic and the footbridge, likewise empty, although Rousseau's urban scenes – unlike his relatively closed forest landscapes – are open and practically invite communication thanks to the interconnecting elements of roads, avenues and rivers, bridges and rows of houses.

One of these anonymous, Chaplinesque figures with stick and broad-brimmed hat might even be the painter, who often added himself to the population of his pictorial world as a marginal observer, a walker or angler. This identifying mark of the black figure is ubiquitous in many of Rousseau's townscapes – equivalent to Alfred Hitchcock's peripheral appearances in his films. Together with his signature, which was precisely thought out in terms of size and design, it became an inevitable part of the picture and an indica-tion of the self-awareness with which the painter operated (cf. nos 46, 52).

The fact that the 'realist' could also be liberal in interpreting a subject is shown by a second version of the painting with some alteration of details.[3]

2 Guy Ballangé, 'Luftschiffe in Frankreich . . .' in the exhibition catalogue *Zeppelin und Frankreich, Szenen einer Hassliebe*, Zeppelin Museum, Friedrichshafen 1998, pp. 74 ff.

3 Vallier 1969, no. 208; Certigny 1984, no. 287.

Instead of the airship, one of Wilbur Wright's biplanes is flying in the sky there and the idle loners have been replaced by anglers. The architecture, identical at first glance, does however display differences when you look more closely, notably as regards storey height, roofing and the sequence of windows and entrances.

Theodor Däubler saw a Rousseau picture with airship and biplane,[4] probably at the Galerie Flechtheim, and spoke in this connection in 1916 of the 'myth of the airship' that Rousseau had introduced.[5] The poet correctly referred to the latter's pioneering role with regard to the objectives of the Futurists, who helped the machine make its entrance into art history. 'He brought something that the Futurists were striving towards without having yet reached it along their path: the myth of the airship. We mean a small landscape, *On the Marne*, and over it a still rather ungainly biplane and a sinister flying mollusc with people in its flea gondola. In the greenery of the region there is also a house, in order to emphasise its lack of connection to what is happening in the air, set among trees. Nothing is going on inside: it conceals no Poe-type romanticism: the people inside certainly have everything very domesticated, whereas those above them in the flying machine must cope with unbelievably awkward circumstances. Just think, people who live in a dragon! And down below it's so simple.'[6]

The airship *Patrie*, 'Le Déserteur', 1907

4 Vallier 1969, no. 203; Certigny 1984, no. 286.

5 Däubler 1916, p. 122.

6 Ibid., 1916, pp. 122 f. The praises of technical and industrial achievements were sung emotively in Marinetti's Futurist manifesto, published in *Le Figaro* on 20 February 1909: '. . . the factories which with their high, writhing threads of smoke hang from the clouds – the bridges which span rivers like gigantic athletes – the steamers looking for adventure which scent the horizon – the broad-chested locomotives . . . and the soaring flight of the aeroplanes . . .'

Provenance: Serge Jastrebzoff, Paris (from 1909 or 1910); Inosuke Hazama, Tokyo; Tosuke Yamamoto, Osaka; Tetsu Nakamura, Tokyo; Shojiro Ishibashi, Tokyo.

Bibliography: Grey 1922, ill.; Grey 1943, ill. 68; Lo Duca 1951, p. 11, ill.; B. Dorival, 'Un Musée japonais d'art français', *Connaissance des arts*, November 1958, p. 62, ill.; Bouret 1961, p. 227, ill. 186; Vallier 1961, ill. 122; Vallier 1969, p. 57, ill. XLI, pp. 96, 106, no. 205A, ill., p. 108; F. Johansen, *Henri Rousseau: Morfars rejse til Vestkoven*, Copenhagen 1972, ill. 5; Keay 1976, p. 150, ill. 52; Le Pichon 1981, p. 98, ill.; Certigny 1984, pp. 538, 540 f., no. 258, ill., p. 614; *Masterworks: Paintings from the Bridgestone Museum of Art*, Tokyo 1990, p. 54; *Bridgestone Museum of Art, Ishibashi Collection*, Tokyo 1991, p. 76; *Ishibashi Collection 1996*, Tokyo 1996, ill. 44, pp. 31, 104, no. 67, ill.; Guy Ballangé, 'Luftschiffe in Frankreich . . .', in the exhibition catalogue *Zeppelin und Frankreich. Szenen einer Hassliebe*, Zeppelin Museum, Friedrichshafen 1998, pp. 68, 101, ill.

Exhibitions: *La Peinture française de Corot à Braque dans la collection Ishibashi de Tokyo*, Musée National d'Art Moderne, Paris 1962, pp. 68 ff., no. 45, ill.; Odakyu 1981, no. 63, ill.; Paris 1984–85, pp. 35, 202, 204 ff., no. 42, ill. (not exhibited in Paris); New York 1985, pp. 33, 194, 196 ff., no. 42, ill.; *Masterworks: Paintings from the Bridgestone Museum of Art*, Tennessee State Museum, Nashville 1990–1991, no. 27.

217

ROBERT DELAUNAY AIRSHIP AND TOWER

Robert Delaunay
Airship and Tower

Of the young painters in Paris, nobody had closer contact to Rousseau or felt a deeper respect for him than Robert Delaunay; nobody supported him more during his lifetime or did more to spread his reputation outside France after his death.[1] In the centre of Delaunay's involvement with the admired 'maître de Plaisance' from the very beginning stood their common interest in the symbols of modernity, which Rousseau had discovered for himself in the form of the Eiffel Tower and airships, and which the forty-years-younger artist adopted from 1909 (cf. nos 24, 44). In Delaunay's first attempt at the Eiffel Tower, whose praises were sung by Apollinaire, Cendrars and others, its slender silhouette is completely overshadowed by a gigantic green and yellow insect which, on closer observation, turns out to be the tail of the airship *République*.[2] The pictorial space into which the disproportionately shortened vessel, heavyweight and full to bulging, is forced in front of the narrow tower shape can be read only with difficulty and no longer has anything to do with Rousseau's lack of proportion. And yet Delaunay's small picture was produced in the autumn of 1909 at roughly the same time as Rousseau's composition *Vue du Pont de Sèvres*, in which the airship *République* was introduced, even if it was added later.[3] The reason for both these depictions must have been the crash on 25 September 1909 of the airship put into service as a successor to the *Patrie* (no. 44) – a disaster that all the daily papers reported in detail.

Rousseau and Delaunay had met in the spring of 1906 during the Salon des Indépendants in which they both took part (cf. nos 39, 40) and quickly became friends. The following year Delaunay's mother, Countess Berthe Félicie de Rose, commissioned from Rousseau the major jungle picture *The Snake Charmer*.[4] The Countess's literary and artistic salon in the former avenue de l'Alma was also where Rousseau encountered the young American painter Max Weber in mid October 1907 (cf. no. 34)[5] and where Wilhelm Uhde first became aware of the elderly painter whose art he would consistently support as his first biographer and interpreter, as collector and expert (cf. no. 1): 'I myself owe my personal acquaintance with Rousseau to the painter Delaunay's mother, who one Sunday led me to him and who, as much as her son, was one of Rousseau's first admirers. The latter received from them the commission for a jungle landscape (*Charmeuse*

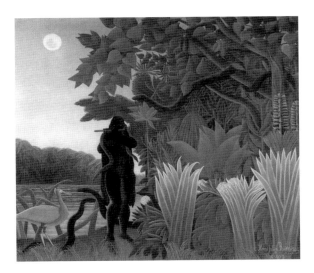

Henri Rousseau, *The Snake Charmer*, 1907
Musée d'Orsay, Paris

1909
Oil on board
34.8 × 26.8 cm
Inscribed and dated bottom left: dirigeable et la Tour/1909
Inscribed, dated and signed on back: dirigeable et la Tour 1909, r. delaunay Paris.
Galerie Gmurzynska, Zug

1 Lachner – Rubin 1984–85, pp. 74 f., 67 f.; Stabenow 1985, pp. 311 ff.; Müller 1993, pp. 101 ff.

2 Guy Ballangé, 'Luftschiffe in Frankreich . . .', in the exhibition catalogue *Zeppelin und Frankreich, Szenen einer Hassliebe*, Zeppelin Museum, Friedrichshafen 1998, pp. 76 f.

3 Vallier 1969, no. 215A; Certigny 1984, no. 273.

4 Vallier 1969, no. 200; Certigny 1984, no. 250. The picture was sold by Delaunay via Breton to the fashion designer Jacques Doucet in 1922 on condition that he bequeath it to the Louvre after his death, which took place in 1936.

5 Weber 1942, p. 17.

de serpents) which aroused much admiration among some experts at the Salon d'automne of 1907. This was the first large commission that Rousseau received from a private quarter. The deceased poet Guillaume Apollinaire and a Russian painter, Serge Jastrebzoff, also supported Rousseau at an early stage. Altogether one can say that it was artists who were first to recognise his importance.'[6]

6 Uhde 1921, pp. 70, 72.

On the occasion of Weber's return to New York Rousseau organised a farewell party in his studio flat on 19 December 1908,[7] which Picasso attend-

7 Apollinaire 1914, pp. 15 f. (p. 632).

ed with Fernande Olivier, Apollinaire with Marie Laurencin, and Delaunay probably with Uhde and Sonia Terk. Delaunay and Uhde had a shared admiration not only for Rousseau but also for the Russian Sonia Terk who, before she moved to Paris in 1905, had studied painting at the Karlsruhe Academy. After a year of marriage to Uhde, she became Robert Delaunay's wife in November 1910.

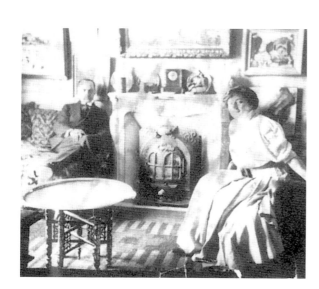

Wilhelm Uhde and Sonia Uhde-Terk in their flat, Paris 1908

In this connection we should again refer to an act of affection that must be unique in art history, when Rousseau's young artist friends took it upon themselves to secure his last resting-place. After Rousseau's death on 2 September 1910, Delaunay called together a circle of donors in 1911, including Vuillard, Denis, Gleizes, Apollinaire, Uhde, Léger, Sérusier, Renoir and Signac, in order to obtain a 30-year gravesite concession for the artist, who had been buried in a pauper's grave. Archipenko even declared himself prepared to set up a monument, although it never came to this.[8] But it was only possible to finance the grave through the sale of two portraits belonging to Delaunay (nos 36, 37) and with the assistance of Rousseau's landlord, Armand Quéval. On the tombstone dressed by Brancusí stands the epitaph composed by Apollinaire: 'Dear Rousseau, hear us / We greet you / Delaunay, his wife, Monsieur Quéval and I / Let our luggage duty-free into heaven / We bring you brush, paint and canvases / May your holy rest be spent in the light of truth and may you paint, as you once did my portrait, / The countenance of the stars now.'[9]

8 Rousseau 1999, pp. 32 f., 35.

9 Apollinaire 1914, p. 29 (p. 641).

In March 1911 Delaunay was asked by representatives of the Société des Artistes Indépendants to organise a Rousseau retrospective for the coming Salon,[10] which duly took place from 21 April to 13 June and brought together 47 of the artist's works. It was followed by the Rousseau exhibition arranged by Uhde in the Galerie Bernheim Jeune, which opened on 28 October 1912; Delaunay loaned four pictures among the 29 exhibits by way of contribution.

10 Rousseau 1999, p. 30.

When Uhde's Rousseau monograph appeared in Paris in 1911, Delaunay too was planning a book entitled *Henri Rousseau, the Douanier – His Life, His Work* which, however, never got further than a provisional draft.[11] In it he set the 'grandfather of the artistic revolution in modern painting' as the representative of a new primitivism and as a great designer, on a level with

11 Parts of it were published in *L'Amour de l'Art*, 7, November 1920, and in *Les Lettres françaises*, July–August 1952.

Cézanne: 'In his very small studio in Plaisance, surrounded by the most important large canvases, he received his friends, labourers, minor employees, craftsmen . . . It was Rousseau who received one with the merry smile of great goodness. He was the man who opened his door, jovial, happy to see one, one of those lovely open types of people whom one finds in their thousands in France, with this merriness in the eyes. He lived very modestly from a small state pension of around 1,200 francs; he gave painting lessons, taught music theory and violin at home and sold his paintings mainly to small pensioners, to the public into whose social rank he fitted. It was in this Parisian atmosphere and in contact with his environment that Rousseau created his – one could say – anonymous œuvre . . . Here Rousseau was in his element – in his true milieu – Rousseau, the people's painter . . . Rousseau is not, like Cézanne, a restless and well-informed bourgeois who sets out every day to purify himself in contact with nature, to check on his setbacks or his progress. Rousseau, the people, is always himself, with the complete certainty of his class, an abundance from the first moment to the end. Here are two trends of our era: Rousseau anonymous and personal, Cézanne destructive and personal. Two peaks who ignored each other, almost completely. The first all sureness of spirit and of hand, a designer, confident, certain of himself throughout his entire development, coming from the people. Cézanne, the bourgeois, the first pioneer, the first saboteur. Two completely different forms in this heroic era of modern painting. Two primitives of a great movement.' Delaunay also expressed himself concerning 'Rousseau, the visionary with a tendency towards the popular in the most representative, the noblest, the clearest sense' vis-à-vis Apollinaire on 17 April 1913: 'Craft work now plays a great role, which does not mean popularisation. Cézanne, the cautious, the modest Cézanne, anticipated this, but he was afraid of it, he was not prepared, his museum [awareness of tradition] impeded him. His middle-class mentality and his taste suffocated him. Rousseau was happier, richer. He is not just museum, he reclaims the tradition through the vision, development makes him modern. I wished he was even more modern.'[12]

Primarily, however, Delaunay and Uhde were the most important mediators of Rousseau's art to Germany (cf. nos 26, 27). As quasi-executor, Delaunay was not just a broker of Rousseau pictures to Kandinsky, he also had the role of representing the contemporary Parisian art scene at the first Blaue Reiter exhibition with four paintings and a drawing. Indeed, it was through Delaunay's Orphism that Cubism first became fruitful for Germany – for Marc, Macke and Klee, for Campendonk, Grosz, Meidner, Kirchner and Feininger. Delaunay it was too, together with Uhde, who was the main lender for the first Rousseau exhibition in Germany, which took place from 20 September to 1 December 1913 within the framework of the First German Herbstsalon (Autumn Salon) organised by the Galerie Der Sturm in Berlin. Rousseau was represented by 21 paintings and a drawing, Delaunay by 21 works. The tireless promoter Herwarth Walden had founded the weekly *Der Sturm* in 1910 and two years later opened the gallery of the same name. This large-scale project – the First German Herbstsalon – encompassing 366

12 Delaunay 1957, pp. 193 f., 161.

exhibits by 90 artists from the most diverse countries was instigated by August Macke and Bernhard Koehler. The inclusion within it of a commemorative exhibition for Rousseau was due to the initiative of Delaunay, Macke, Kandinsky and Marc. In March 1913, while in Paris, Walden had come across 'the most marvellous Rousseau pictures that I have ever seen together in one place, namely in Delaunay's small dining room'.[13] On 8 July he asked Delaunay to let him know urgently, 'which of your Rousseau pictures are definitely coming to be exhibited at the Herbstsalon. Please give me the exact list. We are also getting the Rousseau pictures, as far as their owners in Germany are known to me'. This request was repeated on 2 August: 'Please send the photograph for the catalogue by return. The conditions for the Herbstsalon are very generous . . . The walls are being done in various colours. The exhibition will take place in a single large room of 1,200 square metres [rented premises at Potsdamerstraße 75] in which stands will be erected. The stand height is 2.20 metres. Finally, I ask you urgently to provide immediate details of the titles of the Rousseau pictures and the works by Mrs Delaunay. If any Rousseau pictures are for sale, please let me have their prices at the same time. Please reply very precisely and quickly regarding all these technical matters.' On this letter Delaunay jotted down in his handwriting the possible list of loans of Rousseau works in his possession: '1. *Les Joyeuse [sic] Farceurs*, 2. *La Charmeuse de Serpents* [ill. p. 219], 3. *Portrait d'Henri Rousseau à la Lampe* [no. 29], 4. *Portrait de la Dame de Rousseau à la Lampe* [no. 30], 5. *Le Centier des Cognettes*, 6. *La Carmagnole* [no. 9], 7. *Le pont de Grenelle sous la neige*, 8. *Quai Henri IV* [no. 52], 9. *Gare d'Austerlitz*, 10. *étude* [no. 23?], 11. *étude* [no. 50?], 12. *étude*, 13. *étude*.'

13 This and the following extracts from letters are cited after Meißner 1985, pp. 505, 508 f.

Following the opening of the Herbstsalon, Paul Westheim wrote sarcastically in the *Frankfurter Zeitung* of 25 September 1913: 'The much vaunted Delaunay, from whom supposedly the deepest mysteries bubble out like a tireless brook, has exhibited a series of brightly coloured targets . . . In order to analyse . . . the unbridled intellectuality of these concentric circles of colour, one will require no less tricky a morphology than to extol Kandinsky-esque sounds. Henry [sic] Rousseau, the worthy customs guard, whom one would like to make, so to speak, the grandpapa of all this fuss, would quite definitely understand them as little as all the other people who are accustomed to enjoy pictures without footnotes.'[14] The *Neueste Nachrichten* of Dresden took the contrary view on 28 September 1913: 'The focal point of the exhibition is a commemorative exhibition on Henri Rousseau, that memorable precursor of Expressionism, whose works, dealing with a genuine primitiveness, were once laughed at as harmless amateurism. In particular the two portraits with lamp [nos 29, 30] and the picture of the apes in the forest, belonging to Delaunay, are great works of art! Delaunay is – not for the first time – a surprise! Again he has advanced further along his way, to totally abstract colour creations . . .'[15] Apollinaire too devoted a detailed report to the Berlin activities surrounding Rousseau and Delaunay: 'The First German Herbstsalon, organised by the magazine Der Sturm, opened in September. The aim of the organisers, as Herwarth Walden says in the foreword to the catalogue, was to provide an overview of present-day develop-

14 Ibid., p. 51

15 Ibid.

ments in the field of fine arts throughout the world . . . The place of honour at this exhibition is held by the deceased and mourned Henri Rousseau, who is represented by 21 paintings and one Indian ink drawing. I find this German homage to French painting very touching. Although Rousseau did not belong to the intellectual elite, either by birth or by education, he nevertheless participated in general in French culture. He had the great good fortune to embody – as completely and amicably as possible – that fine, unbiased, rich naturalness, coupled with liveliness and irony, simultaneously knowing and naive, that only a few French artists and poets have possessed: for example Villon or Restif de la Bretonne . . . The Douanier could never have been born in Germany, where even the most talented young men must study in order to become artists. That is a land of professors and doctors. This homage to the Douanier is therefore also directed at France, the only country in which he could have been born. Overall the Berlin Herbstsalon is a celebration of the new directions in painting taken by young artists who are either French or who work in Paris, and in particular a celebration of Orphism . . .'[16]

16 Hajo Düchting, *Apollinaire zur Kunst. Texte und Kritiken 1905–1918*, Cologne 1989, p. 216.

A second Rousseau exhibition in Germany took place 13 years later in spring 1926 at Alfred Flechtheim's Berlin gallery thanks to the support of Delaunay, as always indefatigably standing up for Rousseau. The exhibition catalogue lists 32 of Rousseau's paintings. It is in this context that a letter from Delaunay to the art dealer Flechtheim must have been drafted in which he mentions a publication, planned and illustrated by himself, of the Douanier's literary creations: 'I am preparing a French edition of one of the Douanier's manuscripts: *Un voyage à l'exposition Universelle*, with 50 lithographs of Paris since it is set in Paris. Would it not be of interest for a German publisher to publish *La Vengeance d'une Orpheline Russe* [extracts from the manuscript, which was in Delaunay's possession, were published in the Galerie Flechtheim's 1926 Rousseau catalogue] or *L'Etudiant en Goguette*. It seems to me that you would be the right person to give advice and to be involved in this, including financially. One could first publish a luxury edition of these originals and then two months later, in a larger print run, a version in a smaller format and with fewer illustrations. Can you give me your answer to this?'[17]

17 Meißner 1985, p. 526.

View of Malakoff
Vue de Malakoff

'Rousseau is the first who was able to characterise telegraph poles,' wrote Theodor Däubler in 1916. 'It becomes a storm of telephone wires. He is particularly zealous about clusters of power terminals. But he paints all this in faithful shades of grey. In a modest potato yellow. In a good-natured field brown. And then again, all of a sudden, almost as brightly coloured as Bengal lights: as though faced with hail and lightning. Yes, then the iron trees blossom with wire branches. Glass blue, porcelain green. It's going to happen any minute now: lightning.'[1] Fernand Léger too recalled decades later: 'Don't forget that the master of us all, Douanier Rousseau, dared to include telegraph poles with their pretty parallel insulators in his landscapes fifty years ago.'[2]

The German writer and the French painter based their statements on the view of a bend in the road in the village of Malakoff, south of Paris. A wedge of empty field pushes in from the right into the composition consisting of groups of trees backed by the half-light of a thundery sky, cubes of houses, and the sombre church roof towering above. On the grass-green margins of the field are positioned five electricity and telegraph poles whose wires with the porcelain-white insulators introduce high tension into the picture. Pedestrians pass near the foot of an over-sized gas lamp and two road-workers, abruptly reduced, are busy excavating earth in the distance.

Rousseau was not afraid to confront the suburban idyll with the dissonant side-effects of technical progress and tailor his pictorial considerations accordingly. He supported without reservations those developments that Cézanne had strongly warned against in a letter to his niece on 1 September 1902: 'Unfortunately, what one calls technical progress is nothing but the invasion of people who cannot rest until they have transformed everything into hideous waterfronts with gas lamps and – what is worse – with electrical illumination. What times we live in!'[3]

The oil sketch on which the picture is based is marked on the back with a dated dedication to the American painter Max Weber as well as the name of the place: 'offert à mon ami / Weber le 2 décembre 1908 / Paris, 2 xbre / son ami / H. Rousseau / vue de Malakoff / environs de Paris.'[4] Judging from the thundery atmosphere and the greenery on the trees, the sketch was made during the summer months of 1908. The larger studio format must have been completed by the autumn at the latest, since Wilhelm Uhde included it in the exhibition at a furniture dealer's that he opened in November or December 1908: 'About two years before his death', he wrote later, `Rousseau for the first time had the opportunity to show his pictures in

1908
Oil on canvas
46 × 55 cm
Signed and dated bottom right:
Henri Rousseau/1908
Private collection
Courtesy Pieter Coray

1 Däubler 1916, p. 123.
2 Schmalenbach 1998, p. 86.

3 *Paul Cézanne. Briefe*, edited by John Rewald, Zurich 1979, p. 273.

4 Vallier 1969, no. 213B; Certigny 1984, no. 261.

VIEW OF MALAKOFF

a one-man exhibition. A furniture dealer from the Faubourg Saint-Antoine had asked me to display pictures in premises in the rue Notre-Dame-des-Champs in which some of his tables and chairs were simultaneously on show. I first turned to Rousseau, and he himself took some of his works there in a hand-cart. We hung them up together, and I sent out the invitation cards. But since I had forgotten to give the exact address of the still unknown little gallery, not a single visitor turned up. I myself bought the beautiful Malakoff at this exhibition for forty francs. At that time it would not have been possible to resell such a picture for half the price.'[5] According to Certigny, however, the exhibition presented works not just by Rousseau but also by Marie Laurencin and Louis Schelfhout. This emerges from an exhibition review – anonymous, but probably written by Laurencin's friend Apollinaire – in the January–February 1909 issue of the magazine *Pan*: 'The gallery in Notre-Dame-des-Champs is exhibiting works by Marie Laurencin, Henri Rousseau and Louis Schelfhout. One sees in them the always laudable effort made by serious artists in the direction of innovation, noticeable in particular in the works of Marie Laurencin, whose talent is very personal. This exhibition has been visited by everybody who has an interest in our visual art and its new trends.'[6]

5 Uhde 1947, p. 56.

6 Certigny 1984, p. 548.

Provenance: Wilhelm Uhde, Paris (1908–21); auction of the Uhde Collection, Hôtel Drouot, Paris 30 May 1921, no. 59; Galerie Paul Rosenberg, Paris; Léon Guiraud, Paris (1923); Antoine Villard (1927–33), Paris; Georges Renand, Paris; Galerie Henri Bing, Paris; Walter and Gertrud Hadorn, Bern (from 1943).

Bibliography: Uhde 1911, ill. 25; Kandinsky – Marc 1912, p. 83, ill.; Uhde 1914, ill.; Uhde 1920, p. 55; Uhde 1921, p. 74; Basler 1927, p. 30; Zervos 1927, p. 50, ill.; Rich 1942, p. 37, ill.; Grey 1943, ill. 52; Courthion 1944, ill. XL; Uhde 1947, p. 56; Uhde 1948, ill. 13; Lo Duca 1951, p. 11, ill.; Bouret 1961, p. 233, ill. 199; Certigny 1961, p. 336; Vallier 1961, p. 107, ill.; Vallier 1969, p. 107, no. 213 A, ill.; Leonards 1970, pp. 38 f., ill. 123; Bihalji-Merin 1971, p. 38; Descargues 1972, p. 87, ill.; Bihalji-Merin 1976, p. 67; Alley 1978, p. 73, ill. 62; Stabenow 1980, pp. 185 f., ill.; Le Pichon 1981, p. 59, ill.; Certigny 1984, pp. 546, 548 f., no. 262, ill., p. 638; Meißner 1985, p. 483; Stabenow 1985, pp. 315 ff., ill.; Certigny 1991, p. 22; Müller 1993, pp. 106, 189; Stabenow 1994, p. 37, ill., p. 46; Schmalenbach 1998, pp. 60, 83, ill., p. 86; exhibition catalogue *Blauer Reiter*, Städtische Galerie im Lenbachhaus, Munich 1999, no. 248, ill.

Exhibitions: Paris 1908; Paris 1911, no. 24; Paris 1923, no. 2; New York 1931, no. 20; Basel 1933, no. 17, ill.; Paris 1937, no. 4; Paris 1944–1945, no. 5; *Europäische Kunst aus Berner Privatbesitz*, Kunsthalle Bern, Bern 1953, no. 121, ill.; *Chefs-d'œuvre des collections suisses de Manet à Picasso*, Palais de Beaulieu, Lausanne 1964, no. 296, ill.; Munich – Zurich 1974–1975, no. H23, ill.; *Sammlung Hadorn*, Kunstmuseum Bern, Bern 1977, no. 123, ill.; Paris 1984–85, p. 71, ill., pp. 212, 214 f., no. 47, ill.; New York 1985, p. 63, ill., pp. 204, 206 f., no. 47, ill.

Wassily Kandinsky
Railway at Murnau

In contrast to the Frenchman Delaunay, the Russian Kandinsky evinced an almost mystically spiritual reverence for Rousseau. This reached its zenith just at the period 1911–12 when Kandinsky had advanced as far as abstraction in his painting (cf. nos 26, 27). In the almanac *Der Blaue Reiter*, which he and Franz Marc edited in Munich in mid May 1912, Kandinsky wrote 'Über die Formfrage' (On the Question of Form). This was the longest essay in the almanac and Kandinsky's most important contribution to art theory, which he illustrated with seven Rousseau pictures (including nos 16, 26, 29, 30, 45).[1] In it he emphasised the pluralism of 'current art', which he linked to the poles of 'great abstraction' and 'great realism'. The author started dialectically from the polarity of the 'objective' in Rousseau's art and the 'purely artistic', in other words from contrary fundamental standpoints which 'open up two paths' and 'ultimately lead to one goal'.[2] He saw the synthesis of his abstract–realistic concept of art in the idea of the 'inner sound of the image' and its 'inner necessity': 'The artist who throughout his life is in many ways like a child can often reach to the inner sound of things more easily than somebody else would. In this respect it is especially interesting to see how the composer Arnold Schönberg applies painterly means simply and surely. As a rule he is interested solely in this inner sound . . . Here lies the root of the new great realism . . . Henri Rousseau, who can be termed the father of this realism, showed the way with a simple and convincing gesture . . . Henri Rousseau opened up the way for the new possibilities of simplicity. This quality of his versatile talent is the most important for us at present.'[3]

Kandinsky had already written to Franz Marc from Murnau on 29 October 1911 while the almanac was still at the planning stage: 'What a wonderful person this Rousseau was! And naturally in contact with the "other world". And what depth there is in the pictures! . . . And now I became as though whipped, quite shaken. Oh God! There is the very root of realism, the new realism! . . . I find that Rousseau belongs to the company: Kahler, Kubin, Epstein, Schönberg, Münter. My exact opposites!'[4] Under the all-embracing and unifying span of that which was 'created from necessity' Kandinsky saw in Rousseau the 'father of great realism', the opposite pole to his own ambitions for 'great abstraction'.

How widely, in Kandinsky's opinion, the artistic means of expression should be defined in order to 'extend the previous borders of the power of artistic expression' is seen from a letter of 19 June 1911. In it he confided to Marc his plan to publish an almanac which should contain texts and illustrations about painting, music and drama as well as a chronicle of current events: 'Now! I have a new plan. Piper must look after publishing and we two

1909
Oil on board
36 × 49 cm
Inscribed on the back by
Gabriele Münter and dated in
another hand: Kandinsky / 1909
Städtische Galerie im
Lenbachhaus, Munich
(Inv. No. GMS 49)

1 Kandinsky – Marc 1912, pp. 74 ff. Kandinsky expressed thanks for permission to reproduce the illustrations in a note: 'The majority of Rousseau's pictures reproduced here are taken from Uhde's pleasant, warm book (Henri Rousseau), Paris, Eugène Figuière et Cie. Editeurs 1911. I took the opportunity to thank Mr Uhde very sincerely for his kindness.' – Ibid., p. 94.

2 Ibid., p. 82.

3 Ibid., pp. 94 f.

4 Meißner 1985, p. 483.

WASSILY KANDINSKY RAILWAY AT MURNAU

– be the editors. A sort of (annual) almanac with reproductions and articles . . . and chronicle!! i.e. reports on exhibition reviews, only by artists. The book must reflect the entire year, and a chain to the past and a ray of light into the future must give full life to this mirror. The authors will probably not be paid. Probably they will pay for their own plates etc., etc. We will put an Egyptian next to a little Zeh [name of two children with a gift for drawing], a Chinese next to Rousseau, a folk print next to Picasso and much more of the same sort of thing! Gradually we will get literary people and musicians. The book can be called "Die Kette" [The Chain] or something else . . . Don't talk about it. Or only if it can be of direct use to us. In such cases "discretion" is very important.'[5] In the compendium, to appear on a yearly basis, the princi-ples of modern aesthetics were to be outlined and the true sources of art traced – using examples from past epochs, non-European cultures, Russian folk art, Upper Bavarian *verre églomisé* painting, expressions of primitive art, children's drawings and votive pictures – and made plain through self-explanatory comparisons of illustrations. The aim of these ideas, extending as far as the Bauhaus, was to revive visual possibilities by incorporating previously neglected or disregarded artistic modes of expression from orna-ment and illustration, fine art and folk art (cf. no. 14).

5 Klaus Lankheit, *Der Blaue Reiter . . . Dokumentarische Neuausgabe*, Munich 1979, p. 259.

Kandinsky and Gabriele Münter had become aware of Rousseau years earlier when they spent a year together in Paris and Sèvres in 1906–7 and Kandinsky had the opportunity to send his work regularly to the Salon des Indépendants. A letter to Marc of 2 November 1911 mentions this first encounter – probably at the Indépendants' exhibition from 20 March to 30 April 1907, where among other things Rousseau displayed his allegory on Peace (no. 41): 'I have only seen Rousseau on 1 occasion so far, 4 years ago in Paris (2 things that made a strong impression on me, but to my eyes at that time seemed rather accidentally here and there in form).'[6]

6 Meißner 1985, p. 483.

Kandinsky's painting *Railway at Murnau* was produced between the mentioned dates of 1907 and 1911 and bears evidence of the impression that the Frenchman had left in Murnau.[7] One only has to compare this with Rousseau's *View of Malakoff* (no. 45), dated 1908, to confirm the correspon-dences between the works of two such different artistic characters. They both involved themselves with the technical achievements of their time, almost simultaneously and in similar formal rhythms. On his path towards 'great abstraction' Kandinsky still paid clear tribute in 1909 to 'great realism' in his picture of the Munich–Garmisch railway line that ran past the grounds of the house in Murnau in which he and Gabriele Münter were living, with the castle and parish church higher up, as well as the telegraph poles whose artistic use Theodor Däubler first determined in the work of Rousseau.[8]

7 Rosel Gollek, *Der Blaue Reiter im Lenbachhaus München*, Munich 1982, no. 113.

8 Däubler 1916, p. 123.

229

The Avenue in the Park at Saint-Cloud
L'Allée au parc à Saint-Cloud

The view, formulated leaf by leaf, in which a central perspective – further strengthened by the opposed triangle of sky – is crucial (cf. nos 34, 40, 48, 50), gives the effect of a solemn backcloth for the Baroque stage. Slightly off the symmetrical axis, it centres on garden architecture in a faded pink that, admittedly, has little to do with the tower monument, already destroyed in 1870, that Certigny proposed as the model.[1] The spatial distance is marked out on both sides by a line of nine tree-trunks. Their mass, lit from the right, is kept flat like stage wings and throws long shadows horizontally across the picture surface. The trunks in their serial sequence bear a massive roof of leaves whose uniformity dominates the picture. The diverse individual green brushstrokes tending towards yellow add up to the sum total of an exemplary foliage. The often-invoked additive elements in Rousseau's work that make a mockery of all naturalism are however only one aspect of his leanings towards abstraction. In the foreground of his artistic endeavours there always stood the need to incorporate every detail into the overall appearance with a clearly determined function. Only in this way was the intensity of pictures achieved that allowed no return to naturalism.

Some of the little supernumeraries in black and red, fixed to their spot, function as people out for a stroll. Their coming and going leaves no trace and is not comprehensible in the sequence of movements. Presumably the artist has again included himself in the Sunday ritual of the promenade (cf. nos 44, 51, 52), a nineteenth-century invention for the blasé idler and the dressed-up extended family that had become a welcome leisure activity. Seeing and being seen was of social importance for the ladies and gentlemen promenading with parasol and reticule or hat and stick. The resolute nature of the layout favours a late date for this picture, which was bought by Frankfurt's Städtische Galerie as early as 1926.

c. 1908
Oil on canvas
46.2 × 37.6 cm
Signed bottom right: H Rousseau
Städtische Galerie im Städelschen Kunstinstitut, Frankfurt am Main
(Inv. No. SG 404)

1 Certigny 1984, p. 170.

Provenance: Pauline Kowarzik, Frankfurt am Main.

Bibliography: Kolle 1922, ill. 15; Eichmann 1938, p. 307; Courthion 1944, ill. XLIII; Uhde 1948, ill. 15; Lo Duca 1951, ill.; Bouret 1961, p. 103, ill. 22; Certigny 1961, p. 230; Vallier 1961, ill. frontispiece; Salmon 1962, p. 38, ill.; Vallier 1969, p. 63, ill. XLVII, p. 108, no. 219A, ill.; Bihalji-Merin 1971, p. 110, ill. 10; Jakovsky 1971, p. 29, ill.; Descargues 1972, p. 115, ill.; Ernst Holzinger – Hans Joachim Ziemke, *Kataloge der Gemälde im Städelschen Kunstinstitut Frankfurt am Main*, Frankfurt 1972, p. 321, ill. 277; Bihalji-Merin 1976, p. 143, ill. 15; Keay 1976, pp. 35, 135, ill. 33; Alley 1978, p. 40, ill. 32; Stabenow 1980, pp. 184, 225; Le Pichon 1981, p. 109, ill.; Certigny 1984, pp. 168, 170 f., no. 87, ill.; Rousseau 1986, p. 11, ill.; *ReVision: Die Moderne im Städel 1906–1937*, Städtische Galerie im Städelschen Kunstinstitut, Frankfurt am Main 1991, p. 112, ill.

Exhibitions: Basel 1933, no. 28; *Henri Rousseau*, XXV Biennale, Venice, 1950, p. 235, no. 6; *Maler des einfältigen Herzens*, Museum am Ostwall, Dortmund 1952, no. 2; Paris 1961, no. 36; *Französische Malerei von Delacroix bis Picasso*, Stadthalle, Wolfsburg 1961, no. 136, ill. 22; Paris 1964, no. 10, ill.; Rotterdam 1964, no. 10, ill.; Munich – Zurich 1974–75, no. H.14, ill.; Paris 1984–85, pp. 208 f., no. 44, ill., p. 228; New York 1985, pp. 200 f., no. 44, ill., p. 224.

THE AVENUE IN THE PARK AT SAINT-CLOUD

Walking in the Parc des Buttes-Chaumont
La Promenade au parc des Buttes-Chaumont

Rousseau's landscapes are richer in variety than his portraits and still-lifes. Rapidly sketched initially, they were then worked up layer by layer in thin applications of paint; finally pigment was applied *impasto* with the pointed brush. A *pièce de résistance* of this type depicts a family taking a stroll: the father, a soldier in red trousers, black jacket with red epaulettes and red cap, is holding the hand of the child with a hoop, while the mother has gone on ahead. Their path is cut as straight as a die into the neatly painted lawn. The blue of the sky and the autumnal yellow – interspersed with reddish brown – of the leaves on the tidily trimmed trees are supplemented by the evergreen of the tall, cypress-like conifers. The picture needed the horizontal line on the right, suggesting a wide view, in order to balance out the heavily emphasised verticals.

The Buttes-Chaumont are hills in the north-eastern industrial region of Paris. The park laid out there in 1863–67 at the behest of Napoleon III on the basis of plans drawn up by the engineer J.-C. Alphaud was intended to contribute to the renovation of the unhealthy district and complete the chain of green spaces in and around the city (cf. nos 23, 48). The three figures have walked along the avenue that leads to a central lake and are now standing in front of a cave-like tunnel constructed artificially from rocks.

A receipt verifies that Rousseau sold the landscape to Vollard: 'Received from M. Vollard the sum of 50 francs for a painting (Buttes-Chaumont) Paris the 30 8ber [October] 1909 H. Rousseau.'[1] The art dealer sold the picture shortly thereafter to Serge Jastrebzoff, as the latter loaned the work for the Rousseau retrospective organised in 1911 within the framework of the 27th Salon des Indépendants. The loan was exhibited in the Salle Rousseau there under the title *Paysage, Buttes-Chaumont*.

1908–9
Oil on canvas
46.2 × 38.4 cm
Signed bottom right: H Rousseau
Setagaya Art Museum, Tokyo

1 Certigny 1984, p. 630.

Provenance: Ambroise Vollard, Paris (from October 1909); Serge Jastrebzoff, Paris (from 1910/1911 to 1922); Léon Giraud, Paris (from 1923); Antoine Villard, Paris; Madame E. Villard, Paris; Galerie Bernheim Jeune, Paris; Sotheby's London, 3 December 1975, lot no. 64; Sotheby's London, 26 March 1985, lot no. 14.

Bibliography: Delaunay 1920, p. 230, ill.; Grey 1922, ill.; Zervos 1927, ill. 52; Grey 1943, ill. 72; Courthion 1944, ill. VI; Gauthier 1949, ill. VIII; Lo Duca 1951, p. 5, ill.; Bouret 1961, p. 188, ill. 81; Vallier 1961, ill. 142; Vallier 1969, pp. 102, 108 f., no. 220, ill., p. 116; Le Pichon 1981, p. 110, ill.; Certigny 1984, pp. 536, 630 f., no. 295, ill.; Werner 1987, ill. in connection with no. 24.

Exhibitions: Paris 1911, no. 8; Paris 1923, no. 1; Basel 1933, no. 14; *Les Maîtres de l'Art Indépendant*, Petit Palais, Paris 1937, no. 3; *Exposición de Pintura Francesca*, Museo Nacional de Bellas Artes, Buenos Aires 1939, no. 191; *Exposición de Pintura Francesca*, Comisión Nacional de Bellas Artes, Montevideo 1940, no. 38; *Exposiciao de Pintura Francesca*, Museo Nacional de Bellas Artes, Rio de Janeiro 1940, no. 158; *Masterpieces of French Art lent by the Museums and Collectors of France*, Art Institute, Chicago 1941, no. 138; *The Painting of France since the French Revolution*, DeYoung Memorial Museum, San Francisco 1941, no. 191; Setagaya 1996, p. 37, no. 4, ill.

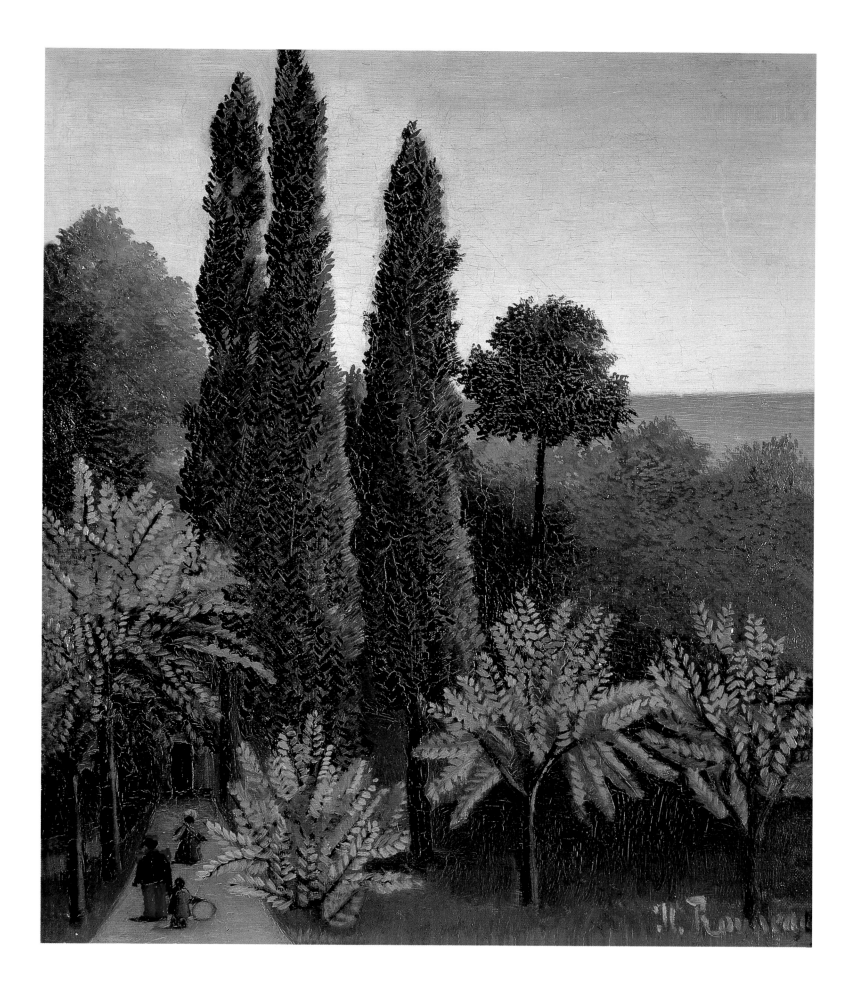

WALKING IN THE PARC DES BUTTES-CHAUMONT

Walking in the Parc Montsouris
La Promenade au parc Montsouris

Rousseau's realistic landscapes, observed from nature, affect as fantastical a manner as the fantasy jungle scenes appear to be realistic. The poetic power of Rousseau's imagination was able to do both: transport the close at hand of the urban periphery far away from everyday life and bring close the remote with every sign of being lost in a dream. The sole deciding factor in each case was the intensive formalisation of the theme of nature, which allowed virgin forests to proliferate into something monstrous and made parks the embodiment of domesticated nature.

c. 1909
Oil on canvas
46 × 38 cm
Signed bottom left: H. Rousseau
State Pushkin Museum of Fine
Arts, Moscow
(Inv. No. 3332)

The path through the park being followed by a few people on an outing has always been associated with the Parc Montsouris without it having been possible to pinpoint the locality precisely (cf. no. 23). The attempt to open up the space by a central perspective through the line of the path, the fences and walls, as well as the pronounced colouring, leads us to believe this is a late work by the painter. Such a conclusion is also suggested by the imbalance between, on the one hand, the pairs of pedestrians in which the male partner again boasts the black, red and gold of a uniform and, on the other, the mighty backdrop of the trees (cf. nos 46, 47, 49).

Certigny suspected that the composition, sold by Ambroise Vollard in 1913 to the Russian industrialist Sergej Schtschukin, a major collector of French painting of the nineteenth and early twentieth centuries, was produced on the basis of a 'first version' conceived in the mid 1890s in response to the art dealer's urging when the demand for Rousseau's works increased in 1909.[1] This theory is unconvincing because, even faced with increasing demand and a certain amount of pressure from Vollard, Rousseau would hardly have gone back to a work after such a long interval to develop a revived version from it. Dora Vallier was certainly justified in classifying the 'precursor model'[2] that turned up in 1922 as one of the numerous doubtful works.[3]

1 Certigny 1984, no. 118.

2 Kolle 1922, ill. frontispiece.

3 Vallier 1969, no. L 49.

Provenance: Ambroise Vollard, Paris; Sergej Schtschukin, Moscow (1913–18); Museum of Modern Western Art, Moscow.

Bibliography: Bouret 1961, p. 191, ill. 89; Vallier 1961, ill. 163; Vallier 1969, pp. 112 f., no. 245, ill.; Bihalji-Merin 1971, p. 118, ill. 18; Bihalji-Merin 1976, pp. 24, 73, ill. 20; Keay 1976, p. 65, ill. IX; Le Pichon 1981, p. 58, ill.; Certigny 1984, pp. 238, 644 f., no. 301, ill.; Stabenow 1994, p. 46, ill.; State Pushkin Museum of Fine Arts. *Catalogue of Painting*, Moscow 1995, p. 391, no. 3332, ill.

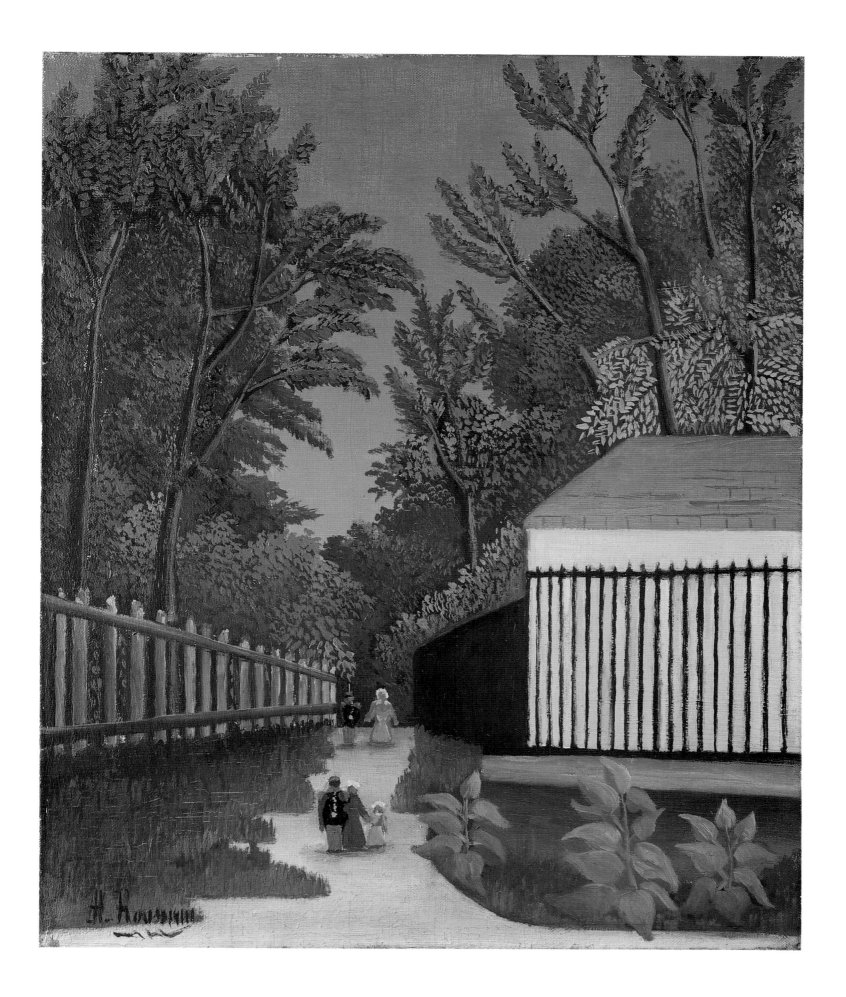

WALKING IN THE PARC MONTSOURIS

Landscape on the Banks of the Bièvre at Bicêtre, Spring

Paysage des bords de la Bièvre près Bicêtre printemps

49

The title of the picture is recorded together with the additional remark '23 février 1909 H. Rousseau' on a label attached to the stretcher. The date may refer either to the completion of the painting towards the end of February 1909 or to its date of purchase by the art dealer Vollard, who was Rousseau's main customer in the last years of his life.[1] Whatever the case, the masterly distribution of the large-scale and small-scale as well as the advanced abstraction tendencies suggest a late date for the spring landscape. If it was created in the winter of 1909, then this could have been done with the aid of a study (no longer extant) sketched in the Bièvre Valley the previous year, from which Rousseau then worked in his studio without regard to the actual season (cf. no. 23).

A few trees entwined to form an arabesque and their acacia-like, pinnate foliage overlie a landscape detail from the Ile de France. While the foreground made up of paths and meadows and traversed by the river is minimalised into an ornamental striped pattern, the foliage behind, with its yellow and reddish-brown highlights, seems all the richer. The trees at the sides of the path tower gigantically over the picture by comparison with the four small figures dressed in peasant fashion who open up the space (cf. nos 46–48). They determine the composition through their size and their uniform olive green that darkens from right to left. A horizontal counterbalance to the eel-smooth coils of the predominantly denuded trunks is provided through the heavily schematised barrier of a fence whose lifeless black is repeated in the chimneys and dark window sockets of the two houses as well as in the horizontal lines of rounded arches of the Arcades des Buc, an aqueduct that crosses the valley of the Bièvre. Built after the Roman model in the reign of Louis XIV and restored under Napoleon III, it supplied water for the fountains and water features in the park at Versailles.

1908–9
Oil on canvas
54.6 × 45.7 cm
Signed bottom right: H Rousseau
The Metropolitan Museum of Art, New York
Gift of Marshall Field, 1939
(Inv. No. 39.15)

1 Certigny 1984, p. 536.

Provenance: Ambroise Vollard, Paris; Alex Reid and Lefevre, London (until 1936); Etienne Bignou, Paris – New York (1936); Marshall Field, New York (1936–1939).

Bibliography: Basler 1927, ill. XXIV; Zervos 1927, ill. 31; H.B. Wehle, in *Metropolitan Museum of Art Bulletin*, XXXIV, 1939, p. 64, ill.; Rich 1942, p. 57, ill.; Grey 1943, ill. 76; D. Cooper, 'Henri Rousseau: artiste peintre', *The Burlington Magazine*, LXXXIV–LXXXV, July 1944, p. 159, ill., p. 164; Uhde 1948, ill. 40; Cooper 1951, p. 56, ill.; Lo Duca 1951, p. 12, ill.; Bouret 1961, p. 135, ill. 38; Vallier 1961, ill. 92; Salmon 1962, p. 58, ill.; Charles Sterling – Margaretha M. Salinger, *French Paintings: A Catalogue of the Collection of the Metropolitan Museum of Art,* New York 1967, pp. 167 f., ill.; Vallier 1969, p. 40, ill. XXIV, p. 102, no. 162, ill.; Bihalji-Merin 1971, pp. 37, 114, ill. 14; Bihalji-Merin 1976, pp. 24, 67 f., ill. 15; Keay 1976, p. 97, ill. XXV; Werner 1976, p. 10; Stabenow 1980, p. 185; Certigny 1984, pp. 536 f., no. 256, ill.; Certigny 1991, p. 22; Müller 1993, pp. 107, 189; Stabenow 1994, pp. 41, 47, ill.; Schmalenbach 1998, p. 85, ill.

Exhibitions: Chicago – New York 1942; *Henri Rousseau*, XXV Biennale, Venice 1950, p. 235, no. 19; Paris 1961, no. 63, ill.; Paris 1964, no. 21, ill.; Rotterdam 1964, no. 21, ill.; Paris 1984–85, pp. 226 f., no. 53, ill.; New York 1985, pp. 222 f., no. 54, ill.

236

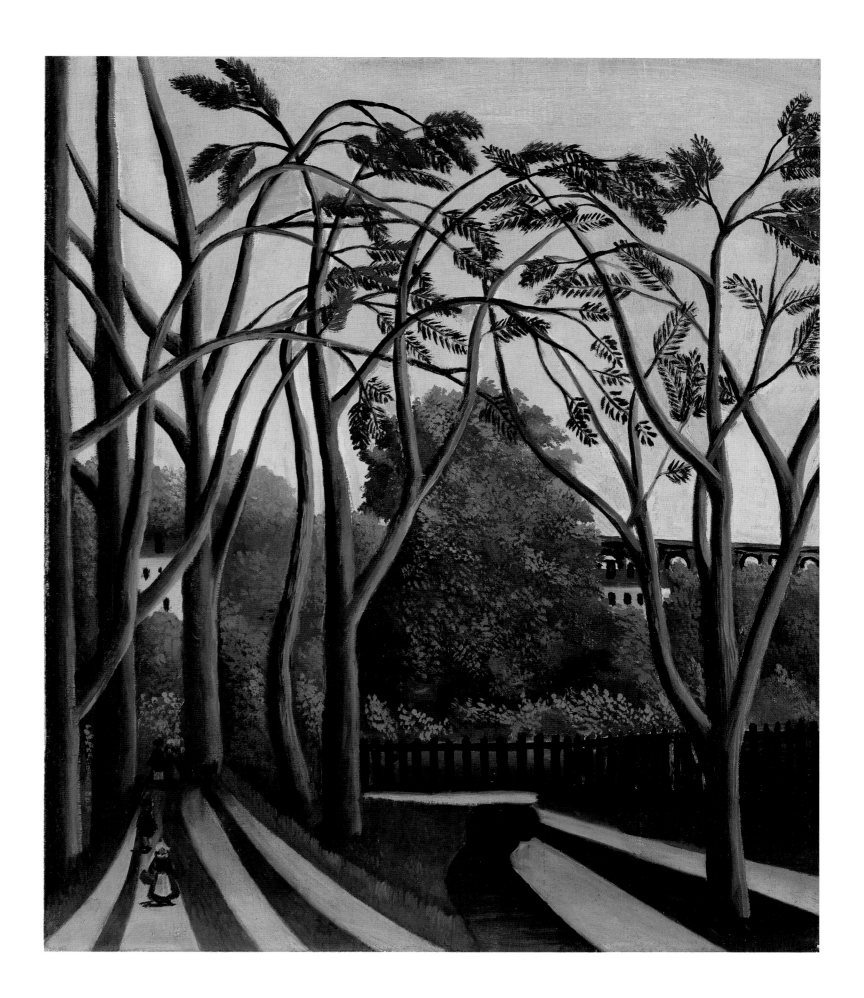

LANDSCAPE ON THE BANKS OF THE BIÈVRE AT BICÊTRE, SPRING

FERNAND LÉGER MAN WITH DOG

Fernand Léger
Man with Dog

Forms and content with clear references to the work of Rousseau crop up regularly in Léger's œuvre.[1] The two artists shared the same feeling for the solidity of things and their formulistic effects, for richly contrasted colouring without transition, for meticulously stamped contours and an emphasis on the parallelism of planes. Although Léger's mechanised world view following the First World War was based on a different temporal horizon of experience, Rousseau in many ways anticipated its prosaic nature. His use of smoking chimneys, airships and aeroplanes, iron bridges, the Eiffel Tower and telegraph poles set priorities that were also seen as such by Léger (cf. nos 24, 39, 44, 45).

Léger's landscape with 'man and dog' looks as though it were designed on the drawing board and – as a product of the machine age – shaped, filed, polished and finished on the lathe.[2] Admittedly, the rural idyll of hills, trees and clouds, houses and pathways is unambiguously put into question by the first few letters of the word 'commerce'. The perfection proper to machinery is joined at the beginning of the 1920s by the insistent, persuasive aesthetics of advertising. Their joint product is the beauty of denaturised modern life, which may crop up in signal-bright colours or in the grey-on-grey of grisaille. As in Rousseau's work, the leafless tree trunks snake upwards, fat and dark green, and the anonym reminds one of the strange clumsiness of the Douanier's faceless supernumerary figures. This 'new man' stands as a manipulable, robot-like object within the geometrised order of his environment.

1921
Oil on canvas
60 × 92 cm
Signed and dated bottom right:
F.LEGER/21
Private collection

1 Lanchner – Rubin 1984–85, pp. 71 ff., 62 ff.

2 Georges Bauquier, *Fernand Léger. Catalogue raisonné de l'œuvre peint, 1920–1924*, Paris 1992, no. 264.

Study, View of the Palais du Métropolitain 50
Esquisse, vue du Palais du Métropolitain

The somewhat smaller painting that was worked up from this spirited sketch and that Uhde published in 1914 under the title *Ausblick vom Quai d'Auster-litz* bears on its back a label with the inscription 'Vue prise côté gauche . . . gare d'Austerlitz août 1909 Henri Rousseau'.[1] The reference is to the time it was produced in the summer of 1909 and the illustrated locality at the Gare d'Austerlitz. Located on the left bank of the Seine, this station lies close to the Jardin des Plantes, to which Rousseau was a frequent visitor.

According to Certigny, the building depicted is the Palais du Métro-politain, which formerly lay between the Gare d'Austerlitz and the Quai d'Austerlitz. The road along which three black hackney carriages are travel-ling leads to the multi-storey central projection of the railway company's administration building, built c. 1900 and demolished in the 1970s. A factory chimney partially hidden behind the trees, its smoke rising above the foliage into the sky of white and grey clouds, is part of the extensive industrial complexes in the area.

The first owner of the sketchily painted wooden board was Robert Delaunay who, after the artist's death, primarily bought sketches from his estate (cf. no. 23). He lent this one for the Rousseau retrospective that he organised in 1911.

1909
Oil on wood
27 x 22 cm
Private collection

1 Vallier 1969, no. 231A; Certigny 1984, no. 283.

Provenance: Robert Delaunay, Paris (from 1910); Franz Meyer senior, Zurich.

Bibliography: Uhde 1911, ill. 22; Uhde 1914, ill.; Zervos 1927, no. 81, ill.; Grey 1943, ill. 86; Bouret 1961, p. 242, ill. 222; Vallier 1961, ill. 161; Vallier 1969, p. 110, no. 231B, ill.; Certigny 1984, pp. 604 f., no. 282, ill., p. 606; Stabenow 1994, p. 36, ill., p. 42.

Exhibitions: Paris 1911, no. 42; Paris 1912, no. 23; Berlin 1913 (?), Paris 1984–85, pp. 228 f., no. 54, ill.; New York 1985, pp. 224 f., no. 55, ill.

STUDY, VIEW OF THE PALAIS DU MÉTROPOLITAIN

HENRI MATISSE VIEW OF NOTRE-DAME FROM THE PAINTER'S STUDIO WINDOW

Henri Matisse
View of Notre-Dame from the Painter's Studio Window

While his two students, the American Max Weber (cf. no. 34) and the Hungarian-born sculptor and art dealer Joseph Brummer, saw it as part of their task to make Rousseau's work known, Matisse kept his distance.[1] He was not among the inner circle around the 'Douanier'. There may even have been a certain animosity between the two since we learn from Weber's friend Adolphe Basler that, although most of Matisse's students shared Weber's admiration for Rousseau, Matisse's attitude towards Rousseau's 'guileless painting' was indifferent, even hostile.[2] According to Hélène d'Oettingen, alias Roch Grey, who supported Rousseau and collected his work, Matisse was the only artist whom he did not like: 'Matisse annoyed him . . . "If only it were amusing at least! But, my love, it is sad, it is dreadfully ugly!".'[3]

Rousseau would certainly also have branded this view from Matisse's studio on the Quai Saint-Michel as ugly. It would have been too far removed from that completeness of picture that he himself strove to achieve. Nevertheless Rousseau must have been familiar with examples of the Parisian views produced by Matisse and Marquet from 1900 onwards. Matisse had exhibited at the Salon des Indépendants since 1901, he had his first solo exhibition at the Galerie Vollard in 1904, and at the Salon d'Automne of 1905 he was the central figure – together with Derain and Vlaminck – in the scandal surrounding the new, notorious 'Fauves' (wild beasts) (cf. no. 33). It must have been no accident that in his pictorial studies Rousseau orientated himself towards the sketch-like manner of painting of the latest artistic development at the start of the century, represented by Matisse, and that he chose similar city motifs (cf. nos 23–25, 50, 51).

1902
Oil on canvas
46.5 x 55 cm
Signed bottom right:
Henri Matisse
Private collection

1 According to Rubin, Rousseau seems to have been of interest to Matisse up until 1906. – Rubin 1984, p. 295.

2 Basler 1927, p. 10.

3 Roch Grey, 'Souvenir de Rousseau', in Apollinaire 1914, p. 68.

Study, View of the Île Saint-Louis from the Quai Henri IV

Esquisse, Vue de l'île Saint-Louis prise du Quai Henri IV

Rousseau, who domesticated urban nature into a park, who tamed the river into a canal and reduced avenues to road lines, reconnoitred Paris from its margins. Following the Seine as the main artery, he orientated himself from the outer districts towards the interior. This approach of the provincial from the west was completely different from that of his supporter from the south, the Albigensian Toulouse-Lautrec. Despite his origin, the aristocrat's interest in people concentrated on the Parisian milieu, whereas the custom's employee kept his distance from the bustle of the city and its people. Starting from the basis of his field of activity, the outsider saw the metropolis from its edges as a distant vision of an urban ensemble.

If one compares the sketch with the completed painting (no. 52), it is noticeable that nothing remains of the initial impetus that would have done honour to the Fauvists Matisse and Marquet (pp. 242 f.), indeed that starting point and destination are far apart (cf. no. 23). The sketch Rousseau made when faced with the darkened city silhouette, viewed against the light, and a diffuse Parisian sky served purely as a memory aid for the resulting picture polished in the studio. The discrepancy between the study revelling in suggestion and the definitive solution could not be greater, whereby the latter's perfected form may appear less real to the present-day viewer than its sketchy precursor.

The individual stages of development of Rousseau's procedure reveal how he perfected his compositions by means of additions and deletions, and with what a feeling for tonal sequence he determined the palette. Anything but unconsciously, he had a precise idea when he set out to realise his pictures, whose totally painted-over surfaces leave us with no sense of the preliminary studies – whether these were sketches, preparatory drawings or underpaintings on the canvas.

1909

Oil on board (mounted on canvas)

21.8 x 28.1 cm

Musée du Vieux-Château, Laval

(Inv. No. 94.114.1)

Provenance: Wilhelm Uhde, Paris (from 1910); Ferargil Galleries, New York; Arthur B. Davies, New York; auctioned at American Art Galleries, New York, 17 April 1929, lot no. 360; Julius H. Weitzner; Henry D. Sharpe, Providence; Mrs Henry D. Sharpe, Providence; Brown University, Providence; Christie's New York, 3 November 1982, lot no. 43; private collection, New York; Christie's New York, 11 May 1994, lot no. 162.

Bibliography: Rich 1942, pp. 58, 60, ill.; Bouret 1961, p. 240, ill. 218; Certigny 1961, ill.; Vallier 1961, p. 124, ill. 24; Vallier 1969, p. 110, no. 228B, ill.; Alley 1978, p. 44, ill. 35; Certigny 1984, pp. 608 f., no. 284, ill.; Stabenow 1994, p. 35, ill., p. 42; M.-C. Depierre, 'Acquisition, Vue de l'île Saint-Louis prise du quai Henri IV (esquisse) d'Henri Rousseau', *Revue du Louvre*, 2, 1995, pp. 86 f., ill.; Marie-Colette Depierre – Claire Bandry, *Le Guide de la collection d'Art Naïf, Musée du Vieux-Château Laval*, Laval (1996), pp. 30 f., ill.

Exhibitions: Paris 1911, no. 30; Chicago – New York 1942; Paris 1961, no. 68; New York 1963, no. 57, ill.; Paris 1984–85, pp. 238 ff., no. 58, ill.; New York 1985, pp. 42, 234 ff., no. 59, ill.

View of the Île Saint-Louis from the Quai Henri IV

Vue de l'île Saint-Louis pris du quai Henri IV

Nowhere did Rousseau convey his view of the unified townscape more convincingly than in this depiction of the Seine with the Ile Saint-Louis and the Ile de la Cité. Painted in the summer of 1909 and acquired by Robert Delaunay in 1910, it has a signature set conspicuously on the road surface and an unmistakable figural mark. Dressed in the usual black suit with hat and stick, the painter has once again placed himself in the picture as a silent observer (cf. nos 44, 46). The observer accentuated against the base of the light quay wall himself becomes an object of observation and incidentally also a symbol for the isolation of the modern artist. After the apotheosis that had exaggeratedly elevated *I Myself* against the backdrop of the metropolis from a low viewpoint (ill. p. 138), the way in which Rousseau now saw himself was limited to the role of the ubiquitous watcher who remains anonymous. Just as Alfred Jarry conducted himself like the *Père Ubu* he had called into being (pp. 31 f.), so Rousseau made himself an integral component of the scene, both figurally and in writing. As a supernumerary in his own pieces, he led the way into the complex structure of his topographies. In this case his viewpoint was the Quai Henri IV, cutting across on the diagonal, where four black rings, used to fasten ships' ropes, take the eye to the moored barge. At its mast a flag billows in the wind, its bright red blazing against the otherwise subdued colour range. The arches of the Pont de Sully, resting on light-coloured piers, are a horizontal reaction to the pronounced verticals. The iron construction of the bridge, under which the next pier shows up as brown, crosses the Seine from the Rive Gauche to the southern tip of the Ile Saint-Louis. The latter's house facades on the Quai de Béthune are seen on the right. If we follow the gaze of the figure shown in rear view, then it is wandering across to the Ile de la Cité, where the apse and massive transept of the Cathedral of Notre-Dame are surmounted by the two stumps of towers and the pointed roof turret. To the left of them we see the buildings of the Prefecture of Police.

1909
Oil on canvas
33 x 40.6 cm
Signed and dated bottom right:
H Rousseau / 1909
The Phillips Collection,
Washington DC
(acquired in 1930, Inv. No. 1964)

Provenance: Robert Delaunay, Paris (from 1910); Paul Guillaume, Paris (from 1927).

Bibliography: Uhde 1911, ill. 6; Uhde 1914, ill.; Grey 1922, ill.; Kolle 1922, ill. 19; Basler 1927, p. 30, ill. XV; Salmon 1927, ill. 38; Soupault 1927, ill. 34; Zervos 1927, ill. 79; Rich 1942, pp. 58, 61, ill.; Grey 1943, p. 48, ill. 67; Courthion 1944, pp. 18, 29, ill. XXXII; Cooper 1951, p. 56; Lo Duca 1951, p. 11, ill.; Bouret 1961, p. 149, ill. 45; Certigny 1961, ill.; Vallier 1961, p. 125, ill.; Vallier 1969, p. 68, ill. LII, p. 110, no. 228A, ill.; Bihalji-Merin 1971, p. 111, ill. 11; Jakovsky 1971, p. 30, ill.; Descargues 1972, p. 84, ill.; Bihalji-Merin 1976, pp. 24, 66, ill. 14; Keay 1976, p. 161, ill. 70; Werner 1976, pp. 42 f., ill.; Alley 1978, p. 45, ill. 36; Stabenow 1980, pp. 164, 184; Le Pichon 1981, p. 107, ill.; Certigny 1984, pp. 608, 610 f., no. 285, ill.; Werner 1987, no. 26, ill.; Certigny 1991, p. 22; Stabenow 1994, p. 34, ill.; Schmalenbach 1998, pp. 60 f., ill.

Exhibitions: Paris 1911, no. 34; Berlin 1913, no. 9; Chicago – New York 1942; New York 1951, no. 21; Baden-Baden 1961, no. 170, ill.; Paris 1961, no. 67, ill.; New York 1963, no. 58, ill.; Paris 1964, no. 23; Rotterdam 1964, no. 23; Paris 1984–85, pp. 81, 238, no. 59, pp. 240 f., ill.; New York 1985, pp. 42, 72, 234, no. 60, pp. 236 f., ill.; Tokyo 1985, no. 13, ill.

STUDY, VIEW OF THE ÎLE SAINT-LOUIS FROM THE QUAI HENRI IV

VIEW OF THE ÎLE SAINT-LOUIS FROM THE QUAI HENRI IV

AUGUST MACKE CATHEDRAL AT FRIBOURG IN SWITZERLAND

August Macke
Cathedral at Fribourg in Switzerland

Although the Rousseau connection was less relevant for August Macke than for Kandinsky and Marc, it nevertheless left traces on his work. Painted in spring 1914, this combination of technoid antenna mast and Gothic church tower, of large, relatively homogeneous surfaces and small-scale architectural elements would have been unthinkable without Rousseau's down-to-earth experience of objects, without his cubic conglomerations of houses and his feeling for serial structures. In the milder form of Macke's reflection, here Rousseau's views encounter those of Delaunay and there is a meeting between quiet surface patterns and abrupt spatial distortions, between the signals of the present and those of the past.

On 22 January 1912 Macke reported to Marc concerning his visit to the Blaue Reiter exhibition at the Gereonsklub in Cologne, where it was housed from 13 to 31 January 1912: 'I was at the Blaue Reiter exhibition on Saturday and Sunday. Very interested crowd there again, and there was a lot of talk about the pictures. Rousseau, Delaunay, Epstein, Kahler, Kandinsky, Campendonk and some of the Burljuks interested me most. I am thinking just now about how the Blaue Reiter does not reproduce me . . . Love of self, henpeckedness and blindness play a great role in the Blaue Reiter. The big words about the beginning of the great spiritual are still ringing in my ears. Kandinsky personally may say that and a lot more besides about radical change. I find that unpleasant, particularly after this exhibition. My advice to you is just to work without thinking too much about the Blaue Reiter and blue horses. The good Rousseau. And the good Helmuth.'[1] Marc responded the following day: 'One thing pleases me too, that you love the things by Rousseau; because when recently here in the presence of Dr Braune you took his side about the little Rousseau picture, I became quite sad inside.'[2] And Macke again acknowledged Rousseau's avant-garde role when he wrote to Herwarth Walden on 19 February 1913: 'In "Kunst und Künstler" recently Director Pauli also wrote so pityingly about Kandinsky and Picasso. So we stand like this. Here the hope of the century Beckmann, Rösler, Brockhusen, Cassierer [sic], Lehmbruck, Meier-Gräfe, Corinth, Paul etc. – There the idiots Kandinsky, Picasso, Marc, Kokoschka, Nolde, Delaunay, Heckel, Rousseau, Matisse, Walden, Däubler. Hurrah, I'm going stupid . . .'[3]

1914
Oil on canvas
60.6 x 50.3 cm
Kunstsammlung Nordrhein-Westfalen, Düsseldorf
(Inv. No. 139)

1 *August Macke – Franz Marc, Briefwechsel*, edited by Wolfgang Macke, Cologne 1964, pp. 96 f.

2 Ibid., p. 98.

3 Meißner 1985, p. 503.

Bouquet of Flowers with an Ivy Branch
Bouquet de fleurs à la branche de lierre

In 1897 Rousseau took part in an exhibition of the Société des Artistes Indépendants for the first time with a still-life, namely a bouquet of wild flowers. Three further *Bouquets de fleurs* followed, but not until 1902, 1903 and 1904. By comparison with the frequently shown landscapes, portraits and allegorical figure scenes, the still-life, which ranked lowest in the hierarchy of genres, was for him too a rather subordinate category – although, or perhaps because, all his works have something of the still-life about them. Limited with few exceptions (no. 55) to simple flower paintings, they served primarily to satisfy his customers' and creditors' wish to have a perpetually blossoming decoration in the room. Correctly gauging his specific clientele and their level of taste, the painter usually left it at rapid execution and the bare necessities by way of creative input. Indeed, he probably also had recourse to colour plates from the flower encyclopedias popular in the nineteenth century in laying out his flower arrangements.

The merchandise character of his artificial flower bouquets, eleven of which, according to Certigny (nos 54, 56, 57),[1] are known, has nothing to do with a magnificent display nor with the theme of transitoriness of their Baroque predecessors. The flatness of the table layout, vases and flowers leaves no scope for further interpretation in the sense of the symbolism of flowers, valid from time immemorial. The conventionally arranged presentations vary only with regard to the species selected and the colour combinations chosen to complement them. The indigenous garden plants – tulips, dahlias and forget-me-nots, hydrangeas, mimosa, begonias and pansies – cut from their natural environment, placed in vases and transplanted into the unreality of the picture were set against gathered curtains to become the props for a *nature morte*.

1909
Oil on canvas
45.4 × 32.7 cm
Signed and dated bottom left:
Henri Rousseau / 1909
Albright-Knox Art Gallery,
Buffalo, NY
Room of Contemporary Art Fund,
1939

1 Certigny 1984, nos 150, 151, 186, 207, 212, 290, 304, 311–14.

Provenance: Count Sandor, Budapest; A. Tooth and Sons Gallery, London; M. Knoedler and Co., London – New York.

Bibliography: Rich 1942, p. 63, ill.; Lo Duca 1951, ill.; Bouret 1961, p. 238, ill. 214; Vallier 1961, pp. 118, 121, ill.; Vallier 1969, pp. 110 f., no. 232 A, ill.; Jakovsky 1971, p. 34, ill.; Keay 1976, p. 157, ill. 65; Alley 1978, p. 72, ill. 61; Certigny 1984, pp. 380, 620, no. 290, ill.; Stabenow 1994, pp. 26 f., ill.

Exhibitions: *Contrasts and Affinities, four centuries of flower-peinting [sic]*, Tooth and Sons Gallery, London 1939, no. 35, ill.; Chicago – New York 1942; *Henri Rousseau*, XXV Biennale, Venice 1950, no. 18, ill. 58; New York 1951, no. 20; New York 1963, no. 55, ill.; Paris 1964, no. 25, ill.; Rotterdam 1964, no. 25, ill.; Paris 1984–85, pp. 222 f., no. 51, ill.; New York 1985, pp. 218 f., no. 52, ill.

Bouquet of Flowers with an Ivy Branch

Bouquet de fleurs à la branche de lierre

Closely related to the previous still-life, this flower painting in which, against all the laws of gravity, the ivy spray has slipped from the top to the front side of the table, must have been in Paul Guillaume's possession by 1927 at the latest, since he was named as the owner at that time.[1] The Parisian art dealer had the painting photographed for archival purposes and noted on the photo 'Salon des Indépendants 1902'.[2] And a *Bouquet de fleurs* was indeed exhibited at that Salon des Indépendants. Whether it really was this particular still-life, however, remains as doubtful as the evidence for the information jotted down a quarter of a century later.

As Rousseau always produced replicas or variations within a short space of time, it is unlikely that the *Bouquet of Flowers with an Ivy Branch* was exhibited in 1902 and that a new version of it, dated 1909, was made only some years later (no. 53). There are no differences in style or content that would make such a long interval plausible. Only in Rousseau's late period did the demand for still-lifes increase to such an extent that a version with a slightly altered structure, palette and selection of flowers based on the dated example would make sense.

1909
Oil on canvas
46.4 × 33 cm
Signed bottom left:
Henri Rousseau
The Museum of Modern Art,
New York
The William S. Paley Collection

1 Salmon 1927, p. 140 photographic evidence.

2 Certigny 1984, p. 380.

Provenance: Paul Guillaume, Paris; Marie Harriman Gallery, New York; William S. Paley, New York.

Bibliography: Basler 1927, ill. LIV; Salmon 1927, ill. 14; Soupault 1927, ill. 11; Zervos 1927, ill. 8; Rich 1942, p. 62, ill.; Grey 1943, ill. 40; Lo Duca 1951, p. 10, ill.; Bouret 1961, p. 131, ill. 36; Vallier 1961, ill. 174; Vallier 1969, p. 70, ill. LIV, pp. 110 f., no. 232 B, ill., p. 121; Keay 1976, p. 154, ill. 59; Le Pichon 1981, p. 240, ill.; Certigny 1984, pp. 380 f., no. 186, ill.; exhibition catalogues Paris 1984–85, p. 222, and New York 1985, p. 218.

Exhibitions: Basel 1933, no. 24; Chicago – New York 1942; Paris 1961, no. 33, ill.

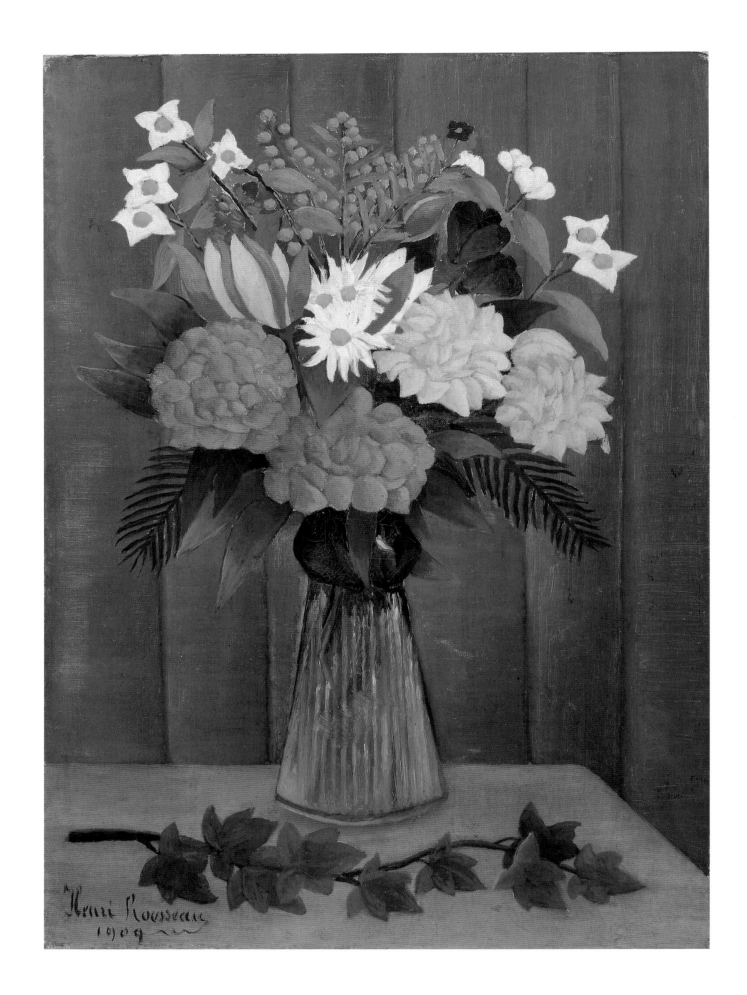

BOUQUET OF FLOWERS WITH AN IVY BRANCH

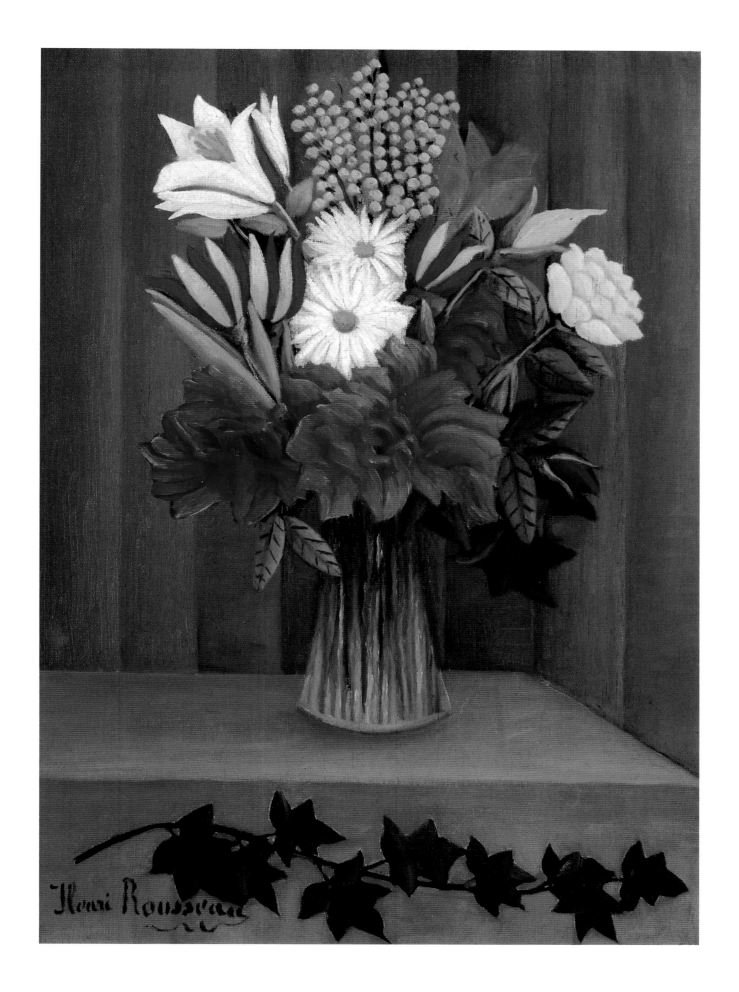

BOUQUET OF FLOWERS WITH AN IVY BRANCH

The Pink Candle
La Bougie rose

In addition to the rather uniform floral bouquets (nos 53, 54, 56, 57) just three so-called 'kitchen pieces' were made, which in art history occupy a modest position between the inventions of the early Baroque still-life specialist Georg Flegel of Frankfurt and the Rousseau admirer Giorgio Morandi. The latter was friendly with Ardengo Soffici, according to whom Rousseau – who already in August 1908 had given Max Weber a kitchen piece with pot, cherries and candlestick[1] – painted a still-life with coffee pot, fruit and oil lamp in the first week of April 1910.[2]

The Pink Candle should also be seen in this context. The candle on a table with a white covering is joined by a dark-green bottle of Benedictine with the red seal and the labels that are still customary today, some fruit and – mindful of the carpets in Cezanne's still-lifes – a red cloth patterned with black. Instead of a lavishly decked board at which one might have eaten one's fill, here we have nothing but a bare, frugal grouping that excludes anything culinary. The profusion of the Baroque still-life decorations that spilled over into the nineteenth century has been reduced to a few practical utensils and the burnt wick, as well as the rust-blackened, enamelled holder for the candle uniting the contrasts of red and white, permits no conclusions at all vis-à-vis the symbolism of the transitory that had been familiar ever since the start of still-life painting in the early seventeenth century.

1909-10
Oil on canvas
16.2 × 22.2 cm
Signed bottom left: H.Rousseau
The Phillips Collection,
Washington, D.C.
(acquired in 1930, Inv. No. 1695)

1 Vallier 1969, no. 216; Certigny 1984, no. 1.

2 Vallier 1969, no. 254; Certigny 1984, no. 308. Cf. Rousseau's letter to Soffici of 7 April 1910, in Apollinaire 1914, p. 58.

Provenance: Wilhelm Uhde, Paris; Etienne Bignou, Paris; R.A. Workman, London; Reid & Lefevre, London; M. Knoedler & Co., Inc., New York (1930).

Bibliography: Basler 1927, ill. LI; Zervos 1927, ill. 37; Rich 1942, pp. 52, 55, ill.; Courthion 1944, ill. II; Lo Duca 1951, p. 6, ill.; Bouret 1961, p. 217, ill. 156; Vallier 1961, ill. 126; Vallier 1969, p. 66, ill. L, p. 108, no. 221, ill.; Keay 1976, p. 147, ill. 47; Le Pichon 1981, p. 243, ill.; Certigny 1984, pp. 460 f., no. 227, ill. (with further literature references); Werner 1987, no. 16, ill.

Exhibitions: Paris 1911, no. 27 (?); Chicago – New York 1942; Baden-Baden 1961, no. 168, ill.; Paris 1964, no. 12, ill.; Rotterdam 1964, no. 12, ill.; Tokyo 1985, no. 11, ill.; *Meisterwerke aus der Phillips Collection*, Washington, Schirn Kunsthalle, Frankfurt am Main 1988, pp. 88 f., no. 36, ill.

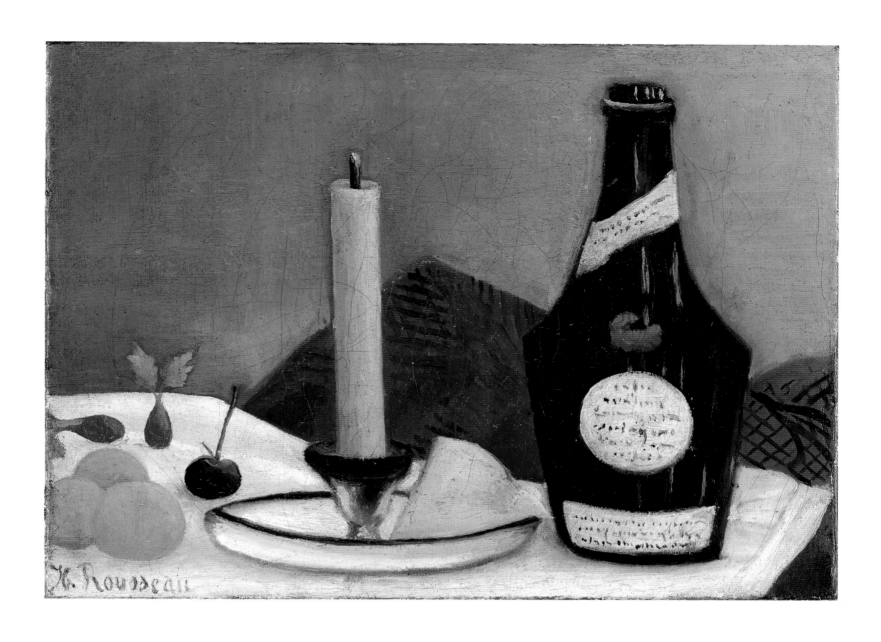

THE PINK CANDLE

Bouquet of flowers
Bouquet de fleurs

The flower painting, published in 1944, is a variation on the following still-life as regards the choice of flowers and colour palette.

1910
Oil on canvas
55 × 46 cm
Signed and dated bottom right:
Henri Rousseau/1910
Kunstmuseum Winterthur,
Winterthur
Permanent loan from a private
collection
(Inv. No. 1617)

Provenance: Claus Vogel-Sulzer, Zurich.

Bibliography: Courthion 1944, ill. XLVI; Bouret 1961, p. 246, ill. 230; Vallier 1961, ill. 179; Vallier 1969, pp. 111, 113, no. 257 A, ill., p. 118; Le Pichon 1981, p. 236, ill.; Certigny 1984, pp. 674, 676 f., no. 312, ill., p. 678; Certigny 1990, p. 13.

Exhibitions: Munich – Zurich 1974–1975, no. H27, ill. 76.

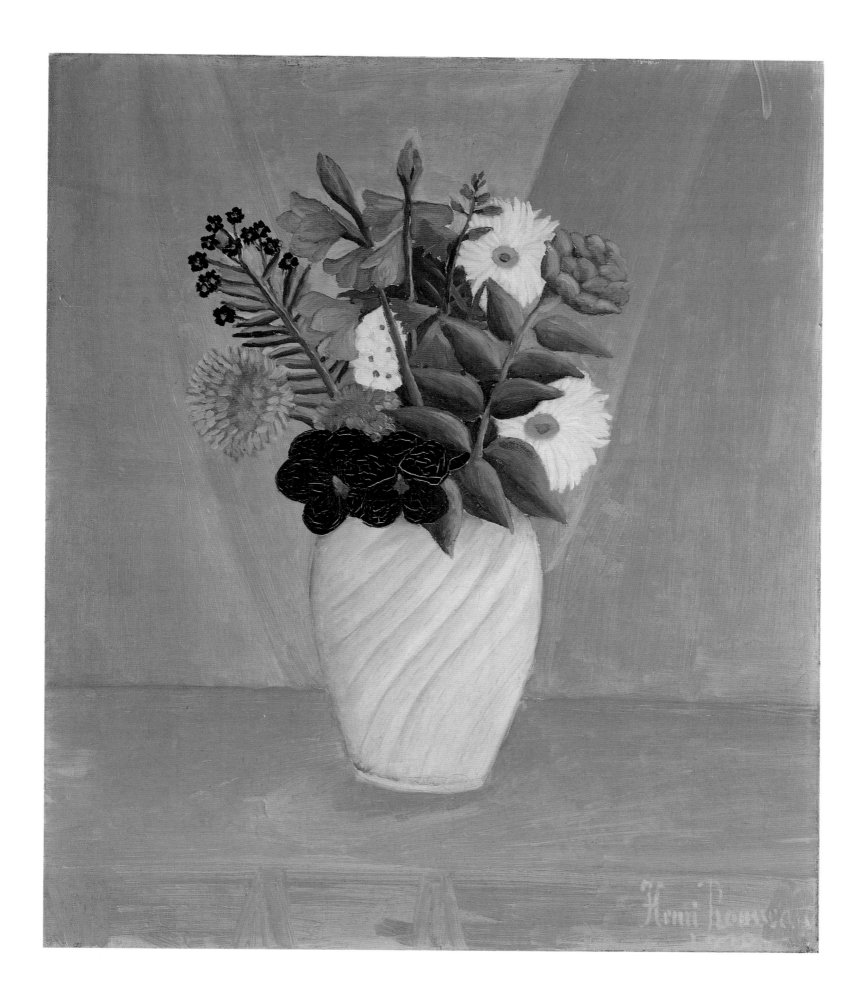

BOUQUET OF FLOWERS

Bouquet of Flowers
Bouquet de fleurs

Four similar-sounding flower paintings, almost identical in size, with the table top running right across, a curving curtain behind and a vase patterned with diagonal spirals survive from the last months of the artist's life.[1] Two of them are dated 1910 (see also no. 56). Identical in layout, the paintings differ only in their colouring and in the combinations of flowers. Dora Vallier starts from the assumption that the present *Bouquet* was painted in 1895–1900 and the three others more than a decade later. Apart from the fact that there is little difference stylistically between the four variations, Vallier's proposed date contradicts the above-mentioned practice of the artist to paint different versions one after the other at short intervals (cf. no. 54).

The floral arrangement completes the minimalistically simplified division of the picture in exemplary fashion. The group of flowers arranged in a diamond shape stands outs delicately against the salmon red of the curtain, based on the white of the vase and the red of the table. Red chrysanthemums, dark-edged pansies, a spray of yellow mimosa and blue forget-me-nots coordinate with the green of the leaves – in other words, homely balcony and house plants that had been employed earlier in the context of a portrait (no. 16).

1910
Oil on canvas
61×49.5 cm
Signed bottom right:
Henri Rousseau
Tate Gallery, London
Bequeathed by C. Frank Stoop,
1933 (Inv. No. 4727)

1 Vallier 1969, nos 115, 239, 257A, 257B; Certigny 1984, nos 311–314.

Provenance: Alfred Flechtheim, Düsseldorf; Bernheim Jeune, Paris (from 1921); Kurt Vollmoeller, Basel; C. Frank Stoop, London (from 1931).

Bibliography: Grey 1922, ill.; Kolle 1922, ill. 55; J.H. Johnstone, 'La Collection Stoop', *L'Amour de l'art*, June 1932, p. 198, no. 20, ill., p. 201; Courthion 1944, ill. XLVIII; Uhde 1948, ill. 22; Wilenski 1953, pp. 14 f., ill. 6; Ronald Alley, *Tate Gallery Catalogues: The Foreign Paintings, Drawings and Sculptures*, London 1959, p. 122, ill. 8; Charles Sterling, *Still Life Painting: From Antiquity to the Present Time*, New York – Paris 1959, p. 119, ill. 106; Bouret 1961, p. 101, ill. 21; Vallier 1961, p. 141, ill. 51; Shattuck 1963, p. 97; Vallier 1969, p. 99, no. 115, ill., p. 101; Bihalji-Merin 1971, pp. 78, 142, ill. 43; Jakovsky 1971, p. 34, ill.; Bihalji-Merin 1976, pp. 123 f., ill. 34; Keay 1976, p. 79, ill. XVI; Werner 1976, p. 11; Alley 1978, p. 78, ill. 66; Ronald Alley, *Catalogue of the Tate Gallery's Collection of Modern Art other than Works by British Artists*, London 1981, pp. 666 f., ill.; Le Pichon 1981, p. 237, ill.; Vallier 1981, p. 77, ill.; Certigny 1984, pp. 678, 680 f., no. 314, ill.; Werner 1987, ill.; Certigny 1990, p. 13; Stabenow 1994, pp. 26, 29, ill.

Exhibitions: Basel 1933, no. 25; Paris 1964, no. 26, ill.; Rotterdam 1964, no. 26, ill.; *De Grote Naiven*, Stedelijk Museum, Amsterdam 1974, no. 6, ill.; Paris 1984–85, pp. 154 f., no. 21, ill.; New York 1985, pp. 146 f., no. 21, ill.

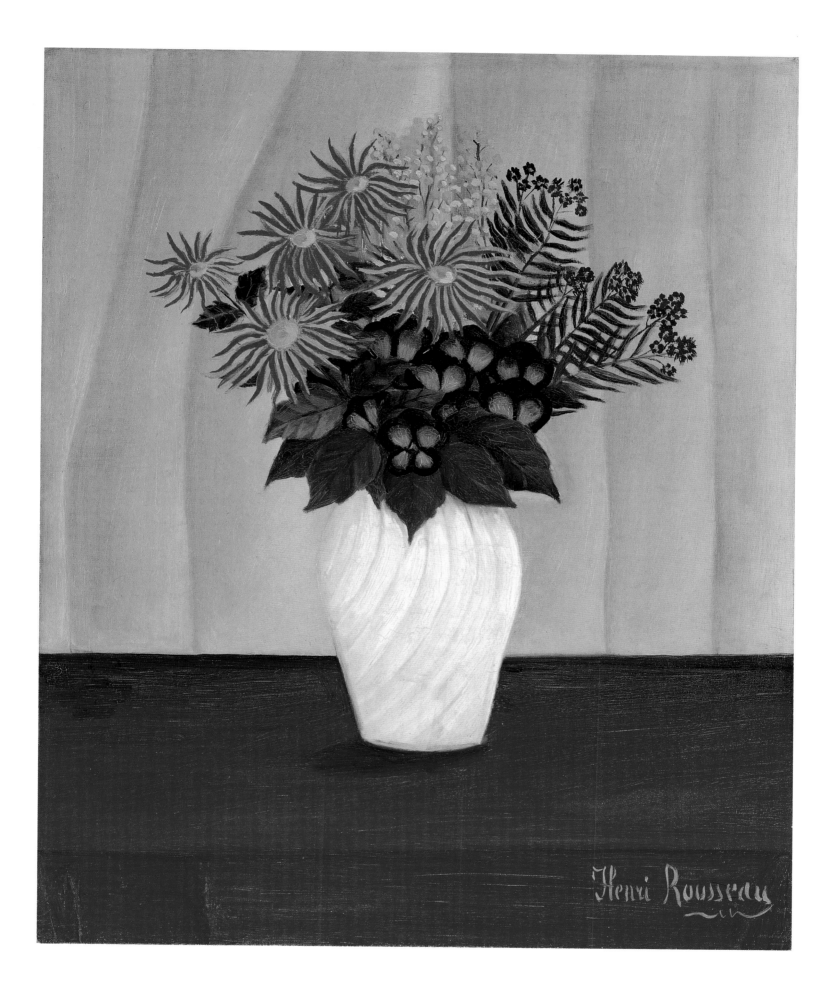

BOUQUET OF FLOWERS

Tropical Forest with Apes and Snake
Forêt tropicale avec singes et serpent

What is going on in this jungle among whose branches five apes romp is not quite as peaceful as it may appear. Armed with net and rod, the larger apes have set themselves down beside a pond to catch fish. Through visual contact they are holding in check the aggression of a huge, dark-skinned snake which is up to no good behind a barrier of red foliage, effectively positioned in the picture like a screen, and which introduces a note of menace into the play of the gibbons and macaques. Once again the ever more impenetrable all-over design of trunks and branches, twigs, leaf forms and calyxes shows itself from its dreamlike and dangerous side (cf. nos 32, 33, 43, 59). The flowers of the beautiful do not hide the lurking evil that is inherent in the natural paradise.

Rousseau latched on to the great tradition of animal representation from Delacroix to Gérôme and Degas. He lifted his animal actors out of their illustrated textbooks and made them into beings of the imagination, even, in the case of the apes, providing them with human activities. He liberated them from their cages in zoological gardens and transposed them into the artificial plant environment of the greenhouses and hothouses that had become fashionable in the great cities of Europe and shaped the understanding for nature of an industrial society through their colossal crystal and glass palaces. This society expected the interplay of animals and landscapes to be as entertaining as possible, and the painter did not hesitate to provide his fantasies of jungles, tailored to the synthetic ideas of the age, with decorative additions. He allowed the flower forms to rise ever more voluminously on their delicate stalks and made the three-dimensional leaf-bodies of agaves and ferns alternate with the thin, flat shapes of reeds and palm fronds. The spatial compartments are compressed right against the surface and the profusion of plants from among which the apes emerge is condensed into sophisticated lattice structures.[1]

1910
Oil on canvas
129.5 × 162.6 cm
Signed and dated bottom right:
Henri Rousseau/1910
National Gallery of Art,
Washington DC
John Hay Whitney Collection
(Inv. No. 1982.76.7)

1 Once the demand for jungle pictures rose and artists and collectors such as Delaunay, Jastrebzoff and Soffici or the art dealers Vollard, Uhde and Joseph Brummer took an interest in them, prices of 100 to 200 francs were achieved for paintings of this sort of size. From Rousseau's notebook we learn: 'Sale of a wonderfully beautiful, Mexican [sic] landscape with apes for 100 francs to M. Delaunay.' And a few weeks before he died, having for so long been unsuccessful, he was able to tell Ardengo Soffici that he had orders from all sides and he would just have to wait.

Provenance: Wilhelm Uhde, Paris (?); Paul and Lotte von Mendelssohn-Bartholdy, Berlin; Lotte Gräfin Kesselstadt-Mendelssohn, Vaduz; John Hay Whitney (from 1950), Manhasset, New York; John Hay Whitney Charitable Trust, New York.

Bibliography: Uhde 1914, ill.; Uhde 1920, p. 18, ill.; Scheffer 1926, p. 292, ill.; P. Schumann, 'Internationale Kunstausstellung Dresden 1926', *Die Kunst*, 55, XXXXII, 1927, p. 13, ill.; Zervos 1927, ill. 74; Grey 1943, ill. 124; J. Rewald, 'French Paintings in the Collection of Mr and Mrs John Hay Whitney', *The Connoisseur*, 134, 552, April 1956, p. 136, ill.; Bouret 1961, p. 155, ill. 48; Vallier 1961, ill. 170; Vallier 1969, p. 75, ill. LIX, pp. 112 f., no. 253, ill.; Stabenow 1980, pp. 120 f.; Le Pichon 1981, p. 165, ill.; Certigny 1984, pp. 696 f., no. 321, ill.; *European Paintings: An Illustrated Catalogue*, National Gallery of Art, Washington 1985, p. 359, ill.; Schmalenbach 1998, p. 50, ill.

Exhibitions: Berlin 1926, no. 27, ill.; *The John Hay Whitney Collection*, Tate Gallery, London 1960–61, no. 51, ill.; Paris 1961, no. 79, ill.; *The John Hay Whitney Collection*, National Gallery of Art, Washington 1983, no. 28, ill.; Paris 1984–85, pp. 249 ff., no. 63, ill.; New York 1985, pp. 245 ff., no. 64, ill.

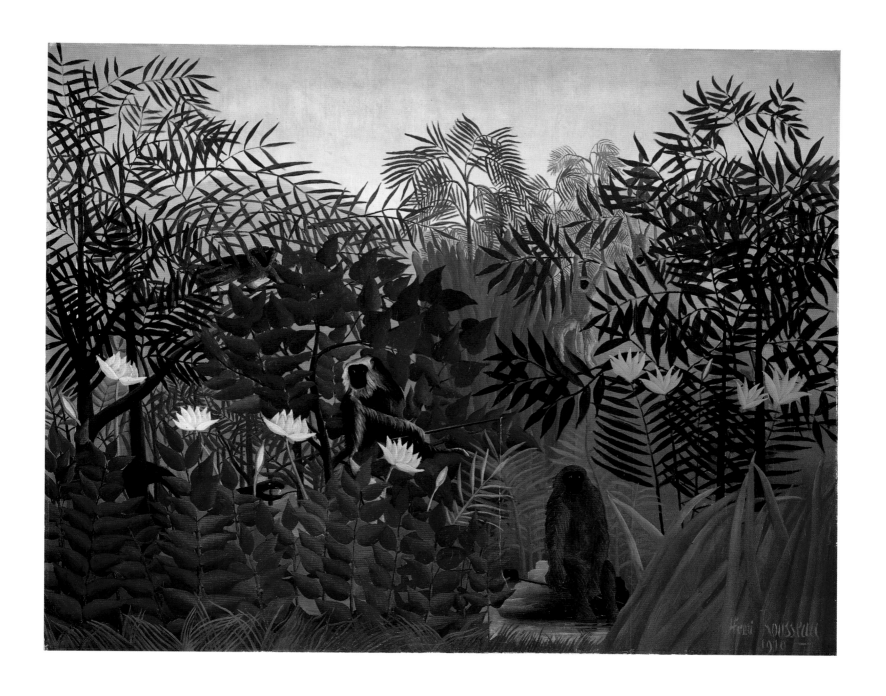

TROPICAL FOREST WITH APES AND SNAKE

Virgin Forest with Setting Sun
Forêt vierge au coucher du soleil

Rousseau's inspiration for this grandiose jungle landscape was an illustration of a zoo keeper playing with a jaguar in the album *Bêtes sauvages*. He transposed the event from the zoological garden to the impenetrable depths of a jungle that has become a figment of the imagination. Rousseau converted the playful act into a fight to the death between the American big cat and a figure which is merely glimpsed in profile against the red cacti flowers as a fleeting black shadow. The wounded animal, a knife stuck in its back, has its fangs fixed deep in its opponent's shoulder. The struggle, which may end fatally for the combatants, admittedly plays only a supporting role within the burgeoning tropical vegetation that leaves little space for the thrilling scene. Indeed, it is engulfed in the beauty of nature which again – completely unnaturally – displays those tall yellow and pink calyxes which appeared in the *Flamingoes* (no. 42) as aquatic plants. The variations of green, rich in luminosity and tone, culminate in the disc of the sun, which stands signal-red in the sky and only recurs in this form in a counterpart of the same size, dated 1910, which again deals with the conflict between man and beast (ill. p. 212).[1]

A letter of 23 May 1910 that the Russian painter Serge Jastrebzoff wrote to his Italian colleague Ardengo Soffici may be considered a *terminus ante quem* for the composition painted in the spring of 1910: 'It is nevertheless funny: Rousseau and the jungles like a parquet floor and, like the terrifying in life, a tiger dancing with a negro – a knife in its back.'[2] Although rather cryptic, the text – which transforms the jaguar into a tiger – nevertheless draws a graphic comparison between the elongated, parallel leaf forms with hard, clear outlines and sequences of parquet flooring, similarly laid out on the diagonal. Nor did Uhde adhere closely to the actual reading of the picture when in 1911 he reported the 'shriek of the negro whose throat is being torn open by the panther'.[3]

1910
Oil on canvas
114 × 162.5 cm
Signed bottom right:
Henri Rousseau
Öffentliche Kunstsammlung
Kunstmuseum, Basel
(Inv. No. 2225)

Illustration from the album
Bêtes sauvages (cf. p. 206)

1 Vallier 1969, no. 247; Certigny 1984, no. 320.

2 Certigny 1984, p. 648.

3 Uhde 1911, p. 43.

Provenance: Galerie Alfred Flechtheim, Düsseldorf (1922); Paul and Lotte von Mendelssohn-Bartholdy, Berlin (1927); Lotte Gräfin Kesselstadt-Mendelssohn, Vaduz; Christoph Bernoulli, Basel.

Bibliography: Uhde 1911, p. 43; Uhde 1914, p. 42, ill.; Uhde 1921, p. 50; Grey 1922, ill.; Roh 1927, p. 104, ill.; Soupault 1927, ill.; Zervos 1927, ill. 75; Grey 1943, ill. 117; Courthion 1944, ill. XVII; M. Netter, 'Neuerwerbung einer Urwaldlandschaft: Hommage à Rousseau', *Schweizer Museen*, November 1949, pp. 101 ff.; Cooper 1951, ill.; Perruchot 1957, ill.; Bouret 1961, ill. 31; Vallier 1961, ill. 167; Vallier 1969, ill. LV–LVI, pp. 112 f., no. 249, ill.; Bihalji-Merin 1971, ill. 51; Bihalji-Merin 1976, p. 82, ill. 27; Keay 1976, p. 152, ill. 56; Alley 1978, p. 68, ill. 57; Stabenow 1978, pp. 114, 117 ff.; Vallier 1979, p. 91, ill.; Le Pichon 1981, pp. 156 f., ill.; Certigny 1984, pp. 648 f., no. 303, ill.; Stabenow 1994, p. 81, ill.; Schmalenbach 1998, pp. 36 f., ill.

Exhibitions: Berlin 1926, no. 28; Paris 1984–85, pp. 24, 246 ff., no. 62, ill.; New York 1985, pp. 22, 242 ff., no. 63, ill.

OSKAR SCHLEMMER ANIMAL PARADISE

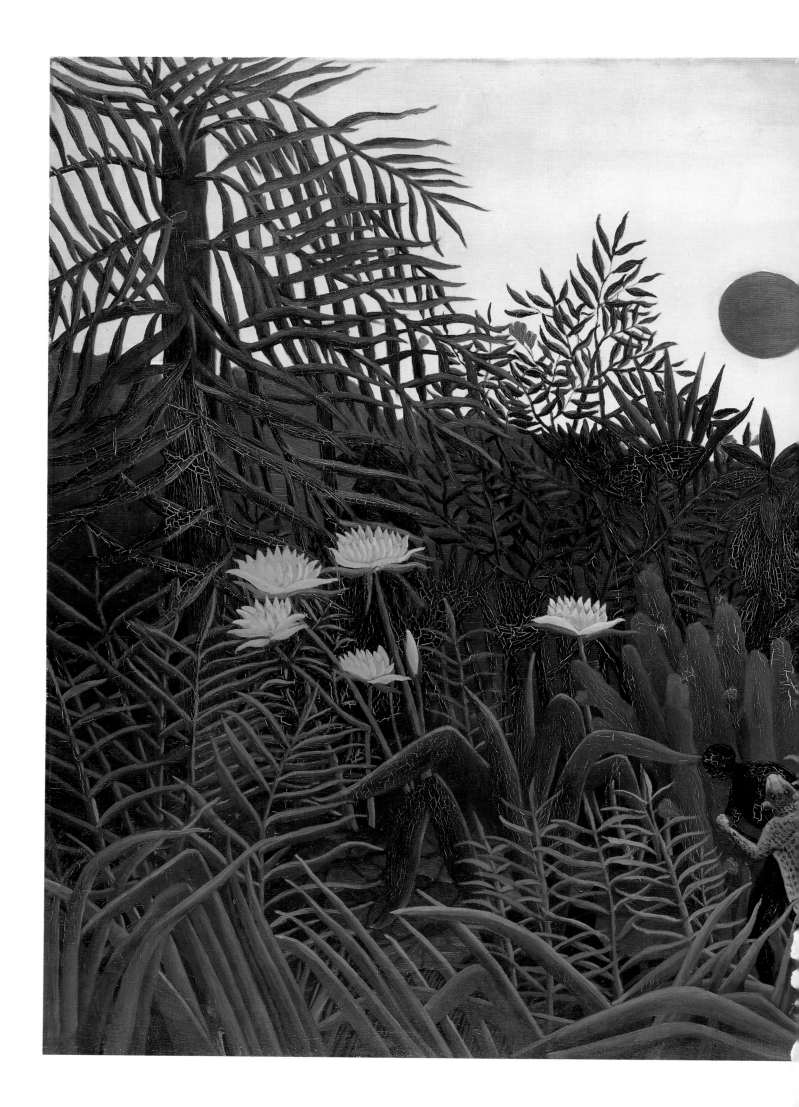

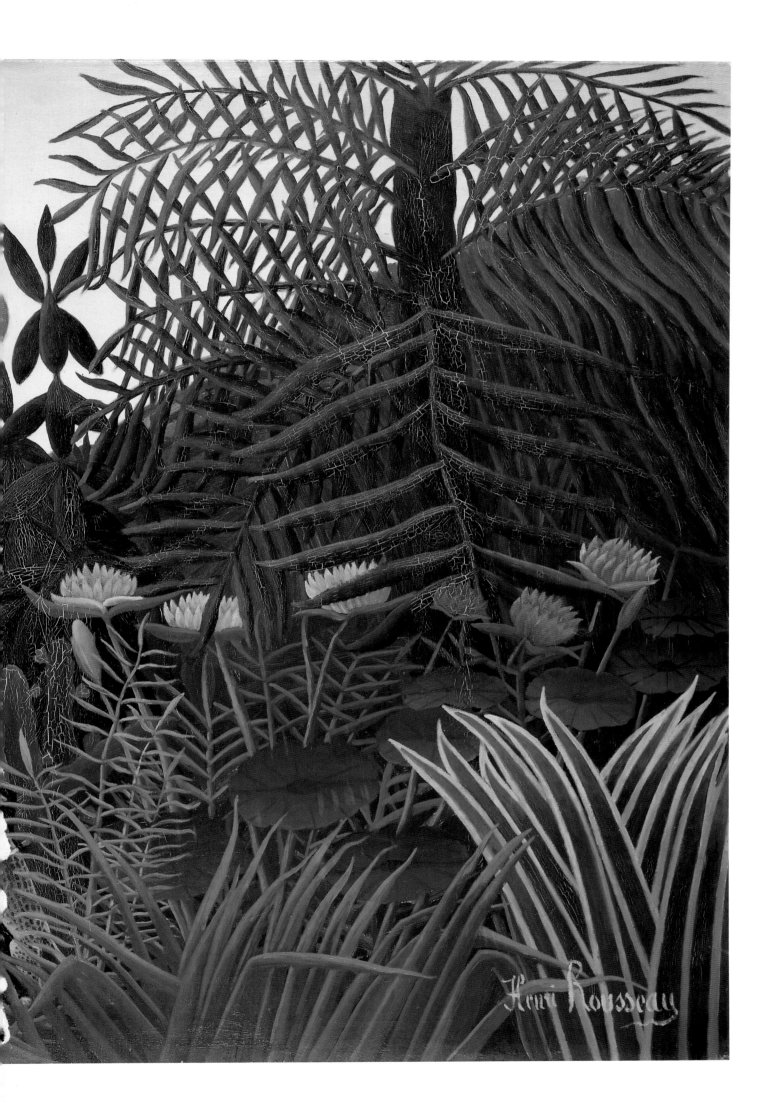

VIRGIN FOREST WITH SETTING SUN

Oskar Schlemmer
Animal Paradise

Oskar Schlemmer had already created an intentionally naive mural decoration for the bowling alley belonging to the military hospital at Galkhausen in September 1915 in emulation of Rousseau's jungle themes.[1] In his diary on 23 March 1916 he wrote: 'Manifestly: it means Henri Rousseau! Like earlier in the Galkhausen hospital, after . . . from the boundlessness of wandering, formless fantasies, tired and ill . . . I reached firm ground: the world of the visible, the yes to myself, to my past, to my wishes too . . . Greetings, Rousseau!'[2]

Years later he again turned to the Rousseauesque jungle scenario under a red ball of sun for a picture in the *verre églomisé* technique.[3] It is mentioned in two letters to Jules Bissier of September and October 1939 under the title *Tierparadies*. In these Schlemmer noted that the *verre églomisé* picture – probably commissioned by the architect Wolfgang Schmohl – 'is technically very much more developed than previously' and that he had 'combined the animals from an old zoology atlas'.[4]

The extent of Schlemmer's preoccupation with Rousseau is evident not least from a diary entry of 17 June 1935: 'The fascinating thing about Henri Rousseau is that he succeeded in completion, in bringing a picture to a conclusion, in brief: painting a beautiful picture as it wants to appear, without any sort of problem. Almost everything modern, on the contrary, is a fragment, if not a wreck, part of a thing which breaks off somewhere and does not wish to be rounded off.'[5]

1939
Verre églomisé picture, tempera and Indian ink on glass
35 × 71 cm
Signed and dated bottom right:
Oskar Schlemmer 25.9.39
Private collection

1 Karin von Maur, *Oskar Schlemmer. Œuvrekatalog der Gemälde, Aquarelle, Pastelle und Plastiken*, Munich 1979, no. G102.

2 *Oskar Schlemmer. Briefe und Tagebücher*, edited by Tut Schlemmer, Munich 1958, pp. 46 f.

3 Karin von Maur, to whom I am indebted for references, included the *verre églomisé* picture in the supplement to the Schlemmer *Œuvrekatalog*.

4 von Maur, op. cit., p. 374. Schlemmer prepared the *verre églomisé* picture in a preliminary drawing, the same size as the picture, which was executed in Indian ink and wax crayons on tracing paper. – Ibid., no. K128.

5 *Oskar Schlemmer. Briefe und Tagebücher*, op. cit., pp. 336 f., cf. also p. 84.

MAX ERNST THE FOREST

Max Ernst
The Forest

It was left for the German Max Ernst to continue the forest theme together with enigmatic suns and stars in countless variations. He transformed the forest as a romantic metaphor for longing, which had filled the hearts of Germans ever since Albrecht Altdorfer and which Caspar David Friedrich supplied with new content, into a world of the unknown, the surreal, determined by calculated chance.

His forest monument, set apart on its pedestal away from any realistic view,[1] achieved a pictorial form that was sympathetic to the jungle visions of Rousseau, whose work Max Ernst had probably known since 1913 when it was shown within the framework of the First German Autumn Salon in Berlin.[2] The charred and petrified remains of a forest long since dead and its animal and plant life stand out against a sky with pale clouds. The exploded stele-like architecture is crowned by an overpowering central representation of the sun. The unreal, hallucinatory appearance of vegetation brought back out into the daylight from primordial depths results not least from the artistic love of experimentation, in other words the techniques of *frottage*, *grattage* and *décalcomanie* introduced by Ernst. Impressions of wood grain and coiled string were made by pressing through the canvas with paint and spatula and then enriched by means of scraping and casting techniques.

With Max Ernst's forests the twentieth century took its leave of Rousseau, who had heightened the concept of forest, trees and plants in an incomparable manner and accordingly had an effect that extended far into the modern era.

1927
Oil on canvas
114 × 146 cm
Signed bottom right: max ernst
Staatliche Kunsthalle, Karlsruhe
(Inv. No. 2769)

1 Max Ernst. *Werke 1927–1929*, edited by Werner Spies, Cologne 1976, no. 1171.

2 Lachner – Rubin 1984–85, pp. 99 ff., 79 ff.

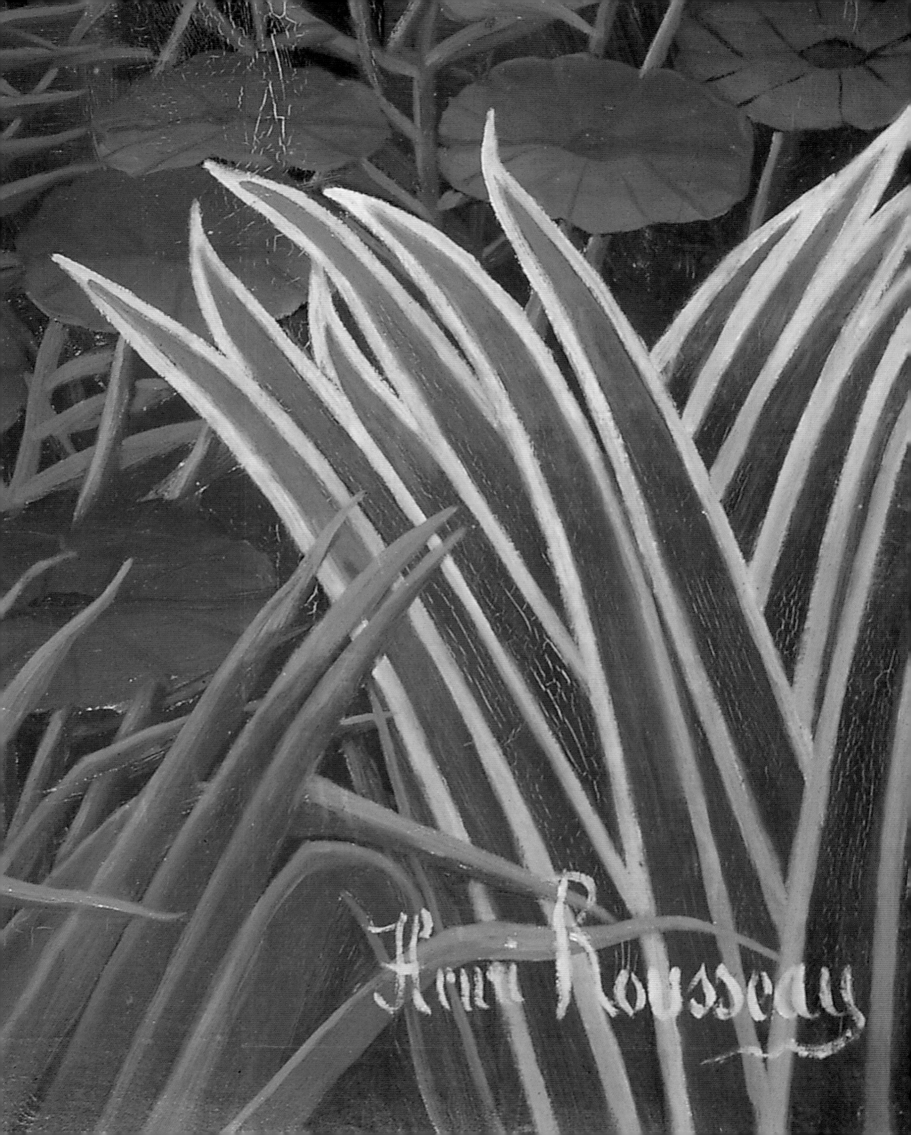

Biography

References Cited

Exhibitions and
Exhibition Catalogues

Index

Picture Credits

Virgin Forest with Setting Sun
(detail), 1910 (no. 59)

Biography

1844 Henri-Julien Félix Rousseau is born in Laval (Mayenne) on 21 May, the third child of plumber Julien Rousseau and his wife Eléonore Guyard.

1849 Schooling until 1860.

1861 The family moves to Angers.

1863 In Angers Rousseau finds a job with an advocate. Although exempted from military service, he enlists voluntarily in the army for seven years because of a petty theft.

1864 After serving a short prison sentence in Nantes, from March he continues his military service in the 52nd Infantry Regiment, stationed in Caen.

1868 Death of his father. Rousseau leaves the army early and moves to rue Rousselet 25, Paris. He works for a bailiff.

1869 Rousseau marries 18-year-old seamstress Clémence Boitard. Only two of their seven children survive to adulthood.

1870 On 19 July Napoleon III declares war on Prussia; on 20 July Rousseau is called up as a reservist but is allowed to return home on 15 September.

1871 In December he joins the Parisian customs service.

1872 Probably his first attempts at painting.

1881 In a list of personnel Rousseau is recorded as an administration employee, second class.

1884 Rousseau is given permission to make copies for study purposes at the Musée du Louvre, the Musée du Luxembourg and the palaces of Versailles and Saint-Germain.

1885 For the first time he exhibits two of his pictures in public. The painter receives a diploma from the Académie Musicale de France for his composition, the 'Clémence' waltz.

Giorgio de Chirico, *Picasso at Table with the Painters Leopold Survage, Serge Jastrebzoff and the Baroness d'Oettingen in Front of Rousseau's Self-portrait* (ill. p. 138), 1915
Private collection

1886	He makes his début at the second annual exhibition (Salon) of the Société des Artistes Indépendants, which has no jury, with the painting *A Carnival Evening* (no. 7) and three other works. Thereafter he exhibits regularly at the Salon des Indépendants, except for 1899 and 1900.
1888	His first wife Clémence dies of tuberculosis at the age of 37.
1889	Paris World Exhibition. Rousseau writes the vaudeville *Une Visite à l'Exposition de 1889*.
1890	At the Salon des Indépendants Gauguin admires the painting of Rousseau, who exhibits the self-portrait *I Myself, Portrait-landscape* (ill. p. 138) in addition to city views and landscapes. Death of his mother.
1891	At the Salon des Indépendants Rousseau shows his first jungle painting, *Surprise!* (ill. p. 154), which is praised in an article by Félix Vallotton.
1893	In December Rousseau takes early retirement at the age of 49 with an annual pension of 1,019 francs.
1894	He exhibits his major work *War* (no. 13). He makes the acquaintance of the poet Alfred Jarry, also originally from Laval.
1895	The journal *L'Ymagier*, edited by Jarry and Rémy de Gourmont, prints a lithograph which Rousseau based on the painting *War* (no. 14). At this time he plays in an amateur orchestra and earns extra as a street musician.

273

1897	For a while Jarry lodges with Rousseau at Avenue du Maine 14.
1898	Studio apartment at rue Vercingétorix 3.
1899	Rousseau finishes the stage play *La Vengeance d'une orpheline russe* (The Revenge of a Russian Orphan). In September he marries a widow, Joséphine-Rosalie Noury.
1901	They move to rue Gassendi 36; there his wife opens a stationery shop in which she also offers Rousseau's pictures for sale. He is heavily in debt to the paint seller Paul Foinet.
1902	Until 1909 Rousseau teaches courses in porcelain painting, watercolours and pastels at the Association Philotéchnique, a sort of adult education centre.
1903	On 14 March his second wife Joséphine dies at the age of 51. Rousseau participates at the 19th Salon des Indépendants, where he also exhibits *To Celebrate the Baby* (no. 31).
1905	Participation at the third Salon d'Automne with the monumental jungle painting *The Hungry Lion* (no. 33), the first of Rousseau's pictures to be illustrated in the press.
1906	Move to rue Perrel 2bis. Makes the acquaintance of the poet Guillaume Apollinaire and the painter Robert Delaunay.
1907	Paints *The Snake Charmer* (ill. p. 219) on commission for Robert Delaunay's mother. Meets his first biographer, the German art historian Wilhelm Uhde.

Entrance to Rousseau's
studio / apartment at
rue Perrel 2bis

274

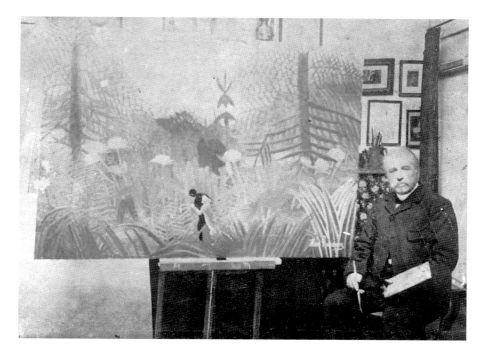

Henri Rousseau in front of the painting
Virgin Forest with Setting Sun, 1910
(no. 59)

In his studio flat in rue Perrel Rousseau gives music and drawing lessons for the children of the neighbourhood. From now on he also holds *soirées* to which he invites not just the neighbours but also young avant-garde artists who admire him, including Delaunay, Apollinaire, Picasso, Braque and Brancusí.

1908	In the autumn the 27-year-old Picasso buys Rousseau's *Portrait of a Woman* (no. 16) from a Montmartre junk dealer. Picasso organises the legendary 'Rousseau Banquet' in his studio in honour of Rousseau. Among the guests are Georges Braque, Marie Laurencin, Guillaume Apollinaire, Max Jacob, André Salmon, and Gertrude and Leo Stein.
1909	In January Rousseau is fined 200 francs and receives a two-year suspended prison sentence for a bank fraud in which he had become involved.
1910	Rousseau dies of blood poisoning on 2 September. Among the seven mourners at his funeral in the Bagneux cemetery are Paul Signac and Robert Delaunay.
1911	A retrospective of 47 of Rousseau's works is organised by Delaunay at the Salon des Indépendants. Uhde publishes the first monograph. Rousseau is represented at the Blaue Reiter exhibition in Munich by the painting *The Poultry Yard* (no. 26), belonging to Kandinsky.
1912	Delaunay, with assistance from Picasso, finances a 30-year grave concession for Rousseau through the sale of two portraits (nos 36, 37). Apollinaire designs an epitaph, which is eventually engraved on Rousseau's tombstone by Brancusí.

References Cited

Alexandre 1910	Arsène Alexandre, 'La Vie et l'œuvre d'Henri Rousseau, peintre et ancien employé de l'Octroi', *Comoedia*, 19 March 1910 (reproduced in Certigny 1984, pp. 700 ff.)
Alley 1978	Ronald Alley, *Portrait of a Primitive. The Art of Henri Rousseau*, New York 1978
Apollinaire 1914	Guillaume Apollinaire, 'Le Douanier', *Les Soirées de Paris, Chronique Mensuelle*, 20, 15 January 1914, pp. 7 ff. (reprint Geneva 1971)
Apollinaire 1991	Apollinaire, *Œuvres en prose complètes*, II, Textes établis, présentés et annotés par Pierre Caizergues et Michel Décaudin, Paris 1991, pp. 627 ff.
Basler 1923	Adolphe Basler, 'Henri Rousseau bei Paul Rosenberg', *Cicerone*, XV, September 1923, pp. 839 f.
Basler 1927	Adolphe Basler, *Henri Rousseau – Sa vie, son œuvre*, New York 1927
Bazin 1946	Germain Bazin, 'La Guerre du Douanier Rousseau', *Bulletin des Musées de France*, 2, 1946, pp. 8 f.
Beckmann 1984	Max Beckmann, *Die Realität der Träume in den Bildern. Aufsätze und Vorträge. Aus Tagebüchern, Briefen, Gesprächen 1903–1950*, Leipzig 1984
Bihalji-Merin 1971	Lise and Oto Bihalji-Merin, *Leben und Werk des Malers Henri Rousseau*, Dresden 1971
Bihalji-Merin 1976	Lise and Oto Bihalji-Merin, *Henri Rousseau – Leben und Werk*, Cologne 1976
Boime 1971	Albert Boime, 'Jean-Léon Gérôme, Henri Rousseau's Sleeping Gypsy and the Academic Legacy', *The Art Quarterly*, 34, Spring 1971, pp. 3 ff.
Bouret 1961	Jean Bouret, *Henri Rousseau*, Neuchâtel 1961
Brassaï 1964	Brassaï, *Conversations avec Picasso*, Paris 1964
Bryars 1976	Gavin Bryars, 'Berners, Rousseau, Satie', *Studio International*, 192, 984, November–December 1976, pp. 311 ff.
Cendrars	Blaise Cendrars, 'Le Douanier Henri Rousseau', *Der Sturm*, 4, 178/179, September 1913, p. 99
Certigny 1961	Henry Certigny, *La Vérité sur le Douanier Rousseau*, Paris 1961
Certigny 1984	Henry Certigny, *Le Douanier Rousseau en son temps. Biographie et Catalogue Raisonné, I, II*, Tokyo 1984 (with extensive literature references)
Certigny 1989	Henry Certigny, *Le Douanier Rousseau en son temps, Catalogue Raisonné*, Supplément No. 1, Paris 1989
Certigny 1990	Henry Certigny, *Le Douanier Rousseau en son temps, Catalogue Raisonné*, Supplément No. 2, Paris 1990
Certigny 1991	Henry Certigny, *Le Douanier Rousseau en son temps, Catalogue Raisonné*, Supplément No. 3, Paris 1991
Certigny 1992	Henry Certigny, *Le Douanier Rousseau en son temps, Catalogue Raisonné*, Supplément No. 4, Paris 1992
Cooper 1951	Douglas Cooper, *Rousseau*, Paris 1951
Coquiot 1920	Gustave Coquiot, *les indépendants 1884–1920*, Paris (1920)
Courthion 1944	Pierre Courthion, *Henri Rousseau. Le Douanier*, Geneva 1944
Däubler 1916	Theodor Däubler, *Der neue Standpunkt*, Dresden-Hellerau 1916, pp. 121 ff.
Delaunay 1920	Robert Delaunay, 'Henri Rousseau le Douanier', *L'Amour de l'Art*, 7 November 1920, pp. 228 ff.
Delaunay 1952	Robert Delaunay, 'Mon ami Henri Rousseau', in *Les Lettres françaises*, 31 July 1952, p. 8; 7 August 1952, pp. 1, 9; 21 August 1952, p. 7; 28 August 1952, pp. 1, 7
Delaunay 1957	Robert Delaunay, *Du Cubisme à l'art abstrait, Documents inédits*, edited by Pierre Francastel, Paris 1957
Derouet – Boissel 1985	Christian Derouet – Jessica Boissel, *Œuvres de Vassily Kandinsky. Collections du Musée National d'Art Moderne. Environnement de l'artiste - collection*, Paris 1985, pp. 470 f.
Descargues 1972	Pierre Descargues, *Le Douanier Rousseau*, Geneva 1972
Eichmann 1938	Ingeborg Eichmann, 'Five Sketches by Henri Rousseau', *The Burlington Magazine*, IXXII, CDXXIII, June 1938, pp. 302 ff.
Fels 1925	Florent Fels, *Propos d'Artistes*, Paris 1925
Fleckner – Gaehtgens 1999	*Prenez garde à la peinture! Kunstkritik in Frankreich 1900–1945*, edited by Uwe Fleckner and Thomas W. Gaehtgens, Berlin 1999

Forges 1964	Marie-Thérèse de Forges, 'Une Source du douanier Rousseau', *Art de France*, 4, 1964, pp. 360 f.
Gallego 1974	Julian Gallego, 'De Rousseau à Dubuffet', *Bellas Artes*, 32, April 1974, pp. 3 ff.
Gauthier 1949	Maximilien Gauthier, *Le Douanier Rousseau*, Paris 1949
George 1931	Waldemar George, 'Le Miracle de Rousseau', *Les Arts à Paris*, 18 July 1931, pp. 3 ff.
Giedion-Welcker 1960	Carola Giedion-Welcker, *Alfred Jarry*, Zurich 1960
Gilot – Lake 1987	Françoise Gilot – Carlton Lake, *Leben mit Picasso*, Zurich (1987)
Goldwater 1986	Robert Goldwater, *Primitivism in Modern Art*, Cambridge (Mass.) 1986, pp. 157 ff., 178 ff.
Grey 1914	Roch Grey (pseudonym of Hélène d'Oettingen), 'Souvenirs de Rousseau', *Les Soirées de Paris*, 20, 15 January 1914, pp. 66 ff.
Grey 1922	Roch Grey, *Rousseau*, Rome 1922
Grey 1943	Roch Grey, *Henri Rousseau*, Paris 1943 (with foreword by André Salmon)
Holsten 1976	Siegmar Holsten, *Allegorische Darstellungen des Krieges 1870–1918*, Munich 1976
Hoog 1965	Michel Hoog, 'La Ville de Paris de Robert Delaunay. Sources et développement', *La Revue du Louvre*, 15, 1965, pp. 29 ff.
Hopfengart 2000	*Der Blaue Reiter*, edited by Christine Hopfengart, Kunsthalle Bremen, Bremen 2000
Jakovsky 1961	Anatole Jakovsky, 'Le Douanier et les contrebandiers', *Jardin des Arts*, 70, June 1961, pp. 3ff.
Jakovsky 1971	Anatole Jakovsky, 'Le Douanier Rousseau savait-il peindre?', *Médicine de France*, 218, January 1971, pp. 25 ff.
Janis 1942	Sidney Janis, 'Book review of D.C. Rich, *Henri Rousseau*', *College Art Journal*, 1, 4, 1942, pp. 111 f.
Kandinsky – Marc 1912	*Der Blaue Reiter*, edited by Kandinsky and Franz Marc, Munich 1912 (facsimile printed Munich 1976)
Keay 1976	Carolyn Keay, *Henri Rousseau. Le Douanier*, New York 1976
Kieser 1913	R. Kieser, 'Henri Rousseau', *Kunst und Künstler*, 11, 1913, pp. 218 ff.
Koella 1974	Rudolf Koella, 'Der Triumph des freien Künstlertums. Zu einem Bild des Zöllners Rousseau', in *Gotthard Jedlicka. Eine Gedenkschrift*, Zurich 1974, pp. 115 ff.
Kolle 1922	Helmut Kolle, *Henri Rousseau*, Leipzig 1922
Lanchner – Rubin 1984–1985	Carolyn Lanchner – William Rubin, 'Henri Rousseau et le modernisme', in the exhibition catalogue *Henri Rousseau*, Galeries nationales du Grand Palais, Paris 14 September 1984–7 January 1985, pp. 37 ff.; Museum of Modern Art, New York 5 February– 4 June 1985, pp. 35ff.
Leonard 1970	Sandra E. Leonard, *Henri Rousseau and Max Weber*, New York 1970
Le Pichon 1981	Yann le Pichon, *Le Monde du Douanier Rousseau*, Paris 1981
Lo Duca 1951	Lo Duca, *Henri Rousseau dit le Douanier*, Paris 1951
Meißner 1985	Karl-Heinz Meißner, 'Delaunay – Dokumente', in the exhibition catalogue *Delaunay und Deutschland*, Staatsgalerie moderner Kunst, Munich 4 October 1985–6 January 1986, pp. 482 ff.
Michailow 1935	Nikola Michailow, 'Zur Begriffsbestimmung der Laienmalerei', *Zeitschrift für Kunstgeschichte*, 4, 5/6, 1935, pp. 283 ff.
Müller 1993	Eva Müller, *Henri Rousseau und die Künstler des Bateau-Lavoir*, Bochum 1993
Olivier 1933	Fernande Olivier, *Picasso et ses amis*, Paris 1933
Olivier 1982	Fernande Olivier, *Picasso und seine Freunde*, Zurich 1982
Parmelin 1974	Hélène Parmelin, 'Picasso ou le collectionneur qui n'en est pas un', *L'Oeil*, 230, September 1974
Pernoud 1997	Emmanuel Pernoud, 'De l'image à L'Ymage. Les revues d'Alfred Jarry et Remy de Gourmont', *Revue de l'art*, 115, 1997, pp. 59 ff.
Perruchot 1957	Henri Perruchot, *Henri Rousseau – Eine Biographie*, Eßlingen 1957
Raynal 1914	Maurice Raynal, 'Le »Banquet« Rousseau', *Les Soirées de Paris*, 20, 15 January 1914, pp. 69 ff.
Rich 1942	Daniel Catton Rich, *Henri Rousseau*, New York 1942 (publication for the Chicago – New York 1942 exhibition)
Roh 1924	Franz Roh, 'Ein neuer Henri Rousseau. Zur kunstgeschichtlichen Stellung des Meisters', *Cicerone*, XVI, July 1924, pp. 713 ff.
Roh 1925	Franz Roh, *Nach-Expressionismus. Magischer Realismus*, Leipzig 1925
Roh 1927	Franz Roh, 'Henri Rousseaus Bildform und Bedeutung für die Gegenwart', *Die Kunst*, 55, XXXXII, January 1927, pp. 105 ff.
Rousseau 1918	`Briefe Henri Rousseaus', *Das Kunstblatt*, 1918, pp. 254 ff.
Rousseau 1958	*Henri Rousseau, Dichtung und Zeugnisse*, in collaboration with Tristan Tzara, edited by Peter Schifferli, Zurich 1958

Rousseau 1986 Henri Rousseau, *Die Gegenwart und das Vergangene. Gedichte und Gemälde*, Vienna – Munich 1986

Rousseau 1999 Pascal Rousseau et al., 'Robert Delaunay 1906–1914. Chronologie', in the exhibition catalogue *Robert Delaunay*, Centre Georges Pompidou, Paris 3 June–16 August 1999, pp. 15 ff.

Rubin 1972 William S. Rubin, 'Henri Rousseau', in *Dada und Surrealismus*, Stuttgart 1972, pp. 127 f.

Rubin 1984 William S. Rubin, 'Pablo Picasso', in *Primitivismus in der Kunst des zwanzigsten Jahrhunderts*, Munich 1984, pp. 249 ff., 295 ff.

Salmon 1927 André Salmon, *Henri Rousseau dit le Douanier*, Paris 1927

Salmon 1956 André Salmon, 'Le Douanier Rousseau dine chez Picasso', in *Souvenirs Sans Fin, II*, Paris 1956, pp. 48 ff.

Salmon 1962 André Salmon, *Henri Rousseau*, Paris 1962

Scheffer 1926 Kurt Scheffer, 'Henri Rousseau', *Kunst und Künstler*, 24, 1926, pp. 290 ff.

Schmalenbach 1998 Werner Schmalenbach, *Henri Rousseau. Träume vom Dschungel* [*Henri Rousseau. Dreams of the Jungle*], Munich – New York, 1998

Schmidt 1988 Silvia Schmidt, 'Bernhard Koehler. Ein Mäzen und Sammler August Mackes und der Künstler des »Blauen Reiter«', *Zeitschrift des Deutschen Vereins für Kunstwissenschaft*, 42, 3, 1988, pp. 76 ff.

Shattuck 1963 Roger Shattuck, *Die Belle Epoque. Kultur und Gesellschaft in Frankreich 1885–1918*, Munich 1963 (first edition: *The Banquet Years. The Arts in France 1885–1918*, London 1955)

Soffici 1910 Ardengo Soffici, 'Le Peintre Henry [*sic*] Rousseau', *Le Mercure de France*, 87, 16 October 1910, pp. 748 ff.

Soupault 1922 Philippe Soupault, 'Le Douanier Rousseau', *Les Feuilles libres*, August-September 1922, pp. 255 ff.

Soupault 1927 Philippe Soupault, *Henri Rousseau – Le Douanier*, Paris 1927

Stabenow 1980 Cornelia Stabenow, *Die Urwaldbilder des Henri Rousseau*, Munich 1980 (with extensive bibliography)

Stabenow 1985 Cornelia Stabenow, 'Der zerbrochene Eiffelturm. Robert Delaunay und die frühe Rousseau-Rezeption in Deutschland', in the exhibition catalogue *Delaunay und Deutschland*, Staatsgalerie moderner Kunst, Munich 4 October 1985–6 January 1986, pp. 311 ff.

Stabenow 1994 Cornelia Stabenow, *Henri Rousseau 1844–1910*, Cologne 1994

Stein 1980 Gertrude Stein, *Autobiographie d'Alice*, Paris 1980

Thiel 1992 Heinz Thiel, 'Wilhelm Uhde – Ein offener und engagierter Marchand-Amateur in Paris vor dem Ersten Weltkrieg', in *Avantgarde und Publikum*, edited by Henrike Junge, Cologne 1992, pp. 307 ff.

Tzara 1947 Tristan Tzara, *Henri Rousseau oder vom Begriff des »totalen Künstlers«*, Paris 1947, in Rousseau 1958, pp. 8 ff.

Tzara 1962 Tristan Tzara, 'Le Rôle du temps et de l'espace dans l'œuvre du Douanier Rousseau', *Art de France*, 2, 1962, pp. 323 ff.

Uhde 1911 Wilhelm Uhde, *Henri Rousseau*, Paris 1911

Uhde 1914 Wilhelm Uhde, *Henri Rousseau*, Düsseldorf 1914

Uhde 1920 Wilhelm Uhde, 'Der Kampf um Henri Rousseau', *Das Kunstblatt*, 1920, pp. 51 ff.

Uhde 1921 Wilhelm Uhde, *Henri Rousseau*, Dresden 1921 (unrevised new edition Berlin and Dresden 1923)

Uhde 1947 Wilhelm Uhde, *Fünf primitive Meister, Rousseau – Vivin – Bombois – Bauchant – Seraphine*, Zurich 1947

Uhde 1948 Wilhelm Uhde, *Rousseau (Le Douanier)*, Bern 1948

Vallier 1961 Dora Vallier, *Henri Rousseau*, Cologne 1961

Vallier 1969 Dora Vallier, *Das Gesamtwerk von Rousseau*, Lucerne 1969

Vallier 1970 Dora Vallier, 'L'Emploi du pantographe dans l'œuvre du Douanier Rousseau', *Revue de l'art*, 7, 1970, pp. 90 ff.

Vallier 1981 Dora Vallier, *Henri Rousseau*, Munich 1981

Vallier 1998 Dora Vallier, 'Bateaux à voile. Le plus ancien tableau de Henri Rousseau le Douanier connu à ce jour. Un découverte récente', *Artibus et historiae*, 38, XIX, 1998, pp. 191 ff.

Verdet 1955 André Verdet, *Fernand Léger*, Geneva 1955

Viatte 1962 Germain Viatte, 'Lettres inédites à Ambroise Vollard', *Art de France*, 2, 1962, pp. 330 ff.

Warnod 1976 Jeanine Warnod, *Bateau-Lavoir. Wiege des Kubismus 1892–1914*, Geneva 1976

Weber 1942 Max Weber, 'Rousseau as I knew him', *Art News*, 41, 15 February 1942, pp. 17, 35

Werner 1976 Klaus Werner, *Henri Rousseau*, Berlin 1976

Werner 1987 Klaus Werner, *Henri Rousseau*, Berlin 1987

Wilenski 1953 R. H. Wilenski, *Rousseau*, Novara 1953

Zervos 1926 Christian Zervos, 'Henri Rousseau et le sentiment poétique', *Cahiers d'Art*, 9, 1926, pp. 229 ff.

Zervos 1927 Christian Zervos, *Rousseau*, Paris 1927

Exhibitions and Exhibition Catalogues

Baden-Baden 1961 *Das naive Bild der Welt*, Staatliche Kunsthalle Baden-Baden, Baden-Baden 2 July–4 September 1961 (texts by Dietrich Mahlow, Georg Schmidt, Anatole Jakovsky et al.)

Basel 1933 *Henri Rousseau*, Kunsthalle Basel, Basel 1 March–2 April 1933

Berlin 1912 *Erste Ausstellung – Tiergartenstrasse 34 a. Der Blaue Reiter*, Galerie Der Sturm, Berlin 12 March–10 April 1912

Berlin 1913 First German Autumn Salon. *Henri Rousseau Gedächtnisausstellung*, Galerie Der Sturm, Berlin 20 September–1 December 1913, p. 11 (text by Herwarth Walden)

Berlin 1926 *Ausstellung Henri Rousseau*, Galerie Alfred Flechtheim, Berlin March 1926 (texts by Wilhelm Uhde, Guillaume Apollinaire, Hans Siemsen, André Warnod)

Chicago 1931 *Paintings by Henri Rousseau*, Arts Club of Chicago, Chicago 1931

Chicago – New York 1942 *Henri Rousseau*, Art Institute of Chicago, Chicago – The Museum of Modern Art, New York 1942 (see Rich 1942)

Geneva 1997 *Le Douanier Rousseau et les peintres naïfs français*, Musée d'art moderne, Geneva 6 March–15 June 1997 (text by Ofir Scheps)

Munich – Zurich 1974–75 *Die Kunst der Naiven, Themen und Beziehungen*, Haus der Kunst, Munich 1 November 1974–12 January 1975 (text by Oto Bihalji-Merin). Seen later at the Kunsthaus Zürich, Zurich

Munich 1998 *Picasso und seine Sammlung*, Kunsthalle der Hypo-Kulturstiftung, Munich 30 April–16 August 1998 (texts by André Malraux, Hélène Parmelin, Jean Leymarie, Hélène Seckel-Klein)

New York 1910 *Henri Rousseau*, Gallery 291, New York 18 November–8 December 1910

New York 1931 *Henri Rousseau*, Marie Harriman Gallery, New York 1931

New York 1951 *Henri Rousseau*, Sidney Janis Gallery, New York 1951 (text by Tristan Tzara)

New York 1963 *Henri Rousseau*, Wildenstein Gallery, New York 17 April–25 May 1963 (text by Maximilien Gauthier)

New York 1985 *Henri Rousseau*, The Museum of Modern Art, New York 21 February–4 June 1985. Seen earlier in Paris

Odakyu 1981 *Henri Rousseau et l'Univers des Naïfs Français*, Grande Galerie, Odakyu 16 October–4 November 1981

Paris 1911 *Henri Rousseau*, 27me Salon des Artistes Indépendants, Paris 21 April–13 June 1911

Paris 1912 *Henri Rousseau*, Galerie Bernheim Jeune, Paris 28 October–9 November 1912

Paris 1923 *Henri Rousseau*, Galerie Paul Rosenberg, Paris June 1923

Paris 1937 *Les Maîtres Populaires de la Réalité*, Salle Royale, Paris 1937 (texts by Raymond Escholier, Maximilien Gauthier). Seen later in Zurich

Paris 1944–45 *Henri Rousseau dit le Douanier*, Musée d'Art Moderne de la Ville de Paris, Paris 22 December 1944–21 January 1945 (texts by Paul Eluard, Anatole Jakovsky, Maximilien Gauthier)

Paris 1961 *Henri Rousseau dit »Le Douanier«*, Galerie Charpentier, Paris 1961 (texts by Raymond Nacenta, Jean Bouret, Maximilien Gauthier)

Paris 1964 *Le Monde des Naïfs*, Musée National d'Art Moderne, Paris 1964 (texts by Jean Cassou, Ebbinge Wubben, Oto Bihalji-Merin). Seen later in Rotterdam

Paris 1984–85 *Le Douanier Rousseau*, Galeries Nationales du Grand Palais, Paris 14 September 1984–7 January 1985 (texts by Roger Shattuck, Henri Béhar, Michel Hoog, Carolyn Lanchner, William Rubin). Seen later in New York

Rotterdam 1964 *De Lusthof der Naïven*, Museum Boymans – van Beuningen, Rotterdam 1964. Seen earlier in Paris

Setagaya 1996 *Naivety in Art. A Decade of Exploration*, Setagaya Art Museum, Setagaya 5 October–1 December 1996

Tokyo 1966 *Henri Rousseau et le Monde des Naïfs*, Tokyo 1966

Tokyo 1985 *Le Banquet du Douanier Rousseau*, Isetan Museum, Tokyo 26 September–22 October 1985 (text by Jeanine Warnod)

Zurich 1937 *Les Maîtres Populaires de la Réalité*, Kunsthaus Zürich, Zurich 16 October–21 November 1937. Seen earlier in Paris

Index

This index covers the main text and the notes. It does not cover the details of provenance, bibliography and exhibition history given in the catalogue entries. References in *italics* are to illustrations.

Alexandre, Arsène 104, 156
Alphaud, J.-C. 116, 232
Altdorfer, Albrecht 269
Andreiew, Pierre 80
Angué, J. L. 83
Apollinaire, Guillaume 6, 13, 17, 26, 30, 32 f., *32*, 35,
 36, 61, 72, 86, 145, 156, 168, 201, 204, 210, 219,
 220, 221, 222, 226, 274, 275
Archipenko, Alexander 220
Atget, Eugène 65, 66, *102*, 124, 186, 187

Baltasar Carlos (Spanish prince) *149*
Barr, Alfred H. 7
Bartholdi, Frédéric-Auguste 193,
Basler, Adolphe 6
Beckmann, Max 7, 21, 27, *84*, *122*, 123, *170*, 171, *174*,
 175, 184, 189, *189*
Beckmann, Quappi 123, 171
Bellini, Giovanni 171
Bernard, Emile 86
Bernheim Jeune, Alexandre 42, 54, 208, 220
Beuys, Joseph 74, *78*
Biche, Frumence 68, *69*, 72, 150
Bignou, Etienne 83
Bissier, Jules 267
Blanchard, Henri-Pierre-Leon-Pharamond *156*
Böcklin, Arnold *82*
Boitard, Clémence *see* Rousseau, Clémence
Bonnard, Pierre 32, 190
Bonnat, Léon 19, 32, 91
Bouguereau, Adolphe-William 19, 32
Bouret, Jean 172
Brancusí, Constantin 17, 35, 36, 220, 275
Braque, Georges 23, 35, 36, *37*, 113, 121, 160, 275
Brassaï 96, 96, 99
Breton, André 84, 200, 219
Brière, de la (critic) 56
Brontë, Emily 84
Brueghel, Pieter 73, *74*
Brummer, Joseph 187, 212, 243, 260
Burljuk, David 129, 249

Cabanel, Alexandre 19
Caillebotte, Gustave 29, *94*
Campendonk, Heinrich 129, *181*, 221, 249
Carco, Francis 35
Carnot, Marie François Sadi 198
Carpaccio, Vittore 88
Carrà, Carlo 204
Catton Rich, Daniel 7

Cendrars, Blaise 219
Certigny, Henry 6, 44, 83, 90, 102, 116, 117, 124, 139,
 166, 187, 226, 230, 234, 240, 250
Cézanne, Paul 15, 18, 21, 22, 23, 26, 28, 29, 38, 41,
 50, 56, 83, 88, 114, 121, 147, 156, 160, 166, 184,
 192, 193, 199, 214, 220, 221, 224
Chaplin, Charlie 31
Charles V (Holy Roman Emperor) 91
Charpentier, Georges 186
Chirico, Giorgio De 18, 27, 204, *204*, *273*
Christo 117
Claretie, Georges 23
Clément, Félix Auguste 14, 15, 16, 19
Combe, J. 208
Coquiot, Gustave 16, 22
Corinth, Lovis 249
Corot, Camille 96, 121
Courbet, Gustave 19, 22, 29, 88, 193, 194
Courteline, Georges 186, 187, 194
Coysevox, Antoine 193

Däubler, Theodor 95, 102, 149, 176, 190, 209, 217,
 224, 229, 249
Danton, Georges Jacques 60
Daumier, Honoré 28, 121
Davioud, Gabriel Jean-Antoine 117
Degas, Edgar 15, 16, 27, 28, 32, 88, 176, 184, *184*, 260
Delacroix, Eugène 78, 79, *79*, 260
Delaunay, Robert 7, 17, 25, 26, 35, 39, 42, 61, *94*, 99,
 113, 116, 118, *120*, 121, 126, 128, 129, 130, 131, 139,
 145, 146 f., 177, 180, 212, *218*, 219, 220, 221, 222,
 223, 227, 240, 245, 249, 260, 274, 275
Delaunay, Sonia 126, 220, *220*
Denis, Maurice 220
Derain, André 39, 121, 160, 243
Detaille, Edouard 32
Dix, Otto *202*, 203
Dolet, Etienne 196
Dongen, Kees van 36
Doucet, Jacques 219
Draner, Jules *20*, 117, *118*
Dubois-Pillet, Albert 190
Dürer, Albrecht 86
Dufy, Raoul 160
Duhamel, Georges 35
Dupont, André 16

Edward VII (English king) 198
Eiffel, Gustave 60
Elsheimer, Adam 55, *55*
Ensor, James 33, *87*
Eon, Henry 164
Epstein, Elisabeth 126, 128, 129, 130, 131, 227, 249
Ernst, Max 7, 21, 158, 208, *208*, 269
Ernst, Rodolphe 88, *88*

Fallieres, Clément Armand 198
Faure, Félix 198
Feininger, Lyonel 221
Fénéon, Félix 35, 54
Flechtheim, Alfred 7, 44, 100, 217, 223
Flegel, Georg 254
Foinet, Paul 25, 41, 274
Foucher, Cécile 150
Foucher, Marie 68, 150
Fourcaud 160
Frank, Edmond Achille 186, 187
Franke, Günther 171
Franz Joseph I (Emperor of Austria) 198
Freundlich, Otto 36
Freyhold, Eduard von 152
Friedrich, Caspar David 55, 269
Friesz, Othon 199
Fuchs, Leonhart 92

Gauguin, Paul 6, 18, 21, 25, 29, 35, 38, 39, 82, 86, *146*,
 153, 154, 186, 199, *273*
Gauthier, Maximilien 25
Gautier, Charles Albert 190
George I (King of Greece) 198
Gérôme, Jean-Léon 14, 16, 19, *19*, 61, 260
Gilot, Françoise 139, 200
Giotto 210
Girard-Coutances 14
Girieud, Pierre-Paul 128
Gleizes, Albert 220
Gogh, Theo Van 15
Gogh, Vincent Van 6, 13, 16, 18, 39, 121, 190, 210
Gomés, André *142*
Gourmont, Rémy de 31, 86, *273*
Goya, Francisco 73, *78*, 80, 91, 149
Grévy, Jules 198
Grey, Roch (pseudonym) *see* Oettingen
Gris, Juan 36
Gropius, Walter 130
Grosz, George 203, *203*, 221
Gsell, Paul 199
Guérin, Pierre Narcisse 160
Guilbert, Ernest 196, *196*
Guillaume, Paul 251
Guillaumin, Armand 160
Guillemet, Antoine 192
Guyard, Eléonore 272

Hartmann, Thomas von *181*
Heartfield, John 203, *203*
Heckel, Erich 249
Heine, Heinrich 176
Herbin, Auguste 36
Hitchcock, Alfred 216
Hölderlin, Johann Christian Friedrich 192
Hoetger, Bernhard 212, *212*

Hohenheim, Theophrastus Bombastus von *188*, 189
Hoog, Michel 7
Hugo, Victor 60

Ingres, Jean Auguste Dominique 78, 121, 193, 200
Isabella of Bourbon *91*
Jacob, Max 35, 36, 97, 275
Jarry, Alfred 13, 26, 30 ff., *30*, 33, 81 f., 86, 92, 150, 245, 273, 274
Jastrebzoff, Serge 35, 54, 212, 220, 260, 262, *273*
Jiménez y Aranda, Luis 117, *117*
Jünger, Ernst 83

Kahlo, Frida *95*
Kahnweiler, Daniel-Henry 200
Kandinsky, Nina 130
Kandinsky, Wassily 6, 7, 18, 27, 31, 39, 95, 99, 126, 128, 129, 130, *130*, 131 f., *131*, 134, 139, 145, 146, 171, 177, 180, *181*, 221, 222, 227 f., *228*, 249, 275
Kirchner, Ernst Ludwig 221
Klee, Paul 42, 50, 130, 221
Kleist, Heinrich von 150
Koehler, Bernhard 129, 145, 177, 180, *181*, 221
Kokoschka, Oskar 249
Kubin, Alfred 128, 227
Kullmann, Herbert 102

La Fontaine, Jean de 192
Laurencin, Marie 35, 36, 168, 220, 226, 275
Lautréamont, Conte de 28
Le Fauconnier 128
Lebaudy, Paul 216
Lebaudy, Pierre 216
Léger, Fernand 15, 18, 86, 99, *112*, 113, 184, *186*, 220, 224, *238*, 239
Lehmbruck, Wilhelm 249
Leopold II (King of Belgium) 198
Lorrain, Claude 55
Loti, Pierre 184, *185*, 186, 187, *187*
Loubet, Emile 198
Louis XIV (King of France) 236
Louis XVI (King of France) 60
Luce, Maximilien 193, 194

Macke, August 129, 177, 221, 222, *248*, 249
Maillol, Aristide 159, 164
Mallarmé, Stephane 35
Manet, Edouard 19, 28, 29, 91
Marat, Jean Paul 60
Marc, Franz 6, 7, 31, 95, 126, 128, 129, 145, 146, 147, 177, *181*, 221, 222, 227, 229, 249
Marc, Maria *181*
Marie Antoinette (Queen of France) 60
Marquet, Albert 160, 243, 244
Matisse, Henri 160, 190, 194, 199, *242*, 243, 244, 249
Méaulle, Fortuné 60, *61*
Meidner, Ludwig 221
Meier-Graefe, Julius 249
Mendelssohn, Moses 184
Mendelssohn-Bartholdy, Felix 184
Mendelssohn-Bartholdy, Lotte 184
Mendolssohn-Bartholdy, Paul von 6, 184
Menelik II (Emperor of Ethiopia) 198
Merson, Luc 61
Modersohn-Becker, Paula 212
Modigliani, Amedeo 36
Monet, Claude 29, 32, 156

Morandi, Giorgio 254
Müller, Eva 6
Münter, Gabriele 126, 128, *128*, 131, *131*, 132, *132*, 145, 227, 229
Munkácsy, M. von *157*, 193
Muzafarr-ed-Din (Shah of Persia) 198

Napoleon III (Emperor of the French) 116, 156, 232, 236
Natanson, Thadée 100
Nicholas II (Tsar of Russia) 198
Nobillet, Auguste Michel *156*
Nolde, Emil 249
Noury, Joséphine see Rousseau, Joséphine

Oettingen, Hélène d' 35, 99, 212, 243, *273*
Olivier, Fernande 35, 36, *37*, 38, 94, 95, 97, *98*, 220

Paracelsus see Hohenheim
Parmelin, Hélène 200
Paul, Bruno 186
Pauli, Gustav 249
Périer, Jean Paul 198
Perls, Hugo 180
Peter I (King of Serbia) 198
Philip II (King of Spain) 91
Picasso, Maya *152*
Picasso, Pablo 7, *11*, 13, 17, 23, 27, 29, *32*, 35 f., *37*, 38, *38*, 39, 78, 80, *81*, 84, *85*, 88, 92, 94, 95, 96, *96*, 97 f., *97*, 99, 113, 121, 139, *142*, 149, *152*, 153, *153*, 166, 168, 171, 182, 200, 201, 212, 220, 249, *273*, 275
Piper, Reinhard 128, 145, 146, 229
Pirodon, Eugène 209
Pissarro, Camille 21, 56, 193, 194
Post, Frans 208
Puvis de Chavannes, Pierre 32, 61

Quéval, Armand 33, 220

Rainer, Arnulf 32
Raynal, Maurice 35, 36, 38
Redon, Odilon 21, 56, 190
Rembrandt 55
Renoir, Auguste 21, 29, 32, 41, 121, 220
Restif de la Bretonne, Nicolas 223
Robespierre, Maximilien de 60
Roh, Franz 203
Roll, Alfred 61
Roosevelt, Theodore 196
Rose, Berthe Félicie de 168, 219, 274
Rosenberg, Paul 139, 182, 186, 187, 195
Rouart, Henri *184*
Rouault, Georges 160, 199
Rousseau, Clémence 52, 68, 139, 272, 273
Rousseau, Jean-Jacques 39, 150
Rousseau, Joséphine 131, 138, *141*, 274
Rousseau, Julia 52
Rousseau, Julien 272
Rousseau, Théodore 28, 46
Roy, Louis 82, 86
Rubens, Peter Paul 55
Rubin, William 7
Runge, Philipp Otto 149

Salmon, André 6, 35, 36, 38, *38*, 201, 275
Schelfhout, Louis 226
Schlemmer, Oskar 7, *188*, 189, *266*, 267
Schmalenbach, Werner 129
Schmohl, Wolfgang 267
Schönberg, Arnold 126, 128, 129, 227
Schtschukin, Sergej 234
Segantini, Giovanni 82
Seisenegger, Jacob 91
Sérusier, Paul 220
Seurat, Georges 21, 29, 56, 80, 117, 184, 190, 193, 194
Siemsen, Hans 100
Signac, Paul 21, 56, 68, 190, 193, 194, 220, 275
Soffici, Ardengo 35, 54, 204, 212, 254, 260, 262
Soulier, Eugène 92, 94
Soupault, Philippe 6, 35, 200
Speer, Albert 186
Stabenow, Cornelia 6
Stein, Gertrude 36, 38, 168, 275
Stein, Leo 36, 168, 275
Steinlen, Théophile Alexandre 121
Stieglitz, Alfred 168
Stuck, Franz von *83*
Suermondt, Edwin 6, 42
Survage, Leopold *273*

Terk, Sonia see Delaunay
Thannhauser, Heinrich 128, 129, 180
Titian 91
Toklas, Alice B. 38
Toulouse-Lautrec, Henri de 6, 21, 28, 68, 80, *80*, 100, 114, 121, 176, 190, 244
Tzara, Tristan 33, 39, 60

Uccello, Paolo 73, 88, 204, *204*
Uhde, Wilhelm 6, 15, 35, 42, 44, 46, 47, 52, *54*, 95, 97, 124, 126, 128, 129, 145, 150, 152, 171, 172, 177, 184, 186, 189, 199, 208, 212, 219, 220, *220*, 221, 224, 240, 260, 262, 274, 275

Vallier, Dora 6, 44, 148, 234, 258
Vallotton, Félix 39, 273
Valton, Edmond 192, 193, 194
Vauxcelles, Louis 160, 164, 187, 194
Velazquez, Diego 91, *91*, 149, *149*
Verlat, Charles 210, *210*
Viaud, Julien (pseudonym) see Loti
Victor Emmanuel III (King of Italy) 198
Villon, François 223
Vlaminck, Maurice de 19, 160, 199, 243
Vollard, Ambroise 19, 29, 33, 83, 97, 128, 166, 200, 209, 212, 232, 234, 236, 260
Vuillard, Edouard 160, 220

Walden, Herwarth 7, 129, 146, 147, 180, 221, 222, 249
Warnod, André 35, 208
Watteau, Jean-Antoine 88, *90*, 92
Weber, Max 95, 167, 168, 212, 219, 220, 224, 243, 254
Westheim, Paul 222
Whistler, James McNeill 32
Wilhelm II (German emperor) 184, 198
Willette, Adolphe 193
Wright, Wilbur 216

Zeppelin, Count Ferdinand von 216
Zervos, Christian 6, 100, 130

Picture Credits

Photographs were generously made available by the lenders, or came from the author's or publisher's archives. Photographs from museums which are credited in the relevant caption or catalogue entry are not listed again here.

Artothek, Peißenberg, Jürgen Hinrichs (Blauel-Gnamm) p. 231
Bibliothèque Nationale de France, Paris pp. 12, 34, 65, 275
Martin Bühler, Basel pp. 263–34
Cliché Carbonnier, Laval p. 246
Richard Carafelli, New York p. 59
C & M Arts, New York pp. 205, 207
Foto Garbani SA, Locarno pp. 103, 173
Erik Gould, New York p. 137
Courtesy Galerie Gunzenhauser, Munich pp. 122, 202
David Heald, New York p. 71
Gerhard Howald, Kirchlindach/Bern p. 105
Walter Klein, Düsseldorf pp. 98, 248
Reto Klenk, Zurich p. 241
Philippe Migeat, Paris p. 134
Photo-Müller-Jim, Oberstdorf pp. 238, 242
Réunion des Musées Nationaux, Paris pp. 75–76; photo R. G. Ojeda
pp. 93, 127, 133, 140, 141, 197
Staatsgalerie Stuttgart, Franziska Adriani pp. 120, 188
Richard Stoner, Pittsburgh p. 169
Elke Walford, Hamburg p. 155

Georges Brassaï: © Gilberte Brassaï
Robert Delaunay: © L & M Services BV, Amsterdam 201002
Oskar Schlemmer: © 2001 Oskar Schlemmer Archiv und Familiennachlaß, Badenweiler
Henri Matisse: © Succession Matisse/VG Bild-Kunst, Bonn 2001
Pablo Picasso: © Succession Picasso/VG Bild-Kunst, Bonn 2001
Joseph Beuys, Max Beckmann, Giorgio de Chirico, Otto Dix, James Ensor, Max Ernst, Wassily Kandinsky, Fernand Léger, Gabriele Münter:
© VG Bild-Kunst, Bonn 2001